DRAWING AS EXPRESSION

DRAWING AS EXPRESSION

Techniques and Concepts

SANDY BROOKE

Oregon State University

Upper Saddle River, New Jersey 07458

Library of Congress Cataloging-in-Publication Data

BROOKE, SANDY.
 Drawing as expression : techniques and concepts / Sandy Brooke.
 p. cm.
 Includes index.
 ISBN 0-13-089313-7
 1. Drawing—Technique. I. Title.
NC650 .B697 2002
741.2—dc21 2001034597

Editorial Director: *Charlyce Jones Owen*
Publisher: *Bud Therien*
AVP, Director of Production and Manufacturing: *Barbara Kittle*
Production Coordinator: *Barbara DeVries*
Production Manager: *Judith Winthrop*
Manufacturing Manager: *Nick Sklitsis*
Prepress and Manufacturing Buyer: *Sherry Lewis*
Editorial Assistant: *Wendy Yurash*
Cover Art: Gargiulo Domenico (called Micco Spadaro) *Charioteer.* Used by permission
The Metropolitan Museum of Art, Gift of Henry Walters, 1917. *Also seen on page 47.*
Cover Design: *Bruce Kenselaar*

Permissions begin on page xv and constitute a continuation of the copyright page.

This book was set in 10.5/12 Palatino by Stratford Publishing Services and
was printed and bound by Webcrafters. The cover was printed by Phoenix Color Corp.

© 2002 by Pearson Education, Inc.
Upper Saddle River, New Jersey 07458

Printed in the United States of America
10 9 8 7 6 5 4 3 2

ISBN 0-13-089313-7

PEARSON EDUCATION LTD., London
PEARSON EDUCATION AUSTRALIA PTY, Limited, Sydney
PEARSON EDUCATION SINGAPORE, Pte. Ltd.
PEARSON EDUCATION NORTH ASIA LTD, Hong Kong
PEARSON EDUCATION CANADA, LTD., Toronto
PEARSON EDUCATION DE MEXICO, S.A. de C.V.
PEARSON EDUCATION--Tokyo, Japan
PEARSON EDUCATION MALAYSIA, Pte. Ltd.
PEARSON EDUCATION, Upper Saddle River, New Jersey

To my best friend, Henry M. Sayre,
whose opinions I don't always agree with but whose advice I value.

Contents

CHAPTER 6
THE FORMAL ELEMENTS: PERSPECTIVE 110

CHAPTER 7
THE FORMAL ELEMENTS: TEXTURE AND PATTERN 140

Contents

Contents

Preface

The title *Drawing as Expression* directly refers to both the tradition of drawing prior to 1900 and the change in the direction that drawing has undertaken since the beginning of the twentieth century. Drawing has changed even more dramatically since 1940, when the possibilities of drawing expanded across media and disciplines. But in addition to discussing this historical division, *Drawing as Expression* is about thinking through drawing. Through drawing we express our ideas, create a visual language, a narrative, and use critical thinking skills in addition to our intuition. Drawing is equally a function of the left brain—structure and logic—and the right brain—chaos, deconstruction, and dreams.

The book is addressed directly to the student and designed to be user-friendly. It was not intended to cover only what an instructor might complete in one term or one semester. It covers all aspects of drawing to help professors with instruction from basic skills to the figure, and concepts. It can be used in many ways. If instructors want students to gain more knowledge about an aspect of drawing that they can only touch on with a couple of lessons in class, they can assign the students to read a few pages of the book. This will reinforce their teaching and increase the students' understanding of the material. The book is not written sequentially. Instructors may use any chapter in any order they prefer. Instructors may also use any amount of the chapter that fits their curriculum. Students can use the book as a resource to look up what the instructor is teaching or to better understand the concepts and techniques of drawing. The book was written with a running glossary. The vocabulary of art is defined as it is used in the text. Some words are defined two or three times because the chapters may not be read in order. Therefore, a student may encounter the word "chiaroscuro" first in Chapter 5, The Formal Elements: Value, and again in a later chapter.

The book was designed to provide instruction on many levels. It provides students information about drawing techniques, the function of drawing, and the concepts associated with good drawing. Drawing exercises are placed throughout the chapters providing students lessons to reinforce the concepts and techniques they are studying. Chapters 3 through 12 of the book cover the basic skills from the tradition of drawing. Historical profiles of artists are distributed through the chapters in which the profiled artist's direction, style, and use of drawing are discussed. Chapter 1 is a brief overview of the history of drawing to orient the students from the beginning of drawing through the changes in its purpose and function. Chapter 2 covers the various drawing media defining them in depth to help students understand the different characteristics of the tools of drawing.

I have tried to keep the writing in the book direct, factual, and short, neither flowery nor ambiguous. I have used quite a few student examples of drawing that I hope will relate to the students and provide them a window into the process of drawing. These student drawings were made in a Drawing I course. There are many new examples of drawing by professional artists. An effort was made to locate fresh, new images different from those available in other drawing books. In addition I have written an in-depth discussion of certain drawing processes, such as hatching and crosshatching, the process of drawing drapery, and foreshortening. Professional and student drawings are analyzed in the book to explain drawing concepts such as the picture plane, the importance of value, and the qualities of line. Drawing Exercises generally follow the discussions about the drawings in the book to give students an

experience in dealing with the concepts that were discussed. I have expanded the discussion of contemporary art into installation and performance. Chapter 13, Modern to Contemporary Drawing, is a discussion of the changes in drawing and thinking in the arts from Paul Cézanne to Jonathon Borofsky. It is the type of chapter that instructors might use in a concepts of drawing course.

No one writes a book like this alone. I would like to thank the people who have helped me. The student work in the book was photographed by an extremely talented young photographer, Elizabeth Miller. She not only photographed all the work but she also scanned the slides onto zip discs and labeled all three copies of the slides. She did a terrific job, saving me hours of work. Thank you so much, Liz. The museums that provided the professional black-and-white photographs and color transparencies were wonderful to work with. I wish to thank the Metropolitan Museum of Art not only for permission to use the museum's art but for allowing me to spend an entire day looking through their photo archives. Thank you Mary. I would also like to thank the Cantor Arts Center at Stanford University and Alicja Egbert; Sarah Clark-Langager of the Washington Consortium; Pamela and Karen at the Portland Art Museum; the San Francisco Museum of Modern Art and Susan Backman; the Hirshhorn Museum and Sculpture Garden and Amy Densford, who was very kind and helpful; the Phillips Collection and Christopher Ketcham in Washington, D.C.; Yale University Art Gallery, the Art Institute of Chicago and Nicole G. Finzer; the Hispanic Society; the Muscarelle Museum of Art at the College of William and Mary in Virginia; the Solomon Guggenheim Museum; the Museum of Fine Arts in Boston; Art Resources and Eileen Doyle; the Artist's Rights Society and Caitlin Miller; and Kate at the Pierpont Morgan Library, New York. The galleries I called were equally helpful and I would like to thank the Paula Cooper Gallery and Simone Subal, Sperone Westwater, thanks, Karen; the Phyllis Kind Gallery and Ron Jagger; and the Bernise Steinbaum Gallery in Miami. I would like to thank my students in Drawing I at Oregon State University and the University of Oregon for permitting me to publish their work in the book. These students were wonderful to work with and most generous in letting me use their drawings to illustrate the book. I want to thank Pat Passlof and Milton Resnick for the hours they spent with me on the phone getting the text correct and helping me to better understand their work. I would like to thank Christian Gladu, an artist and designer of the Bungalow Company for contributing drawings to illustrate concepts in the Perspective Chapter (6). Having someone else do the drawings was a huge help. Thank you to the people at Prentice Hall, Wendy Yurash, Kimberly Chastain, Barbara DeVries, and the production editor Judy Winthrop, for their constructive, constant, and invaluable help. Thanks to my editor, Bud Therien, for giving me the chance to write this book; it has been a most rewarding experience. I would like to thank the Prentice Hall reviewers: Ricki Klages, University of Wyoming; Janice D. Kmetz, University of Minnesota, Duluth; Wil Martin, The University of Texas-Pan American; William A. Marriott, University of Georgia; L. Beatriz Arnillas, Seton Hill College. It took over a year to write this book. I know I was difficult for my family to deal with, starting with their listening to my daily progress reports to hearing the lists of what I had left to do, so for your patience and support, I salute Alberta and Milton Griffith, Christen Gladu, Rob, and John Sayre. Thank you all.

CREDITS

66.2026.A-B. **p. 157** Hirshhorn Museum and Sculpture Garden Smithsonian Institution. Gift of Joseph H. Hirshhorn, 1966. Photography by Lee Stalsworth. **p. 158** (left) Chandra Allison, student drawing; (right) Misako Mataga, student drawing. **p. 159** The Pierpont Morgan Library, New York/Art Resource, NY. **p. 160** Iris & Gerald Cantor Center of Visual Arts at Stanford University. 1965.128. Estate of Oliver C. Frieseke, Jr. **p. 161** (top) Jennifer Borg, student drawing; (bottom) Andrea Galluzzo, student drawing. **p. 162** (top) Michael Taddesse, student drawing; (bottom) Josh Turner, student drawing. **p. 163** (top) Alisa Baker, student drawing; (bottom) Iris & Gerald Cantor Center of Visual Arts at Stanford University; 1955.1077. Bequest of Florence Williams. **p. 164** (top) Joseph Davis, student drawing; (bottom) Iris & Gerald Cantor Center of Visual Arts at Stanford University; 1984.502. Bequest of Dr. and Mrs. Harold C. Torbert. **p. 165** Virginia Wright Fund, Washington Art Consortium. Photography by Paul Brower. **p. 166** Virginia Wright Fund, Washington Art Consortium. Photography by Paul Brower. **p. 167** Ron Graff. Courtesy of the artist. **p. 168** Lili Xu, student drawing. **p. 169** Iris & Gerald Cantor Center of Visual Arts at Stanford University; 1976.94. Mortimer C. Leventritt Fund. **p. 170** The Metropolitan Museum of Art, The Robert Lehman Collection, 1975 (1975.1.272v). **p. 172** (top) Megan Brown, student drawing; (bottom) Joseph Davis, student drawing. **p. 173** (top) Chandra Allison, student drawing; (bottom) Matt McDonal, student drawing. **p. 175** The Metropolitan Museum of Art, Bequest of Walter C. Baker, 1971 (1972.118.238). **p. 176** The Metropolitan Museum of Art, Rogers Fund, 1961 (61.128). **p. 177** (top, bottom left) Megan Brown, student drawings; (bottom, right) Charles Greene, student drawing. **p. 179** The Metropolitan Museum of Art, Rogers Fund, 1961 (61.161.1). **p. 180** (top) John Whitaker, student drawing; (bottom) Mike Vandeberghe, student drawing. **p. 181** Virginia Wright Fund. Washington Art Consortium. Photography by Paul Brower. **p. 182** Hirshhorn Museum and Sculpture Garden Smithsonian Institution. Museum Purchase, 1979. **p. 183** Hirshhorn Museum and Sculpture Garden Smithsonian Institution. Gift of Joseph H. Hirshhorn, 1966. **p. 184** San Francisco Museum of Modern Art. Gift of the Diebenkorn family and purchased through a gift of Leanne B. Roberts, Thomas W. Weisel, and the Mnuchin Foundation. **p. 185** (top) The Metropolitan Museum of Art, Harris Brisbane Dick fund, 1935 (35.103.49); (bottom) Deborah Finch, student drawing. **p. 186** (left) Matt McDonal, student drawing; (right) Sabrina Benson, student drawing. **p. 187** Lili Xu, student drawing. **p. 188** (top) Joseph Davis, student drawing; (bottom) Beth Stinson, student drawing. **p. 189** (top) Sabrina Benson, student drawing; (bottom) Justin Smith, student drawing. **p. 190** Iris & Gerald Cantor Center of Visual Arts at Stanford University; 1974.199. Committee for Art Acquisitions Fund. **p. 192** (top) Charlie Greene, student drawing; (middle) Megan Brown, student drawing; (bottom) Lili Xu, student drawing. **p. 193** (top) Joseph Davis, student drawing; (bottom, left) Ryan Coffman, student drawing; (bottom, right) Chandra Allison, student drawing. **p. 194** Lili Xu, student drawing. **p. 195** The Metropolitan Museum of Art, Pfeiffer Fund, 1962. (62.120.7). **p. 196** Portland Art Museum. Ella Hirsch Fund. **p. 197** (top) Lili Xu, student drawing; (bottom) Justin Smith, student drawing. **p. 198** The Metropolitan Museum of Art, Rogers Fund, 1963 (63.125). **p. 200** McKee Fund, 1957.358. Photograph © 2001, The Art Institute of Chicago. All rights reserved. **p. 201** (top) Chandra Allison, student drawing; (middle) Brooke Cutsforth, student drawing; (bottom) Lili Xu, student drawing. **p. 203** Iris & Gerald Cantor Center of Visual Arts at Stanford University; 1982.170. Committee for Art Acquisitions Funds. **p. 204** (top) Arthur Heun Fund, 1951.1 Photograph © 2001 The Art Institute of Chicago. All rights reserved; (bottom) Gift of Mr. and Mrs. Allan Frumkin, 1975.1127. Photograph © 1995. The Art Institute of Chicago. All rights reserved. **p. 205** (top) Arthur Heun Fund, 1951.1 The Art Institute of Chicago. All rights reserved; (bottom) Erin Stephenson, student drawing. **p. 207** The Pierpont Morgan Library/Art Resource, NY. **p. 208** (top) Matt McDonal, student drawing; (bottom) Michael Taddesse, student drawing. **p. 209** (top) Kevin Cunningham, student drawing; (bottom) Andrea Galluzzo, student drawing. **p. 211** Hirshhorn Museum and Sculpture Garden Smithsonian Institution, 66.1182. **p. 212** The Pierpont Morgan Library/Art Resource, NY. **p. 214** (top) Eric Bailey, student drawing; (bottom) Sabrina Benson, student drawing. **p. 215** (top) Misako Mataga, student drawing; (bottom) Alicia Frederick, student drawing. **p. 216** (top) Sarah Parish, student drawing; (bottom) Mandy Reeves, student drawing. **p. 217** (top) Ashley Carter, student drawing; (bottom) Mandy Reeves, student drawing. **p. 218** (top) Vlad Voitovski, student drawing; (bottom) Amelia Eveland, student drawing. **p. 219** Courtesy of the artist. **p. 220** The Pierpont Morgan Library/Art Resource, NY. **p. 221** (top) Amelia Eveland, student drawing; (bottom) Mandy Reeves, student drawing. **p. 222** Metropolitan Museum of Art, Rogers Fund, 1925 (25.107.1). **p. 223** (top) The Metropolitan Museum of Art, Fletcher Fund, 1942 (42.186.2); (bottom, left) Erin Stephenson, student drawing; (bottom, right) Angela Gross, student drawing. **p. 224** Amelia Eveland, student drawing. **p. 225** The Metropolitan Museum of Art, Gift of Paul J. Sachs, 1916 (16.2.6). **p. 226** Chandra Allison, student drawing. **p. 227** Francis A Countway Library of Medicine, Boston. **p. 228** The Metropolitan Museum of Art, Rogers Fund, 1968 (68.113 recto). **p. 229** (top) Mandy Reeves, student drawing; (bottom) Sarah Parish, student drawing. The Metropolitan Museum of Art, Bequest of Mrs. H. O. Havenmeyer, 1929. The H. O. Havenmeyer Collection (29.100.05). **p. 231** Portland Art Museum, Oregon. Gift of Lucienne Bloch and Stephen Dimitroff. © Banco de Mexico Diego Rivera Museum Trust. **p. 232** Iris & Gerald Cantor Center of Visual Arts at Stanford University; 1973. 123.3 Anonymous gift. **p. 233** Portland Art Museum, Oregon. Purchased from Anonymous Purchase Fund. **p. 234** Portland Art Museum, Oregon. Gift of Mrs. Mildred Beail. **p. 235** Hirshhorn Museum and Sculpture Garden Smithsonian Institution. Gift of Joseph H. Hirshhorn, 1966. **p. 236** Iris & Gerald Cantor Center of Visual Arts at Stanford University; 1971.35. Museum Purchase Fund. **p. 238** Iris & Gerald Cantor Center of Visual Arts at Stanford University; 1989.62 Committee for Art Acquisitions Fund. **p. 240** Portland Art Museum, Oregon. Hirsch Fund Purchase. **p. 241** The Metropolitan Museum of Art, The Robert Lehman Collection, 1975 (1975.1.801). **p. 242** The Pierpont Morgan Library/Art Resource, NY. **p. 243** Gift of Mr. and Mrs. Eugene Victor Thaw. The Pierpont Morgan Library/Art Resource, NY. **p. 244** Portland Art Museum, Oregon. Gift of Suzanne Vanderwoude. **p. 245** The Pierpont Morgan Library/Art Resource, NY. **p. 246** Iris & Gerald Cantor Center of Visual Arts at Stanford University; 1971.33. Museum Purchase Fund. **p. 247** (top) The Metropolitan Museum of Art; (bottom) Iris & Gerald Cantor Center of Visual Arts at Stanford University; 1981.264. Robert E. and Mary B. P. Gross Fund. **p. 248** (top) The Pierpont Morgan Library/Art Resource, NY.; (bottom) Iris & Gerald Cantor Center of Visual Arts at Stanford University; 1983.87. Committee for Art Acquisitions Fund. **p. 249** Portland Art Museum, Oregon. Gift of Mark Rothko Foundation. **pp. 250–54** Hirshhorn Museum and Sculpture Garden Smithsonian Institution. **p. 257** Courtesy of the artist. **p. 258** Acquired 1955. The Phillips Collection, Washington, D.C. **p. 259** Portland Art Museum, Oregon. Blanche Eloise Day Ellis and Robert Hale Ellis Memorial Collection Fund. **p. 260** (top) Photograph © 2001 The Art Institute of Chicago. All rights reserved; (bottom) Courtesy of the artist. **pp. 261–63** Courtesy of the artist. **p. 264** Courtesy of the artist. **p. 265** Portland Art Museum, Oregon. Pratt Fund Purchase. **p. 266** Portland Art Museum, Oregon. Binney Fund Purchase. **p. 267** Jennifer Tavel, student drawing. **p. 268** Sherry Holiday, student drawing. **p. 269** (top) Christopher Pangle, student drawing; (bottom) Edward Cheong, student drawing. **pp. 270–71** Courtesy of Bernice Steinbaum Gallery, Miami, FL. **p. 273** Courtesy of Bernice Steinbaum Gallery, Miami, FL. **p. 275** Hirshhorn Museum and Sculpture Garden Smithsonian Institution. **p. 276** Hirshhorn Museum and Sculpture Garden Smithsonian Institution. **p. 277** Virginia Wright Fund, Seattle; Museum of Art. Photographer: Paul Brower. **p. 278** Virginia Wright Fund, Seattle; Museum of Art. Photographer: Paul Brower. **p. 279** Iris & Gerald Cantor Center of Visual Arts at Stanford University; 1984.521. Bequest of Dr. and Mrs. Harold C. Torbert. **p. 280** Courtesy of the artist. **p. 281** Nicole Williams, student drawing. **p. 282** Virginia Wright Fund, Seattle; Museum of Art. Photographer: Paul Brower. **p. 283** (top) Virginia Wright Fund, Seattle; Museum of Art. Photographer: Paul Brower; (bottom) Washington Art Consortium. Photographer, Paul McCapia. **p. 285** The Metropolitan Museum of Art. Gift of Arlene and Harold Schnitzer, 1982 (1982.153.1) **p. 286** Gift of Virginia and Bagley Wright. Washington Art Consortium. Photographer: Paul Brower. **p. 287** Virginia Wright Fund. Washington Art Consortium. Photographer: Paul Brower. **p. 288** Virginia Wright Fund. Washington Art Consortium. Photographer: Paul Brower. **p. 289** (top) Gift of Virginia and Bagley Wright, Seattle Art Museum. Photographer: Paul Brower; (bottom) Gift of Charles Cowles, Seattle Art Museum. Photographer: Paul Brower. **p. 290** Virginia Wright Fund, Seattle Museum of Art. Photographer: Paul Brower. **p. 291** Virginia Wright Fund, Seattle Museum of Art. Photographer: Paul Brower. **p. 292** Hirshhorn Museum and Sculpture Garden Smithsonian Institution. **p. 293** Hirshhorn Museum and Sculpture Garden Smithsonian Institution. **p. 294** Hirshhorn Museum and Sculpture Garden Smithsonian Institution. **p. 295** Hirshhorn Museum and Sculpture Garden Smithsonian Institution. **pp. 296-97** Courtesy of Goat Island. **pp. 298-99** Courtesy of Paula Cooper Gallery. **p. 300** (top) Courtesy of the artist; (bottom) Courtesy of the artist. **p. 301** Virginia Wright Fund, Seattle; Museum of Art. Photographer: Paul Brower.

Credits

CHAPTER 1
INTRODUCTION

DRAWING THROUGH TIME: A BRIEF HISTORY OF THE EVOLUTION OF DRAWING

HUMAN BEINGS first drew the outlines of animals on the walls of a cave thirty thousand years ago. The recent discovery of Chauvet in the south of France has been determined to hold the oldest recorded marks by human beings. Previously Lascaux cave had the oldest known drawings. The drawings at Lascaux were 14,000 years old. So before the human race had written or an extensive verbal language, humans communicated with drawing.

The walls were scraped before the drawings were put on, illustrating that these early people consciously prepared the surface to make the drawings. Drawing can be thought of as an early form of language and as such is directly tied to thinking as well as seeing. The walls contain not only drawings but prints of hands that show completely and fully developed fingers and thumb.

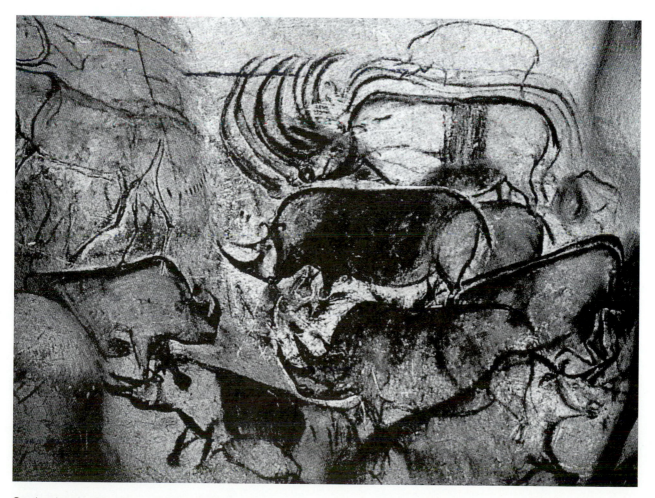

Overlapping shapes of rhinos in Chauvet Cave.

There were not only drawings on the walls but, some images were engraved or carved into the walls. This early bas relief links printmaking as a descendant of these early engravings. Printmaking and drawing are closely related, sharing techniques today such as cross-hatching and other mark marking techniques. The word "technique" comes from *techne,* which in Greek means a way of making art.

Drawing books will often use an etching or lithograph to illustrate a concept of drawing. A lithograph is a drawing done on transfer paper or directly on a stone. Once it is etched the drawing can be reproduced in an edition by the printing press. The initial development of the print is technically a drawing.

Drawing is directly related to visual awareness and our thinking process.

The people who lived in Chauvet cave understood how to translate real space into two-dimensional space. There is a drawing of Rhinos in which each outline overlaps another. They may have been drawing a herd of Rhinos but in drawing overlapping shapes they were demonstrating advanced thinking processes. Overlapping shapes create space and are the first step in perspective. There is another drawing of a bison with eight legs that reinforces our senses that these early people had a certain understanding of space and rhythm or motion.

Linear perspective was first recorded in a book on painting in 1419. Filippo Brunelleschi in Italy during the Renaissance made an astute observation about how we could translate three dimensions into two dimensions. The ability of these early people to interpret, translate, and draw spacially indicates an earlier elevated visual awareness and technical prowess that we hadn't suspected. These people could translate three-dimensional space into two-dimensional space, thereby demonstrating visual skills and an understanding of space exceeding that of civilizations who followed them.

Drawing plays a significant role in one of the last primitive cultures living today, the (Aborigines.) The Australian Aborigines have no word for art. They have only songs, ceremonies, maps, rock paintings, and body painting as lifestyle forms. They communicate through symbols, marks, and pictures. They have developed a series of symbols that we might class as abstract but to them represent ideas, locations, descriptions of events, and symbols for ceremonies crucially important to their way of living. The aborigines drew in the sand or in the earth, on rock walls, on birch panels and on sticks. The drawings were used in their lives.

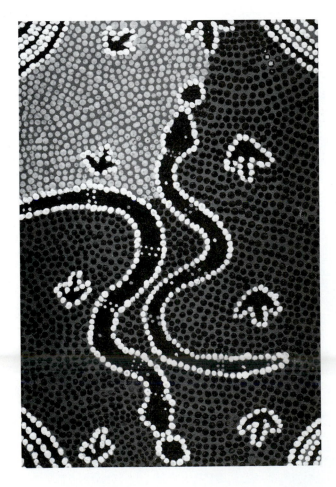

Anthropologists in the 1970s feared the Aborigine stories and symbols would be lost as nature eroded the work away. In an effort to save the culture they provided the Aborigines with acrylic paints and canvas board on which the designs and stories could be preserved. In the past the "Dreaming" which is how they refer to images, would be laid out in the sand, and the wind would blow it away when the ceremony ended. Today you can purchase paintings like the one on the left by aborigine artists.

Billy Jaburula, *Snake Traveling North.* Acrylic on canvas board 9 × 12". From the collection of Henry Sayre and Sandy Brooke.

Introduction

Each composition of these marks has full meaning to the Aborigines. For instance, when they need to give instructions to get across the desert, they draw a map with symbols for the person traveling. When one member of a tribe travels to another, he will carry to that tribe a pole with symbols on it to relate the purpose of his journey and visit. When young men are initiated, their bodies are painted. Drawings and paintings are drawn in the earth to enhance the ceremony and to call on the people's ancestors for a blessing. At the closure of the ceremony, all the images created for the event blow away with the wind.

The Aborigines also have ancient drawings of animals on the walls of caves and cliffs made by their ancestors thousands of years ago. They believe that through drawings and paintings they can communicate with their ancestors, whom they revere on the highest levels as the creators of all things in their world.

Drawing was first considered an art during the Renaissance. The Italians refer to sketches as *pensieri,* meaning "thoughts" or "rough drafts." The intellectual curiosity and inventiveness of Leonardo da Vinci is recorded in his drawings. It was impossible for him to create all the projects he thought of, but he could work his ideas out in his drawings. Some feel that Leonardo never intended to build many of his plans. Some—like the flying machine—were visions of what would come in the future. He could only imagine man could fly; he had no process to take the idea any further. Drawing provided an outlet for the thousands of ideas he had. Drawing preserved his thinking process. There lies the difference between an artist's sketches and a finished work. The sketches can be done quickly, working out problems of space, volume, form, and other relationships. The artwork would often take years and many apprentices to complete. "Tell me if anything was ever done," Leonardo asked in his manuscripts. It expresses his frustration at having limitless vision in all fields, with finite constraints leaving him powerless to realize a final form, or a product.

Leonardo is credited with developing a soft modeling in light and dark called *sfumato,* which enabled him to overcome the previous process *Quattrocento* that Vasari described as "the dry and hard manner."

Leonardo was born the illegitimate son of Caterina a peasant girl, who later married Pieros, a man from a Florentine family with a house in Vinci, which became Leonardo's first home. In 1469 Leonardo entered the workshop of Andrea Verrocchio, whose other apprentices included Sandro Botticelli and Pietro Perugino.

The artist's course in the Renaissance was gradual. The first drawing surfaces were wooden tablets, boxwood panels the size of the hand. The young student artist would draw on this box with a steel point. After each drawing was completed, it was smoothed out with a powdered cuttlebone on both sides. Bone dust and saliva were mixed together to create the working surface. The metal point used for drawing was similar to that used in silverpoint.

Leonardo da Vinci, *Studi tecnologici.* Pen with traces of lead, 283 × 201 mm. New York, Pierpont Morgan Library. inv. 1986.50.

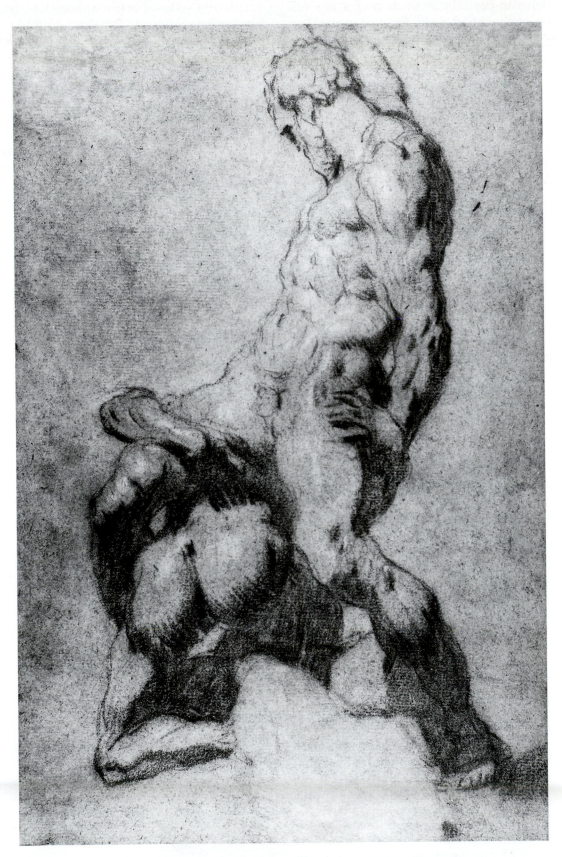

Tintoretto (Jacopo Robusti), 1518–94. Study after Michelangelo's *Group of Samson Slaying the Philistines.* Black chalk heightened with touches of white chalk, on buff-gray paper. 345 × 227 mm. 1983.231 Committee for Art Fund, Canter Arts Center, Stanford University.

Introduction

Leonardo described the plan of study for the apprentice. First he must learn perspective, then the shapes and measurements of many objects. After that he could draw copies of the master's work in order to accustom himself to good proportions. He went from drawing outlines, to comparing sizes and relationships between near and distant objects, to developing a sensitivity to light and shape. Finally he drew from nature to test his learning. He was expected to spend time looking at the work of various masters. Finally he must learn to exercise his art practically.

In addition to everything else students of the Carracci family in Bologna drew studies of bones, muscles, sinews, and veins from dissected corpses. Drawing the nude model was the last step in the five-year apprenticeship. Students started with silverpoint on wood boxes for the first year. The second year they made pen and ink sketches with wash and then ink on colored paper with highlights, and finally they drew with charcoal. The process of studying to be an artist was a long one. They schooled the hand, the eye, and the memory first to understand form. In "rilievo," the second stage, they analyzed the surface by drawing from a simple natural object or a plaster cast. By the third stage a student was expected to understand proportion, perspective, space, and light. This would involve drawing outdoors. Drawing from a live model was five years from the beginning of a young artist's training.

The stages of knowledge, initiation, learning, and illumination are completed by creativity. An idea is the beginning, expressing the unity and integrity of a whole work. For the great artists of the Renaissance, the path to art began in drawing.

By the end of the fifteenth century drawing was considered an act that embodied the artist's personality and creative genius. The fact that people began collecting drawings confirmed their value. Vasari was a major collector of drawings. At the same time, Michelangelo destroyed most of his drawings because he didn't want anyone to steal his creative process or discover his way of working. He felt the drawings exposed his ideas. Vasari agreed and being the first to recognize drawing as important observed that the drawings of Michelangelo and Leonardo were as close as we could come to seeing the "actual creative moment." Drawing for Vasari was a manifestation of creative thinking.

Leonardo was left-handed and capable of "mirror-writing," which is to write backwards. He used his skill in mirror writing to record

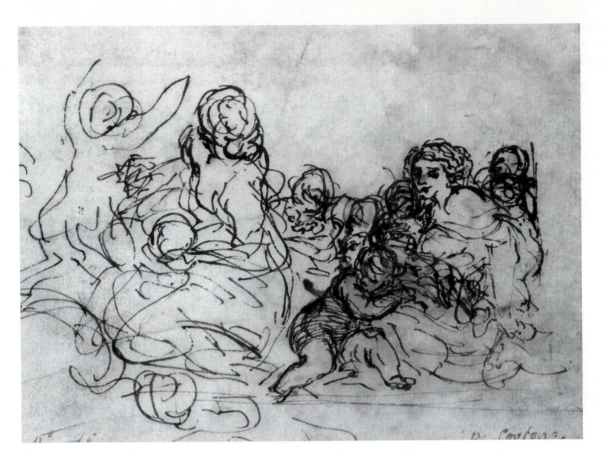

Pietro Da Cortona (Pietro Berrettini), 1596–1669, Study for a Figure Group in the Ceiling Fresco of the Palazzo Barberini c. 1623. Pen and brown ink on ivory laid paper. 110 × 149 mm, Inscribed lower right in another hand: P Cortona. 1977.12 Mortimer C. Leventritt Fund, Stanford University.

things in his notebooks that he did not want people to see or read. In addition he had his own system of signs and abbreviations that he used in writings about his working drawings to hide their meaning. We surmise this was for his own protection against those who might charge him with heresy and witchcraft because his ideas and projects were so far ahead of their time. He also feared the uses to which the destructive nature of man might put some of his inventions. He once wrote, "What would secure the good, if the bad invaded from the sky?"

Unlike Albrecht Dürer, who regarded each natural object as a unique phenomenon, Leonardo sought analogies and universal principles of organic growth. A drawing of swirling grasses in his mind might relate to winding tresses of hair or the spiral movement of eddies of water. Each of his drawings were a complete statement influenced by a deep awareness of the relationships between all that exists and tireless exploration.

Pietro Da Cortona's sketch above is one of very few "first-idea" drawings that exist. It is an example of a working drawing that sacrifices an attractive finish to address the balance and the scale of the space it would later be painted in at the Palazzo Barberini. He designed a grand fresco decoration for the vault of the reception chamber of the Palazzo Barberini in Rome, and painted it between (1633–1669).

Albrecht Dürer was a painter, draftsman, engraver, writer, and traveler. He was the most important artist of the German school and did more than anyone to bring the spirit and artistic ideals of the Italian Renaissance to Germany. A contemporary of Leonardo, he spent time in Venice. Artists were respected in Italy but not in Germany. The insight below from his writings seems to transcend time. While in Venice Dürer found time between his studies to attend dance class. He wrote to his portly friend Pirkheimer in Germany that he would dearly love to see him do a new dance called "the Imperial hop." The hop has been reinvented ever since. Dürer succeeded in replacing the German view of the artist as the humble artisan with the Italian ideal of the artist as gentleman, humanist, and scholar. While his theoretical writings on geometry, per-

spective, and human proportions remained intensely Germanic, the Italian ideas of harmony and beauty found their way into his work. Intellectually Dürer grasped the significance of volume, mass, and selectivity of form, absorbing those elements into his work. He was the master of wood and copper engraving. He left hundreds of drawings from records of costumes, landscapes, people animals, buildings to preparatory studies. To Dürer every reed in a clump of turf and every hair on a rabbit's back was equally important. Dürer had the ability to embrace the most varied aspects of life. His searching vision provided a vivid commentary on the world around him. Dürer once declared that all his creative work sprang from one source: "the gathered secret treasure of the heart."

The progress and significance of drawing can be seen in the lines of the artists following Dürer. Rembrandt lived from 1606–1669. He did not regard his drawings as moneymakers. They were a highly personal activity. Drawing was a means of training his eye and keeping his hand in practice. His drawings reveal the inventiveness of his mind. Rembrandt might use an element from one of his drawings in a painting, but the sketches were independent works of art, or ends in themselves for him.

Francisco José de Goya y Lucientes was born in 1746 in Spain. He died in 1828 at forty, but his work spanned the eighteenth and nineteenth centuries. A rococo decorator, a genius, he created work that was comic, tragic, light and dark, passionate yet sardonic. He saw the political and social upheavals of the French Revolution and the Napoleonic invasion of Spain. Goya is the father of the contemporary use of value in drawing as the artist's tool rather than the reflection of actual light falling across form.

The period 1780–1867 saw the rise of the great French draftsman Jean Auguste Dominique Ingres. Théodore Géricault followed Ingres from 1791–1824. After Géricault came Eugène Delacroix (1798–1863) and

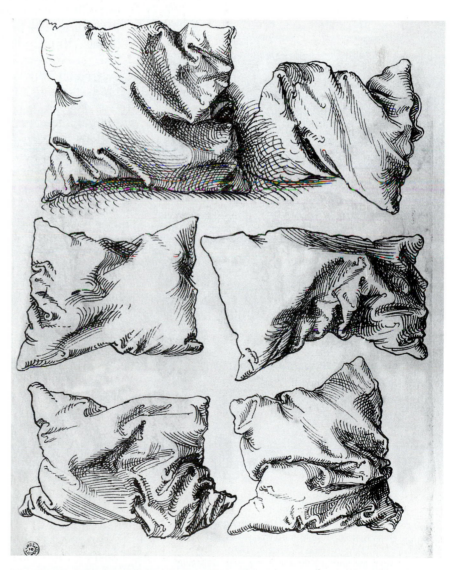

Albrecht Dürer, *Six Pillows*. Pen and Ink. German. 15th C., 1493. H. 11 × W. 8" (28 × 20.3 cm) The Metropolitan Museum of Art, Robert Lehman Collection, 1975. (1975.1.862).

Introduction

Jean-Baptiste-Camille Corot (1796–1875). Born in 1832 Edouard Manet broke with the traditions of drawing that had began in the Renaissance. Along with other artists, such as Vincent van Gogh (1853–1890), Henri de Toulouse-Lautrec and Edgar Degas drawing changed and was redefined.

Modernism freed drawing from its role as a planning tool. Richard Diebenkorn's *Ocean Park* series is an example of drawing's new role. This work was seen as meditations on the local landscape of Santa Monica in 1968. These drawings from 1970 were not studies for paintings but were finished pieces of art. The drawings, done after the paintings, may be considered on their own terms. They find their beginnings in formal structure, balanced by sensual geometry and often painterly effects.

This drawing on the facing page is austere but still reflects Diebenkorn's delight in the vitality of line. His line grows, takes on weight and bends, thins out and resumes moving. Some lines are drawn; others are formed by tearing or cutting and then pasting the paper back together. He veils the drawing in white gouache.

Diebenkorn always acknowledged his debt to the influences of our rich culture of modern art and artists such as Henri Matisse, who said once he would rather students did not see his drawings because the uninitiated think his simple line is easy, whereas he would do at least a hundred drawings to find that simple line.

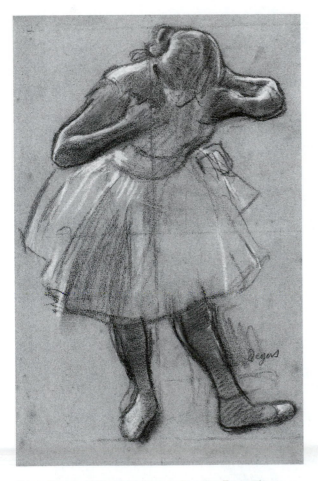

Edgar Degas, 1834–1917, *Dancer Bending Forward.* Charcoal with stumping heightened with white and yellow pastel with stumping, on blue laid paper, 1874–1917, 46.2 x 30.4 cm. Mr. and Mrs. Martin A. Ryerson Collection, 1933.1230. Photograph ©2001. The Art Institute of Chicago. All rights reserved.

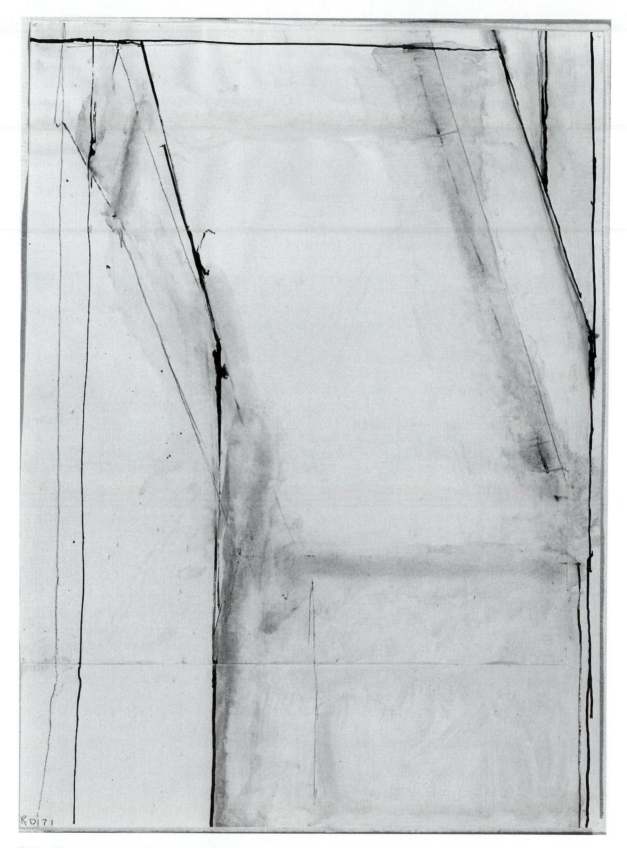

Richard Diebenkorn, (b.1922), *Untitled (Ocean Park)* 1971. Ink and gouache on cut-and-pasted coated paper. 604 x 451 mm. signed and dated lower left: RD 71. 1983.322. Gift of Paul Rickert. Provenance: Paul Rickert, San Francisco. Stanford University.

Introduction

GENDER AND RACE ISSUES IN ART

One of the difficulties an author faces in writing an art book is finding art that represents the work of women artists and artists of color or men and women artists who are not white Europeans. It is a fact that through 1971 discrimination by museums, galleries, and art publications was evident against white women as well as men and women of color. These statistics are from Henry Sayre's book *The Object of Performance*.

In 1960, 60% of all bachelor degrees awarded in studio art and art history were awarded to women. As of 1976, approximately 50% of the professional artists in this country were women. Despite the . . . predominance of women in the profession, in 1970–71 of the forty-five New York galleries showing the work of living artists, only 13.5% . . . were women. By 1976 . . . only 15% of the one (man) shows in New York were by women. Worse . . . of the 995 one-person exhibitions at the Museum of Modern Art from 1928 to 1972 only five were by women. Coverage in arts magazines of living men and women artists for the year June 1970–June 1971: in Art in America the number of artists reviewed were 12 men to 1 woman; in Artforum it was 7 men to 1 woman; in Artnews it was 4 men to 1 woman and Arts Magazine it was 5 to 1.

These odds have been radically reduced to where in 1990 the ratio of men to women art shows in New York is closer to 1 to 1. Therefore, we have greater access to the work of contemporary women and artists from backgrounds other than white European. We still do not have well-documented records of art by women prior to 1850. This was one of the driving forces behind the foundation of the National Museum of Women in the Arts in Washington, D.C.

Artists of color have the exact same problem in being represented. That is why the contemporary chapter in this book is the most diverse, discussing work by Native American and Asian artists, white women, and African-American artists. You understand the depth of this problem when you consider that H. W. Jansen's *History of Art* was for years the definitive book for art history courses around the country, and there was not a single woman mentioned in the first edition. Women's work was considered to be craft, folk art, or decorative arts and not considered important or serious by the art historians and art critics. Women who painted and sculpted were ignored, or their work was credited to the men they worked with in the studios.

There are a few women artists recognized today who worked prior to the nineteenth century. Their work is included more and more in new art history books. Recently a film was made about Artemisia Gentileschi, who painted a self portrait in 1630 showing herself as the painter. This painting possesses all the intellectual authority and dignity of a Leonardo or a Michelangelo. We know over twenty male artists from the Renaissance but only a few women.

The seventeenth-century Dutch artist Judith Leyster (1609–60) has been given credit for paintings previously thought to be by Frans Hals. When they were cleaned, her signature was discovered. Misattributions were often genuine mistakes made by art dealers, but unscrupulous dealers have been found to have removed the original signatures of women artists and lesser-known male painters posthumously to ascribe the work to better-known masters, thus generating a higher price for the work.

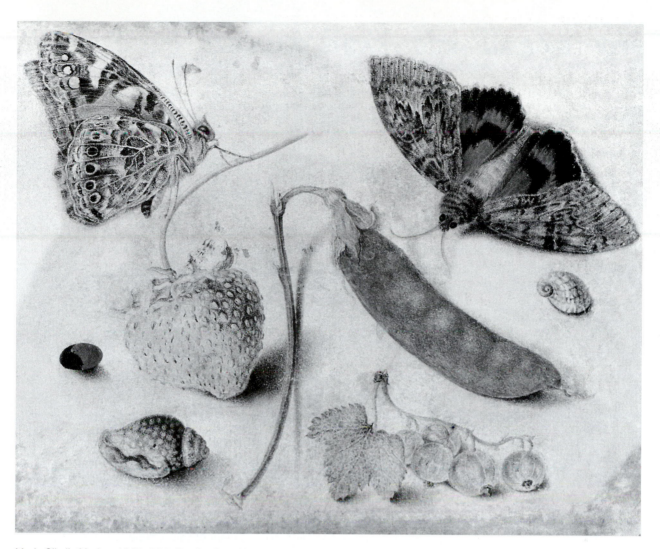

Maria Sibylla Merian, 1647–1717. Studies from Nature: butterfly, moth, strawberry, pea pod, white currants, shells. Watercolor on vellum. H. 9.2 cm., W. 11.3 cm. The Metropolitan Museum of Art, Fletcher Fund, 1939. (39.12).

Maria Sibylla Merian (1647–1717) was a naturalist and an artist. She was the daughter of Mattheus Merian, the owner of a publishing company. Her first engravings were published at the age of twenty-two. Her father was very supportive of her developing an art career and provided her with instruction in painting and engraving while she was young.

Her marriage to the painter Johann Andreas Graff was unhappy, and in 1699 after twenty years of marriage and two daughters she declared herself a widow prematurely, and sailed to the tropics. She spent two years in Surinam with her daughter, Dorothea, making draw-

ings or renderings of butterflies. When she returned to Amsterdam her book *Metamorphosis Insectorum Surinamensium* was published. The sixty engravings of butterflies, banana plants, and pea pods are referenced today by botanists. Her work was so elegant, delicate, and precisely accurate that it can be used today by botanists studying these life forms.

One of the reasons women could not compete in the arts was that they had to balance the demands of raising a family with making art. Thus we find few women in the arts until the 1800s.

PROFILE OF AN ARTIST: KÄTHE KOLLWITZ

Käthe Kollwitz, German, 1867–1945, *The Time Will Come.* Pencil on paper, 1919, 21.5 × 36.5 cm. Portland Art Museum, Oregon, Vivian and Gordon Gilkey Graphic Arts Collection. © 2001 Artists Rights Society (ARS), New York/VG Bild-Kunst, Bonn.

Käthe Kollwitz, born in 1867, was given instruction in the arts, and when she decided to marry at a very young age, her father was very disappointed. He feared that, as happened with her sister, her marriage would end her art career. He warned her it would be hard to combine her art and her family. But Kollwitz struggled with the demands of family and art and was able to balance her two lives. She believed her art had a purpose, "to be effective in this time when people are so helpless and in need of aid." Kollwitz was married to a doctor who felt his calling was to help poor workers, not the middle and upper class, a philosophy she shared.

Käthe Kollwitz could be called "The Mother of Expressionsim," as the artist Edvard Munch, who painted *The Scream,* could be called the "Father of Expressionism." Although her work came well before the work we call German Expressionism.

Her work combined the personal and the political. Like Goya, she was a master of using chiaroscuro, or balancing black and white, to create the greatest drama and the richest space of drawing. The human figure was her subject. She showed us the horror of hunger, war, and poverty as well as beauty, love, and caring.

Her son Peter's death in World War I confirmed her lifelong opposition to war. She saw the irony of the old sending the young to kill one another. To her death she worked as an antiwar promoter.

Working mainly in black and white, she concentrated on the life of the workers in Germany. She illustrated the working conditions in Germany which were worse than sweat shops today. She made posters that called attention to the issues of abortion, hunger, alcoholism, children's safety, and worker safety.

Her private suffering and political oppression were reflected in her art. Her politics and her aesthetics joined in her prints and drawings. Determined to make prints that the workers could afford, she worked in black and white, simply and inexpensively.

For Kollwitz drawing and graphic techniques were best suited to her quest to express the darker aspects of life. She believed in the power of line and gesture and always insisted upon the human figure as her subject. In this drawing on the left she provides us with a fine example of the strength with which she empowered lines. The hands are drawn large which makes them extremely expressive.

She made over a hundred drawings, lithographs, and sculptures of herself—leaving an amazing biography. Looking from one to another, we watch her grow old, and it seems her face begins to reflect the faces of the workers. She said once that bisexuality was a necessary factor in artistic production and that it was the piece of masculinity within her that helped her in her work.

With stoic strength she endured World War II and defended her art to the Nazis. She died convinced that one day a new ideal would arise and never again would there be war.

LEFT- AND RIGHT-BRAIN THINKING: LEARNING TO SEE

Mandy Reeves. Conté, student drawing, 2000.

Seeing is at the heart of the interactive process of drawing. We perceive the external reality—or the real world, as it is commonly referred to—with our eyes open. With our eyes closed, the mind's eye searches the images of our inner reality. Our inner reality stores memories of past adventures, activities, interactions, loves, feelings, and fears. In addition it is here we imagine the future. Our drawings come out of these two forms of vision—one external and one internal.

A drawing can communicate our thoughts and perceptions as well as our awareness of the world. The mind's eye is powerful. The information your eyes send to your brain begins an active search by the brain and the mind's eye for structure and meaning. Drawing will take more than manual skill. You will need your imagination. The imagination triggers the imagining and the visual thinking skills. In many ways drawing creates a separate but parallel world to our reality. These drawn and created images speak to the viewer's eye. No matter how real they look, they can never be what the reality is. They are an interpretation.

We think in images. We are visual thinkers. For example, we search for images in the clouds, making up animals out of cloud shapes—imagining, if you will. We see images in the star outlines in the night sky and we can make images up out of stars. To see these forms—basically seeing in the abstract—we match images and information in the mind's eye. The imagination is a visual bridge between the memories of the past and our vision of the future.

Drawing influences and changes thought just as thought informs drawing. Leonardo da Vinci is a marvelous example of someone who recorded his thoughts in his sketches and drawings. Leonardo knew that the design process began with an idea. The idea could be preserved in a drawing to be used later in a painting or sculpture.

One drawing can express only a limited amount of our perception. Both the area we focus on and the drawing tool or medium we choose to

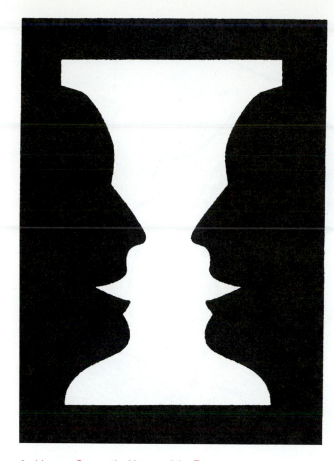

Ambiguous Space, the Vase and the Face.

use will alter the perceived information. In this way a drawing never reproduces reality; it parallels our experience. With drawing we create another reality. Drawing is visual communication that stimulates awareness. A good drawing engages the viewer's eye and imagination.

You can challenge your perception and check it by turning a drawing upside down to look at it. Change the distance at which you look at the drawing, move in very close, and then turn your back and walk twenty feet away. Set the drawing up in front of a mirror and look at it in the mirror. You will be able to see the problems in the drawing if you change the way you look at it. Small errors that muddy the communication of the drawing's meaning become clearer if you can change the way you see.

Ambiguous figures created to represent two different figures in one picture challenge our visual awareness. Think about the figures above as positive and negative space. Look at the white shape and then look at the black shape. You should be able to shift between the vase and the faces. In addition, the perception of these pictures is altered by their placement. The one on the left is enclosed by a black border. That is generally easier for the mind's eye to deal with. The one on the right has no outside border; thus it is a bit more difficult to visually form the images inside it.

Betty Edwards wrote a very perceptive book called *Drawing on the Right Side of the Brain*, in which she discusses the two sides of the brain. The left side is dominant, controlling (1) verbal abilities; (2) analytic figuring; (3) symbolic understanding, where we recognize a symbol stands for something; (4) rational thinking, including reason and facts; (5) digital thought,

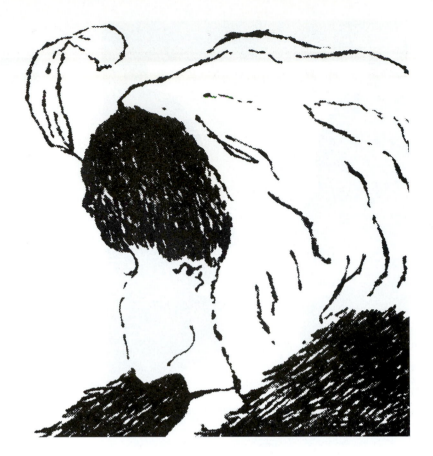

An illusion designed by psychologist
E. G. Boring in 1930. The profile of a young
woman or the head of an older woman.

the use of numbers; (6) temporal awareness, which keeps track of time; and (7) abstract thinking, which can take small bits of information and create a logical and linear process by which one thought directly follows another. The right side of the brain controls (1) nonverbal awareness; (2) synthetic meaning in which we can put things together; (3) the nonrational, in which we suspend judgment; (4) the spatial, where we put parts together in relation to each other; (5) the intuitive, which controls leaps of faith; and (6) holistic thinking, which allows you to see whole things all at once and perceive overall patterns leading to divergent conclusions.

The image above is an illusion designed by psychologist E. G. Goring in 1930. If you look carefully, you will see either the profile of a younger woman or the head of an older woman. Illusions like these should convince you that you don't always see what is sitting right in front of you and that your brain doesn't just automatically deal with perceived information on its own. You have to make an effort to see all that is around you, and you need to practice looking to improve your drawings. Seeing is a learned and developed skill.

Often students draw much better when the image is placed upside down. The reason may rest in the separation of powers in the brain. When the logical left side can't match this information logically in the mind's eye, it quits and turns the job over to the right side. It is the perfect task for the right side, which rises to the occasion. In addition, to draw better, you may need to readdress the crisis period of early adolescence where drawing realistically and perfectly became an issue. We attempt to draw the perfect image at this age, and we even draw one favorite subject over and over to make it perfect. When they don't achieve perfection, some people quit, thinking they have no talent for art, and they push it away. If you think about it, you really had no talent for walking either when you were born, but you are doing quite well at the age you are now. You got here with practice, and practice will also teach you to draw.

Introduction

CHAPTER 2
MEDIA

DRAWING TOOLS

GRAPHIC THINKING is the way that artists, through drawing and the use of drawing tools, connect their pictorial vision with their personal style in creating artwork. It is an individual and personal solution with as many ways to do this as there are artists and materials. Artists develop drawn images by trial and error; one tool may suit one idea and another may be better for the next problem. Tools are a means to an end.

Through drawing an artist can work out many different solutions very quickly. Drawing is a thinking process, a planning process, and an experimenting process that will allow you to manipulate, invent, and lay out a variety of combinations. Drawing can also be a finished piece in its own right.

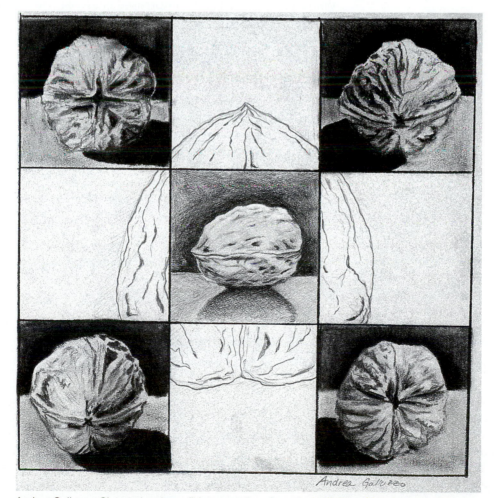

Andrea Galluzzo. Charcoal and pencil. Interpretation of a walnut with the grid and values, student drawing 1999.

DRAWING TOOLS AND PAPER

Supplies for Drawing Courses

Drawing tools vary from easy to use to difficult. Each medium works well for certain drawing exercises. Pencils are good for line drawings, cross-hatching, and sketching. Vine charcoal, charcoal pencils, Conté, and pen and ink are excellent for value studies. Conté with white is exciting to use in figure drawing and on colored charcoal papers. Practicing with each tool will help you understand its individual properties. The act of drawing teaches drawing as well as verbal instructions. The following is a list of equipment and materials generally standard to drawing exercises in drawing courses.

A drawing board (20 × 26″ for 18 × 24″ paper)
Masking tape to attach the paper to the board
 (push pins or clips are another option)
18 × 24″ newsprint pad
18 × 24″ 80lb white paper pad
Graphite drawing pencils (HB, 3B and 6B)
Kneaded eraser
White plastic mars eraser
Vine charcoal (soft) and compressed charcoal
A chamois, and stumps
Fixative (Blair no-odor workable fix is best)
Sharpie permanent ink pens, fine point
India ink
No. 10 or 12 Chinese brush
Conté (black, white, and sanguine or sepia tone-soft B)
Woodless pencils
Ebony pencils

Charcoal

Vine charcoal is made from processing vine limbs into sticks about six inches long. It comes in hard, medium, and soft grades. The thin sticks of vine wear down quickly needing to be replaced. Vine ranges from thin to thick sticks. I like Bob's Fine Vine which is made by hand in Eugene, Oregon. The sticks are square and have a nice softness for drawing. Vine is easy to use, not considered permanent, and can be wiped off with a chamois. Students will find vine very user friendly, first lines placed incorrectly can be replaced by a second line easily removing the first line by wiping it off with the chamois or your hand. Vine charcoal allows the artist to continually shift the planes and contours adjusting the perspective to the final composition.

Charcoal can be used on the side, tip, or corner edge of the stick. By changing the pressure you change the value of the line. Light pressure results in light lines, and firm or heavy pressure creates dark lines. Charcoal can also be removed with a kneaded eraser or tissue. It can be blended by rubbing it with your fingers or rubbing it with a stump known as a tortillon. The chamois is cleaned by washing it or flicking it against a hard surface to shake out the charcoal.

Compressed charcoal is rich, black, and velvety in tone. It is harder to remove and should be used after vine in a drawing that combines the two. Compressed charcoal is good for creating both mass and line. The kneaded eraser, chamois, or white plastic eraser will lift some of the blackness off the paper. Sometimes compressed charcoal will leave a trace or shadow of the mark being removed. Compressed charcoal can be used with water to create a wash.

Compressed charcoal

Draw an outline of any cylinder with compressed charcoal and then dip a Chinese soft-hair brush in water and wipe the wet brush over the line with horizontal strokes, extending the outline into a plane. The brush now has charcoal in the bristles. If you lightly tip it in a little water, you can continue to create lines or surfaces. They will be a lighter value than the original marks which allows you to move from the dark value to the lighter areas.

Exercise for Practice

Charcoal pencils

Lead Ratings,
Light to Dark

DRAWING EXERCISE

Charcoal pencils by Ritmo are superior to other brands. The HB, B, and 6B provide a good range of light to dark lines. These wooden pencils can be sharpened to a point for fine and dark lines. Some charcoal pencils have a greasy quality or seem to be made with wax. The Ritmo's don't have either quality. They are dry yet soft.

Both pencils and other forms of charcoal are rated from light to dark or hard to soft. B pencils get softer and blacker as the numbers increase from F in the middle to HB , then B, 2B, 3B, 4B, 5B, and 6B. A 9B is a very soft charcoal or lead and often breaks easily.

On the other side are the H leads. H leads get harder and lighter the larger the number. From 2H to 6H the marks get lighter. Architects prefer the nonsmearing, light hard leads for their drawings.

1. On a sheet of white paper practice with vine charcoal first, then with compressed. Draw a circle with vine charcoal, holding the charcoal between your thumb, forefinger, and middle finger. Wipe strokes of charcoal from the side plane of the stick, in overlapping layers to cover the bottom half of your circle. Using your finger or a stump, rub the vine charcoal from the middle of the ball toward the top of the circle, stretching it across the top half of the circle. With light to firm pressure add another layer of vine charcoal over the bottom of the circle. Use the kneaded eraser and remove the top fourth of the charcoal off the circle.

2. Do the same with the compressed charcoal, drawing a second circle beside the first. Compare the difference in value between these two types of charcoal.

3. Draw a three-inch square and fill it in with a layer of vine charcoal. Rub the charcoal gently into the paper with a tissue or stump. Using the compressed charcoal, draw lines on top of this

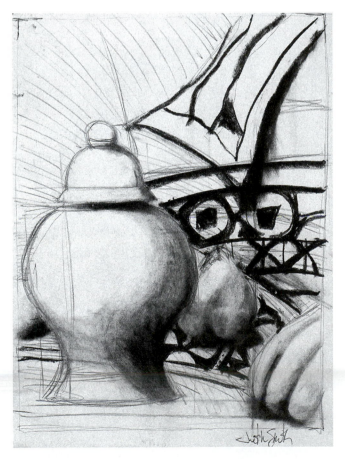

Justin Smith. Charcoal sketch, student drawing, 1999.

first layer. Make wide lines and thin lines. Rub some of the compressed into the layer of vine.

The preferred paper for charcoal has grainy texture. Newsprint, by contrast, has no grain. The grainy papers hold the charcoal. The grain may show through a light layer of charcoal. This would be considered a light to medium value. It is considered a good quality in charcoal drawing. Often beginners want to completely cover the paper, eliminating the possibility that any of the paper will show through. The more paper showing through, the lighter the value of the area. Layering charcoal will darken the area.

Charcoal must be spray fixed. The protective coating of fixative will prevent smudging. Workable fix allows you to work back into a drawing after it has been sprayed. In this way you can add another layer to the drawing. It is a little hard to erase parts of a drawing that have been spray fixed with workable fix but adding layers is easy. To apply fix, hold the can nine to twelve inches over the surface of the drawing and spray slowly by moving horizontally from side to side. Do this outside or in a well-ventilated room.

Spray Fix

Drawing pencils come in lead weights that are scaled by value from F grade in the middle. The B pencils are softer and blacker the higher the number. 6B is darker than HB or 2B. The H pencils are light and hard the higher the number, a 6H is lighter than a 2H. A 6B and a 6H are complete opposites.

Pressure is important when drawing. The firmer the pressure on a pencil, the darker the line will be. Always start your drawing with light lines using light pressure. To make adjustments in the proportions or move the lines, draw the darker, over the original light lines.

By not erasing the first line you have something to judge against to place correcting lines.

Lead Pencils

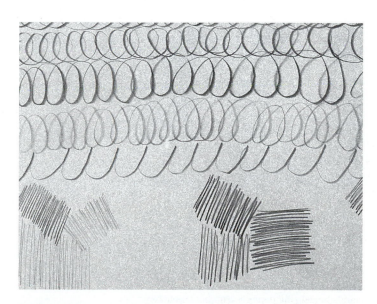

Practice Marks

Illustration 1

Illustration 2

Illustration 3

Above, Hands holding the pencil in different positions; below, Practice marks

Pencil drawing is cleaner than drawing with charcoal. The pencil can be used on its tip or side. There are two ways to hold a pencil. In illustration 1 the index finger is flattened, not curled as in writing. Illustrations 2 and 3 show the hand gripping the pencil and the pencil being used under the hand. In this position the artist can push and pull the lines around the drawing and move from thin to thick lines easily.

Ebony pencils have a silvery quality of medium dark lead. They are soft and nice to draw with. They have the same soft lead as the 6B but have a different tone of lead.

Woodless pencils are lead in grades of B to 6B. They can be sharpened and the lead shavings saved to use as powdered graphite for rubbing over areas of the drawing. The tip can be extended to a larger surface than the tip of a wood pencil can, providing the artist with a different quality of line in drawing.

DRAWING EXERCISE

Practice with the pencils on newsprint using both hand positions. Work from the tip of the pencil, rolling it over to its side. Notice the change in line quality. Make a value scale of each pencil lead by laying out nine one-inch squares in a row. Leave the first square the white of the paper. In the second use the lightest pressure of the HB pencil and apply only one layer of lead. In each following box increase the pressure and number of overlapping layers of lead. Try to create a gradual scale from white to black through gray with each pencil.

Media

Graphite or lead sticks are three inches long by a quarter-inch square. These flattened sticks have blunt ends rather than pointed ends. They are useful in making rubbings where you lay a thin paper over a surface and then rub the stick across the back of the paper, transferring the image under the paper onto the surface. They are available in grades from B to 6B. This blunt tool is excellent for sketching and loose gestural drawings. Being flat, it allows the artist to wipe smooth planes of light gray on to the paper. Using the flat sides offers an alternative to hatching and scribbling to create surface, plane, and texture.

Powdered graphite is applied with a soft cloth or your finger. Wiping graphite on paper creates a smooth textured tone. It is very soft and lines can be used to shape forms on top of it. Graphite can be dissolved in benzine or turpentine for wash effects. Powdered graphite is finely ground and packaged in squeeze tubes. It can be purchased in hardware stores and is often used for lubrication. It is pale and silvery in tone. On Bristol board it can be rubbed to a rich silver tone, conveying soft light for shadows, window surfaces, or doorways.

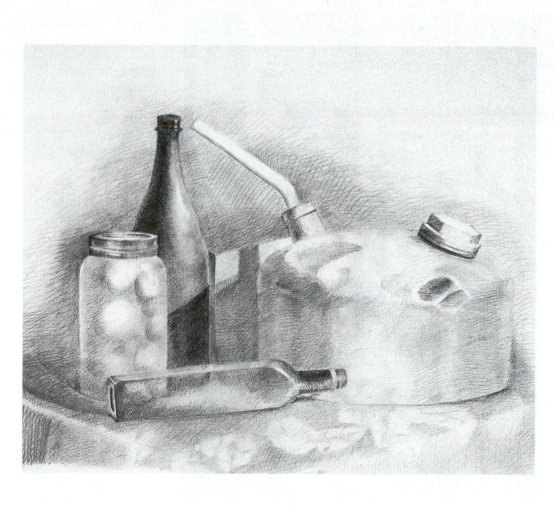

Lili Xu. Pencil, student drawing, 1999.

Conté

Conté crayons come in soft, medium, and hard grades. Conté has a clay base and is made of compressed pigments. It is a hard chalk that comes in shades of black, brown, white, and red. This tool may be handled in various ways. It is superior to charcoal in creating a finer line and is somewhat less messy. Conté is applied with hatching strokes and light pressure. To darken an area, another layer of Conté is added with firm pressure on top of the first. On a heavy weave or deckled paper the Conté can be lightly wiped across an area to create a light or medium value in the drawing. When rubbed in, the Conté smoothes out, but one last top layer should be added over any rubbed area to visually lift it up. Rubbing tends to dull the area; thus adding a light final layer gives the drawing a richer feeling.

White Conté can be used to "heighten" or add light planes. In charcoal drawings the white of the paper is often left for the light planes. Conté should be applied gradually, building up overlapping layers.

A kneaded eraser will lift light strokes out and off the paper. Once it is rubbed in, it is hard to remove. Crosshatching is used to build up the dark values. Cross hatching consists of diagonal, horizontal, and overlapping vertical strokes drawn on top of one another. Increase the pressure of the stroke to darken areas. Use light pressure and one layer of Conté in light areas of the composition. Conté is held between the fingers like charcoal. It can be used on its side plane or its end plane. On the end there are four corners and four surfaces between the corners that can be used for drawing. Both water and turpentine will dissolve Conté and charcoal to make a wash.

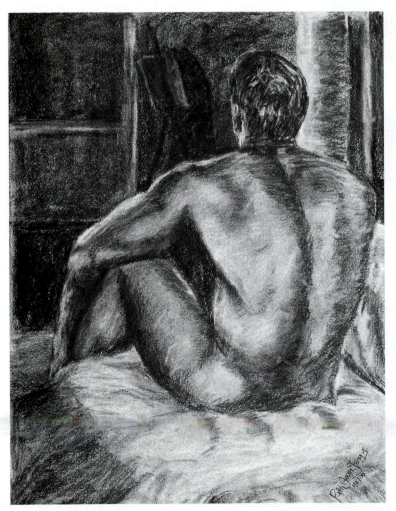

Patti Jean Fergus. Black and white Conté on colored paper, student drawing, 2000.

Pen and ink produce different qualities of line from pencil. India ink or permanent ink can be used with a brush or a quill pen. There are steel points, lettering points, crow-quill points, bamboo pens, reed and turkey quill pen points. Each pen tip will make a different type of line. The crow-quill steel pen produces a scratchy line that is thin, textureless, and straight. Fine line is used in crosshatching to create modeling on forms, converting their outline into a volume. Steel points have tips that range from very thin to thick. The lettering points make wide strokes and can make beautiful curves.

A brush creates a flowing and expressive line. The brush will hold more ink than the pen but is harder to control. Landscape has always been a good subject for pen and ink drawings. The textures of trees and plants are easy to draw in pen and ink. A wash can be used to change the values in the picture. Line can be placed under the wash or over dry wash.

Wet and dry media may be used together in a drawing. To layer start with charcoal and put a wash over it. After it dries, you can add charcoal pencil on top of the wash or add another layer of wash. Each layer of wash darkens the one before it. Wash dries lighter than straight ink, allowing for great subtleties in value changes. Ink straight out of the bottle obliterates whatever it covers. As long as the ink is diluted with water, it can be layered with other media and is transparent. The amount of water to ink in a wash determines the value. The more water, the lighter the value.

Ink lines are manipulated in drawings from thin to thick. Light falling on a form can be reflected by drawing thin lines for the bright light. Thick lines indicate weight and shadow. Air, straw, fabric, and other textures can be created in pen and ink drawings.

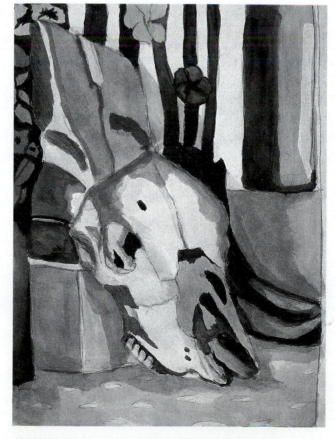

Jennifer Springstead. Ink wash, student drawing, 1999.

Ball-Point, Felt-Tip and Roller Ball Pens

Drawing with a pen has a distinct advantage over pencil in that you can't erase. Pens are easy to use and good for simple, loose outlines. The sketchy, loose pen line tends to be more energetic. Free flowing pens are excellent in creating texture in a drawing. The nonpermanent colored inks will fade if exposed to direct sunlight. You can test for fading by making an ink drawing then covering half of the drawing with lightproof paper, leaving the other half of the paper exposed to direct sunlight for two or three weeks.

Free flowing ink pens are good for gesture drawing. Since you can't erase, you will feel a certain freedom. A flowing line allows your drawing to move forward from start to finish without stopping. When you stop to correct lines you lose your train of thought.

Franz Kline, 1910–62, *Two Studies for Shenandoah Wall,* 1957–58. Sumi ink 8 × 53.5 cm each. 74.11 VWF. Collection. Virginia Wright Fund. Washington Art Consortium: Henry Art Gallery, University of Washington, Seattle; Museum of Art, Washington State University, Pullman; Northwest Museum of Arts and Culture, Spokane; Seattle Art Museum; Tacoma Art Museum; Western Gallery, Western Washington University, Bellingham; Whatcom Museum of History and Art, Bellingham. Photo Paul Brower.

Media

Silverpoint is a dry drawing medium that uses a piece of metal with a firm, sharp point. Silverpoint drawings are very delicate gray lines that gradually change from the silver deposited on the paper to a mellow brown color after exposure to air in a month's time. Every stroke shows in the drawing. Silverpoint is closely related to etching, a printmaking process, in the way lines are laid down in fine hatching strokes.

The tool may be constructed by attaching a long silver wire to a stick with string or cord. Wrap the string tightly around the wire and the stick. You may also put the wire in a mechanical pencil as you would load lead. A piece of wire one inch long is sufficient. To sharpen the point, rub the end on sandpaper. Sharpen the end of the wire to a fine point. Silver wire can be purchased in jewelry and craft supply stores. In addition to using a silver wire you can use copper wire, which will produce a dull green, or lead wire, which turns to blue-gray on the paper.

Silverpoint cannot be done on ordinary paper. A special ground must be prepared to hold the silver left by the marking action. Tones are produced by the way lines are grouped together. The drawing surface is coated paper. Using a large watercolor brush, cover a smooth piece of two-ply bristol board or rag paper (BFK or Arches hot press) with Chinese (zinc) white watercolor that has been diluted with just enough water to keep it fluid. The paper should have two or three smooth coats and be dry. You can also coat cardboard, tagboard, or drawing paper. Since paper warps when dampened, to keep it flat, tape the sides of the paper down to a drawing board or a piece of smooth masonite before you start. The paper may also be coated with casein, or a thin size of glue, rabbit skin glue, mixed with a fine abrasive material such as bone dust.

You can practice on clay-coated paper called "cameo." Cameo takes the marks, but the silverpoint does not "skate" on the surface, nor are the lines as clear as on the Chinese (zinc) white. Silverpoint creates a thin line of even width. Silverpoint lines will not blur; thus gradations in value are achieved through systematic diagonal hatching lines. This is a painstaking process and a methodical procedure that produces an exquisite drawing.

Silverpoint drawings are generally small, and students are encouraged to do preliminary studies in hard pencil like a 6H or 4H.

Acrylic gesso can be used as a coating, in which case you would draw with aluminum nails. It is the contact of metal on the white surface that reacts and leaves a mark or value change. Be careful not to gouge the surface. To make corrections erase lightly and recoat the area with the white ground.

Silverpoint should be completed without erasing. It is a difficult medium where you actually only get one chance to place the marks. Corrections can be made by reapplying the ground over the marks.

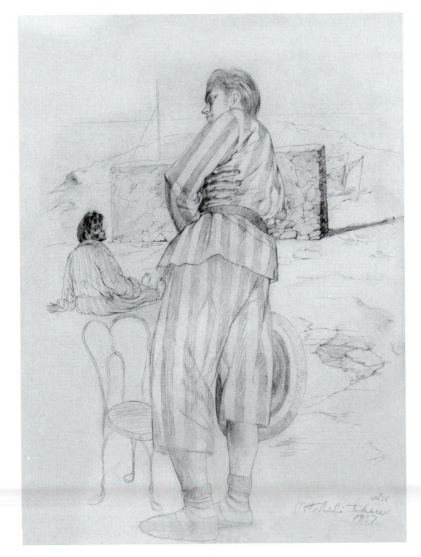

Pavel Tchelitchew, 1898–1957, Russian-American. *Two Figures*. Silverpoint, 19⁹⁄₁₆ × 12³⁄₁₆″. Yale University Art Gallery, New Haven, Conn. (bequest of Oliver Burr Jennings, B. A. 1917, in memory of Annie Burr Jennings).

Media

Newsprint is the cheapest paper. It is manufactured from wood pulp. The smooth surface is best used in studies, quick gesture drawings, or the planning phase. The lack of tooth in the paper, which is the texture of the paper's surface, provides the student no resistance in a long drawing. Drawing tools act differently on 80 lb white paper or charcoal paper. Newsprint will yellow and crumble over time and it isn't strong enough to handle wet media. It is also somewhat misleading, as tools will slide easily over the surface, letting the students feel they understand the drawing medium only to find out when they move to 80-pound white drawing paper that the tools handle completely differently.

White drawing paper or bond paper comes in various weights. Sixty-pound paper is very thin or lightweight and good only for pencil drawings. Eighty-pound paper is better for the classroom, as it will take wet media and erasing in charcoal drawings. One hundred twenty- or 140-pound papers are wonderful to work on as you can work and rework the surface without tearing the paper and when you use wet media, the papers don't ripple badly. If they are taped down, they will often dry flat. The eighty pound papers have a little tooth. The 120- to 140-pound papers can be hot- or cold-pressed and will have more tooth. Hot-pressed paper is smooth and good for ink wash and pencil drawings. Often good papers are sold by the sheet. Arches BFK, Stonehenge, and Copperplate are traditionally printmaking papers, but they are also great drawing papers.

Charcoal paper has a rough surface. This is a paper with a lot of tooth. Tooth can be an imprinted texture that was combined with sand. Charcoal paper comes in various colors from beige to pink to gray. It can be used with vine or compressed charcoal, charcoal pencils, chalk pastels, oil pastels, and Conté.

Bristol board has a hard surface and comes in two surfaces. **Plate** or smooth finish is perfect for pen and ink or very hard pencils. **Vellum** or Kid finish has a slight tooth and works well with rubbed pen and graphite combinations or fine pencil work. It also varies by weight from a 90-pound to 200-pound paper.

Ellsworth Kelly, b. 1923, *Oak Leaves*, 1969, graphite, 73.5 × 58 cm. 75.2. Collection. Virginia Wright Fund. Washington Art Consortium: Henry Art Gallery, University of Washington, Seattle; Museum of Art, Washington State University, Pullman; Northwest Museum of Arts and Culture, Spokane; Seattle Art Museum; Tacoma Art Museum; Western Gallery, Western Washington University, Bellingham; Whatcom Museum of History and Art, Bellingham. Photo Paul Brower.

Illustration board is composed of various layers of surfaced papers mounted on cardboard. It is expensive but durable and has a strong resistance to wrinkling when wet. It is used for pen and ink or clean line work.

Rice paper is extremely sturdy. Traditionally it was used in Oriental brush and ink drawing. It has a soft, absorbent ground. You can use it with chalk pastels, watercolors, or gouache. I have painted on it with acrylics and used it in Chinécolle, a collage printing process in which the paper is placed face down on an inked plate and run through the press, which adheres it to another larger piece of paper.

Watercolor papers generally are heavier-weight papers used for watercolor paintings and overlapping washes. The paper is taped securely to a board before wetting it. Traditionally paper tape was used to secure the paper to the board on all sides. Masking tape will work but it should be wide, and the new blue painter's tape is better than regular masking tape. The taping holds the paper so that after the painting is done, the paper will dry flat. It will ripple and warp during the painting, but it will shrink as it dries back to a flat paper. Watercolor paper has a rough surface. There is cold-press, which is moderately textured and matte, and hot-press, which has the smoothest and least absorbent surface.

Rag paper is made of 100 percent cotton rag. It is generally sold by the sheet and is more expensive than other papers but wonderful to work on. BFK is 90- to 140-pound, Classico Fabriano is 140-pound, and Murillo (Fabriano) from Italy is 360-pound. All are rag papers. Other rag papers are Arches, Copperplate Deluxe, German Etching, Italia, and Strathmore Artists. After you practice on pulp papers and you feel confident, try a piece of rag paper for an extended drawing. Experienced draftsmen pick their paper by the way the surface feels. Every rag paper has a different surface quality. Some feel it is easiest to draw on because the marks stay clearly on the surface and an erasure doesn't damage the paper.

Chuck Dunfee. Ink wash and ink value tests on the bottom of the drawing outside the picture plane, student drawing, 1999.

Paper for class work should be inexpensive. Strathmore, Murillo, and recycled papers are available in pads 18 × 24". Practice on this paper and treat yourself to a sheet of rag when you have worked through a series of drawing exercises.

Media

Colored pencils come in wet and dry varieties. They are applied in loose crosshatched patterns to take advantage of their transparency and semitransparency. The pencils should be sharpened to a fine point. When the hatching strokes are placed side by side the result is solid tones of strong color. A medium pressure creates uniformity in tone. Greater pressure forces the color to fill in the hollows of the paper, eliminating the white of the paper and producing solid darker tones. Light pressure applies the color to the raised portions of the paper's tooth or texture. When the white of the paper shows through, it lightens the tone or value of the color. To build tones and change color, value, and intensities, apply layer upon layer of color. When white or light colors are applied over darker layers of color using heavy pressure, the result is a smooth, polished surface. This is called burnishing. Unburnished areas can be lifted off by pressing the color with a kneaded eraser. Applying repeated layers of color with heavy pressure can produce a foggy quality called wax bloom. This can be eliminated by rubbing the surface of the drawing lightly with a soft cloth. A light application of fixative can be used to prevent bloom.

Lisa Cain. Black and white Conté, student drawing, 1999.

Pastels

Chalk pastels are soft and should be used with light pressure. Pastels are available in over 500 colors. Their texture is generally fine and even. These colors create a rich surface when layered. Secondary or tertiary colors can be mixed by layering one color on top of another.

Chalk pastels may be used on damp paper, dry paper, charcoal paper, and white drawing paper. Soft pastels or French pastels are made of dry pigment mixed with an aqueous binder and then pressed into round sticks. When oil is added to the binder, a semihard pastel is created known as an oil pastel. Oil pastels dissolve in turpentine and thinner. They are less crumbly than chalk pastels. Hard pastels are a recent offering that are firmer and not so oily. Oil and hard pastels cannot be easily erased.

Using pastels allows the artist to draw in color. A drawn painting is constructed by overlapping layers of pastels, with the strokes crosshatched side by side or overlapped. Rubbing will blend colors together. Rubbing too hard will muddy colors. Generally artists will lay in the middle values on the paper first. They may start the drawing with the middle values and then add the darks and the lights. Chalk pastels must be fixed. If you use a workable fix, such as Blair no-odor workable fix you can add more layers on top of the fixed areas and fix it again.

Kneaded Eraser

An eraser is a drawing tool as well as a tool for erasing. A kneaded eraser absorbs charcoal and Conté. The eraser is made of a soft, gray gumlike material. To erase an area press the eraser into the surface and lift the area out. The eraser then gets dirty and is unusable until you clean it by stretching the eraser out and rolling it over on itself back into a small ball. This cleaning is similar to pulling taffy. Try not to pull the eraser apart. Stretch it and then fold it back together. It is very pliable and can be formed into a drawing point. Twisting a small section of the kneaded eraser into a pencil point can also be helpful in erasing out narrow areas in a drawing.

Plastic Eraser

The white Staedtler Mars plastic eraser will lift charcoal out as you rub over the area. It also removes pencil and Conté. The surface of the plastic eraser will get dirty. It stops working when it is covered in charcoal or lead. To clean it rub the dark areas of the eraser on a white area of the paper. The edge of the paper is usually clean and available, or you can have a piece of scratch paper next to you.

Media

Oil sticks are made of oil paint, wax, and linseed oil. Each manufacturer has a little different ratio among the ingredients. Oil sticks dry slowly. Both Winsor Newton and Gamblin make alkyd mediums that can be painted on a primed surface first to enhance the drying time. Draw into the medium while it is wet. This surface will dry overnight, sealing the oil stick under the dry surface. You can continue to layer the surface with thin layers of medium, oil stick and oil paints can be added into the composition.

The purest oil sticks with the least amount of wax and additives are made by R&F Pigment Sticks & Encaustic Paint, N.Y. (800-206-8088). They are like having oil paint in a stick. They are well pigmented and do not get a thick, leathery skin. They also do not crack when dry. They are not a hard waxy crayon but more a malleable paint. They will make a smooth, richly colored stroke. R& F oil sticks are made of pure refined linseed oil, beeswax, and purified natural plant waxes. No fillers or adulterants or inferior waxes are used. Oil sticks can be thinned with turpentine or oil. They should be used on a gesso surface or rabbit-skin glue primer.

Joel Retzlaff. Black and white Conté on tan wove paper, student drawing, 2000.

CHAPTER 3
THE FORMAL ELEMENTS: GESTURE

DEVELOPING VISUAL AWARENESS

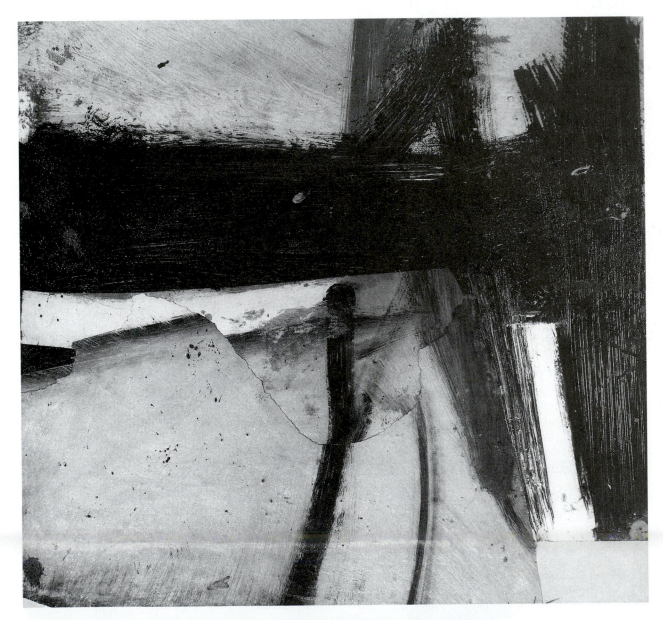

Willem de Kooning, b. 1904. *Dissent* 1957–58. Oil and collage with strips of paper on tan wove mount. 310 × 305 mm. Signed lower right in pencil: de kooning. 1984.511. Bequest of Dr. and Mrs. Harold C. Torbert. Stanford University. © 2001 Willem de Kooning Revocable Trust/Artists Rights Society (ARS), New York.

When you attend a physical education class, you have to warm up. They want you to warm up the muscle groups to avoid pulling a muscle and hurting yourself. So you gently stretch and move each body part until they are warmed up. During this time you also begin to focus on what you will be doing later. Drawing is the same way. You are stiff and perhaps full of anxiety at the start. You may have expectations or fears that get in your way of seeing. Sometimes your mind is thinking about other problems. In an effort to focus on the drawing at hand, start with a gesture drawing. This loose, uncommitted style of drawing will loosen your hand, eye, and mind, getting them all directed on the problems of drawing. Pick a starting point on the subject, place the pen on the paper, and begin making lines that follow the contour of your subject. While you are looking carefully at the subject, you are gathering unconsciously information. Your eyes can wander over, around, back and forth across the forms or figure. Let the line follow your eyes. In some gesture drawings you look briefly at your paper to locate your line then return quickly to looking carefully at the subject. This act informs you and builds a working knowledge of your subject.

In figure drawing you begin to record the relationships and location of the body parts. Gesture drawing allows you to study the shapes and their relationships freely. This information is stored in your brain and it will inform you later when you make a longer, more detailed drawing.

Learning to see is learning to look at your subject and understand how to translate the three-dimensional information onto the two-dimensional paper.

Willem de Kooning, American, born Rotterdam, The Netherlands, 1904–1997. *Figure*, 1966, Charcoal on paper. 17 × 14$^{1}/_{16}$ in. (43.1 × 35.6 cm.). Hirshhorn Museum and Sculpture Garden, Smithsonian Institution. The Joseph H. Hirshhorn Bequest 1981. 86.1345. © 2001 Willem de Kooning Revocable Trust/Artists Rights Society (ARS), New York.

WARMING UP WITH
GESTURE DRAWING

For a description of each tool refer to the media section in Chapter 2. Conté, compressed charcoal, ink, charcoal pencil, woodless pencils, lead sticks, and 6B drawing pencils can all be used for gesture drawing. Use 18 × 24" newsprint or 60-pound paper. Smaller paper will restrict the freedom of the drawing.

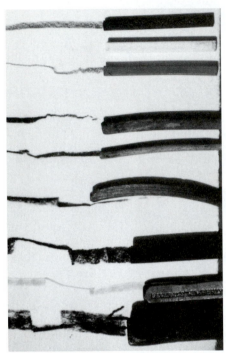

Conté above in various colors. Charcoal sticks on the top in hard and soft sticks.

Rather than sitting down, stand at an easel or stand over your drawing table. Keep your drawing hand free and do not rest your arm on the drawing board. A drawing starts in the brain, the eyes gather and send the information to the hand. Keep the shoulder, the elbow, and the wrist free, to respond to the brain's directions. Don't rest your drawing hand on the paper. When the drawing tool is in contact with the paper, you may rest on your little finger using it to guide the line. Large arm movements or short strokes depend on your arm being free. In some gesture drawings you will keep the drawing tool in contact with the paper at all times.

Gesture is a thinking line. The drawing is done in overlapping strokes by moving the tool across the paper to represent what you see. However it may not look like your subject it will be more of an impression of the subject.

Gesture drawing develops "seeing." Art instructors will direct you to really look and see what you are drawing, but unless you have a process to develop this level of seeing, it is extremely hard for the beginning student to understand what is being expected. Gesture drawings should be relaxed and loose with a jagged or incomplete line. You should look mostly at the subject and concentrate on where one part connects to another as well as the relationships of the shapes or forms by height and placement. The line can go over the planes and through the air. Gesture drawings are more volumetric than outlines. The process of seeing improves with each drawing.

Gesture drawings can also represent energy, action, or movement in a drawing. Gesture represents the way an object lies on a table. It is an active drawing of the subject.

Maya Hayes, negative space drawing, student drawing, slide 188, 1999.

The Formal Elements: Gesture

PROFILE OF AN ARTIST: WILLEM DE KOONING

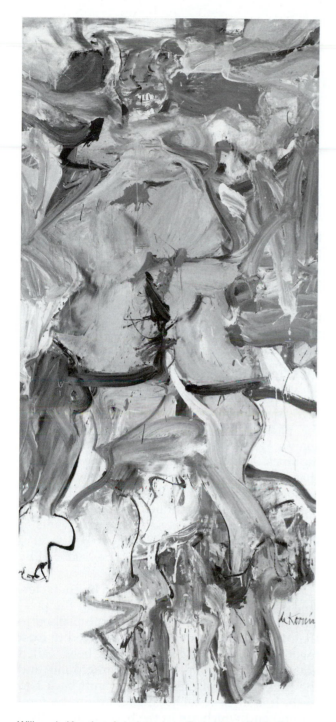

Willem de Kooning, American, born Rotterdam, The Netherlands, 1904–1997. *Woman, Sag Harbor*, Oil and Charcoal on wood. 80 × 36″ (203.1 × 91.2 cm.) (1964). Hirshhorn Museum and Sculpture Garden, Smithsonian Institution, Gift of Joseph H. Hirshhorn, 1966. 66.1209. © 2001 Willem de Kooning Revocable Trust/Artists Rights Society (ARS), New York.

Willem de Kooning's drawings are almost all working drawings. They do not grow into a painting at any certain point. His paintings and drawings evolve dependent on each other but the drawings can stand without a painting. De Kooning was a very skilled draftsman who trained in a traditional art school in Holland. Like Rembrandt he drew constantly.

With painting he felt he needed to be in a certain state of awareness to work. The drawings he could do while his mind was idling, while he was resting during crucial stages in the progress of the painting.

De Kooning preferred a hard-surface paper for both painting and drawing. He bought smooth stock, evenly glazed or sized papers, in which the rag or wood pulp fibers are compressed to a smooth, even plane. The smooth, hard surfaces enabled him to work at the high velocity he preferred. A highly absorbent surface would impede the free motion of his line. His friends said he had stacks of paper in his studio that he purchased from industries or businesses that used paper to wrap goods.

He is one of the twentieth century's finest draftsman. His calligraphic line whips across the surface and is probably partly responsible for the label "action painting," which was applied to his work by Harold Rosenberg. Tom Hess and Harold Rosenberg were the two major art critics of the 1940s and fifties along with Clement Greenberg. Hess called the artists of the fifties abstract expressionists. But these artists resented being grouped into one movement, and when you consider the work of Mark Rothko, Pat Passlof, Helen Frankenthaler, Jackson Pollock, and Milton Resnick along with Franz Kline and Willem de Kooning, it is clear that they were not working on one theme or all working in one direction.

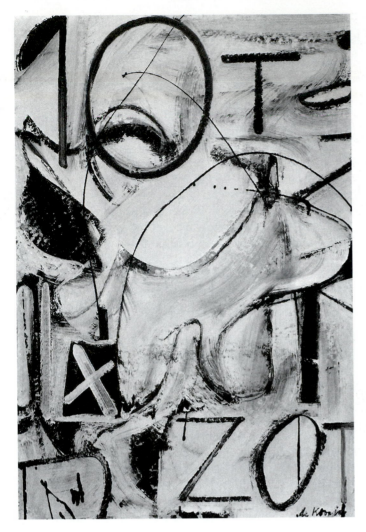

Willem de Kooning, American, 1904–97, *Zurich*. Oil and enamel on paper mounted on fiberboard. 36 × 24¹/₈″. Hirshhorn Museum and Sculpture Garden, Smithsonian Institution. The Joseph H. Hirshhorn Bequest, 1981. 86.13355. © 2001 Willem de Kooning Revocable Trust/Artists Rights Society (ARS), New York.

De Kooning liked tracing papers, commercial vellums, or parchments that were semitransparent and slightly oily. He often wanted to save a passage in his paintings before he wiped the area off the canvas. Parchment and vellum were perfect for this. He would press them onto the painting's surface and lift the area off. He would then be able to refer back to that passage by looking at his print or tracing. *Woman* (1964), on page 37, has the look of one of his tracings.

De Kooning's drawings tend to dissolve the definition of "drawing." In the black enamel drawings of 1950 he drew with sapolin, black house-paint enamel, on white paper. While the drawings were on bare white paper, the paintings were white paint on a black ground. *Zurich*, above, is such a painting. The drawings and paintings slip elusively from one to another, making it hard to pin de Kooning down.

We seldom get to watch an artist work. The following insight by Thomas Hess, an art critic of the fifties and editor of *Art News*, gives us a glimpse. "I watched de Kooning begin a drawing, using an ordinary pencil, the point sharpened with a knife to expose the maximum amount of lead. He made a few strokes, then almost instinctively, began to go over the graphite marks with the eraser, moving them across the paper to turn them into planes."

Erasing was a technique de Kooning used to create, not destroy. His line—the essence of drawing—is always under attack. It is smeared across the paper, pushed into widening planes and shapes. He rubs the surface of the drawing across the lines, lightening the value of the lines and shapes, which allows for another level of lines to be added on top of the rubbed surface. The wiping, erasing action continues until he sees something in it, until he sees something he wants to keep—or destroy. For the drawing to be useful in launching a painting, it needs to be balanced by line and plane held in tension.

De Kooning's drawings could be characterized as an open composition in which the positive and the negative spaces are both pushed to their fullest statement and then allowed to exist together. De Kooning's work has been called ambiguous, meaning that the foreground and the background of the drawings shift back and forth. It is unclear which marks are in the foreground and which are in the background. Often his meaning is unclear, the structure problematic, and the space of the drawing capable of having two or more interpretations. In his drawings de Kooning sacrifices nothing to the academic ideals of harmony or unity.

The Formal Elements: Gesture

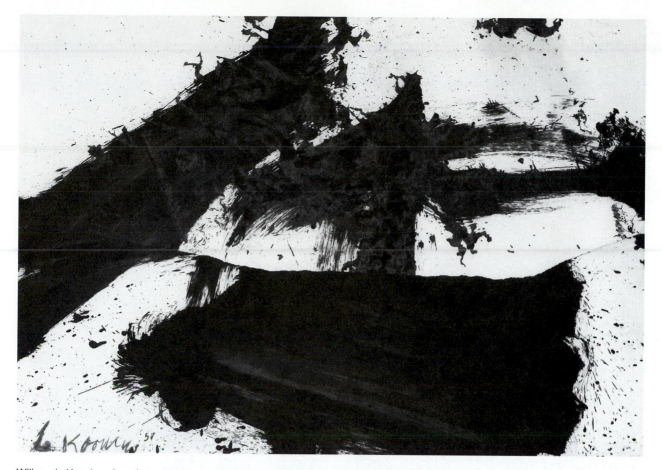

Willem de Kooning, American, 1904–97. b. Rotterdam, the Netherlands. *Untitled*, 1959, collage. Ink and paper mounted on paperboard. 27⅝ × 39⅛″ (mounted 28⅝ × 40¼). Hirshhorn Museum and Sculpture Garden, Smithsonian Institution. The Joseph H. Hirshhorn bequest, 1981.JH63.117. © 2001 Willem de Kooning Revocable Trust/Artists Rights Society (ARS), New York.

This same spirit and philosophical attitude were the basis for de Kooning's process of tearing drawings and paintings and reassembling them. One of the reasons he liked paper was that he could cut and tear it. By tearing a drawing into parts and reassembling the parts in a different order, he could study the shapes in an unlimited number of associations and relationships. De Kooning's collage drawings describe three principal relationships between man and the world. First, to develop awareness, and knowledge of the space around us. Second, to process these perceptions, or this awareness. Third, to appropriate the shapes we have discovered as our own. They no longer belong to the world— they belong to the artist.

De Kooning once said, "Content is a glimpse of something, an encounter, like a flash." He refers to perception as a "glimpse." To make sense of perception, de Kooning alters his glimpse of a given shape by reorienting and manipulating it. He reverses it, turns it on its side, tears it in half, or combines it with half of a shape from another drawing. In the end, de Kooning appropriates the shapes, making the picture he wants out of the glimpsed reassembled shapes. The torn edge of the paper acts like a line in de Kooning's collage. It is a constructed line rather than a drawn line. Subtle changes occur as a result of the shifted marks, colors, and textures. *Untitled, December 1959,* is such a collaged drawing. Willem de Kooning reinvented and redefined line.

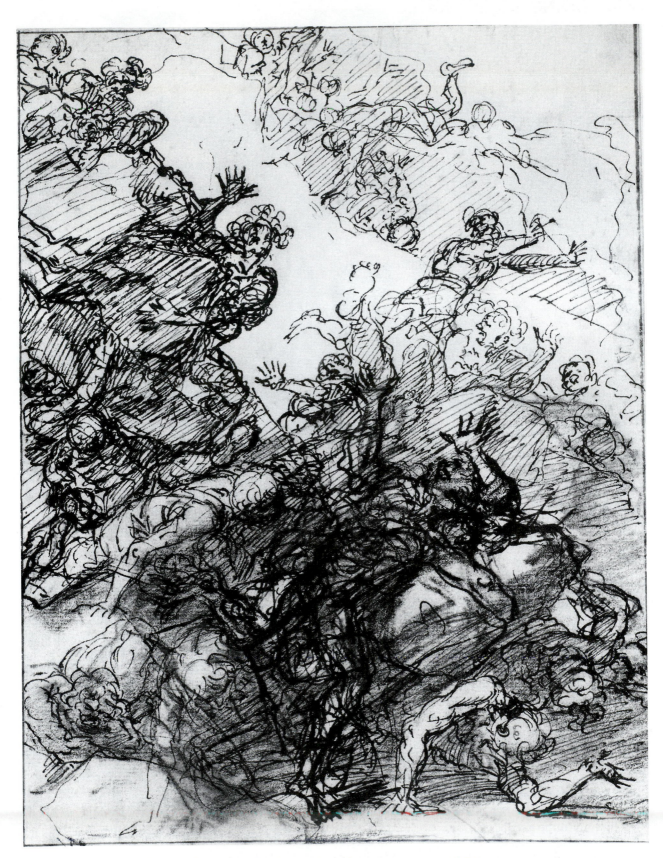

Salvator Rosa, 1615–73, *Fall of the Giants,* study for a large etching. Pen and brown ink, overblack chalk. 10⅜ × 7¹³⁄₁₆″. The Metropolitan Museum of Art, Rogers Fund, 1964. (64.197.6).

COMPOSING DRAWINGS
WITH GESTURE

Salvator Rosa's drawing is a complete plan for a large etching. Gesture allows him to think out the sequences he needs for the composition. In the drawing the giants are being thrown off Mount Olympus by the Greek gods. They tumble through the air, turning and twisting through the clouds to the ground. He has overlapped figures and stacked them. Everything is moving. The hatching strokes are diagonals drawn toward the right top corner while the figures are on a diagonal line from the top left corner. This is a deliberate attempt to create tension in the drawing. He has small figures in the top right and medium figures in the middle and foreground. Then he draws one large figure on top of all the figures at the bottom of the page. The gesture lines forming the large figure are dark and bold. The figures to the left are mostly white. They float out at us as the hatched figures are pushed back. To create the space, he has manipulated the value with hatching from light to dark. His memory of the human form served him well.

Gesture is a fluid line. Gesture drawings can integrate accurate descriptions with a studied placement of forms. In order to develop the fluency of visual thought that artists like Rosa and Willem de Kooning have, you must understand the basic construction blocks of drawing. You must be able to analyze visual and spatial relationships and then interpret that information through drawing media (charcoal, ink, or pencil) into a drawing.

DRAWING EXERCISE:
TESTING YOUR VISUAL MEMORY

Take a pen and a sketch pad and go outside. Focus your attention on a specific space, building, or group of people and analyze the forms and shapes. Look away and try to draw, or sketch loosely what you saw. Allow your hand to scribble as you think about the relationships of the forms in the space. The lines may be unconnected. Take only five minutes and then look back at the scene. Study it to draw it again.
Use a loose, flowing line. The pen facilitates this kind of line, and by using a pen you cannot erase.

The Formal Elements: Gesture

TIME REQUIRED TO MAKE A GESTURE DRAWING

Gesture drawings can be done in one minute or five minutes. Sustained gesture drawings can take up to twenty or thirty minutes. The time depends on the reason for doing the drawing. Warming up needs only thirty seconds to three minutes. You can make four or five quick drawings on one piece of paper. The drawings may overlap, change in size and scale. Twenty minute gesture drawings show the figures wrapped in line.

Learning "to see" is to accumulate visual knowledge about the subject to be drawn. In the first minute you should just look at the subject before you start moving the drawing tool. Let your eyes roam over the figure and the ground (the ground is the space around the subject).

GESTURE FIGURE DRAWING EXERCISE

Use 18 x 24" paper with a pen or 6B pencil. When the focus is the figure, a good place to start is on the backbone or spine. Study the angle of the back and then draw as if the pencil were sitting on the figure—as if you are drawing a line directly on the figure. Curve the line to copy the angle the figure is bent or turned. Move the line from the spine across the back to the side of the body and the arms. Don't stay on the contour. You can draw across the planes of the figure as well as across empty space like between the legs or from the arm to the chest. Let the line rest and thinning on the top planes. Push the line into the indentations and darken it. Move the line from light to dark with the pressure of your hand on the drawing tool. Your line is a record of the figure and how it fits in the space. You should be mentally defining the proportions, shapes, and relationships of the parts to each other during this drawing. In this drawing, wrap the form in line top to bottom, side to side. The line may cross empty space to continue the drawing.

Eric Bailey. Three- and four-minute gesture drawings, student drawings, 2000.

The Formal Elements: Gesture

MASS GESTURE

There are no lines in mass gesture drawings, only volumes and planes to create form. Drawing mass allows you to think about your subject from a different stance. The shape of the form results from concentrating on creating the mass of the planes and connecting them. The edges of this drawing will be fuzzy.

DRAWING EXERCISE

Use a piece of Conté crayon that has been broken to fit between your thumb, forefinger, and middle finger. Place the flat side of the stick down on the paper. Look at the subject. Pick a starting place and then push the Conté across the surface, twisting and turning it up and down, back and forth with overlapping strokes to create the volume of the chest, then the arm, back to the stomach, and down the legs.

Pretend your hand is moving on the surface of your subject. Move your hand as if you were drawing right on the surface you are representing on the paper. Like a sculptor, you are creating a volume that should fill the page. When the Conté finds the edge of the figure, turn it back into the paper to continue developing the surface of the subject.

MASS TO LINE GESTURE

Conté may be used on its side or tipped up on the end. Either the corner or the side plane will make marks. Using the corner will make a thin, rich line. Turning the Conté to use the square end will make a wider line, and using it on its side creates a large, flat plane. In mass to line, you establish the mass as described in mass gesture. To increase the definition of the form, line is added on the contour of the form. The line reinforces the contour and the volume of the plane.

DRAWING EXERCISE

After the entire subject is rendered in flat strokes as mass gesture, use the corner at the end of the stick of Conté to introduce a contour line. Since beginning students seldom draw the figure, a still life can be drawn using this technique.

As you search to define the contour, you may need to draw on the inside of the fuzzy edge or on top of the mass of Conté strokes, as well as outside the mass of strokes. Use line only where you absolutely need to better define the subject. It should not become one continuous outline that destroys the quality of volume the mass gesture created. The value of the line and the value of the mass should be the same. The line should be unconnected.

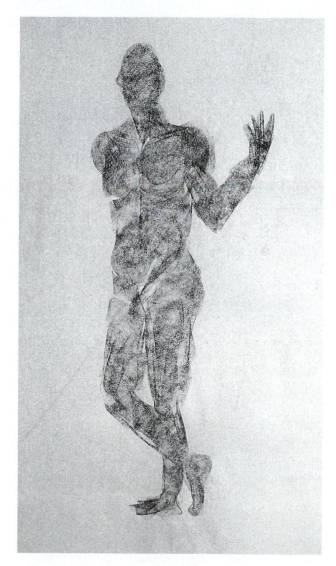

Sabrina Benson. Mass gesture drawing, student drawing, 2000.

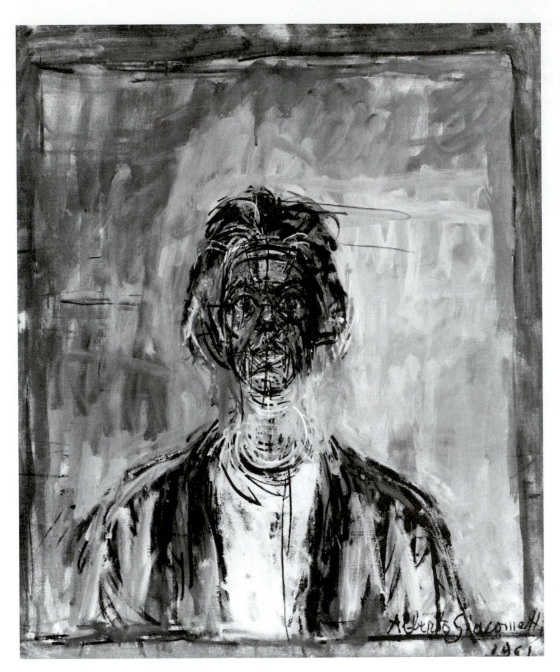

Alberto Giacometti, *Annette*, 1961. Oil on canvas, 21⅝ × 18⅛". (54.8 × 46.0 cm.). Hirshhorn Museum and Sculpture Garden Smithsonian Institution. Gift of Joseph H. Hirshhorn, Purchase Fund, 1966. © 2001 Artists Rights Society (ARS), New York/ADAGP, Paris.

MASS GESTURE
AND VALUE CHANGE

Starting a drawing very loosely gives you time to think. In this drawing you establish the mass and the planes first. The lines are drawn covering the planes and then the light planes are erased. This drawing takes time. You will create volume and depth by manipulating and balancing the values through the entire space of the drawing.

The Formal Elements: Gesture

DRAWING EXERCISE

Using a piece of compressed charcoal or Conté broken to fit between your thumb, forefinger, and middle finger, to make a mass gesture drawing start with very light pressure on the drawing tool. The subject may be a still life. The still life is easiest to draw with a selection of large round forms. Choose vases, three bottles sitting close together, large sunflowers, plates sitting on edge, a watermelon or other large fruits. The distance you stand from the subject will make a difference. Standing within five feet of the still life is best.

Pick a starting point on your subject and begin moving the charcoal on the paper making overlapping strokes to construct the volume of each form plane by plane in the still life. Pretend the charcoal is actually on the form you are looking at; turn your hand as you would need to if you were actually drawing directly on the form.

Consider the ground the objects are sitting on. Draw the space of the ground and the background which is the area behind your objects in large flat strokes. Your strokes depict the presence of the ground or the table and the air behind the table.

Look at the still life setup and decide which planes are lightest. If the lighting is poor and undirected, you will need to decide how to balance the light. If the top planes are light then the left or right side of each object will be gray or black. Be consistent in placing the dark values. You may use gray on all the right sides and black on all the left sides. With a kneaded eraser remove the charcoal from the light planes or the designated lightest planes. Wiping the charcoal off changes each form into a volume. Balance the light and the dark planes on each form. Assign a value to the ground planes under the forms. Balance the space front to back by rotating from light to dark through the space. Increase the dark values for the background objects. The areas in between or behind the objects will tend to fall into shadow. Darken those areas. The harder you rub with an eraser, the more charcoal you can remove, which will give you lightest white possible. Light rubbing will leave more charcoal on the object's side plane, which will read as gray. Continue wiping to achieve a balance between the light planes and the dark planes. The lighter rubbing can also be used in the background, where you may not want areas as light as the planes in the front of the picture plane. The white plastic eraser can be used for the whitest areas but the kneaded eraser is easier to control. The beauty of charcoal is that it is so easy to add and subtract values.

Return to the darkest areas of the drawing and add another layer of charcoal to darken these areas. Value changes are effected by light falling on objects and by the location of the object in the space of the picture plane. Areas and objects in the background or forms behind others tend to be darker. Areas of the drawing catching the light first either on the top or the side of an object—which have been referred to as planes—tend to have the lightest values.

You can reverse the perception of space by darkening the foreground while using the light values in the background. Select one plane on each cylinder to lighten. Darken the plane farthest from the light. Leave a gray plane between them. The manipulation of light to dark creates volume and space in the drawing. Alberto Giacometti has overlapped and wrapped the portrait tightly in lines creating rich volumes.

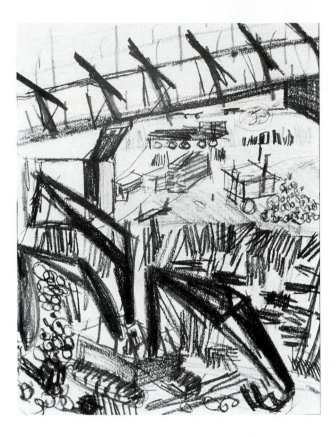

CREATING SPACE IN GESTURE DRAWINGS

The space in a landscape can be organized from well developed dark values in the foreground to faint light values on the horizon. This arrangement visually reads to the eye as distance. A still life drawing tends to be arranged with light to dark. A light foreground relative to a dark background establishes the volumes of the still life in space. This is of course a generalization to begin thinking about the effects of light and dark. We feel a sense of space in a drawing depending on the placement of light and dark in the picture plane. If in a still life the objects in the foreground are rendered in dark lines and values and the background are light your eye reads space of the foreground in shadow. In gesture drawing value is controlled by changing the pressure of your hand on the pencil or pen to move the value from light to dark. Layering lines in hatching strokes will darken the value.

Simple lines and marks in gesture drawing are not meaningless. They may represent space, texture, the distance and space between objects, the ground, the surface of the forms, the contour of the forms, and light.

Jan Reaves' sketches, on the left are studies of a construction site. We perceive space in the drawings first from the changes of value in the lines, and then from the size and scale of the marks. Diagonal lines in the drawings suggest receding space but without value change it is hard for the eye to read depth. A rule of perspective states that things get smaller the further away they are from you, and she uses this in the bottom drawing to increase the space of the drawing. Notice the little forms up the page towards the back. The more densely placed lines in the front of the bottom drawing increase the feeling of weight and mass in the drawing. The top drawing is more open and the relative sameness in the marks tends to flatten the space.

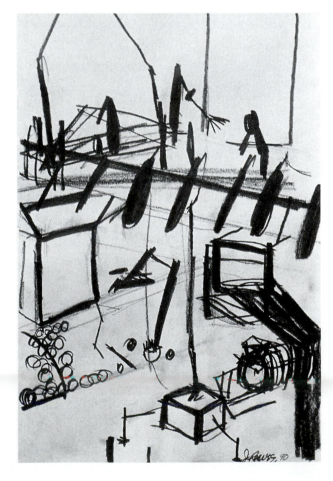

Jan Reaves. Black drawings, pencil, 12 × 9″, 1990. Courtesy of the artist.

The Formal Elements: Gesture

Gargiulo, Domenico (called Micco Spadaro) ca. 1612–75, *Charioteer*. Pen and brown ink. H. 5¹³⁄₁₆ × 5⅜" (14.7 × 13.8 cm.). The Metropolitan Museum of Art, Gift of Henry Walters, 1917 (17.236.36) 17.236.36.

GESTURE LINE DRAWING

Gesture drawing captures the subject in action without rendering it an outline. Gesture lines are drawn rapidly. They are used to record information about the subject quickly. Gesture drawing is excellent practice in developing the ability to see. Seeing takes time and practice. Each time you look at your subject, you will see more. The charioteer above is a highly energized gesture drawing The loose marks are completely understandable. We can easily see and feel that this is a charioteer.

For gesture drawing you may use a 6B pencil, an ebony pencil, a ritmo charcoal pencil, a woodless 6B pencil, or a pen. The pen is the best choice as it can't be erased. In the beginning students fear the misplaced line, but in gesture drawing there are no wrong lines.

DRAWING EXERCISE

Go outside and pick a view of an alley with buildings on either side or another framed space. Before you start let your eyes roam over the area to be drawn. Start by framing the wall in the front of the space with a series of loose lines. Then add each space or object that follows behind and beside the first one you drew. Let the line roam through the air, stop, start, and circle the space and the surface of the objects in the space. Respond to the space by drawing lines to represent the information you are perceiving.

Lisa Cain. Continuous line drawing, student drawing, 1999.

SUBJECTS TO CONSIDER FOR GESTURE DRAWINGS

Giorgio Morandi used the same objects in hundreds of still life paintings and drawings. It wasn't the objects but the spatial relationships of the objects that interested him. The light on the objects when they were dusty, and the space around them kept him interested. He manipulated the space in his drawings and paintings of the objects by studying the value relationships front to back as well as side to side.

If you are not in a classroom with a professor setting up a still life or life model, a good subject is a chair or a group of chairs. Chairs occupy space and have a volumetric quality similar to that of the figure. You can be your own subject by using a mirror to draw your own head. The interior of a room or the space of the landscape outside a window is a good subject. Frank Auerbach made studies of the walkway to his studio in London. Draw the buildings in your town, or the trees on your street. A construction site and a factory or a power station can be a subject for drawing.

MAJOR POINTS OF GESTURE DRAWING

1. Look at the subject for three full minutes before beginning to draw
2. Follow the contour with your eyes and using your forefinger draw that contour with your finger in the air.
3. Start the drawing from the inside of the form and move to the edge. Don't draw the contour of the form, draw across the form to establish relationships.
4. Keep your drawing arm free and unrestricted.
5. Maintain a continuous line by keeping the drawing tool in contact with the paper.
6. Look at the subject as much as possible and at the paper as little as possible.
7. Use charcoal pencils, 6B pencils or a flowing pen line, on 18 × 24″ paper.

Honoré Daumier, 1808–79, detail from *Sheet Show* see entire art on page 67. The Metropolitan Museum of Art, Rogers Fund, 1927. 27.152.2.

SUSTAINED GESTURE DRAWING

In a sustained gesture drawing you need to be patient. The purpose of the drawing is for you to explore the space of the picture plane. You build the drawing by drawing one area or one object and then the objects next to it which are constructed in terms of the size and placement in relationship to the first area drawn. You use a loose unconnected line, not a contour line. The line is layered to create volume and mass. It's important to relax and not worry about making a bad drawing. Gesture is invaluable in training your eyes to see and making them work at seeing. It is easy to change shapes in gesture since your first lines should be very light. Each layer can change the proportion, shape, and value of each object in the picture plane.

SUSTAINED DRAWING EXERCISE

Study the subject selecting a starting point. Consider the placement of the subject on the page. Draw first with light pressure creating the lightest line possible. Try to draw quickly at first keeping the energy of the form in your brief cross contour that moves from the edge onto the surface of the plane. This drawing should have energy at the end. After three minutes you should have marks representing the objects filling the picture plane and the paper. Step back and study the drawing. Determine the focus point, the main point of interest, in the

drawing. The focus point will be the section of the drawing that will attract the viewer's eye first. It may be the point most in the foreground or a place off to the side. It can be merely the object that you find most interesting. It doesn't matter. It is what controls how you develop a visual space using light to dark. Don't resort to outlining the forms. Allow them to exist with loose line edges and planes wrapped up in gesture lines. Determine the light source and direction the light falls. Move to the gray planes and areas increasing the layer of lines to darken these areas. Increase the pressure on the drawing tool as you draw the darkest sections, avoid outlining the contour or making impatient marks.
The line may cross open space, negative space and the space of the table or ground. This line defines more than the outline. The loose edge and absence of a solid or firm outline is what gives the drawing the energized look. Stop and start, lifting the tool off the paper. Restart depending on where you feel the drawing needs more development in terms of value. Look at the light and dark on the ground planes and on the planes of the forms.
A chamois can be used to rub out lines that should be reduced or eliminated. A chamois is sold in art stores. It is a soft cloth much like the cloth sold in hardware stores to detail cars after you wash them. The chamois will lighten the charcoal or Conté. These first faint lines create body in the drawing. They don't interfere with the final reading of the drawing.
You may also use a kneaded eraser to lighten areas and lift off lines. Wipe the eraser across the lines. When the eraser gets dirty—which is almost immediately—pull it, stretching the area with charcoal on it, and

then roll the eraser back on itself, exposing a clean area to continue wiping the drawing. Sustained gesture drawings look more like an expressionistic rather than formal or tightly rendered drawing.

Alberto Giacometti once remarked that he drew his family because he knew them. In his drawing of his wife, Annette, she seems to float in the space. She sits in the space pushed back by the lines that define the air in the space not the forms. He has focused most on her head, wrapping it over and over with line searching for the real form. His attempt to find the true or real form of Annette's head is represented by continuing adding and subtracting lines to the drawing. His lines represent his thinking.

The Formal Elements: Gesture

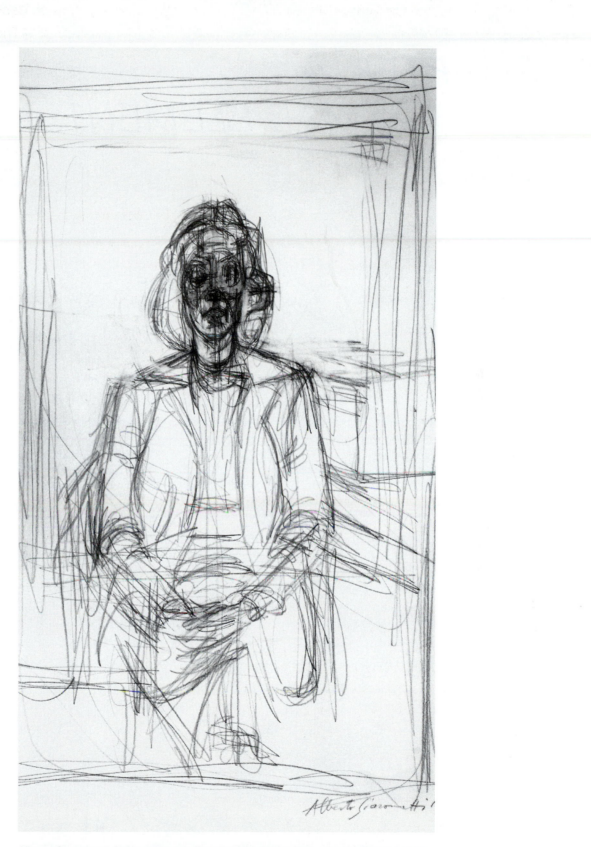

Alberto Giacometti, Swiss, 1901–66, *Portrait of the Artist's Wife, Annette.* Pencil on ivory wove paper, 63.8 × 49.9 cm, Adelaide C. Brown Fund, 1955.636. Photograph © 2001, The Art Institute of Chicago, All Rights Reserved. The Art Institute of Chicago Collection. © 2001 Artists Rights Society (ARS), New York/ADAGP, Paris.

The Formal Elements: Gesture

CHAPTER 4
THE FORMAL ELEMENTS: LINE

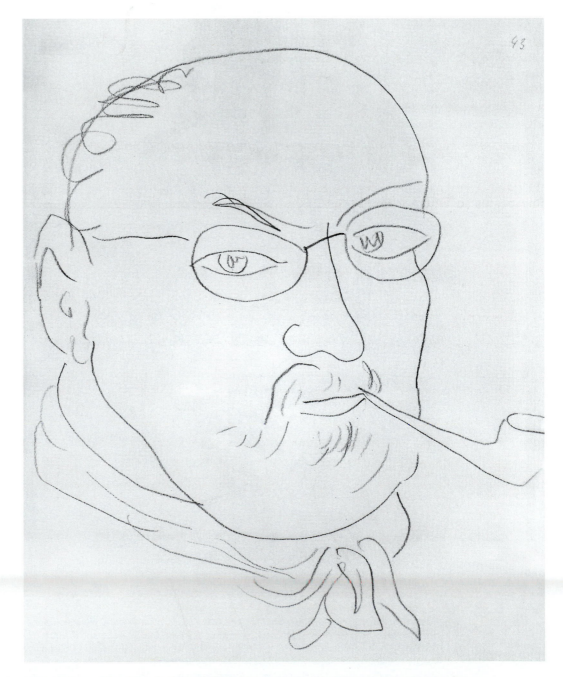

Henri Matisse, 1869–1954, *Self-Portrait*. The Thaw Collection. The Pierpont Morgan Library/Art Resource, New York, N.Y., U.S.A. SO156461. © 2001 Succession H. Matisse, Paris/Artists Rights Society (ARS), New York.

OUTLINE DRAWING

THERE IS A DIFFERENCE between outline drawings and contour drawings. Outline drawings are like silhouettes or cast shadows of a form. An outline can be made of the hand by laying the hand on the paper and drawing around the the edge of the shape. We recognize the shape of the hand, but it could be any hand and it has no defining characteristics. Outline drawings have no fine-line quality; they simply define the shape.

CONTOUR LINE DRAWINGS

In contour drawings the line is specific in defining the edge of the form. The line reflects the way the edge of a form turns and rolls. Contour line drawings reflect a volume, outline merely defines the shape.

A contour line drawing can take a very long time to complete because the artist needs to look very carefully at the subject to render it. As you study your subject, look at where the line begins. Your line will define where you perceive the edge of the form. Look from where the line begins to where it ends. Return and inspect the distance between the beginning and the end for other important line qualifiers.

Line quality is important in contour line drawings. In contour drawings the line is manipulated from light to dark, thick to thin, to define form accurately. Richard Diebenkorn's drawings exemplify the high quality of contour line drawing. Like Henri Matisse, he makes it look simple.

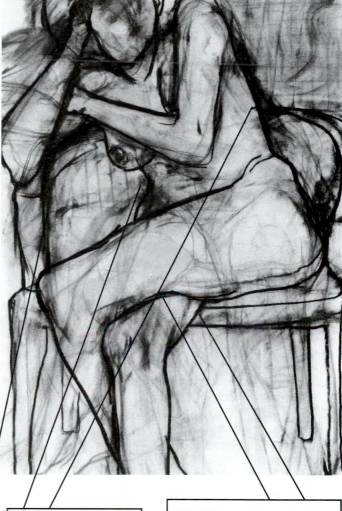

Notice how he has created the curved space of the chair so the figure sits in the chair. Look at the chair legs. The back legs in perspective sit just a bit higher up the paper on a diagonal line from the front legs.

To understand the volume of the figure take note of where all lines start and where they end.

He has clearly defined the torso. It sits foreshortened inside the legs. We see the side plane of the torso on the right.

Using a heavy contour line he defines the bottom of the thigh sitting across the top plane of the other leg. The right leg pushes the left leg changing its shape. The bottom leg has a top plane, side plane and back plane all defined by two contour lines carefully placed.

Richard Diebenkorn, *Seated Nude* (1966). Charcoal on paper, 33 × 23½" (83.8 × 59.7 cm). San Francisco Museum of Modern Art: Gift of the Diebenkorn family and purchased through a gift of Leanne B. Roberts, Thomas W. Wiesel, and the Mnuchin Foundation.

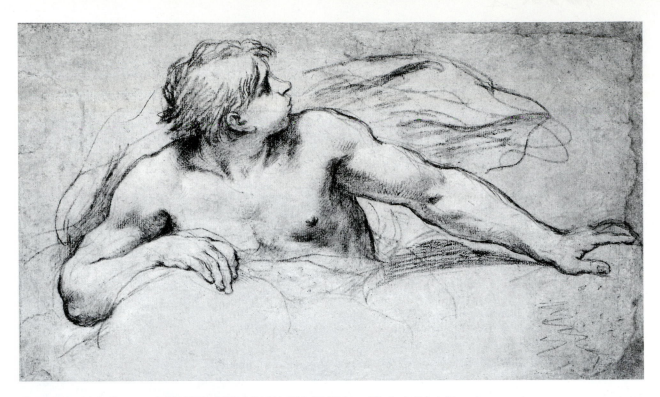

Pietro Berrettini da Cortona, 1596–1669, *A Wind God.* H. 18.9, W. 33.3 cm. Black chalk heightened with white on brownish paper. The Metropolitan Museum of Art, The Elisha Whittelsey Collection, The Elisha Whittelsey Fund, 1961 (61.129.1).

LINE TONE AND QUALITY

Pietro Berrettini da Cortona's *Wind God*, above, is a good example of a contour line drawing in which the tone, the light and dark, of the line changes. A thick line will be dark in value, and thin lines are light in value. The weight of a line is judged by how dark or light the line is in the drawing. Thin lines can be weightless, or fragile. Thick lines are heavy, describing mass and weight.

The lines curving across the muscles of the wind god's shoulders are thick, to render the large muscles. Imagine thin lines on these contours. Thin lines would not convey the power and form of his arms.

Learning to see, means developing the ability to translate volume into line, the way the lines define the wind god. If we examine the lines constructing the wind god we start by looking at how the arm on our right fits into the side plane of the body. The line forming the god's back under the arm describes the volume of the chest. This line under the arm is placed an inch or so down the arm. Look carefully at this area: the

line for his back is drawn behind the arm. The side planes of both the chest and the arm are modeled in a gray value turning these planes under and back from the front plane. The arm on the right is not connected by any lines to the chest. Look closely at the contour line forming the top of this arm. Where the muscle curves in, the line increases in width and darkness to describe the mass. As the line lifts out of the groove, it thins out, revealing the top plane of the muscle on the arm in the light. The lines on top of the hand at the left are thin and the bottom lines are thick in comparison. Line can completely expand into a plane. The left elbow is drawn with line moving to plane. This is the virtuosity of line. This graphic tool has many functions and qualities in drawing.

This drawing combines contour line and gesture. The lines on the left and just behind the arm look like a false start. Perhaps the arm started further back and then the artist moved it forward. The wind god's breath is drawn on the right with gesture lines. A few lines in the foreground define the clouds surrounding the wind god. He sits in the space because of these lines.

The Formal Elements: Line

DRAWING EXERCISE: LOOSE CONTOUR LINE AND VALUE

Hold a 6B pencil between your thumb and flattened index finger, keeping your wrist and elbow free. Practice making lines by drawing across a sheet of newsprint.

Start on the pencil's tip using light pressure, to draw a line across the paper. Make a second, third, and fourth line under the first and increase the pressure as you draw each line across the page. Next draw a curving line, moving it in and out. Move down your paper drawing lines that change from light to dark, thick to thin by rotating the pressure on the pencil from light to firm. Change your hand position and hold the pencil under your hand, pushing it with your thumb to control the drawing tool.

Stack a few vases, jars or bottles together on a table. Practice looking at the contour of the shapes and use light lines and dark lines to define the shapes. Select one form that seems dark. Using the pencil on the side of the lead start the line on the contour and expand it to cover the entire side plane.

CONTOUR AND GESTURE WITH VALUE

John Singer Sargent in his drawing of Paul Manship uses a loose gesture line that is thin and flowing. It follows the drapery, breaking into hatching strokes to form planes. This technique separates the top planes from the side planes. The few dark areas pull the viewer's eye around. The bow tie in a dark value frames the chin. The top and bottom of the collar are divided by the dark value underneath it.

His line does not flail around looking for the form. He directs this line. He doesn't tightly model the sleeves or the face with value. The value is used as loosely as the contour line.

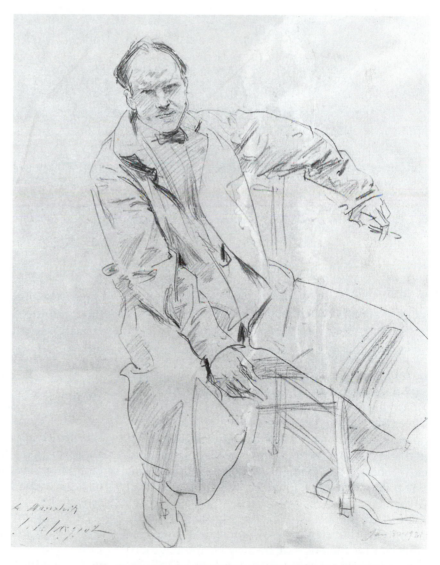

John Singer Sargent, 1885–1966, *Paul Manship*. Pencil on brown paper. 21¼ × 16⁷⁄₁₆″. The Metropolitan Museum of Art. 66.70.

Dan Christensen, *Study for Vela,* 1968, crayon, 32 × 37 cm. The Washington Art Consortium Collection. Virginia Wright Fund. Washington Art Consortium: Henry Art Gallery, University of Washington, Seattle; Museum of Art, Washington State University, Pullman; Northwest Museum of Arts and Culture, Spokane; Seattle Art Museum; Tacoma Art Museum; Western Gallery, Western Washington University, Bellingham; Whatcom Museum of History and Art, Bellingham. Photo Paul Brower.

WRAPPED LINE RHYTHM DRAWING

Dan Christensen in *Study for Vela* above has regularized the continuous line and motion of Jackson Pollock's dripped line. Christensen was a formalist or minimalism artist. These art movements developed alternative theories and ideas to the abstract expressionists before them. This drawing is made out of a colored line across the grid. One can associate the feeling of these wrapped lines to either a two-dimensional scrawl or the vortex. Minimalism took issue with the edge. The edge of the picture plane as well as the edge of the canvas or paper. They sought solutions that were not confined by the edge or framed by the edge but transcended it visually moving beyond it infinity if possible. There are no abrupt transitions in the color of his line. Whatever image you perceive in this drawing is only the result of the process for creating the drawing. The drawing is the result of the repetitive quality of the gesture.

RHYTHM DRAWINGS

Rhythm drawings may be done in felt tip pen or charcoal pencil or lead pencil. Pencils must be kept sharp during the drawing to create a clean outline. Pens are probably best since by their nature they provide a clean line.

A rhythm drawing repeats one form over and over itself which creates the effect of a form moving across the stationary two dimensional surface of the paper.

RHYTHM DRAWING EXERCISE:

Select one object, such as a tool. Hammers, scissors or screwdrivers are easy to use. Draw the object once on the paper. The second drawing of this same object must overlap the first drawing somewhere on the outline of the first drawing. Continue drawing the outline of the object with each succeeding drawing overlapping the drawing before it. The drawings may go horizontally, vertically or diagonally across the paper. Size can be varied. The space between the outlines may be tight or far enough apart to allow you to see the complete outline. The object may start out as a very small drawing and expand to a larger and larger drawing in each object's outline. If the drawings go off two or three edges of the paper, the figure will seem to move through and off the paper.

Susan Rothenberg by 1985 was investigating the qualities of speed and motion in her drawings and paintings. In this drawing the figures spin continuously. Like the Futurists of the early 1900s and Marcel Duchamp in *Nude Descending the Staircase*, Rothenberg challenges the space of the picture plane. This is an active drawing—there is nothing static about this composition. She draws creating continuous motion with a sense of air whipping around the body or bodies. The dancer becomes a blur of light, sending off sparks or kicking up dust as it twirls across a floor.

The advantage she has in using graphite is she can erase into her lines to lighten the value of the overlapping lines in some areas. This change of value enhances the sense of motion moving the figure from the background into the foreground and we feel the figure return into the background.

Susan Rothenberg, *Untitled*, 1987. Graphite on paper, 22⅝ × 31″. Collection Charles Lund. © 2001 Susan Rothenberg/Artists Rights Society (ARS), New York.

The Formal Elements: Line

Willem de Kooning, 1904–97, *Untitled*. Enamel on paper, 1949, 21¹¹⁄₁₆ × 30". Hirshhorn Museum and Sculpture Garden Smithsonian Institution, The Joseph H. Hirshhorn Bequest 1981. 66.1220. © 2001 Willem de Kooning Revocable Trust / Artists Rights Society (ARS), New York.

CONTINUOUS-LINE DRAWINGS

The best tool for continuous-line drawings is a pen, a marker or any other free-flowing tool. Drawing pencils like the 6B or charcoal pencils are soft and make beautiful lines, but you can't sharpen them in the middle of the drawing, so the lead will get flat and the line larger as a result. There is no erasing in this drawing; all changes are made by drawing another line to correct or restructure the line you feel is inaccurate.

The intrinsic value in making continuous-line drawings is in the increased understanding you will have of the objects you are drawing and the three dimensional space they occupy. A continuous-line drawing is composed of one line from start to finish. The drawing tool never loses contact with the paper. When you are drawing, if you lose your place keep your pen on the paper, glance down to see where you are, then look back at the subject and continue the line. The entire 18 × 24" piece of paper should be filled from side to side, top to bottom.

DRAWING EXERCISE: STILL LIFE

Pick a starting point on the left or the right of the still life. Place your pen on the paper to correlate with that spot. The line should flow around the contour of the first object. The line may also move off the contour and onto a plane of the form. Your hand follows your eyes as they look from one object to the next. Don't let your eyes get ahead of your hand or your hand get ahead of your eyes . Draw one object at a time. The line may define the object from the middle of the front plane to the edge as well as staying on

the contour. The line must cross the top of the table's surface in order to move from the first object to the second object. The line defines the objects, the air between the objects, and the ground under the objects. The line defines both the contour and the surface of the objects in the drawing. Line is not only used to draw the outline or contour. It can also be used to indicate a solid flat and empty surface. The line in the drawing will overlap itself because you are searching to define the space, not trying to keep tight control of the line's location. It will wander. The overlapping is fine; it gives the drawing a transparent effect. The objects don't feel quite solid. We can look through them to the objects in the background and the space of the table and the space of the wall behind them.

Lisa Cain. Continuous line drawing, 1999.

Continuous-line drawing is a drawing process that provides artists time to think about the space they are studying. As you direct this line, you make choices and decisions about the size, location, and scale of the objects in the space. Your knowledge and understanding of how to translate the three-dimensional space into the two dimensional space of the paper increases. Don't worry about what the drawing looks like. The purpose of a continuous line drawing is to investigate the spatial relationships between the objects and the ground. In each following drawing you will understand the space of the still life in terms of the space of the paper better.

Summary
Continuous-Line Drawings

- use a free-flowing drawing tool that stays in contact with the paper for the entire drawing
- are composed of one line that defines the contour and the spaces between the objects
- are thinking lines
- have lines that define both the negative and positive spaces
- are related to gesture drawings
- should fill an 18 × 24" piece of newsprint

CROSS-CONTOUR

Line begins as a point, one small dot on a surface. When two points are placed on a surface with space between them, it is considered a line. We visually connect the two points, and in an abstract sense it becomes a line. When rows of points are repeated across a surface, they form lines. These lines indicate visual direction and create the illusion of movement. Line, then, is more than just an outline of shapes and forms. It is direction. It can also define texture and value and plane. Cross-contour line drawing describes the topography of the surface rather than the outside contour.

DRAWING EXERCISE

Select something organic, round with soft edges. A hat, a stuffed bird, a cow skull, an acorn squash, a folded drapery, a folded coat, a pair of blue jeans, or a sweater. Study the form and pick a starting place. Draw a line from one side of the form to the other that follows the ups and downs or ins and outs on the form's surface. Move off that line one inch up or down and draw a second line across the surface defining the form. Continue drawing lines indicating the contour of the surface, moving with the concave and convex or depressions and bumps of the surface to render it without drawing a contour line. The contour is established by where the cross-contour lines ending. The contour or the edge is open between the lines. This type of study helps the beginning student slow down and look at the structure of the surface. In cross-contour you work from the inside of the form to the outside. The outside edge does not dominate the drawing or your thoughts; rather, the relationships of the curves, grooves, dips, rises and valleys across the surfaces of the form are the focus.

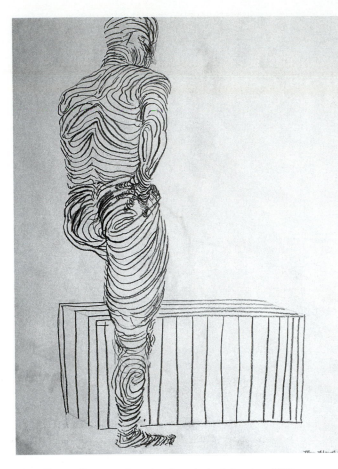

Maya Hayes. Cross-contour drawing, student drawing, 2000.

The Formal Elements: Line

Cross-contour still life, student drawing.

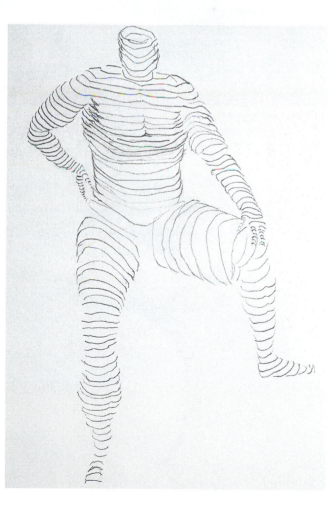

Vlad Voitovski. Cross-contour drawings, student drawings,
2000.

The Formal Elements: Line

EXPRESSIVE AND CALLIGRAPHIC LINES

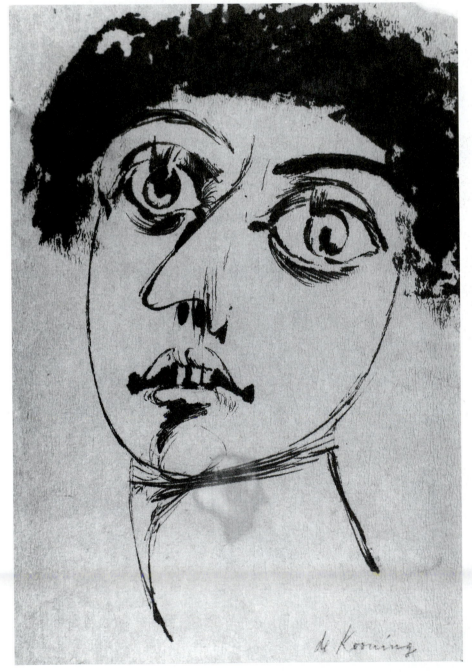

Known as the master of "the calligraphic line," de Kooning drew this head on a paper towel in pen and ink. That fact alone signals what can be called "the expressive moment." The wide-staring almond-shaped eyes reflect the quality of expressive line drawing. They are anatomically accurate with full pupils, eyelids, and eyelashes, indicating de Kooning's deep knowledge of form. The spontaneity of this drawing demonstrates the quality of expressive line. *Head of a Woman* has an overall expressive effect. The mouth curls into a grimace, the nose turns to a profile, the nostrils are placed under the nose, and the hair is a scrubbed mass. Quick lines on the neck support the turning head, which appears to have been whipped out on the towel directed flowing strokes.

Calligraphic line comes from letter forms. The Japanese and Chinese characters drawn with brush and ink had a strong influence on the French Impressionists and then the abstract expressionists in America. Mark Tobey, an artist from the Pacific Northwest, produced drawings in overall textural patterns he called "white writing." Jackson Pollock used an expressive line that freed line forever from its previous role as outline.

Willem De Kooning, *Head of a Woman* (Study for *Queen of Hearts*), c.1945. Pen and wash on brown wove paper (paper towel) 280 × 195 mm. signed: de Kooning. 1984.224 Anonymous gift. © 2001 Willem de Kooning Revocable Trust/Artists Rights Society (ARS), New York.

Spatial ambiguity results from the shift of scale in the marks in Pollock's drawing. The layers of thick and thin gestures created without a horizon creates a space that makes us uncertain which layers are on top in the front, and which are behind or in the background.

Ambiguous space is space in which we can't distinguish foreground, background, and middle ground. In Pollock's drawing the grounds shift visually back and forth with the calligraphic marks. Crucial to calligraphic line drawing is the quality of the line. It is usually done with a pointed soft hairbrush. The brush stroke will change according to the amount of ink and water in the bristles as well the pressure the artist puts on the brush from the start of the stroke to the end.

De Kooning was extremely proficient in using thick and thin calligraphic lines. His sweeping strokes made rapidly created a tapered line that is probably the quality in the work of the late forties that caused Harold Rosenberg, one of the first art critics in New York, to name it "action" painting.

De Kooning used a sign painter's brush called a liner to draw the long flowing lines. A flat bristle brush can also be used which will produce an abrupt change from thick to thin.

The expressive line and calligraphic line have been popular tools of the artists in the late twentieth century. Pablo Picasso, Henri Matisse, Pat Steir, Robert Raushenberg, Pat Passlof, Jasper Johns, Cy Twombly, and Jean Michel Basquiet scribbled and wrote words on their paintings. Text may be added in art work as graphic marks or unrecognizeable lines and marks.

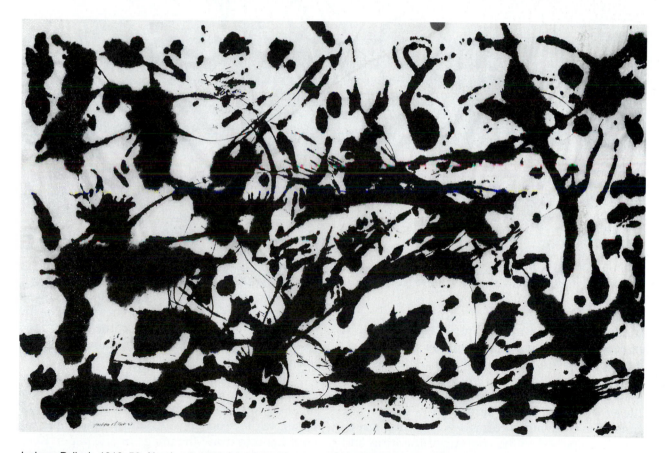

Jackson Pollock, 1912–56, *Number 3*, 1951. Ink 62.5 × 98.5 cm. 74.9 VWF Washington consortium. Virginia Wright Fund. Washington Art Consortium: Henry Art Gallery, University of Washington, Seattle; Museum of Art, Washington State University, Pullman; Northwest Museum of Arts and Culture, Spokane; Seattle Art Museum; Tacoma Art Museum; Western Gallery, Western Washington University, Bellingham; Whatcom Museum of History and Art, Bellingham. Photo Paul Brower. © 2001 The Pollock-Krasner Foundation/Artists Rights Society (ARS), New York.

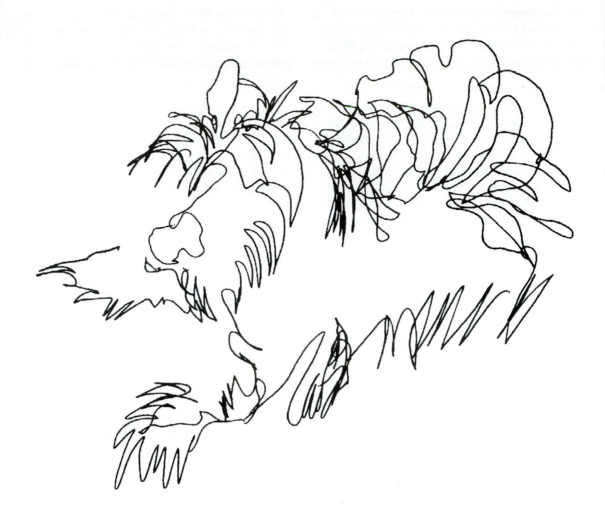

Blind contour drawing, *Cutty, the West Highland Terrier,* 2000.

BLIND CONTOUR

Blind contour differs from gesture drawings in the form of concentration and focus involved in making a drawing. Blind contour is so named because you do not look at the paper as you draw. You look only at the subject. You draw slowly, centering your vision on each section of the subject to be drawn, studying one section at a time. The drawing is formed with a single contour line specific to the contour of the form and to the surface of the subject.

The line should not be a general outline. This line should twist and turn following the curves, dents, in, and outs of the contour on the form being drawn. This line can move in onto planes and cross the planes of the form. If the surface has texture, the line will wave to imitate things like the texture of hair. In blind contour you try to create a complex line that describes the planes as well as the edges or contour. You may include the contour of a shadow along with the forms.

In blind contour you pick a starting point on the subject, locate the pen or other sharp tool on the paper and then try not to look at the paper, while studying the subject and directing your hand to draw the image on the paper. Keep the drawing tool in constant contact with the paper, try not to retrace your line, do not erase, and look carefully. Don't let your hand get ahead of your eyes. Equally important don't let your eyes get ahead of your hand. The drawing will not be in perspective nor will the proportions be

The Formal Elements: Line

correct. The important thing is to make your eyes focus and study the subject.

If you can relax and have faith in this process, you will learn a great deal about your subject. This drawing uses the right side of the brain more than the left side. The right side is the intuitive not factual side. Drawing uses all the senses as well as logic and reasoning.

To determine the direction of the line, imagine your hand is actually drawing on your subject's contour. Move your hand left or right, up or down, depending on which way you would have to turn the tool if you were actually drawing on the surface of the subject. Blind contour helps you learn to think and see the subject in greater depth.

You may vary the pressure on the drawing tool. Heavy pressure makes dark lines, and light pressure leaves light lines. Dark lines are for the areas of the form in the shadows, the dents, back, and behind places. Light lines are thin, seemingly sitting in light. Manipulating the line from light to dark defines the forms as volumes. In drawing a still life, as you follow the form around, your line may move onto the form to define an entire side plane. At this point you may glance at your paper to reposition the drawing tool to start following the contour of the next form in the still life.

This is not a searching line. You should not add meaningless lines that don't describe the specific edge of the form. Do not try to distort the form, but if the form is distorted because you didn't look at the paper, that is acceptable in blind contour.

The line may cross itself but it is not a wrapped line. Wrapped and scribbled lines create mass, weight, and volume in a drawing. Blind contour creates a shape with depth.

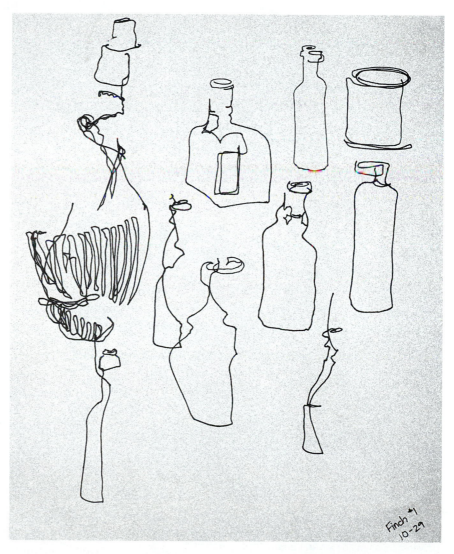

Deborah Finch. Blind contour, student drawing, 1999.

PROFILE OF AN ARTIST: HONORÉ DAUMIER

The drawing below, *Hercules in the Augean Stables*, was made by Honoré Daumier twenty years after he made a series of fifty lithographs in which he used this same theme. Daumier produced the lithographs over a period of two years from 1841 to 1843, in which he lampooned the pseudoclassicism of the period by recasting fifty hallowed episodes from ancient history and myth. They proved to be some of the most hilarious inventions of his career. His intent was to give new life to great tradition of art, to free it and bring it closer to the reality of common experience. The image of Hercules in the Augean stables must have particularly moved him, because he returns to the theme here in this later drawing. Hercules is resting after the fifth of twelve labors. For this labor, he had cleansed the stables of King Augeas of thirty years of dung by diverting two rivers through them. An overweight Hercules leans on a broom, not a club, and Daumier has given him the look of a street cleaner, not a god. The contours of the body are erratic, discontinuous pen strokes that hesitantly shape the figure. The face of Hercules is done in the kind of line that seems spontaneous. The look on his face seems to be that of the deepest disgust with the world. In the first lithographs the look was that of humor. Now it is closer to pathos.

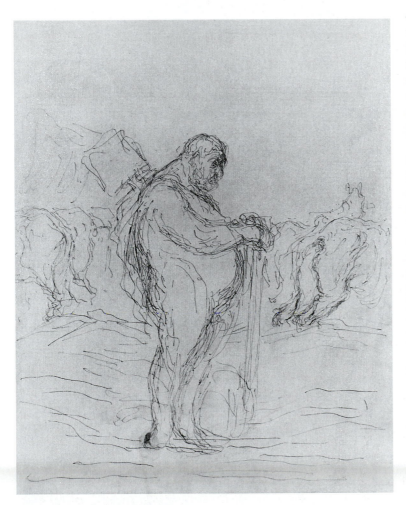

Honoré Daumier, *Hercules in the Augean Stables*, c. 1862. Pen and gray ink on cream paper, 345 × 264 mm. Stanford University, Committee for Art Fund.

In his time, Daumier was criticized for the sketchy, almost unfinished quality of his work. Today this is a more positive quality than a negative one. His animated drawing style conveys and compels empathy with Hercules's human presence and experience. His work depicts compelling narratives.

Daumier did not receive formal training in the arts. He was self-taught; however, he was hyperconscious of his predecessors. He was a gestural master in the tradition of Tiepolo, Goya, and Rembrandt. The state of perpetual movement and instability of his figures anticipate the motion and rhythm of Futurism. His radical but brilliant cartoons would land him in jail for lampooning the corruption of postrevolutionary French politics and society.

Satire and humor permeate his narratives. His figures are usually twisting, turning, swinging, caught in the moment. As a social critic commenting on the institutions of his day, he is perhaps most famous for the many drawings of lawyers and law courts. Gesture is the perfect style to capture moments in time and keep them active. In a Daumier drawing a lawyer's arm might be flung back toward a passive defendant as he passionately addresses the court. You feel the entire moment.

The Formal Elements: Line

In *The Street Show*, below, Daumier's line is loose, defining the end of the form without a outline. It's like a fishing line loose and floating around the form. He reinforces the shapes and volumes in the drawing with an ink wash on the figure, one behind the figure and again on the ground. The figure in the back is dark, which separates him from the front figure.

This active, expressive line describes movement. He places the values very consciously to create a sense of space. The gray figure on the chair is separated by the white drum from the a man, depicted in very dark values. This rotation of values moves the eye through the drawing.

Daumier's drawings were intimately bound up with the human drama of the artist's own time. He was intrigued by the spectacle of city life and by the theater, where long before Toulouse-Lautrec he observed the effect of the footlights on the performers' faces. He drew from memory. Once in the country with a friend he stopped at a pond with ducks. As he stood intently staring at the birds, his friend asked why he didn't draw the birds. He replied, "You know perfectly well that I never draw from nature." He made his living portraying the human comedy, drawing seven lithographs a week for a Paris newspaper.

It was a surprise when at the end of Daumier's life Paul Durand-Ruel's gallery in Paris in 1878 displayed ninety-four paintings, unseen drawings, watercolors, and sculptures in which the full range of his genius was evident. It would not be until 1900 that Daumier, the people's artist, would be acknowledged as one of the great pioneers of the modern movement.

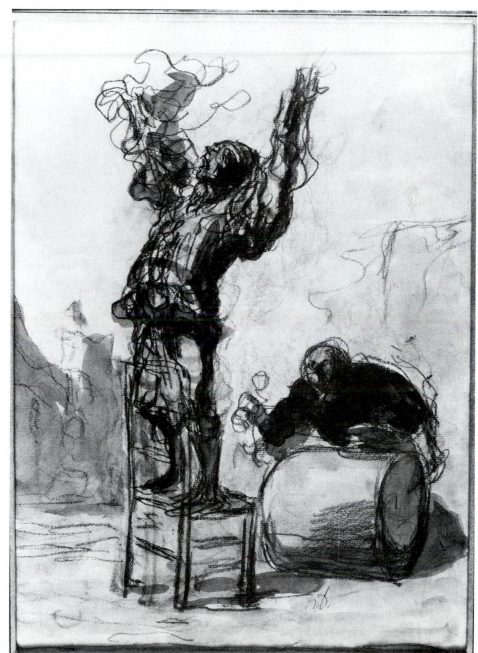

Honoré Daumier, 1808–79, *Street Show* (*Paillasse*). Black chalk and watercolor on laid paper, H. 14⅜ × W. 10¹/₁₆" (365 × 255 mm). The Metropolitan Museum of Art, Rogers Fund, 1927, 27.152.2.

Edouard Vuillard, 1868–1940, *Studies of a Seamstress*, 1891. Brush 3 with India ink on buff wove paper, 361 × 305 mm. Signed and dated.1970.21. Mortimer C. Leventritt Fund, Stanford University. © 2001 Artists Rights Society (ARS), New York/ADAGP, Paris.

IMPLIED LINE

An implied line is a broken outside line that implies contour. The line starts by following the form and then stops, leaving a gap. Our knowledge of form is strong, and our eye completes the form from previous visual information we have stored. The implied line opens up a drawing, releasing a different energy. The form feels as if it flows. This type of drawing is also referred to as having lost and found edges. It is one way artist's create visual interest. Without the edge we are uncertain as to how far a form may move into the paper. Implied line can reflect actual light conditions. The edge of form will dissolve when a bright light falls on the form. Overlapping forms with similar values will destroy the

line separation between them, and as form turns away into light, the edge can be lost. The implied line opens up the picture plane, increasing our sense of space. Ending the line, stopping it short, creates space. A discontinuous contour transforms the information in the picture plane, by adding light, air, and space to the forms and spaces around them.

Line can define shape or a volume and create value and space. Line can represent a thought, as well as an observation or a feeling. Guston's lines pull you in and out of the space they create. The quality of his line is elegant with the broken and blurred edge. There is a small, almost unnoticeable overlapping of lines, which creates a shallow space. The few diagonals against the horizontal and vertical lines either

The Formal Elements: Line

send you into the interior or push out into your viewer's space outside the picture plane. These are thinking lines, representations of spatial relationships.

Drawing refines our level of seeing. To see is to understand the objects and the space they occupy completely, which will increase our ability to translate the three-dimensional space into two-dimensional space. Our eyes are lazy, but by practicing we retrain them to record information we previously overlooked because we didn't think it was important or we didn't look hard enough. Drawing improves our awareness of the world around us.

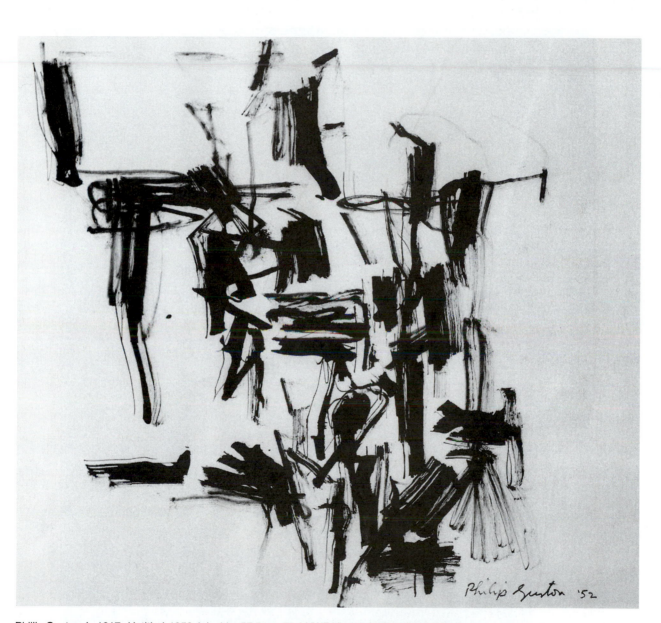

Phillip Guston, b. 1917, *Untitled,* 1952. Ink, 44 × 57.5 cm. 75.3 VWF. Virginia Wright Fund. Washington Art Consortium: Henry Art Gallery, University of Washington, Seattle; Museum of Art, Washington State University, Pullman; Northwest Museum of Arts and Culture, Spokane; Seattle Art Museum; Tacoma Art Museum; Western Gallery, Western Washington University, Bellingham; Whatcom Museum of History and Art, Bellingham. Photo Paul Brower.

CHAPTER 5
THE FORMAL ELEMENTS: VALUE

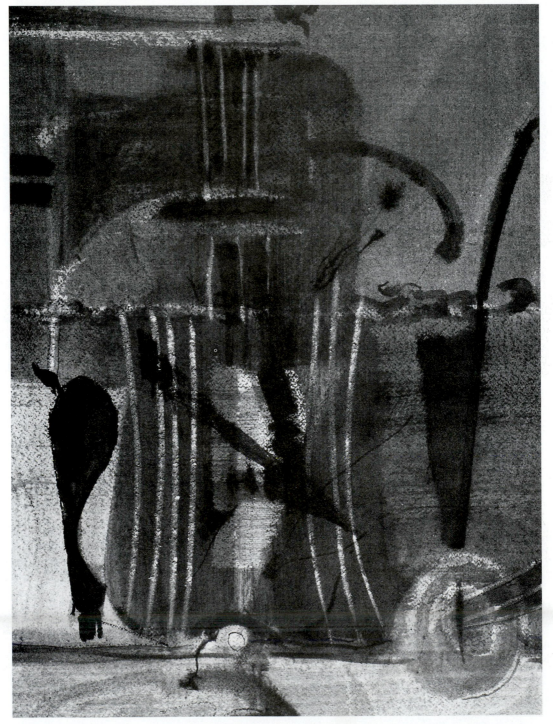

Mark Rothko, 1903–70, *Altar of Orpheus,* 1847–48. Watercolor and ink, 50 × 33 cm. 75.13 VWF. The Washington Consortium. © 2001 Kate Rothko Prizel & Christopher Rothko/Artists Rights Society (ARS), New York.

INTRODUCTION TO VALUE

DRAWING IS AN ILLUSION created by line, value, perspective, texture, and color. The words value, modeling, and shading refer to the range of light to dark in a drawing. Value or value changes create the illusion of volume on a two-dimensional surface. The placement of light and dark in the picture plane can create deep space or a sense of shallow to flat space. The objects in the still life are defined with value changes as well as the ground and negative space between the objects.

Prior to the Renaissance, artists used a process called quattrocento, which was a dry and hard manner of modeling. Leonardo da Vinci developed sfumato, a soft modeling in light and shade. Eventually modeling was called chiaroscuro. Chiaroscuro translates to mean light into dark. Using the process of chiaroscuro, we create the illusion of volume, space, depth, and mass on a two-dimensional surface. Chiaroscuro defines how light falls across a cylinder. "Value" and "tone" are synonymous, referring to gradations of gray between the white of the paper and the darkest value of black that the drawing tool can create. Research has found that our visual system can process approximately nine degrees of light from white to black. The gray scale on page 77 represents the range of value we can perceive. Value expresses the volume of the subject adding a sculptural quality to a rendering. Value changes create weight in the shape drawn by the line.

Hatching and cross-hatching techniques are used to create a value change. Hatching is a series of short, parallel strokes that create a range of values from light to dark. This graphic method is also used by printmakers in etching. Hatching lines are made with a sharp pencil, pen, silverpoint or in etching a metal tool. Hatching lines follow the contour of the surface which is one of the strengths of this technique.

Crosshatching is made up of horizontal, vertical, and diagonal strokes. These parallel lines are applied in overlapping layers. The effect of chiaroscuro as a full range of light to dark tones depends on the number of layers each plane receives. Modeling with crosshatching is strengthened by varying the weight of the line. Line can be read as light or heavy. It is considered heavy when it is dark and weightless when it is thin and light. The forms in a drawing visually advance or recede depending on the degree of light and dark

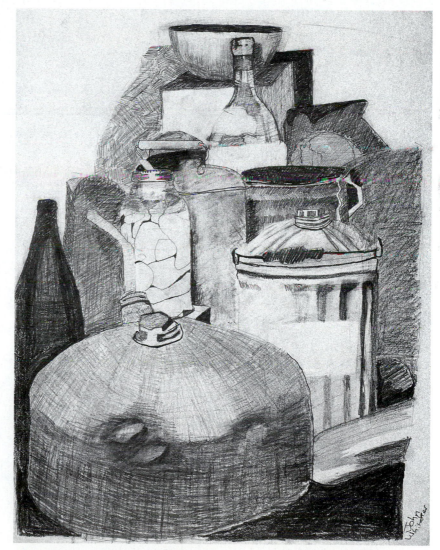

John Whitaker. Pencil, student drawing, 1999.

rendering each subject. The placement of values, light, gray, and black orders the space in the picture plane moving the observer's eye in and around the drawing. The picture plane directly references the space of the drawing surface of the artist's paper. It defines the boundaries of the drawing.

George Bellows in the drawing below has balanced the space from black to white. The value changes from front to back parallel the diagonal eye line of the woman in the front. He moves from the woman in the foreground in a black dress, her skin is lightly modeled, and the floor under her legs is darkened. Her black hair separates her head from the group of men standing six feet behind her in another room. The bold dark values pull her forward from the woman on the couch who has been modeled in light grays. The dark value of the couch behind the woman in gray frames her. On her right the third woman is lightly sketched. Her left shoulder is lightly modeled, separating it from the white of the couch behind her. Notice the way Bellows manipulates the value of the floor, moving from gray to black and opening a white surface on the left. This is not a record of actual light patterns in the room on this night, it is an interpretation of light to create space in drawing.

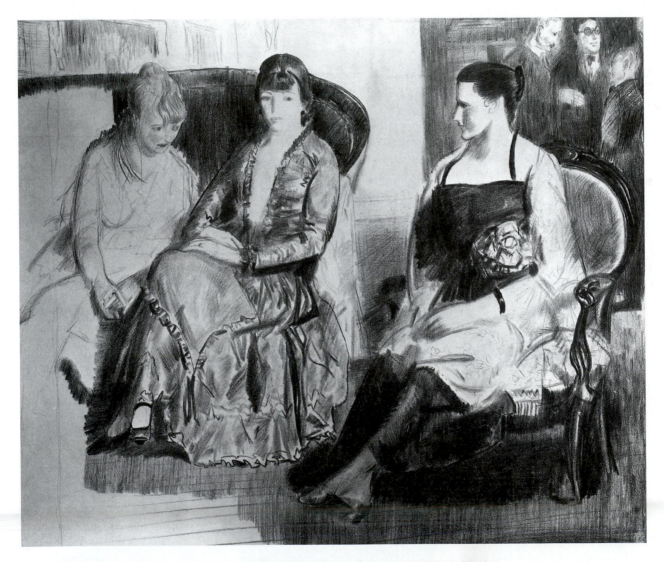

George Wesley Bellows, American, 1882–1925, *Elsie Speicher, Emma Bellows, and Marjorie Henri*. Black crayon over touches of graphite, on cream wove paper, 1921, 44.1 × 52.6 cm. Gift of Friends of American Art Collection, 1922.555.3 Courtesy of The Art Institute of Chicago.

The Formal Elements: Value

Richard Diebenkorn's drawing on the right is a lithograph. Lithographs are drawn directly on a limestone, or on a metal plate. Drawing for a lithograph differs from drawing on paper in two ways. First the drawing on the stone can be made with only grease crayons or tusche, which is a grease based liquid resembling ink. Secondly, when the drawing is printed it will be reversed left to right, a mirror image of itself. Henri Toulouse Lautrec made his drawing for litho on a transfer paper that he could lay face down on the stone, so that he could anticipate the effects of the reversal. Lithographs are created directly by the artist's hand drawing on the stone or the plate. The litho is then a drawing that can be reproduced as an edition.

Diebenkorn's understanding of value balances the space of this drawing. The white table top brings your eye into the space. The woman's black purse stops your eye and then Diebenkorn rotates the values with a white arm into the gray background. The woman is modeled with light gray values placing her in the space. The white cabinet on her right and the white table to her left compositionally, firmly locate her placing her back in space.

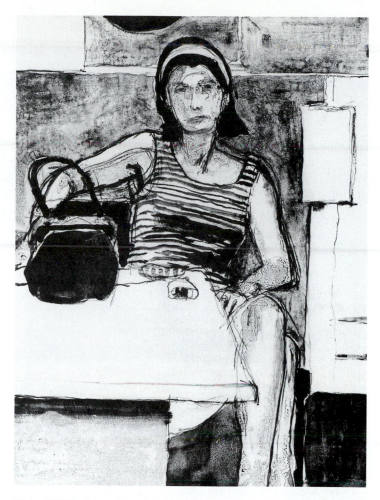

Richard Diebenkorn, *Seated Figure* from the portfolio *Ten West Coast Artists*, 1967. Lithograph, image 29¼ × 22⅜". San Francisco Museum of Modern Art, Gift of Spaulding Taylor. 82.481.3.

FOUR DIVISIONS OF LIGHT

There are four major divisions of light. Light on light is brightest and whitest. It occurs when light falls on a white ground. Light falling on a dark surface is light on dark. A shadow on a white surface is considered dark on light. A shadow covering a dark form is dark on dark and the darkest area of a drawing. The four categories are light on light, light on dark, dark on light and dark on dark. Value changes can create surface textures, control mood of the drawing and guide the viewer through the drawing, moving the eye from side to side, front to back, with the balance of light and dark.

The Formal Elements: Value

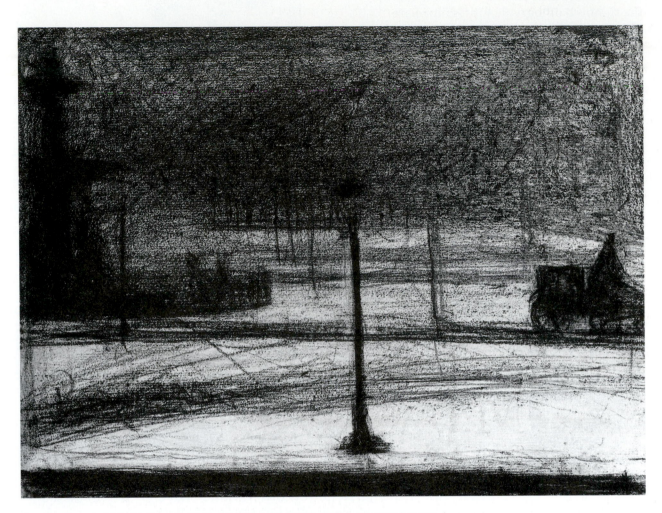

Georges Seurat, 1859–91, French. *Place de la Concorde,* Winter, 1882–83. Conté crayon,
9⅛ × 12⅛″ (23.2 × 30.8 cm). Solomon R. Guggenheim Museum, New York, 1941. 41.721. Photo by
Robert E. Mates © The Solomon R. Guggenheim Foundations.

Landscape is considered deep space or environmental space. Architects compose their drawings with the buildings fully developed in rich lines and values in the foreground. The trees and buildings in the background are light brief washes. Landscape painters contrast the faint hills of the background against the darker subjects in the foreground to create a sense of space in the painting. When the foreground is developed in a full chiaroscuro rendering the forms with the highlight and four to eight values of gray to black, we believe we are looking into a deep space. We can see for miles or one block.

Seurat reverses the balance of light and dark in his drawing above, *Place de la Concorde*. It feels like dusk or night after it has snowed. The ground is white with light reflecting on it, a light-on-light surface in the foreground. Your eye moves back, rotating between the white and black lines of the shadows moving you into the park. The lack of reflected light prevents you from seeing through the treetops. The trees are a dark mass. This is a high contrast drawing balanced between two types of light, light on light and dark on dark. The dense strokes lighten on the right side through the trees, suggesting a gray.

The Formal Elements: Value

Géricault's *The Black Standard Bearer* stands by itself as a finished pictorial composition, not a drawing for a later painting. The subject is based on exemplary acts of courage during the Napoleonic Wars. This is a mixed media drawing using wash and gouache techniques with pencil and black chalk. He has employed chiaroscuro at high contrast drawing a black soldier holding a white flag over a dying white horse. They are flanked by figures in gray wash and charcoal lines growing out of a white cloud. The manipulations of value create a dramatic space. The balance and placement of light and dark are arranged to create a large deep space. It is the space of landscape with the foreground developed in detail while the background is hazy and undefined.

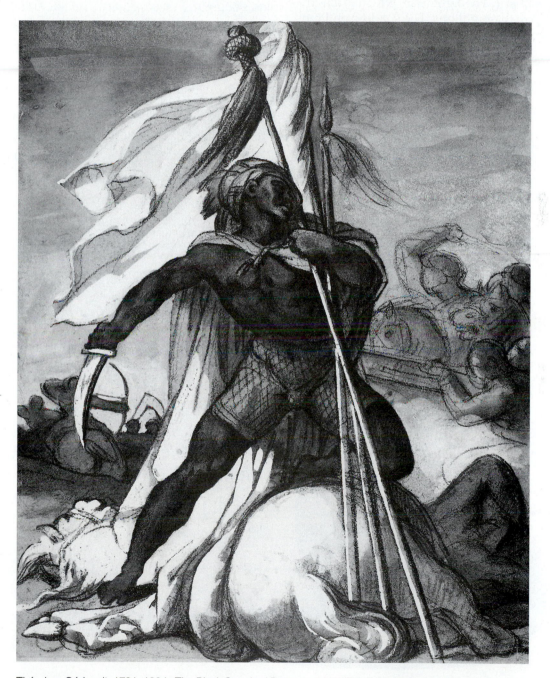

Théodore Géricault, 1791–1824, *The Black Standard Bearer,* c. 1818. Pencil, black chalk, and gray wash heightened with white on buff wove paper 203 × 163 mm. Cantor Center for the Arts, Stanford University, 1972.6.

The Formal Elements: Value

CHIAROSCURO

"Chiaroscuro" was the word coined in the Renaissance to describe light into dark. *Chiaro* means "light," and *oscuro* means "dark" in Italian. It is by manipulating light and dark both on the objects in the composition and in the space of the picture plane that we create the illusion of three-dimensional space on a two-dimensional surface.

Falling light is divided into six areas. The highlight is the first place the light strikes the cylinder or object. The light area, which is a light gray is next to the highlight. The shadow and the core of the shadow are dark gray values further away from the light source. On top of or beside the core of shadow there will be reflected light. Reflected light is a result of a light bouncing off a nearby object. Light strikes one object and bounces at forty-five degrees, landing on the lower curve of the object next to it. This area of the cylinder or sphere where the light is reflected is generally a dark gray value. The cast shadow is at the bottom and lies opposite the direction the light is falling.

EXERCISE: MAKING A VALUE SCALE

Vine and compressed charcoal, Conté, pencil, ink, and charcoal pencil can all be used in value drawings.

The artist cannot duplicate the range of values in nature. We can only approximate the effects. Most people can distinguish nine steps in a value scale that includes white and black. Our perception of value is affected by several factors. The first of these is the color of the object, known as local color. Second, lightness and darkness are relative to the surroundings and the direction light falls. Each tool and medium you work with will produce a different range of value. To determine each tool's range, create a light-to-dark value scale. Draw a rectangle ten inches long and one to two inches high. Divide the rectangle into ten

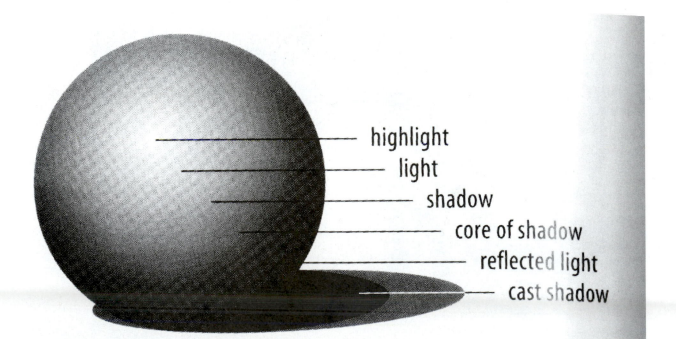

highlight
light
shadow
core of shadow
reflected light
cast shadow

Chiaroscuro light effects on a sphere.

The Formal Elements: Value

Value Scale

one-inch boxes. Leave the first one the white of the paper. Cover the second one with one layer of light pencil lead, using the lightest pressure possible on the tip of the pencil. Hatching and crosshatching work well in applying value to a box. Use a series of repeated diagonal strokes close together within the box to create a layer of value. Each time you overlap the strokes, you darken the value. Increasing the pressure on the pencil will also darken the value. Each box should be darker than the one before it in the row. By using the side of the pencil with medium pressure, you can create dark values. Continue increasing the pressure and the number of layers so that each box is darker than the one before it.

This value scale represents the number of possible changes in value you can make to use in a drawing. By practicing going from white to light gray to medium gray to dark gray to black, you can feel as well as see how to manipulate the tool

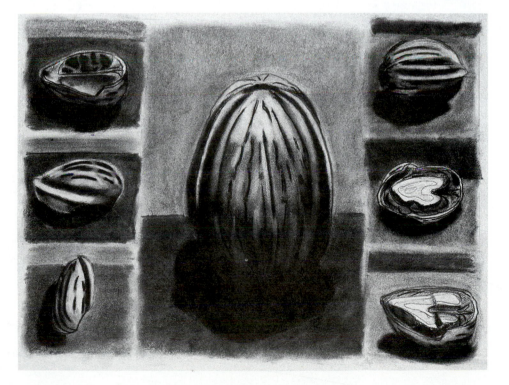

you will draw with. Gradation means drawing gradual steps of gray moving from light to dark between white and black. Make a value scale with each tool at the bottom of your paper or on a separate paper before you start to draw.

Michael Taddesse. Walnut study in charcoal, student drawing, 1999.

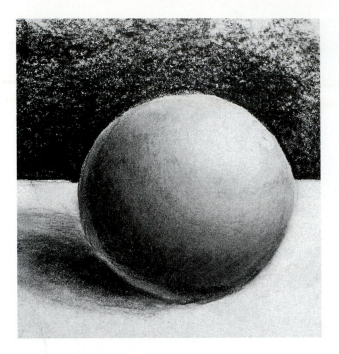

Chris Pangle. Student drawing, 1999.

APPLYING CHIAROSCURO

Light falls on form both vertically and horizontally. Establish the direction the light is falling from first. Light can fall from the left side, the right side, or from the top. Under lighting occurs when light comes from below the object. Back lighting results when objects are illuminated from behind.

The drawings on these two facing pages are examples of light changes across a sphere from light to gray, to medium gray, to dark gray, both vertically and horizontally, with the shadow at the bottom.

DRAWING EXERCISE

Using vine charcoal, draw a circle on a piece of white drawing paper. Holding the charcoal between your thumb, forefinger, and middle finger, lay cross-hatched strokes of charcoal across the entire bottom half of the ball. When your layers reach the middle of the circle, use your finger or a Kleenex wrapped around your finger to rub the charcoal, stretching it from the middle of the circle up one side and around the top of the ball. Leave one-quarter of the top of the ball the white of the paper. Return with the vine charcoal to the bottom of the ball and put another layer over one-quarter of the bottom and up the darker side of the ball. If you covered the top completely in charcoal, use a kneaded eraser to lift a light area out for the highlight.

This exercise is designed for you to manipulate value changes from white to black both vertically and horizontally on this circle. When you stand back from your drawing, it should appear as a sphere. Your circle has volume. It is now a ball instead of the shape of a circle.

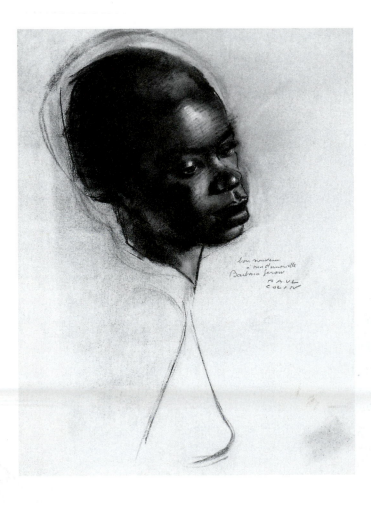

Paul Colin, French, 1892–1985. *Figure of a Woman*, ca. 1930. Black and white crayon on light beige paper. The Frederick and Lucy S. Herman Foundation. Muscarelle Museum of Art, College of William and Mary in Virginia.

The Formal Elements: Value

Light tends to come forward and dark tends to recede. That can be reversed in drawings where the forms in the foreground are dark and the areas of the background are light. Then light recedes and dark advances.

When black is used to entirely fill a form without a graduation through gray and white, a silhouette is created. This is a flat shape that we recognize by its contour. Although we may feel the form is volumetric, it is only because we recognize it and we know the form is three-dimensional. Without modeling from light to dark we cannot create the illusion of volume. The words "model" or "modeling," "shading," "value change," and "gradations" all mean the same thing.

Black and white carry additional meanings in cultures around the world. In the West we wear black at a a funeral, but in Africa white is the color of death and black is the color of life.

In drawing black and white need each other to create a complete illusion of volume and space in and on the picture plane. One without the other results in a flattening of the picture plane.

Right-page top right, Charlie Greene, ink wash; bottom right, Matt McDonal, value study, all student drawings, 1999.

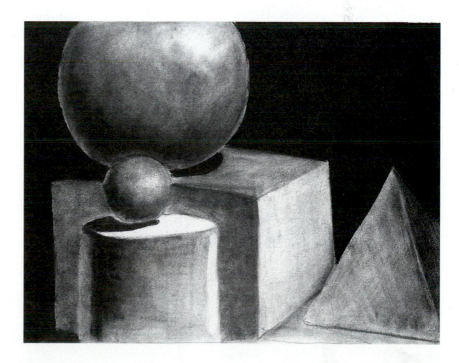

The Formal Elements: Value

QUALITIES OF LIGHT ON FORM: PLANAR ANALYSIS

Light changes on form will vary. You may use only the first half of the value scale, working from white to medium gray. The gray in the middle of the scale would then be the darkest value in the drawing. In the same way you can use only the midpoint to black. Light changes by plane. As the planes change, turning around the cylinder, the value of the light will change.

In a very-high-contrast drawing, a white plane is contrasted with a black plane; the grays in the middle are eliminated. The Andy Warhol silkscreen *Mao* is a high-contrast artwork. In it the light defining the cheek changes abruptly at the end of the cheekbone. We move from the front plane to the side plane at the same time we move from the white plane to the dark plane. Without this change in value Mao's face would look flat.

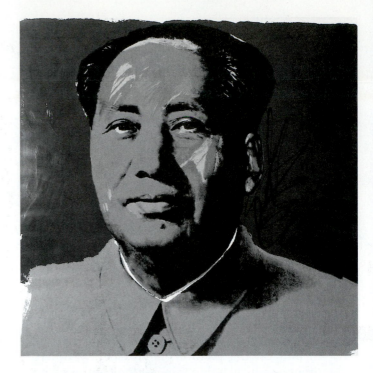

Andy Warhol, b. 1930, *Chairman Mao,* 1973. Portfolio of 10 silkscreen prints, 150/250, 91.5 × 91.5 cm each. 76.25. The Washington Consortium Virginia Wright Fund. Washington Art Consortium: Henry Art Gallery, University of Washington, Seattle; Museum of Art, Washington State University, Pullman; Northwest Museum of Arts and Culture, Spokane; Seattle Art Museum: Tacoma Art Museum; Western Gallery, Western Washington University, Bellingham; Whatcom Museum of History and Art, Bellingham. Photo credit: Paul Brower. © 2001 Andy Warhol Foundation for the Visual Arts/ARS, New York.

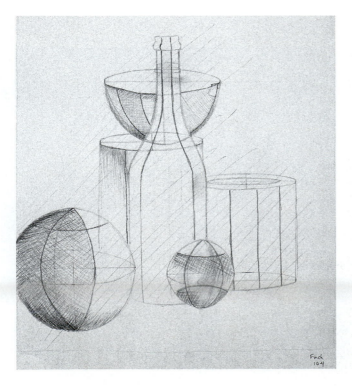

Planar analysis in figure drawing reveals volume of the figure. Locating the planes on the arms and legs alters your perception of the location and connections of the contour lines shaping the figure.

Light falls and changes across the surface of an object both horizontally and vertically. From the point where the light first strikes, the light will begin changing from white to light gray to gray to medium gray and eventually to the black of the shadow.

Deborah Finch. Pencil, study of the planes of cylinders with first value changes added, 1999.

The Formal Elements: Value

Light cannot bend as it moves across the surface. When a plane turns under or away from the direction of the light, it will be a value of gray.

Seeing the planes of a cylinder is difficult. You can feel the changes by placing the palm of your hand flat on the surface of a bottle. Where the palm rests flatly is a plane. To change planes you must turn your palm to touch the area next to the first plane. When you bend your hand to touch the next surface, you have changed planes.

A gradual gradation moving from light to gray, to dark gray, to black creates a most realistic and natural surface. The greater the contrast and the fewer the planes, the more bold the forms appear. Deborah Finch's drawing on the left page and Sabrina Benson's drawing on page 82 are planar studies of a still life. You can see the plane divisions of the surface on the cylinder.

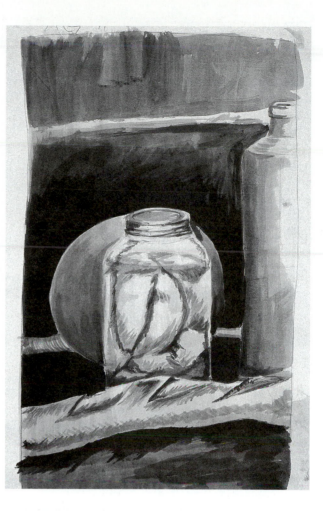

Andrea Galluzzo. Ink wash, 1999.

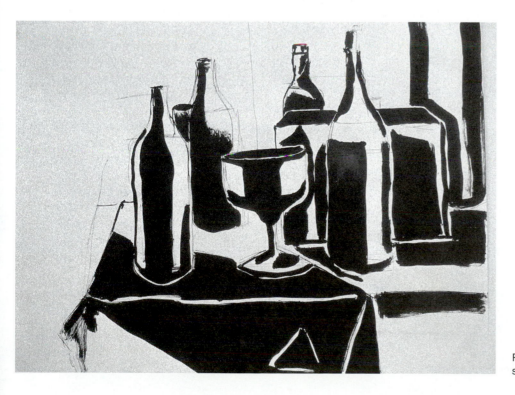

Planar analysis, student drawing, slide C.

The Formal Elements: Value

DRAWING EXERCISE: PLANAR APPROACH TO STILL LIFE

It is important to learn to identify the planes around a cylinder, once you see the form as round with planes, establishing light to dark values will be easier.

Set up a still life of four or five objects and study the surface of each object. It helps to hold the objects in your hand, and put your palm across the surface to feel where the surface turns or curves.

Using vertical lines divide each object by plane. Planes follows the outside contour. On a wine bottle at the bottom of the neck where the bottle expands there is a top plane. At the end of this top surface there is an edge. The body of the bottle starts at the edge.

In the student drawing below note the vertical division on the bottle's neck. Notice that the top plane division follows the outside contour. The planes on the body begin where the top planes end. Apply light-to-dark value changes on the planes.

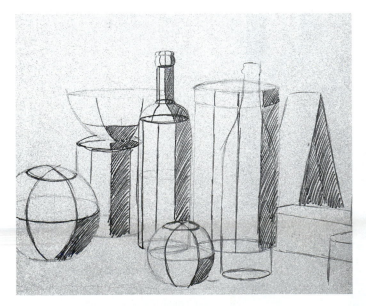

Sabrina Benson. Pencil, planar study, student drawing, 1999.

QUALITIES OF LIGHT IN SPACE

We cannot depend on seeing the gradations of light falling on a still life. We must both represent what we see and add to it with what we know. What you know is the formula for chiaroscuro of light falling on form, which moves from the white of the highlight through a number of grays and finally to black. This change in light occurs both horizontally, vertically, and diagonally in the space of the picture plane. To develop a mood in the space of drawing, artists manipulate the balance of light and dark. When nature doesn't provide enough contrast to make a drawing intriguing, we add or subtract values to push the drawing toward our vision. To create space you must consider the value for the foreground, middle ground, and background. If the foreground is drenched in light, the background may have more darks. When the foreground is dark, the background could be light with gray values. Value change moves our eye through the space, making us feel there is real space in the picture plane.

THE PICTURE PLANE

The picture plane is a direct reference to the two-dimensional space of the surface of the drawing paper. The picture plane frames our composition. It is like an imaginary sheet of glass placed between the artist and the subject, squarely framing what is to be drawn. The drawing subject is translated to the two-dimensional space of the artist's paper by referencing the location of each shape directly through the window to the drawing paper.

If it is difficult to see, understand, and translate objects in real space onto the paper. It sometimes helps to actually put a large glass window between you and your subject and using a permanent marker or glass marker, trace the images on the glass where you see them appearing on the window. Place the glass on a white sheet of paper to see the drawing.

The Formal Elements: Value

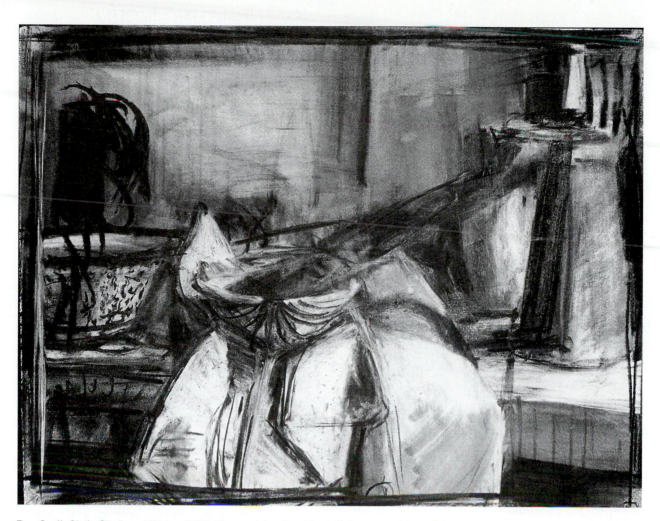

Ron Graff. *Cloth, Shell, and Pitcher.* 2001. Charcoal drawing, 22 × 26″. Courtesy of the artist.

Ron Graff in his charcoal drawing above skillfully manipulates the values in his drawing. The white drape pulls you into the space. The values are placed to guide your eyes through the drawing. You can jump, visually front to back. However the space has conflicts. You have been duped. Look at the lower left corner of the drawing where the drapery hangs over the edge. Then move across the drape to the right. The drapery is lifting up off the table instead of hanging over the edge. The right planes of the coffee pot on the right side of the drawing have been pulled out and turned into a slide of sorts across the front of the picture plane in the space of the drawing. You can look through the coffee pot to the vase in the background. A drawing that at first glance was a simple still life now takes on a new character and mood. It is surreal, abstract and real all at the same time.

He has employed the four categories of light. On the drape, there is light on light and dark on light next to it. The right corner is dark on dark and the back wall is light on dark along with the abstract form on the right.

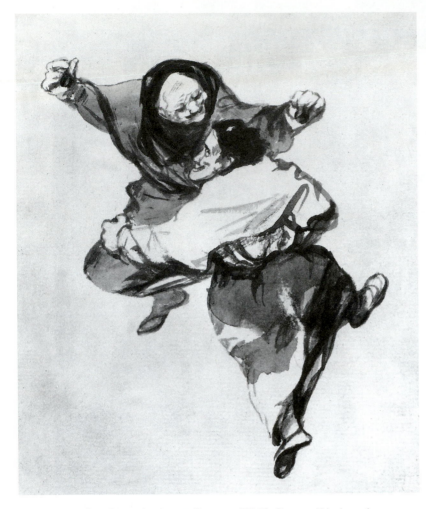

Francisco José de Goya y Lucientes, *Regozyo* (*Mirth*). Gray and black wash on paper, 18 × 28½". Courtesy of the Hispanic Society of America, A3308. New York, New York.

CREATING FORM AND VOLUME BY CHANGING VALUES:

APPLYING THE QUALITIES OF LIGHT TO A DRAWING

Artists draw by making accurate observations of where light is falling across the subject. Light effects spatial relationships, and the shape of each form in the drawing. Careful rendering describes the texture of a surface or form. Artists also manipulate their subject applying value with their understanding of the basic concepts or rules of chiaroscuro. This latter form of drawing has nothing to do with an accurate observation of light.

Goya's *Mirth* is such a drawing. Goya has changed the values from bottom to top to balance these two people in his drawing. Follow the values in Goya's drawing starting with the sole on the woman's slipper in front. Goya starts with a black plane. The top of the slipper and the leg are two small white planes. A gray shadow forms the bottom plane of the skirt. The skirt is white with gray shadows, and the waist recedes in black lines. The white shawl sitting on her shoulders moves the eye to the front of the picture plane. As the right shoulder changes to a side plane, the value turns to the gray of a shadow. The white of her face, is framed by the man's gray tunic and her black hair. The man's face remains on the front plane with her face because Goya has placed it against a dark ground. We feel two people dancing. The value changes in this drawing have nothing to do with rendering reflected light. They have been orchestrated and manipulated to create form and volume in space by the artist.

DRAWING EXERCISE:
A TONAL ANALYSIS

Center and draw a five-inch square on a ten inch square paper. Select a fruit or vegetable—as your subject. Draw the contour of the fruit lightly in HB, filling the five-inch square, leaving very little white around the contour of the fruit.

Set your subject near a light source to see light falling on the form. You are to use five values to render your subject—the five values are the white of the paper, a light gray, a medium gray, a dark gray and black. Use the HB pencil in light gray areas, the 3B pencil in medium-value areas, and the 6B pencil in the darkest areas. Examine the subject to determine where the planes change, and remember that light changes both vertically and horizontally across form. Draw the subject on the 5" square, rendering it in light to dark.

When the drawing is complete, assign each of your five values a number: 1 for black, 2 dark gray, 3 medium gray, 4 light gray, and 5 white. On a piece of tracing paper, draw a five-inch square. Divide this square into a grid of one-fourth- or three-eighths-inch divisions. Tape the tracing paper over the drawing of the fruit. You can see your drawing behind the grid, assign each square a number of 1 to 4 depending on the values in your drawing. Leave the white squares blank. Each square can have only one value. Draw the same size grid on another ten inch paper in a five inch square. Each square in the new grid directly correlates to its counterpart on the tracing paper grid. Fill each square on the second piece of paper with the value you assigned it from your drawing (tape the tracing paper over the second paper to transfer the values in each square).

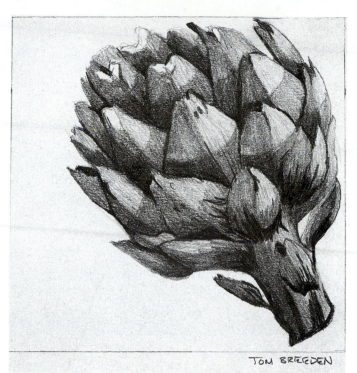

TOM BREEDEN

Tom Breeden. Grid transfer by value from artichoke drawing, student drawing, 1999.

The Formal Elements: Value

CONTÉ AND VALUE

Conté can be used on white drawing paper, but the qualities of the Conté are better realized on colored charcoal and pastel papers. The drawing on the opposite page by Leslie Eleveld was done on gray canson paper with black and white Conté. Charcoal or canson paper has a rough surface, or tooth. When the Conté is wiped or hatched on the surface of the paper lightly without pressing too hard, the rough tooth of the paper will appear through the Conté. If it is rubbed, the tooth of the paper will be covered. Firm layers of pressured strokes will also reduce the amount of paper visible. Leslie's drawing has been layered with Conté and rubbed to achieve a very realistic look.

In this study, students were to draw composing from light in the foreground to dark in the background or the reverse dark forms in the foreground to light in the background. By controlling light to dark they created a sense of space in the composition. The drapery was mapped out first by establishing the location of the top, side, and back planes. The top plane of the drapery tends to be the lightest value; the side planes begin when the drapery turns and curves away toward the dent or fold at the back. The area of fold farthest from the front surface is the back plane. It often rests against the wall or table and generally is the darkest value on the drape. See Chapter 9, Drapery, for a more complete discussion.

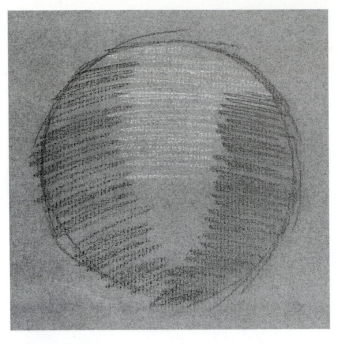

1st layers of Conté.

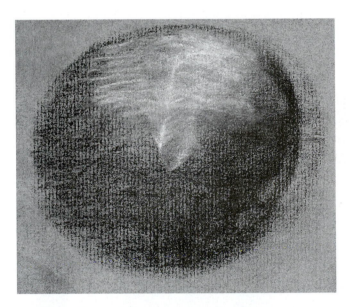

2nd layers of Conté.

Three stages of layering Conté. Building up the values to create volume out of shape using cross-hatching strokes.

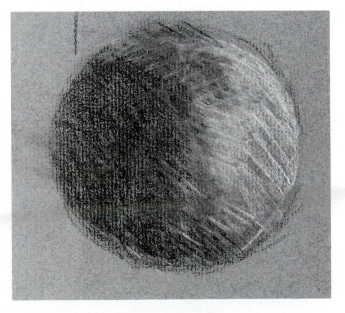

3rd and 4th layers of Conté with white on top.

Break the Conté stick in two and hold the small piece of Conté between your thumb, index finger, and middle finger. Conté can be put on with small, close hatching strokes using the corner of one end. The sides can be used flat to add large planes of value. Pressure is key in this drawing. Start with very light pressure in all areas of the drawing for the first layer. To continue, use very light pressure in the light areas while increasing the pressure on the Conté for darker areas. Plan to put two or three layers on the darker areas. You may blend light and dark layers together to get a gray, and you may rub each layer before adding another layer.

Some artists prefer not to rub but to layer Conté and leave the gray of the paper untouched as the middle tone. White Conté can be added last to create the highlight and whitest planes on the forms or it can be used in the layers. Conté can be rubbed with a stump, your finger, or your finger with a tissue around it. When you rub it in, you dull the value somewhat. To avoid a dull look to the drawing, come back with a second and sometimes third layer of Conté, white and black, that you don't rub. This last layer sits on top of the rubbed layers, giving a rich quality to the values in the drawing.

Leslie Eleveld. Conté still life, student drawing, 2000.

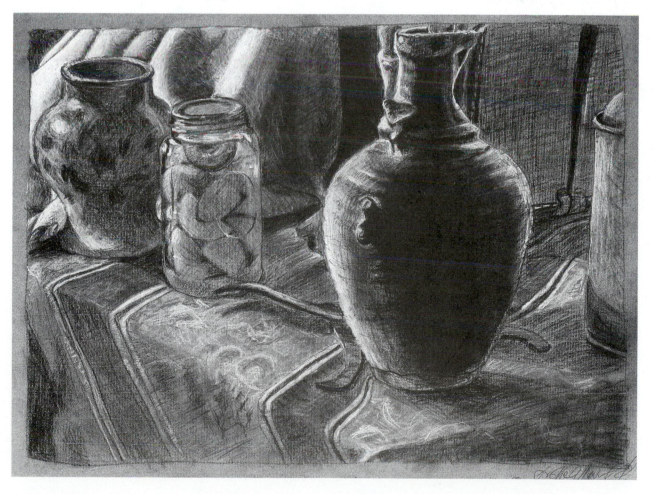

PROFILE OF AN ARTIST: REMBRANDT VAN RIJN

In 1699 the French Academy paid tribute to Rembrandt's originality as a draftsman. Since drawing had no economic value and was not considered important, this was a huge honor.

Rembrandt drew constantly. His concept of drawing as an independent means of personal expression was new to his contemporaries, who painted historical subjects and might use drawing to plan a painting or work of what they intended to paint.

Drawing to Rembrandt was a highly personal activity. It was a means of training his eye and keeping his hand in practice. It satisfied his inner urge to express his most intimate impressions, thoughts, and feelings. It is in Rembrandt's drawings that we see the inventive activity of his mind. Unlike those of other artists of his time, his sketches were independent creations or ends in themselves. He might use an element from a drawing in a painting or etching, but the drawings were not intended to be studies for paintings. He drew daily life: his wife, his son, fleeting gestures, people on the street, animals, and landscapes, studies of common life activities. Only about twenty-five of the fourteen hundred surviving drawings were signed. His drawings were a spontaneous glimpse of daily life expressing his reaction to the things in his life.

In the beginning he preferred to use red or black chalk, but by 1630 ink was his medium. The reed pen or a brush responded to his sense of line and gesture. He had the ability to turn the white of the paper into a source of radiant light. A master of pen and ink. His dramatic use of ink was unrivaled, as was his dramatic use of light against dark in a composition.

Rembrandt van Rijn, Dutch, 1606–69, *Three Studies of Women, Each Holding a Child*. Pen and brown ink, 7⅜ × 5⅞" (19 × 15 cm). Pierpont Morgan Library, New York, U.S.A.SO156059.

The Formal Elements: Value

Rembrandt van Rijn, Dutch, 1606–69, *Two Studies of Saskia Asleep.* c.1635–37. Pen and brown ink, brown wash; 5⅛ × 6¾" (13 × 17 cm). Pierpoint Morgan Library, New York, U.S.A. SO156065.

He was prone to using small pieces of paper rather than large folio sheets like most of the other Flemish and Baroque masters. He preferred half- and three-quarter sheets or the nearest scrap, and he might piece sheets together if the drawing needed more space.

Rembrandt is most noted for dramatic lighting in his drawings, prints, and paintings. Though his followers eagerly collected his drawings, he also had his critics. Some people were unconvinced that a quick sketch had any value. To the people who found his late work lacking in finish he replied that a work was finished when the artist had expressed what he had to say.

Rembrandt was fascinated by the play of light and dark, and there is a dynamic relation-ship between the two in his work. It is Rembrandt who pushes the contrast between light and and dark in the space of his work to achieve great drama and thus a fine sense of volume. Forms seem to emerge out of the darkness in his prints, paintings, and drawings. His pen and ink work is exquisite, with the lines precisely drawn and wrapped on and around the outline, thus indicating more than a contour. It is as if the lines are part of the form. He controls line from thick to thin, light to dark to create a sense of volume with his value changes. It is value, not line, that directs your eye in Rembrandt's work.

The Formal Elements: Value

Rembrandt van Rijn, Dutch, 1606–69, *Sketch of River with Bridge*. Pen and brown ink, brown wash, 5⅝ × 9⅝″ (14 × 24 cm). Pierpont Morgan Library, New York, U.S.A. SO156054.

Light dominates, directing us around and through the space. The atmospheric sense of space seems to stretch beyond the limits of the picture plane. Rembrandt was one of the greatest masters of light and dark. His use of contrast in his work taps our emotions as well as our vision. Rembrandt's portraits look out at you, questioning you the viewer before you can question them. There is often a sense of mystery and spirituality in his work. He can use light and dark in a symbolic way. He creates calm and chaos, revealing the space to us as we have never seen it. Thus Rembrandt fulfills one of the purposes of an artist which is to help us see the world in a new or innovative way and to give visible or tangible form to ideas, philosophies, or feelings.

Rembrandt cuts into the picture plane with crosshatched lines of great density leaving the white to advance out of the dark receding areas. His line may envelop the scene, shroud it in darkness, move you side to side, front to back. His drawings may be elegant, emotionally charged, or serene, but they are always composed from a deep understanding of space and light.

Robert Henri, the legendary early-twentieth-century American painter and teacher, once told his students that the beauty of Rembrandt's lines rests in the fact that you do not realize them as lines, but are conscious only of what they state of the living person.

CREATING SPACE WITH VALUE

WORKING FROM DARK TO LIGHT WITH REVERSED CHARCOAL

Drawing usually begins with a black mark on a white sheet of paper. The whites are left and the gray to black values are added in layers. In reversed charcoal your ground is a dark gray out of which you will erase the light and gray areas. Gray values are added back into the erased areas.

DRAWING EXERCISE

Decide on a subject to draw. It could be a still life, a group of chairs, or a corner of a room. Start by drawing a border around your paper one inch from the edge. This frames the picture plane. Cover the entire area inside the border with a layer of vine charcoal. Apply the charcoal with light pressure to avoid too much loose dust. Shake the loose dust from the charcoal gently into a garbage can; don't blow it off the paper. Blowing it will send it airborne, and when it drifts down, it will put a dirty film on the objects in the room and inside your lungs.

Study your subject, and consider the location of the value in the entire space. Your drawing tools are two erasers, the kneaded eraser and the white plastic eraser. Use the white Mars plastic eraser first. Erase entire forms or only the light and gray planes, leaving the dark areas in the first layer of vine

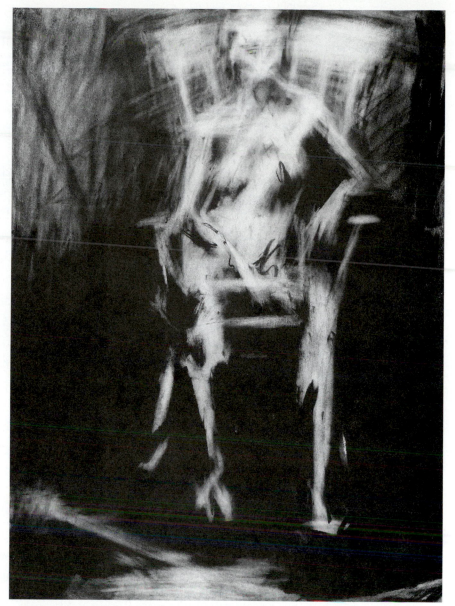

Frank Helmuth Auerbach, British, b. 1913. *Untitled* (E. O. W. Nude). Charcoal and pastel with stumping, erasing, scraping, and brushed fixative on white wove paper, 1961, 78 × 57.3 cm. Restricted gift of Mr. and Mrs. Willard Gidwitz, 1993.17. Photograph © 1995, The Art Institute of Chicago. All rights reserved.

charcoal. The harder you rub, the more charcoal is removed. You can't get it all out and you shouldn't try to as the light charcoal residue in the paper is part of the quality of this drawing. The kneaded eraser will lift out less charcoal, which leaves the area a gray value. Use the vine charcoal to model the planes of each object in the foreground and background areas. Add charcoal over the darks to darken them more. To change values, erase and add more vine charcoal.

WET CHARCOAL DRAWINGS

Compressed charcoal is used for wet charcoal drawings. When water is added to compressed charcoal, it acts like an ink wash. When the wash is dry, either vine or compressed charcoal can be layered on top of a wash area. This process for creating value is labor intensive.

DRAWING EERCISE

You will need compressed charcoal, a soft Chinese brush, or a soft hair brush, and a cup of water.

Line up a row of objects as your subject. Draw the space between the objects, the inner space or the negative space using the compressed charcoal. Follow the outline of the first positive form top to bottom. At the table draw a line across the table connecting the first contour to the next object. Continue outlining each of the spaces in your row of objects. Let the lines run off the top of the paper. Place a layer of compressed charcoal over the bottom quarter of each negative space. Dip the brush in the water squeeze out the excess water and wipe it over the charcoal. The brush picks up the charcoal and holds it for a long time.

Continue by dipping the tip of the brush in the water once before using it in the drawing. Using this wet, dirty brush, paint with the water one section at a time moving up the negative space to the top of the paper. The bristles splay out, when the brush runs out of water dip the tip once in the water to revitalize it and continue brushing up the space. Don't go back over any areas. Once you have placed the value continue to move up the space from the bottom dipping the brush in the water to continue releasing the charcoal. The brush will run out of the charcoal.

Chris Pangle. Above, wet charcoal, top ink and charcoal layers; bottom, compressed charcoal and water in the negative space, student drawing.

The Formal Elements: Value

USING WET CHARCOAL TO GO FROM LINE TO PLANE

Wet charcoal can be used in drawing to create a plane out of the contour line. The line made by the compressed charcoal can be expanded into a top or side plane by washing over the line with a brush. This will lighten the value of the line. The brush holds the charcoal, which can be used to place value on the planes. Outlining shapes flattens form into shape. In value studies you want to lose the outline and create the plane.

LAYERING VALUE TO CREATE WEIGHT

In the beginning students tend to be hesitant in "pushing" a drawing. To push a drawing means to work on it, getting more quality into the drawing with layers of value or line. The purpose of this would be to make a stronger statement.

In a wet-media, layered drawing, each layer dries lighter. Adding water to ink or charcoal dilutes it which is helpful in building layers, and subtle changes. When you paint layer on layer, leave some of each layer exposed. You can always darken areas, but you cannot lighten them. Use the dark wash at the end of the drawing.

DRAWING EXERCISE

To start a layered drawing map out the planes on each object by surrounding the areas with line.

Draw lightly with a 3B pencil, outline the objects, the planes, and the grounds you decide are dark. Using light pressure on an HB charcoal pencil, place a layer of hatching on the darkest planes. Continue the hatching lines into and on the medium gray planes. Hatching through the end of one plane and into the next will give a value gradation from dark to gray.

In addition to adding layers of hatching, in charcoal pencil strokes build use an ink wash over the hatching to darken areas. An ink wash is made of one-fourth cup of water and

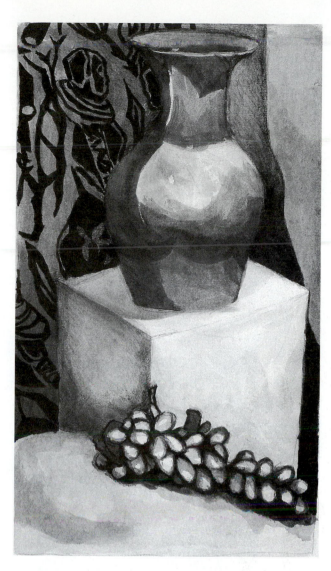

Jennifer Springstead. Ink wash still life, student drawing, 1999.

a drop of ink. Each layer changes the degree of light to dark in the drawing. Layering creates relative light and dark. This means that to create volume and space in a drawing, the areas in shadow must be relatively darker than the lightest areas in highlight. The dark is not the ink straight from the bottle. You cannot expect to put one layer on and have the perfect black or gray. By putting one layer over another, you can build the volume representing light moving to dark across the space of the drawing. This gradation of light to dark represents light in space.

The Formal Elements: Value

Frank Lobdell's *Seated Woman* below is pen and wash in black ink with white gouache and ballpoint pen on ivory wove paper. He has used a range of values in the ink washes. Darker values frame the side planes of the hair and areas between the arms and the legs. The form seems more geometric than organic. This drawing is remarkably weighty. The upper torso and the head seem solid as a stone. A number of false starts are evident in this drawing. They are not mistakes but opportunities to correct and change forms. False starts can not be erased in ink drawing, but they can be covered with a wash or hatching. He uses scribbled hatching combined with the ink, which increases the solid feeling of the blouse and the legs. The claw hand on the left expands forward enlarged by the dark shadow on the forearm and leg above it.

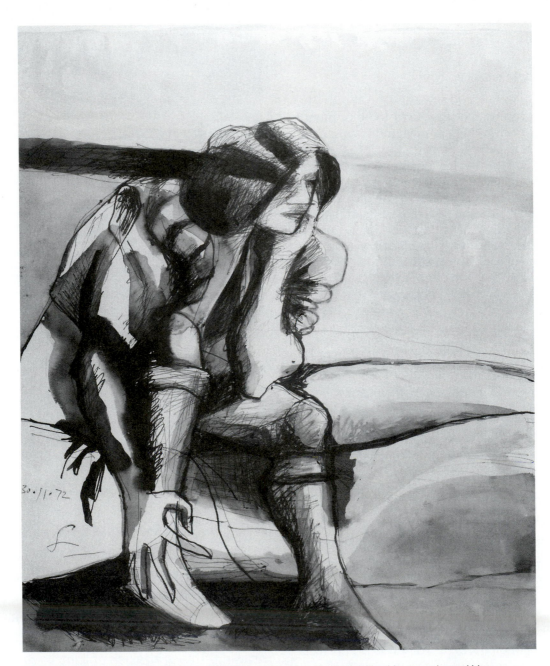

Frank Lobdell, b.1921 *Seated Woman,* 1972. Pen and wash in black ink with white gouache and blue ballpoint pen on ivory wove paper. 363 × 334 mm. dated and signed at left.30.11.72/L. 1988.92 Gift of the artist in honor of Lorenz Eitner. Stanford University.

The Formal Elements: Value

CROSSHATCHING: PENCIL DRAWING AND VALUE

Crosshatching is the traditional form for creating value that was developed during the Renaissance.

It requires intense precision. The hatching lines must be placed close together or the form will look as if it is wrapped up in cobwebs. In addition, the quality of the line is important. Lines should be fine, straight, and thin. Weight is not in the line but in the overlapping layers of lines. Lines are laid down diagonally, horizontally, and vertically on top of each other or side by side. Each layer darkens the one before. Lines also need to follow the direction on the surface of the plane. One layer of lines applied to the surface of a cylinder vertically, will flatten the form. In Géricault's drawing notice how the hatching turns across the form and defines the side planes. Note the changes from light to dark according to the number of layers of hatching strokes.

Hatching becomes crosshatching when a series of parallel lines are drawn in overlapping layers. These lines can create texture as well as value changes. One layer of hatching reads as a light value with each additional layer of hatching darkening the value. Crosshatching alters the

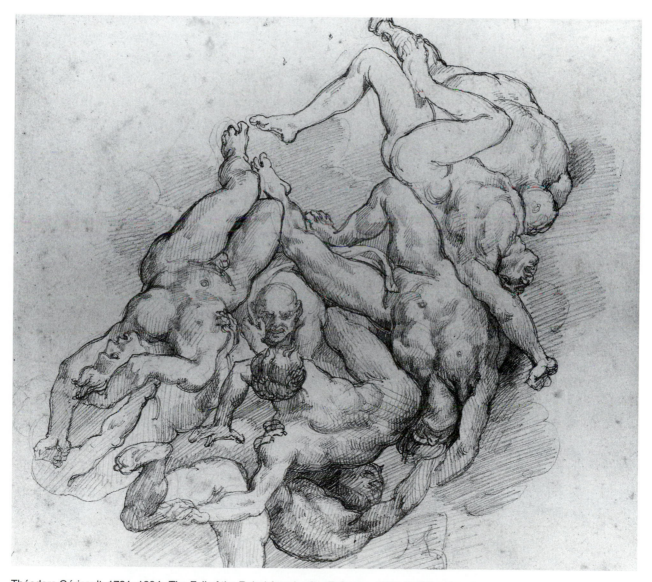

Théodore Géricault, 1791–1894, *The Fall of the Rebel Angels after Rubens* c. 1818. Pencil on ivory laid paper, 205 × 232 mm, 1967.50 Committee for Art Fund. Provenance Eugene Deveria; Seiferheld and Co., New York, Stanford University.

qualities of the values in the drawing. Light pressure with an HB pencil will make a lighter value than light pressure with a 6B pencil. 6B pencils create darker values the more pressure you put on the lead. Pencil, ink, Conté, compressed charcoal, or charcoal pencils can be used in cross-hatched drawings.

Lili's drawing is in its first outline with the first layer of hatching. This is an example of light hatching. Note the planar division on the drapery in the front. The top plane lifts up as the side plane is darkened.

EXERCISE: HATCHING

Apples and pears, sitting on a table make an excellent subject.

Use HB, 3B, and 6B drawing pencils. Study your still life, identify the direction the light is falling on the forms. Make a light outline in HB of all the objects in the drawing and the background. Then map out the divisions of light, dividing the light planes from the gray and dark planes on each form in light lines. This establishes where one value starts and one ends.

Cover the entire picture plane side to side, top to bottom, in one layer of light diagonal lines. Hatching lines may cross through the edge of the form to develop smooth transitions and seamless relationships between the figure and the ground. By going over the entire foreground and background

Lili Xu. *Hatching,* student drawing.

Morgan Hager, student drawing.

The Formal Elements: Value

with the first layer of light line, you unify the surface front to back.

Continue adding hatching lines over the next area, creating a light gray. To darken the value, increase the pressure slightly on the sharpened pencil tip, or add a layer of hatching vertically or horizontally over the first ones.

Change to a sharpened 3B pencil, hatching over the areas to be a medium gray value. The lines on the gray planes should continue into the area of the dark planes.

Change the direction of the hatching stroke from a diagonal to a horizontal or vertical line with each layer.

Continue hatching into and over the dark gray areas on the objects in the drawing that now should have at least two layers of pencil.

Increase the pressure slightly to add another layer over all the dark areas and the shadow. The 6B pencil can be used over the 3B layers diagonally or vertically to increase the darkness.

The cast shadow is the very darkest area at the bottom. Use layers of the 6B with increased pressure.

Bruce Nauman, b. 1941, *Wax Template of My Body Arranged to Make an Abstracted Sculpture,* 1967. Pen, 63.5 × 48.2 cm. 76.7 VWF. The Washington Consortium Virginia Wright Fund. Washington Art Consortium: Henry Art Gallery, University of Washington, Seattle; Museum of Art, Washington State University, Pullman; Northwest Museum of Arts and Culture, Spokane; Seattle Art Museum: Tacoma Art Museum; Western Gallery, Western Washington University, Bellingham; Whatcom Museum of History and Art, Bellingham. Photo credit: Paul Brower. © 2001 Bruce Nauman/Artists Rights Society (ARS), New York.

In drawing hatching lines the pressure on the pencil or pen at the beginning of the stroke may be firm, but at the end of the line the pressure should be light. Let up on the pressure on the pencil as you make the line so that the line fans out as it ends into the next value.

In the student drawing by Morgan Hager on the facing page the background has been hatched to a deep black, while the hatching on the squash defines the planes from light to dark.

Bruce Nauman in his drawing on the right hatches through the edge of the forms continuing the line to the background. The line does not stop at the edge. If you stop the line at the contour of the form, it will make the form stiff and distorted.

Nauman has placed the darker value at the top. This brings the top forward, seeming to lean out of the picture plane. While the top pushes forward, the lighter base recedes.

He has created two points of view. We are looking from a heightened view at the base while at the same time looking directly at the top, a perspective often used by Degas in drawing his dancers.

RUBBED AND ERASED PENCIL DRAWINGS

This process results in a soft, rich finished surface. The pencil is used on its side to avoid marks on the surface of the drawing. The drawing is composed from dark to light. The dark planes are modeled first then, the lead is rubbed across the surface of the paper, creating a rich, even gray. The eraser is used as a drawing tool in to lift out gray sections creating, the white planes.

DRAWING EXERCISE

Set up a still life of objects. Draw the contour of the objects in the picture plane. Determine the direction of the light source and map out the darkest planes on each object in a simple outline.
Using the 6B pencil, cover the dark planes, using medium pressure with the side of the pencil tip. When all the dark planes have been filled, rub the drawing with a Kleenex to spread the 6B lead over the entire drawing. Rub the tissue across the entire surface. Using the plastic eraser erase the shape of the light planes out on each form and on the grounds. The rubbed gray will serve as the intermediate value in the drawing. The erased areas are the lightest planes and the first hatched 6B areas are the darkest. To finish the drawing add another layer of 6B pencil over the dark planes with the side of the pencil. A 3B pencil may be used over gray areas to strengthen them. The hatching on the drawing below was done with the side of pencil, using the side of the pencil smoothes out the crosshatching strokes.

Lisa Cain. Rubbed and erased drawing, student drawing, 1999.

The Formal Elements: Value

PLANAR ANALYSIS OF THE FIGURE

All figures and objects are composed of planes. We have to train our eyes to see form in terms of interlocking planes. Planes are important in determining where value changes and where to place value in a drawing. Light changes according to the direction it falls and the location of the planes on the form. Value changes may be gradual or abrupt depending on the angle of the planes. Understanding the structure of the planes on any form will increase your ability to render a volume.

In planar analysis of the figure examine the arms, the head, the torso, and the legs, locating the shift from the top plane to the side plane. The body is a series of cylinders or tubes that fit together. One drawing instructor referred to understanding the figure as "the garbage can theory of drawing," in which one can fits into the next by sliding together at the joints.

The background of the drawing on the bottom left has been divided into large flat planes. The artist has used dark values on the side and back planes of the figure. The back plane of the thigh on the leg to the left is separated from the front calf with a gray value.

In Mandy's cylinder study below you can outline the plane changes by following the curve of the cylinder. When the lines turns, the plane is changing. Lay a piece of tracing paper over this drawing and divide each limb into its top plane, side plane, and back plane if you can see one.

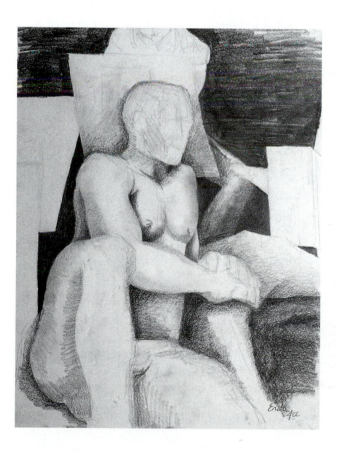

Erin Stephenson, pencil, student drawing, 1999.

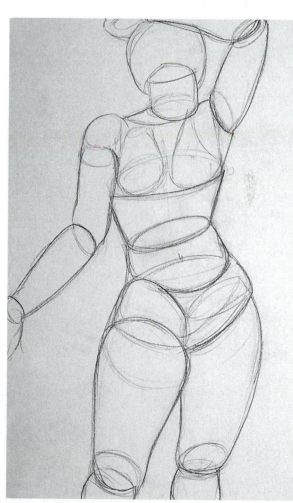

Mandy Reeves, charcoal pencil, student drawing, 1999.

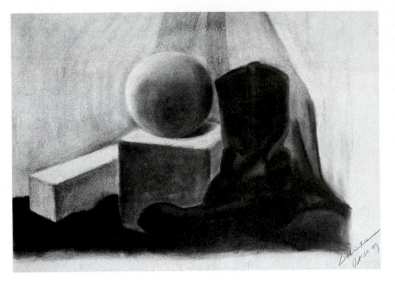

Lili Xu, charcoal, student drawing, 1999.

DRAWING EXERCISE: PLANAR ANALYSIS

Physically touching the objects in a still life can help you understand how planes turn. Place the palm of your hand flat on the surface of the bottle. Notice what part of the surface your palm covers. That is one plane. Bend your fingers to touch the area next to what the palm is covering and that is another plane, perhaps a side plane. On either side of the first plane you touched are side planes.

A pear is a good subject. To construct the pear draw an ellipse for the base, draw another ellipse for the top of the pear and a third ellipse in the middle of the pear. Connect the top ellipse to the middle and bottom ellipse with a contour line. Look at the pear and locate the front and side planes. Reshape the outside line to reflect more accurately the shape of the pear.

Set up a still life, analyze each form, by plane, draw the contour, and identify where the planes stop and start with lines. The shape of the plane follows or echoes the outside edge.

Assign values to each plane from light to dark. Hatch the values onto the planes. Light changes both horizontally and vertically. The value changes on the planes are darker the further a plane is located from the highlight area.

The planes of a geometric form like a cube or a rectangle are easy to separate and identify. The severe ninety degree angle of the sides provides clear value divisions. In Lili's drawing, above you see value changes by plane on the boxes. The sphere has also been gradated light to dark.

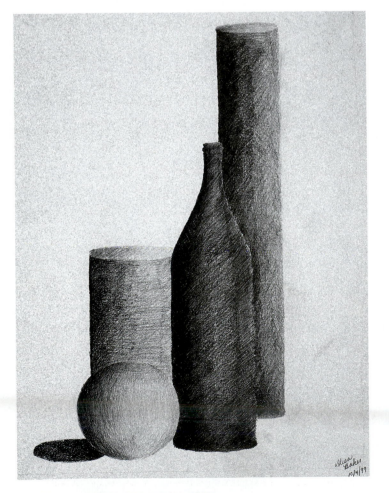

Alisa Baker, pencil, student drawing, 1999.

The Formal Elements: Value

BRUSH AND INK

Jean-Baptiste Greuze's drawing is constructed with a brush. Artists will often start an ink drawing with a light pencil line bringing the brush and ink over this line. Brush lines are very expressive using unconnected, flowing lines.

They aren't scribbles placed whimsically. Each line addresses the plane, to create volume. Greuze has paid strict attention to the back planes, side planes, and areas behind or under a top plane or surface. In this way he pushes the front planes forward. They are framed by modeling with the brush. The back leg sits in shadow along with the chest shadowed by the front arm.

The brush is the most difficult of the drawing tools for ink, but it is perhaps the most expressive. A brush line can easily shift from a line to a plane by flattening out across the surface.

There is an economy of line in this drawing. Often ink line drawing is used for planning, a larger work because it can be done quickly by those who are experienced.

The Chinese have one of the longest traditions of brush painting. Some of the calligraphers would dip their hair or pigtails in the ink and paint with them. They could get kind of crazy. Velvety black India ink can be diluted in to a full tonal range of values for drawing. Ink is elegant, clear, and expressive. In the beginning ink is a difficult medium to work with, but with practice it becomes much easier. One advantage to the student is that in a sketchbook once it is dry it won't smear.

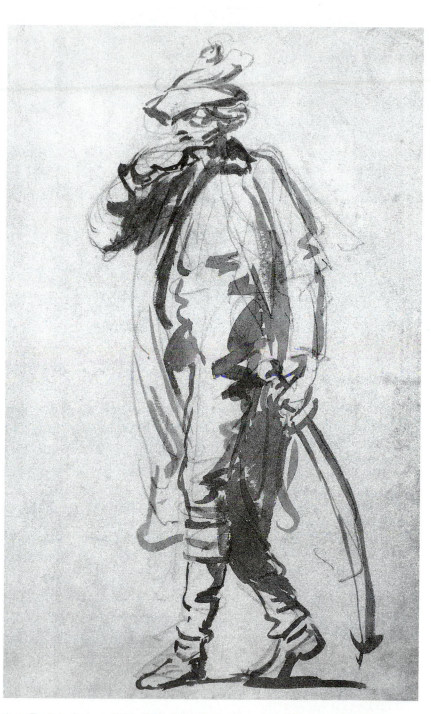

Jean-Baptiste Greuze, 1725–1805, *Study for the Recruiting Officer* in *"The Father's Curse"* c.1777. Gray wash over graphite on ivory laid paper; verso, two pencil sketches, very rough. 1978.23 Stanford University.

The Formal Elements: Value

PEN AND INK WASH

Jean-Honore Fragonard's *Rinaldo Raises the Magic Cup to His Lips,* is wash over black chalk. During the 1780s Fragonard did some 165 large chalk-and-wash sketches for a projected publication. This composition is evenly light and drawn rapidly which densely filled with complex images. The wash is placed through the picture plane by rotating between the planes of the figures and the ground. Wash has a quality of looseness in a drawing. Artists use wash because they can move quickly, keeping up with their thoughts, and recording a plan for future composition. Ink is like shorthand, a symbolic record of the direction a composition may take.

Wash drawings start loosely. The wash is created by diluting India ink with water. To create a light gray wash place a tiny amount of ink, like a brush tip, in ¼ cup of water.

Ink wash drawings are built up from light layers to dark layers. Each wash overlaps and darkens the one before it. The white of the paper must be left for the highlight areas. There is no erasing, no way to remove an errant wash on an area. It is generally best to leave a little more white than you actually need. You can always go over it with a wash at the end. Mistakes are worked into the drawing and covered by more wash or line work. Visually early miscalculations aren't obvious. The dark areas of the drawing will tend to read first as they are strongest, The light areas do not draw the attention, they are subtle.

You can choose from a selection of different pens. The Quill pens are cut from the heavy pinion feather of large birds then shaped to an angular point. They produce a flexible line Calligraphers use quill pens. Reed pens are hollow, wooden stems made from shrubs. They have a stiff nib or point. This line is bold and the pen is hard to handle. It was however the favorite drawing tool of Van Gogh. It is excellent for mark making as opposed to drawing flowing lines.

The metal pen is what we tend to use today. It was introduced at the end of the 18th century. The nibs vary and can be changed in the pen holder. A C6 in speedball pens is often used for line drawing.

DRAWING EXERCISE

Draw several organic shapes on a piece of paper in HB pencil lightly.

You may need to experiment with ratios of ink and water. Make a light wash with a little ink and water. Dip the entire brush in clean water first and squeeze out the excess water by pressing the brush between your fingers. Dip the soft hair, Chinese brush tip in the wash and cover the entire form except for one area which will be the highlight. Let it dry.

Add a second wash of the same mix over the first and leave 1/4 of the first wash showing along with the white highlight.

Add a little ink to your wash to darken it. When the drawing is dry, wash over the darkest areas of the form and over the shadow at the bottom. Finally try straight ink on the cast shadow at the bottom of each form.

Your shape should now appear volumetric. While you are practicing the brush will run out of wash, when it does the bristles tend to bend out and become unmanageable, tip the brush in water to reform the brush.

Now that you have some feel for the brush and the wash. Try drawing from life. Sit outside if it is warm enough and make a light sketch of the buildings or trees then apply a wash to selected planes to add form and volume to your drawing. When the wash is dry it can be drawn on with charcoal pencils or lead pencils which will darken the area one more level.

The Formal Elements: Value

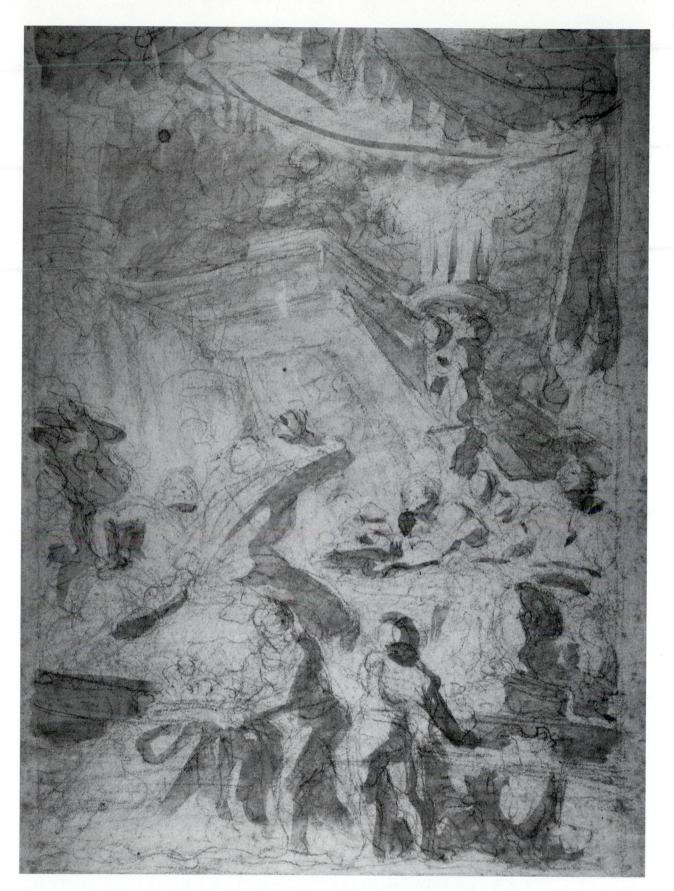

Jean-Honore Fragonard, 1732–1806, *Rinaldo Raises the Magic Cup to His Lips*. Pale brown wash over black chalk on cream laid paper. 440 × 294 mm. Stanford University.

The Formal Elements: Value

PROFILE OF AN ARTIST: AUGUSTE RODIN

Rodin left over eight thousand drawings to the French government as part of his estate in 1917. This huge collection contained student drawings from his studies at Petite École in Paris between 1854 and 1857, sketches from his imagination, thousands of drawings from live models, and drawings done from looking at photographs of his sculpture. These later drawings served as illustrations. He was an artist who never stopped working. As a sculptor he used drawing to plan his work.

The drawing on the following page was made about 1894 by a process Rodin referred to as "instantaneous drawing"; we would call it blind contour. He made this drawing by looking only at the model and never referring to his paper. The continuous line results from his hand going where it will, often leading the pencil off the page. Limbs may be lost, but he caught the movement of the figure, which is acting, not sitting frozen. Proportion is destroyed, but the impression of life is fixed. He would ask his model to take an unstable pose and then make the drawing in less than a minute.

Rodin spoke of this process in 1906 to his secretary, explaining that he felt he had to internally possess a complete knowledge of the human form, along with a deep feeling for every aspect of the figure. "The lines of the human body must become part of myself," he said, "embedded in my instincts so it will all flow naturally from my eye to my hand." As a sculptor he saw the figure as a mass, as a complete volume. Around 1880 when Rodin was working on sketches for *The Gates of Hell*, two huge bronze doors, he had enough money to hire many models at one time. He had these models move freely about the studio without setting them in any particular pose. He preferred nonprofessional models who acted more natural. When he spied a movement or gesture that attracted him, he asked the model to hold the pose. He would then make an instantaneous drawing.

This nude is one of these models frozen unselfconsciously and unposed. These were not traditional académie figure drawings. They were expressive. He revealed big planes which expressed the volume as a whole. The pen line exaggerates the contour but probes as if the point of the pen were in touch with the real contour. He might add light strokes or change lines to rectify the appearance later, and he would often use wash on the figure to increase the sense of volume.

The relation between the figure and the ground shows how strong Rodin's instincts to visualize were. He sets the figure like a cube in space, the contours relating the mass and volume. The unsupported form without modeling is bold, autographic, and kinetically drawn. This is the mark in the work of a Modern.

Rodin felt his études (studies) were complete and on par with Salon art. His continuous drawings were reproduced in periodicals such as *La Revue Blanche* by 1900 and shown internationally in large numbers. Along with Henri Matisse, Rodin redefined drawing and launched it as its own discipline. Drawing had new meaning in the hands of Rodin.

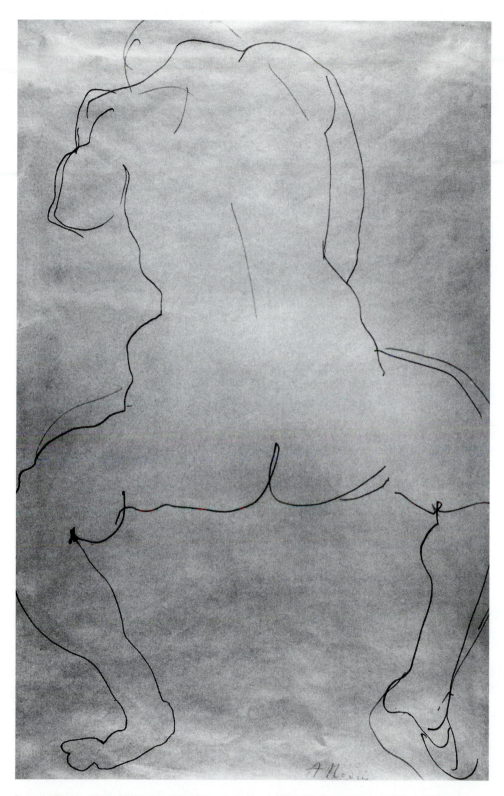

Auguste Rodin, 1840–1917, *Squatting Female Nude,* c. 1895–96. Pen and brown ink on buff wove tracing paper. 305 × 193 mm. 1983.28 Committee for Art Fund. The Cantor Collection at Stanford University.

The Formal Elements: Value

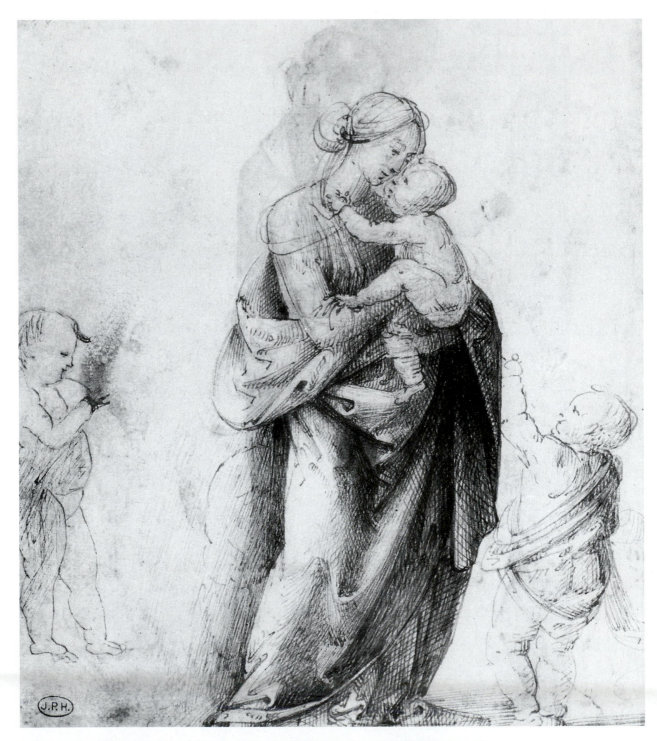

Fra Bartolomeo, Baccio della Porta, 1472–1517, (Recto) *The Virgin with the Holy Children*. Pen and brown ink over black chalk. H. 7¼, W. 6½″ (18.4 × 15.9). The Metropolitan Museum of Art, Robert Lehman Collection, 1975.1.271.

The Formal Elements: Value

INK WASH AND PLANE

Wash is soft in a drawing. It can define all the planes in the drawing without an outline. It can create levels of value from white to black and successful create the modeling effects of chiaroscuro. Wash creates a sense of space in a drawing by the placement and rotation of light to dark and dark to light. In ink drawing it is important and crucial to plan. Once you cover the white of the paper you can't erase the wash. Plan your work from light gray to black leaving the white planes.

Dilute the ink with water to make a large range of gray values. When you layer ink you darken the value of the plane with each successive layer.

Line can be used with wash by adding it on top of the ink washes. Lines are hatched over a wash to increase the modeling effect and to add texture. India ink and Sumi inks are permanent. When they dry, they will not dissolve when another wash is placed over a first wash. Line is added with straight ink that has not been diluted; it is therefore very black and will stand out on the surface over the wash. Steel pens dipped in ink as well as permanent Sharpies can be used with ink wash for line.

Both compressed charcoal and charcoal pencils can be used with ink and wash. When you wash over them, the lines of charcoal will dissolve somewhat—but not completely. The wash will lighten the lines allowing you to add another layer of line or wash. This is a mixed media approach to drawing.

The drawing on the facing page by Fra Bartolomeo balances wash, contour line, and hatching lines. The virgin was first drawn in chalk and then the drawing rubbed out. A second smaller drawing replaced it—resulting in the silhouette behind her head.

The drapery is rendered with washes over black chalk, then reinforced with parallel hatching strokes in pen. The black chalk was most likely used to plan the folds of the drapery and the figures. Since wash will melt black chalk, the lines fade into the wash. The drawing is more a sketch, with the virgin well developed and the children sketchy.

DRAWING EXERCISE

Use a 120-pound to 140-pound Bristol board for wash as it will not shred and ripple. Tape this piece of plate Bristol to a board by completely taping each edge down to a drawing board.

Mix a light wash and loosely apply it to the center of the paper. Let it dry. By abstractly placing a value that is unrelated to any plane, you give yourself something to work against besides the white of the paper.

Set up a still life and use a charcoal pencil to outline the contours over the dry wash in a light line. Hatch the darkest planes of the objects very lightly. Return with your first wash and cover the gray, medium gray, and the dark areas; leaving the white areas. Work between adding hatching lines and adding wash to develop each form by plane from light to dark.

Use the straight black ink in between the objects and behind the lightest side or top of each object. You may use white Conté chalk to heighten the lightest areas on the objects if you loose your white areas.

Hatching and crosshatching are the main techniques for adding line over wash drawings in either pen or charcoal. Place the hatching strokes close together and direct them across the form in the direction the hatching strokes would have to turn if you were actually drawing directly on the form. If you place lines vertically on a cylinder, it will flatten the form.

In a still life drawing don't stop the hatching stroke at the contour line edge. Hatch through the contour, lightening the stroke by lifting the pressure off the drawing tool as you pass through the edge. Let the line feed out into the surrounding space.

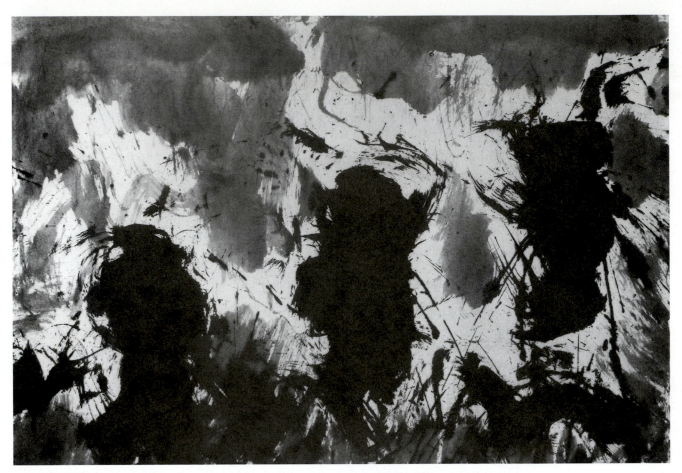

Mark Tobey, *Firedance,* 1957. Sumi ink and pale gray wash on Japanese paper. 540 × 735 mm.
1979.122. Stanford University. © 2001 Artists Rights Society (ARS), New York/ProLitteris, Zürich.

THE EXPRESSIVE USE OF VALUE

The tools and techniques of drawing serve artists and their ideas in expressive drawings. You are not controlled by space or the light. The artist controls the balance of light and the composition of the space.

Except for purely technical drawings, expressiveness is always a major factor in drawings. When the artist goes beyond simple description of the subject to reveal an attitude or an emotion in the drawing, it is expressive. When we have empathy, it means we have the ability to externalize feelings, to give meaning to the commonplace. Our capacity to identify with the subject and to project this attitude in a work of art produces expressive drawings. Emotion or emotional statements should not be confused with expressiveness. Mark Tobey's drawing is explo-

sively expressive, but it is not emotional. The ability to record and render what is observed in perfect accuracy turns into illustration if it lacks personal expression and interpretation. Expressive drawing goes beyond technical prowess.

Degas is the perfect example. He knew no easy formulas for drawing the figure. Each drawing demanded his full concentration, with a review of the proportions, constant readjustments, and then he was still uncertain.

Nathan Oliveria came under the influence of Goya first in 1973 while experimenting with monotype. He produced a series of nearly one hundred variations on a single plate in response to Goya's *Tauromaquia.* This ink drawing on the facing page is a free adaptation of a wash drawing taken from Goya's *Black Border Album,* a collection of drawings about the war between Spain and Napoleon. Oliveira's drawing of a maimed veteran reduced to beggary is sardonically entitled *The Works of War.*

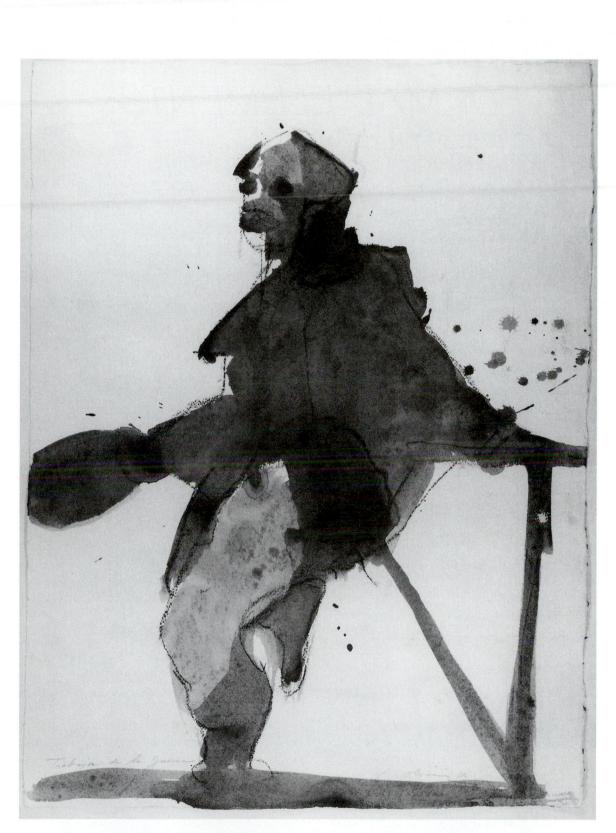

Nathan Oliveira, *Trabajos de la guerra,* after Goya 1989. Charcoal and brown wash on white wove paper 692 × 511 mm. 1989.87. Gift of the artist in honor of Lorenz Eitner. Stanford University.

The Formal Elements: Value

CHAPTER 6
THE FORMAL ELEMENTS: PERSPECTIVE

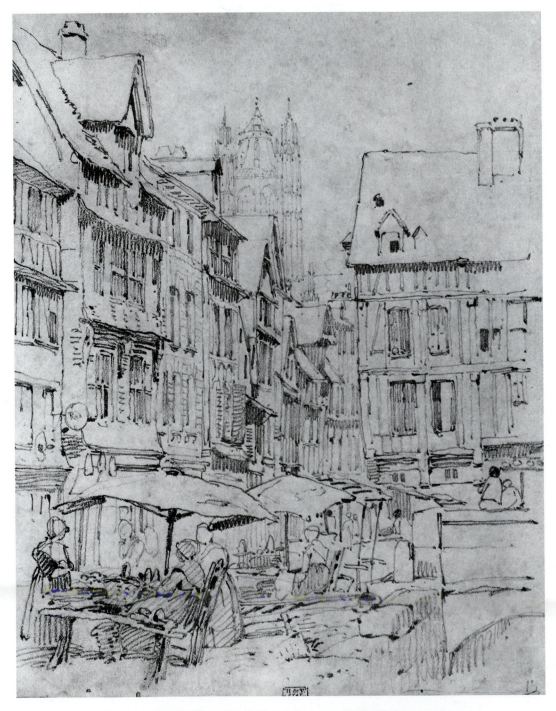

Richard Parkes Bonington, 1802–28, *Place Eau de Robec,* Rouen, c. 1823. Pencil on ivory wove paper. 260 × 198 mm. 1968.83 Committee for Art Fund. Cantor Arts Center, Stanford University.

INTRODUCTION

LINEAR PERSPECTIVE

In the fifteenth century during the Italian Renaissance in Florence, a mathematical or scientific method of determining the correct placement of forms in space was formulated by two architects, Filippo Brunelleschi and Leonbattista Alberti. The first printed description of perspective appeared in Alberti's treatise on painting, *Della Pittura*, published in 1435 dedicated to Brunelleschi. The formal rules for perspective came from direct observations by these men. Brunelleschi had observed a scale change while looking at a colonnade, a line of columns, that he had constructed for a hospital in Florence. As he looked down the line of columns directly in a line in front of him, they appeared to get smaller as they moved away from him. The baseline rose up and the top line dropped down, seemingly meeting at a point on the horizon. Before Brunelleschi and Alberti's discovery of linear perspective, artists had relied on empirical perspective and geometry to arrange space. They hadn't used the horizon, nor had they played with light and dark in their compositions to create a sense of space. They sometimes used a scale change in which the most important people were the largest in the composition and the least important people were the smallest. They used linear orders in which the subjects were arranged in rows from top to bottom and they did some dimensional drawing of buildings but they weren't aligned correctly.

Linear perspective eliminated the suffering and struggle with space. In linear perspective receding lines vanish to a point on the horizon. Lines above the horizon vanish down to the horizon and lines below the horizon vanish up to the horizon. Brunelleschi's observation would prove to be the very tool artists needed to organize their compositions to better reflect three-dimensional reality on a two-dimensional surface. Realistic pictorial illusion depends on linear perspective. Lines, points, and planes are ordered by the distance from the observer's fixed eye point. A mathematical grid can be used to determine the size and scale of the figures in the space. Modifications of the space can be made with light and color and the clarity of forms depends on the distance they are from the eye.

Leonardo da Vinci observed, "These are the two perspectives, reduction in size and distinctness of things seen from a distance, and paling of colors, some of which at the same distance from the eye pale more than others."

The drawing on the left page by Richard Parkes Bonington depicts an animated street scene. The line of old houses on the market square next to the stream, Le Robec (which is now underground), leads the eye back, down the rue Damiette (which no longer exists) toward the distant tower of Saint Maclou. The baseline is covered, but the roofs of the houses fall on a receding line, each lower than the one before it, moving down to the horizon and thus back into the drawing. Bonington increases the feeling of depth by manipulating the values from darker in the foreground to a lightly sketched architectural facade of Saint Maclou in the back of the drawing. The hatching lines for shadows under the eaves are elegant. He has used value to create the space and shape of the windows and to balance the space.

EMPIRICAL PERSPECTIVE

Before linear perspective artists used modular systems that gave a certain unity and comfort to the eye in paintings. The early rule of thumb was to reduce each space by one-third the depth of its forward predecessor. The converging radial lines were difficult to place at best in this system. In the modular system the feet of the smallest and most distant figures had to line up with the knees of the foremost figure.

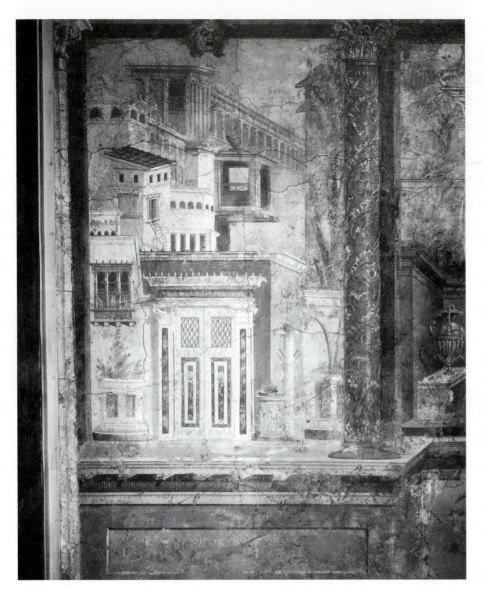

Architectural view. Wall painting from a villa at Boscoreale, near Naples. 1st Century B.C. The Metropolitan Museum of Art, New York. The Rogers Fund, 1903. (03.14.13).

Empirical perspective was used from about 300 B.C. by the Greeks. These perspective devices were used to construct the buildings in the landscape painting on the left which is from a villa wall at Boscoreale. The buildings seem to sit in the space as volumes. The grape arbors are seen at a different angle. The receding lines have no relationship to each other. They are slanted indiscriminately, and they diverge, converge, or lie parallel. The contrasts in illumination between sun and shadows, in the foreground and background have no relationship with actual light. The artists were groping, trying to create a recognizable space.

Empirical perspective reflects direct observation. It relies upon a well-trained eye for seeing size and shape relationships. Sighting is done against established vertical and horizontal lines. A convincing and relatively accurate space can be constructed without a T-square and a triangle. Artists today may well understand the rules of linear perspective and may stretch with that knowledge to organize their compositions by using empirical perspective.

Linear perspective allows artists to check space by exact measuring rather than with spatial intuition. The Florentines were delighted with this new pictorial space that accurately represented real space. Vasari, one of the first biographers of artists and one of the first great collectors of drawings, summed up the feelings in Florence over linear perspective when he said, "What a sweet thing is this perspective!" He understood that the drawings represented the thoughts and perceptions of artists like Leonardo, Pontormo, and Michelangelo. His biographies about the lives of the artists in the Renaissance in Italy are some of the few to survive.

The Formal Elements: Perspective

DO WE SEE IN PERSPECTIVE?

Perspective is an invaluable tool of drawing. It is a process you use to convincingly re-create the three-dimensional world on a two-dimensional surface like a flat piece of paper.

We don't really see in linear perspective. We have binocular vision. Linear perspective operates with a fixed view from a single eye. For you to see in perspective, that single eye would need to be located between your eyes over the bridge of your nose. We see more and sometimes less than what we need to make an accurate drawing.

Test how you see by holding your index finger at arm's length in front of your eyes. Locate it against a fixed background, a defined space, not in open air. Holding your finger out, close one eye and line your finger up with a background. Make a mental note of what your finger was in front of. Change eyes, close the first one, keep your finger in the same position, and open your other eye. What happened to your finger? It seems to have moved, and this is because your eyes are not aimed at one point—they have different focus points. In addition to binocular vision, you also have peripheral vision. In one view you can actually take in 180 degrees without moving your eyes or your head. If you rotate your eyes side to side, you see everything clearly, whereas when you don't, the side view may be a little out of focus. It is therefore important to realize that to use perspective you must make visual adjustments. Things aren't completely like you think you see them.

Dürer's drawing below shows a draftsman drawing a nude. It illustrates how we translate images. The picture plane sits between the artist and his subject. The image appears on the "glass" surface of the picture plane. In this way transferring the image to the flat paper makes the picture plane and the paper the same surface relatively. Here both have been divided into a grid. The draftsman holds his head and eyes in one position, translating the figure to the grid on his paper by placing the points and the lines of the figure's contour on the paper according to where they fall, or he sees them on the correlating sections of the grid on the picture plane.

Drawing by sighting is measuring with the eye and the aid of several devices. The grid is more mechanically percise than sighting. Sighting depends on training the eye and using the intuition.

Drawing in perspective is the means by which we can organize our compositions to represent three dimensions in two dimensions. The principles of linear perspective are guidelines and techniques that help us represent objects, scenes, space, and ideas. Perspective drawing is a practical tool for working out space and design problems. However, these techniques are of little value unless an understanding of the foundations of perception accompanies them. Drawing is a cognitive process that depends on perceptive seeing and visual thinking.

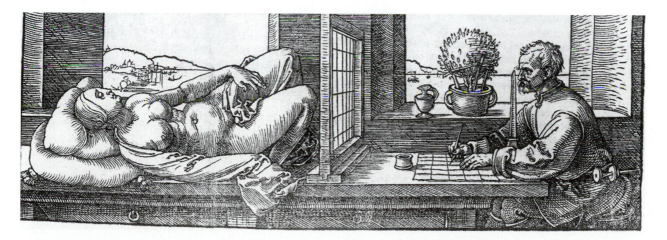

Albrecht Dürer, German (Nuremberg), 1471–1528, *Draftsman Drawing a Reclining Nude.* Woodcut, second edition, 296 × 202 mm. One of 138 woodcuts and diagrams in *Underweysung der Messung, mit dem Zirckel und richtscheyt* (Teaching of Measurement with Compass and Ruler). Horatio Greenough Curtis Fund. Museum of Fine Arts, Boston.

Merrilee Chapin. Perspective practice, student drawing, 1999.

CONE OF VISION

The cone of vision is described by lines radiating out from the fixed point of a single eye of the spectator. The boundaries of the cone of vision determine what is to be included in the perspective drawing. A normal field of vision is a 60-degree cone. The principal subjects should be placed within the 60 degrees. In reality most people have a field of view that extends 180 degrees horizontally and 140 degrees vertically since the vertical field is blocked by the nose, cheeks, and eyebrows. To determine your cone of vision, look directly forward, raise your arms on either side to shoulder height, and just out of your peripheral vision. Bring them forward slowly until they frame the limits of all you can see clearly. Frame what you can see clearly without shifting your eyes left or right.

PICTURE PLANE

The picture plane is an imaginary transparent plane that sits between the spectator and the drawing surface. The drawing surface is the virtual equivalent of the picture plane. Dürer's woodcut on the previous page shows the artist looking through the picture plane, transferring what he sees through the glass onto the drawing surface. In the Renaissance the picture plane was thought of as a window. You looked through the window into the composition.

It is important to frame the picture plane on your drawing paper before you start so you know where to start and where to stop. The four lines of this border are the first four lines of your composition, and they frame your cone of vision and the subjects of the drawing. You can see this border line in Sabrina Benson's drawing on the left.

Sabrina Benson. Still life objects constructed from the inside to the outside contour with ellipses, student drawing, 1999.

The Formal Elements: Perspective

BASELINE

Once the picture plane area is established on the paper with the four border lines, you will need to check your eye level to establish where the horizon will be in the drawing. In a room when you look straight ahead, your eye level coincides with the horizon. If you move your angle of sight by moving your head, the horizon moves accordingly. Lines below the horizon vanish up to the vanishing point on the horizon. In Sabrina Benson's drawing on the left the horizon has been located just about in the middle of the bottles. She has framed the picture plane, which increases the effects of receding forms in space. The baseline of each bottle is placed on an imaginary line that vanishes up to the horizon. The base of each object is positioned up the paper behind one another. As the base of bottles moves up the paper, the bottles seem to be moving back in space.

In perspective overlapping shapes create space. Objects get smaller as they move toward the horizon, and where the baseline of the objects in the still life is placed controls how deep we perceive the space to be. Both the eye level and the baseline are important in creating a sense of space. John Whitaker's drawing on the next page has a horizon above the top edge of the picture plane. His forms recede, moving up the paper and off the top edge, resulting in a large ground plane or table plane.

FOCAL POINT AND VANISHING POINT

These two can be confused. The vanishing point is an imaginary point on the horizon. Seemingly parallel lines recede to the vanishing point. The vanishing point is determined by the angle of the lines receding. It can be located anywhere on the horizon.

The focal point in the drawing is where the artists directs the viewer's eye. This is done by the placement of value and color, the value changes on the objects and the grounds, or with various size and the scale relationships.

A drawing may be composed with multiple vanishing points. Each house in a landscape can vanish to a different point. Objects in one drawing can be drawn where they individually vanish at different points on the horizon. Consistency in perspective must be applied only to a single object like the toolbox on the right. Here all the

Mike Vandeberghe. Pencil, one-point perspective below the horizon, student drawing, 1999.

receding lines of the box vanish to the same point on the horizon.

DRAWING EXERCISE

Tape a piece of tracing paper across the surface of a window, and using a fine point marker, trace the contour of the trees and buildings where you see them on the window. Try to maintain one view and keep your head in one position.
When you finish, place the tracing on a white wall, and you should see a space drawn in perspective.

HORIZON

The horizon is where the earth meets the sky in landscape. When you are drawing in a room, the horizon is your personal eye level. If you move your head, the horizon line moves with you. The artist establishes the horizon level, and in perspective this controls how the subject will be

Ground Plane

drawn by the viewer. The horizon line should always be drawn lightly across the drawing surface to serve as a level line of reference for the entire composition.

GROUND PLANE

The floor plane and the ground plane are the same. The ground plane is a horizontal plane that extends to the horizon from the front of the picture plane. It is flat and may also be called the "table plane" in still life drawing. The ground plane above is in one-point perspective. The two receding side, parallel lines are drawn as diagonals that at some point will meet on the horizon as they move back and up the paper.

By naming the different areas of the drawing it will be easier to discuss drawing in perspective.

DRAWING EXERCISE

Set a number of bottles on a table. Frame the picture plane on the paper with a border. Looking straight ahead, locate the level of the horizon by finding your eye level on the wall

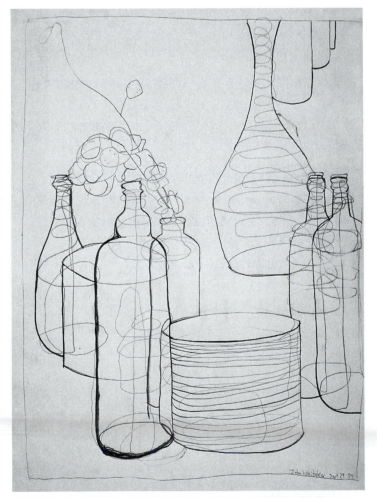

John Whitaker. Continuous line constructed from the inside out with ellipses, student drawing, 1999.

across from you. Note where the horizon intersects the bottles on the table with a line on your paper. Using a circling line to describe the volume of the bottles, start with the bottle in the front. Draw the bottle starting at the bottom, following the contour of one side to the top and then continuing the line back down the other side. Without lifting your pencil, draw a line from the baseline of this first bottle to the baseline of the next bottle. It may be sitting next to the first one or behind it. Bring the line up through the inside of the bottle to the top. Before you draw this line, make a mental note of the second bottle's height by visually sighting across a line from the top of bottle number 2 to the location of bottle number 1. Make a mark on your paper where the top of bottle number 2 should be drawn. Draw bottle number 2. Move to a third bottle without lifting the pencil off the paper and draw its contour, noting where the top and bottom are in relation to the first bottle you drew. Fill your paper with outlines.

CIRCLES

A circle in perspective becomes an ellipse. At the horizon the circle will appear as a flat line. In the diagram 1. on the right illustration you see how the shape of the circle changes as it moves to the horizon from above and then drops below the horizon.

It is important to alter your perception of the shape of a cylinder from a circle to an ellipse. Only when you are looking directly down on a cylinder sitting at your feet or looking directly up at the underside of a can or cylinder could it be round and not elliptical.

The circle or ellipse is the essential base of all cylinders and other circular forms such as arches. The circle can be circumscribed in a square, which will help you draw it in perspective. In the diagram no. 3 below the front circles are parallel to the picture plane so we see the circle as a round shape. The drawings on the top plane show a circle sitting in receding space the same way a cylinder sits on a table. The parallel lines framing the square on either side vanish to a point on the horizon. In this drawing they are all vanishing to the same point. They wouldn't necessarily do that if we were mapping out cylinders in a still life. Notice that the front half of the circle is greater than the back half. It is important to remember that when you are drawing plates or platters.

If you enlarge this diagram 2 of the circle circumscribed in a square on a copy machine, you can place it on a table or over the rim of a bowl and see the circle change. This will help you see the circle in perspective.

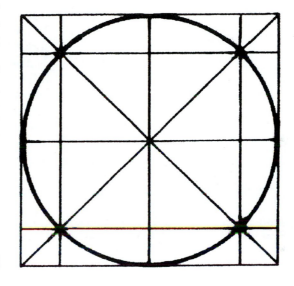

2

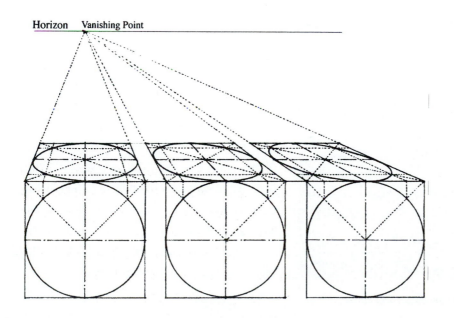

1

Circles in perspective.

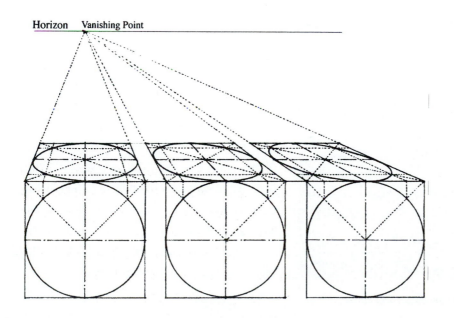

Horizon Vanishing Point

3

The Formal Elements: Perspective

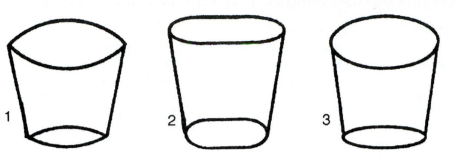

Glasses in perspective.

1. The front and back ellipse should not meet with a point. The outer circle is continuously round.

2. The front and back curve of the ellipse should not be flattened.

3. The upper ellipse should not be drawn fuller than the bottom ellipse. Mismatched ellipses would only result from shifting points of view. The openness of the ellipse is determined by eye level. The curve and the openness of the top and bottom ellipse should be the same.

DRAWING EXERCISE

Practice making ellipses on a sheet of newsprint. To construct an ellipse draw the front curve of the ellipse first, and then draw a matching curve for the back of the the ellipse and join the corners with a curved line. Draw a row of ellipses one on top of another, trying to make them exactly the same in circumference and size.

Draw another row of ellipses in which two ellipses are the same. There can be two small ellipses over two larger ellipses or two large ellipses over two small ones. Connect any two ellipses of the same size with a vertical line on your paper. Connect any two connected ellipses to two larger ellipses with a diagonal line.

Lili Xu. Ellipse practice for cylinder studies, student drawing, 1999.

A CIRCLE IN PERSPECTIVE

To better understand how to draw a circle in perspective, review the circle diagram number 3 on page 117. Using a one-point perspective the circle is shown inscribed in a square. When the circle is drawn in a square you can see how it changes shape in perspective. The illustration number 2 on page 117 demonstrates how the arcs of the circle are formed by dividing the sides of the square. The diagonals drawn through the center help to guide the curve of the arc. Practice drawing cubes in one point perspective and inscribing the circle in the top receding plane as well as in the front plane.

DRAWING EXERCISE

Use a a sharp HB pencil or Sharpie marker to draw with. Test your understanding of the circle in perspective. Draw cylinders whose shapes change from a narrow neck to a curved neck with a round base or bottom. Select a vase or shaped bottle to draw. Analyze the shape, use two ellipses for the top and the place on the cylinder where the shapes changes. Continue moving down the vessel, choosing the size of the ellipses needed to represent the shape as it changes.
Cover a piece of paper in cylinders (a coffeepot, a flowerpot, vases, pitchers, and wine bottles) drawn by creating the skeleton of ellipses to shape the contour lines over.

Lili Xu. Student cylinder study, 1999.

The Formal Elements: Perspective

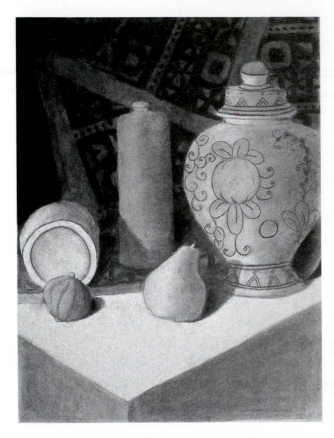

Alisa Baker. Charcoal, still life, student drawing, 1999.

In Tiller DeCato's ink drawing below he has drawn the objects below the horizon. You know that immediately since you can see the entire top of the wood block.

This is a two-point perspective. At first you think it is a one-point perspective vanishing to the right, but the wood block is in two-point perspective. The composition is subtle forming the shape of a triangle on the ground plane.

The horizontal and vertical light changes on both the objects and the grounds create a sense of receding space to the right.

PARALLEL BASELINE

When objects in the composition share the same baseline, the sense of space and of deep space is eliminated. Alisa Baker has two baselines that are parallel to the picture plane and create a shallow space. We sense the horizon may be low, falling across the bottom third of the vase, probably at the top of the pear.

Value affects the way we see and feel space on the two-dimensional surface of the paper. In Alisa's still life the light falls from left to right across the table. The background is the same value from the top to bottom, flattening and pulling the back plane tightly up behind the objects. The objects press forward in the picture plane. The value change on the fabric of the background isn't enough to open up the space of the background.

Tiller DeCato. Ink wash, student drawing, 1999.

The Formal Elements: Perspective

Francesco Guardi, 1712–93, *An Arched Passageway in Venice*. Pen and wash in brown ink, with traces of red chalk, on cream laid paper; 1941.271. Gift of Mortimer C. Leventritt, Stanford University.

ONE-POINT PERSPECTIVE

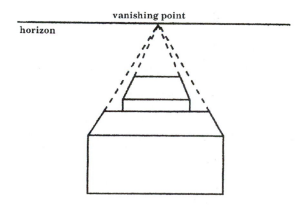

Guardi's drawing above appears to be a sketch from observation. Although it is spontaneous in execution with the irregular, slashing pen strokes, there is a sense of spatial coherence in the play of shadows. The light feels accurate, not made up from the imagination. The nervous speed and energy in execution create an air of drama in the otherwise unremarkable site. It is probably a back alley in the labyrinthine by ways of Venice.

This is a one-point perspective. You can find the vanishing point if you extend the lines of the floor back to the small door. The lines above the horizon drop down through the corners of the arches, ending just left of center in the small door at the back of the alley.

In one-point perspective parallel lines appear to converge toward a common vanishing point. As two parallel lines recede into the distance, the space between them appears to diminish. The lines do not need to meet on the paper. Perspective assumes that if the lines were extended to infinity, they would meet at a point, called the vanishing point. Each set of parallel lines will have its own vanishing point. Therefore,

Sabrina Benson. Two-point perspective study, student drawing, 1999.

Lili Xu. One- and two-point perspective, student drawing, 1999.

objects in a still life will each vanish to their own vanishing point. Although these parallel lines could go to infinity, for drawing purposes we can place the vanishing point on the horizon on the paper if we choose. Sometimes this is easier for determining the direction and angle of the receding lines. A rule of perspective is, lines above the horizon vanish down to the horizon, and lines below the horizon will vanish or angle up to the horizon.

If the vanishing point is placed directly over a form or too close, it will create distortion. Because of this we don't always draw to an exact point but angle the lines back, adjusting the angle with sighting so that eventually they would meet in infinity.

The horizon level, which is the eye level, will be important in determining the angle of the lines. In the drawing of the alley by Guardi on the previous page, you move from the large expanse in the front of the picture plane to a small white door at the back, and it is through the left side of this door that the lines vanish and converge.

DRAWING EXERCISE

Set cardboard boxes on a model stand or a low table. Try to set the boxes up so the front plane is square to you and you can see only one side and the top. If a box is set at 45 degrees to your line of sight, it is a two-point perspective. Locate the horizon line by establishing the location of your eye level. The lines above the horizon will vanish down to the horizon, and the baselines below the horizon will vanish up to the vanishing point on the horizon. Each set of parallel lines defining the side plane of the box will converge toward one point on the horizon. Start by drawing the front plane of a box. If you can see the right side of the box, then the lines will vanish to a point to your right and on the right side of the horizon line. The left side of the box vanishes to the left. The lines may not actually meet at a point on the paper. As long as the distance between them decreases as they move toward one point on the horizon, they will be in perspective. Draw one box at a time.

The Formal Elements: Perspective

SIGHTING

Durer's grid placed between his subject and his drawing guided him in transferring specific points and lines to define the shape of the subject onto his drawing surface. Another device is a viewfinder. It is made by cutting a 3 × 4" rectangle in the middle of an 8½ × 11" sheet of black cardboard. Use two black threads secured with tape to bisect the opening, dividing it into equal quadrants. By holding the viewfinder in front of your eye you can frame the composition, define the picture plane, and compose your drawing. When you look through the rectangular opening with a single eye, the space flattens into overlapped and connected positive and negative shapes.

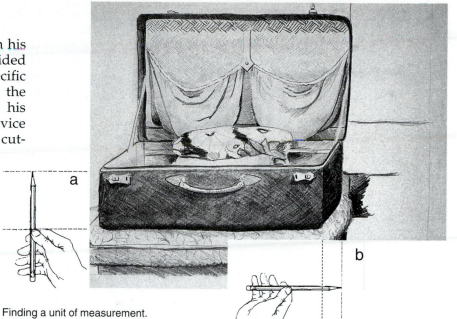

Finding a unit of measurement.

Using the unit of measurement to find the relative length of the case.

Chandra Allison. Pencil, one-point perspective, student drawing, 1999.

A pencil can also be used as a device for measuring. By holding the shaft of a pencil at arm's length directly in our line of sight, we can gauge relative lengths and angles of lines. To make a measurement with a pencil, align the pencil's tip with one short section of the object to be drawn, placing your thumb where the line ends visually on your pencil. For the suitcase on the right you could use the front corner from the top edge to the bottom. Once you have this measurement, you use it to determine the relative length of all other lines by holding the measured length on the lines. Close one eye to measure, and mark off the number of lengths that it will take to construct the bottom line of the suitcase. This is a relative measurement. The bottom of the suitcase is relatively about three side lengths long.

To determine the angle an objects rests at, close one eye, line the pencil up with the receding edge, and drop your arm to the paper, holding the pencil at the gauged angle. The angle you see against the paper is the angle at which the object is sitting.

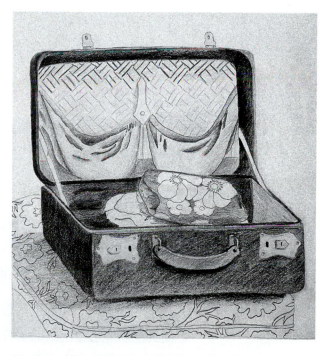

Alisa Baker. Charcoal pencil, one-point perspective, student drawing, 1999.

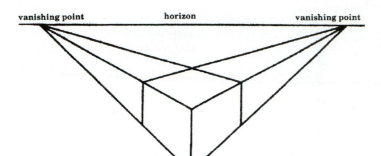

vanishing point horizon vanishing point

TWO-POINT PERSPECTIVE

Two-point perspective is used more often than one-point because the view for drawing in one-point perspective is very limited. When the subject sits at an angle to the picture plane or obliquely rather than square to the picture plane, the object is in two-point perspective. If you look at the subject and you can see planes receding on both the right and the left, it is two-point perspective.

When you draw a two-point perspective, first locate the horizon line and lightly draw it on the paper. This will help you with the direction of the lines. Lines below the horizon will vanish up to the horizon. Lines above the horizon will vanish down to the horizon.

The vertical line for the corner of the box or building that is closest to your line of sight is drawn first. The line for the front corner or vertical establishes the scale for the drawing. All proportions of the drawing depend on this measurement.

The diagram above on the left is a box in two-point perspective drawn below the horizon. When you can see the top of an object, it is below your eye level and below the horizon. When you cannot see the top of an object, it is above your eye level and above the horizon.

Perspective depends on the single fixed eye of the spectator. Therefore, you can judge the angle of an object by using your own body to figure the angle at which the object sits to you. Use your arms to follow the direction the plane is sitting. If a plane is located on your right, raise your right arm and line it up with the baseline of the receding plane. It is the same on the left using your left arm. The angle at which you are holding your arm is exactly the angle you can draw the line on your paper to represent the direction and angle of that plane.

Tiller DeCato. Pencil, two-point perspective, student drawing, 1999.

INCLINED PLANES

The top of the suitcase is an inclined plane. It is not parallel to the ground plane or to the floor. Inclined planes do not vanish to the horizon. The vanishing point for the lid is found on a vertical line that is drawn through the vanishing point on the right side. Ascending planes angle upward away from the viewer; descending planes angle downward.

When you draw the interior space of the lid, the lines vanish to the vanishing points on the horizon. The short lines inside the lid on the left vanish to the right vanishing point. Notice that the short interior lines above the horizon are angled down, but the inside line in the lower left corner angles up slightly. On the right of the lid we see an outside plane of the suitcase. That side plane also vanishes to the right vanishing point.

Sabrina Benson. Two-point suitcase, two-point chair with value, student drawings, 1999.

DRAWING EXERCISE

1. Set a chair or a stool approximately ten feet from one wall. Three feet behind it place another chair or stool and against one wall set a small table or box or a ladder. Frame the picture plane with four border lines on your paper and locate the horizon before you start drawing. Start by drawing the front chair, placing it in the front of the picture plane. Look carefully at the location of the other chairs and stools in the background. If they are to the right of the front chair, place the front chair on the left of the picture plane. If they are on the left, the front chair goes on the right of the picture plane. Plan the space before you start. Use

sighting with your pencil to help you locate where the second object is in terms of the first one. Hold your pencil horizontally lining up the top of the second object with the first one, and mark this location on the paper. Each chair will have its own vanishing points on the horizon. Check the angle each chair sits to the picture plane and the horizon with sighting.

The Formal Elements: Perspective

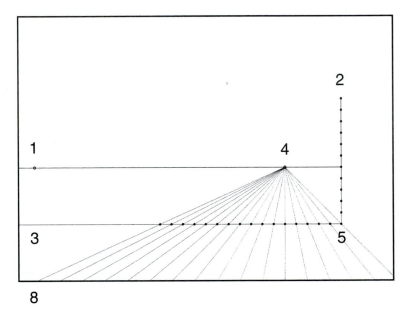

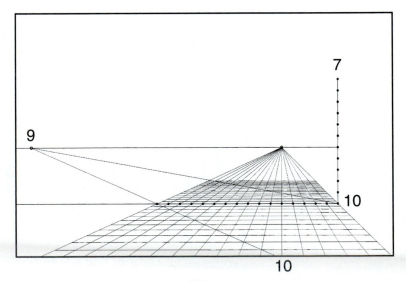

Perspective illustrations by Christian Gladu, architect-designer of the Bungalow Company, Bend, Oregon, Drawings used courtesy of the artist. 2000.

The Formal Elements: Perspective

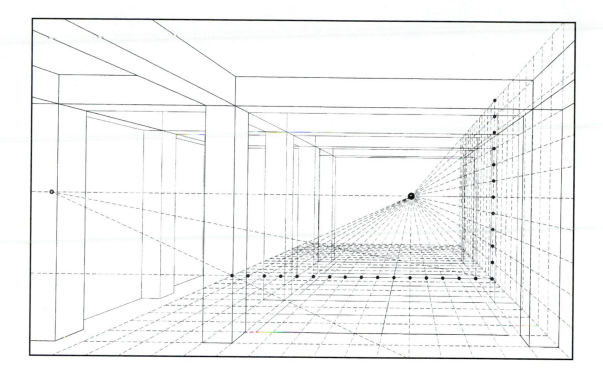

One-Point Perspective, Christian Giladu, architect-designer, The Bungalow Company, Bend, OR, 2000.

PERSPECTIVE GRID

The grid is used to correctly establish the dimensions of an interior or exterior space. This is a system for determining the size and scale of objects in a space. To construct this grid:

1. Draw the horizon line down one-third of your paper's height from the top.
2. Draw a vertical line to the right for scale and measurements.
3. Draw a ground line below the horizon line. Place it two-thirds of the way down the paper.
4. Establish the center of vision or vanishing point on the horizon.
5. Mark off equal increments of one inch on both the horizontal and vertical and front lines from their meeting corner.
6. Draw a line from each mark on the horizontal ground line back to the vanishing point. The front points of this first ground plane are called the end points.
7. Draw a line from each mark on the vertical back to the vanishing point.

8. Extend both sets of lines (on the ground line and the vertical) from their measured marks forward to the paper's edge.
9. Establish another point on the horizon that is equal to or greater than the width of the space. From this diagonal point, draw diagonal lines (a) from the point to the front corner of first grid; (b) through the opposite corner into the extended ground.
10. Where the diagonal line (a) crosses the lines receding to the vanishing point, draw the horizontal lines through each of those intersecting points.
11. This creates a grid in perspective. This ground or floor plane is divided into squares that get smaller as they recede.
12. To divide the receding lines creating the wall to the right. Extend the horizontal lines on the ground plane into vertical lines crossing the receding lines. This will establish receding sections on the wall.

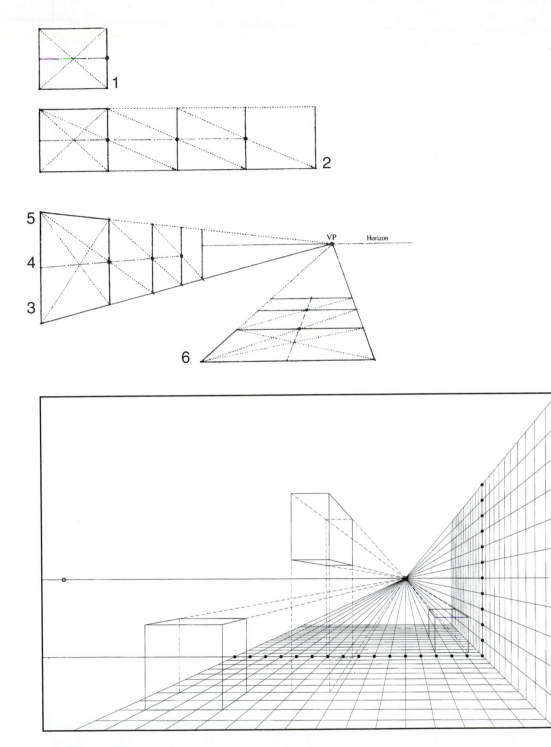

Perspective illustrations by Christian Gladu, architect-designer of the Bungalow Company, Bend, Oregon. Drawings on this page used courtesy of the artist, 2000.

The Formal Elements: Perspective

MEASURING DEPTH

1. **Left Top Diagram on page 128.** Begin with a single square placed at right angles in the picture plane. Divide it in equal parts by drawing two diagonals from corner to corner. Draw a horizontal line through the center point dividing the sides.

2. To extend this plane draw a diagonal line from the top left corner through the midpoint of the opposite side. Extend the top and bottom lines of square number 1 horizontally. When the diagonal line meets the extended baseline, draw a vertical line at ninety degrees from that point to connect the topline. Continue adding square units with this process.

3. To draw a wall in perspective, draw a horizon on the paper. Establish the front edge of the plane with a vertical line. The height of this first line establishes the scale of the following planes. Draw a line from the top and bottom of this first vertical to the vanishing point.

4. Find the midpoint on the first vertical and draw a line from the center point to the vanishing point.

5. Draw a diagonal line from the top left corner of the front plane through the center line. Where the diagonal intersects the vanishing center line, draw a vertical for the backline of the first plane. When this diagonal line intersects the receding baseline, draw a vertical creating the second square unit in perspective.

6. Use the same process to extend the ground plane. Repeat the process to produce seemingly equal spaces creating depth with the squares in a perspective.

DRAWING EXERCISE

Art on bottom left

To construct three-dimensional solids by using the grid, first lay out a ground plane and a wall plane in perspective with the grid divisions. To keep the vertical and horizontal lines straight, or at 90 degrees use a ruler and a 45-degree triangle.

Select a number of squares in the ground plane and draw horizontal and diagonal lines to outline the section. The verticals extend up off this section. Draw the front verticals the height you chose and then draw receding diagonals to the vanishing point. When you draw the back vertical lines and they intersect these receding top lines your square is complete. After you practice making the cubes in perspective, try to draw a room. Using the grid, place bookcases against the wall by extending the lines horizontally from the vertical grid and ground plane. Try constructing tables, chairs, and couches. See if you can design an imaginary living room or kitchen in the space.

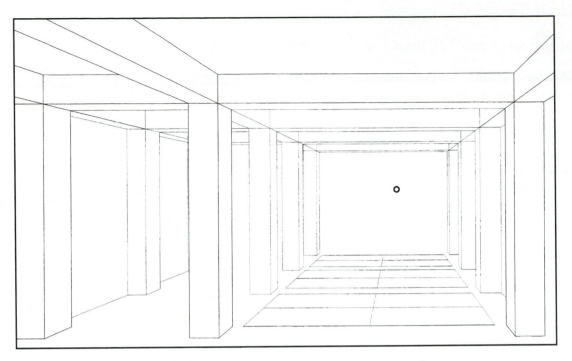

Perspective courtesy of the artist, Christian Gladu, architect-designer of the Bungalow Company, Bend, Oregon, 2000.

DRAWING EXERCISE

A hallway provides an excellent test for creating an interior space in perspective. Sit in the the middle of the hall. Locate the horizon line (at your eye level), and draw a light line on the paper where it falls. Keep your head in one position. Determine where at the end of the hallway the floor lines and ceiling lines are vanishing, and mark your vanishing point on the horizon line. The vanishing point is often through the middle of the doorway at the end of the hall. Draw a ground line at the front of the picture plane and mark it off in one-inch units. Connect each unit to the vanishing point and then extend them forward to create a larger forward floor plan. Mark off one-inch units on a vertical line near the front of the picture plane and draw lines through each point to the vanishing point.

Construct the details of the walls and the floor using your horizontal and vertical grid.

FIGURES IN SPACE

The figure in the foreground establishes the scale for other receding figures in the drawing. To establish size and proportion draw a line from the top or the head of the front figure and a second line from the feet to the vanishing point. The other figures are drawn in between two lines. The eye level of every figure is on the horizon.

To create human figures receding in space, the ground and vertical planes can be divided on a proportional basis. Each receding ground plane is one-half the size of the one in front of it.

Figures in space provide the human scale. If the space dwarfs the figures, it is bigger than human scale, whereas if the figures fit in the space well, we say the space is human scale. Figures are in proportion to each other when the eye level of all figures is on the horizon.

The Formal Elements: Perspective

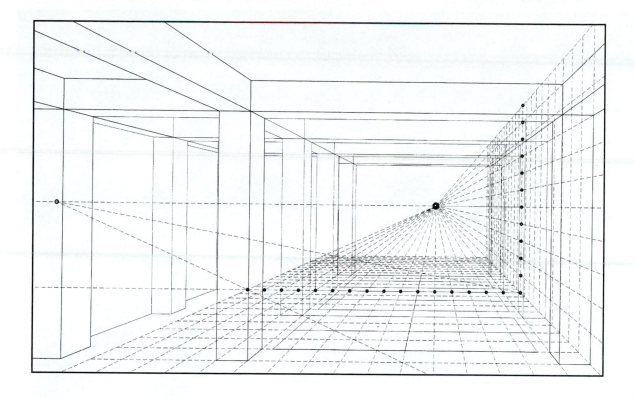

Perspective courtesy of the artist, Christian Gladu, architect-designer, the Bungalow Company, Bend, Oregon, 2000.

DRAWING EXERCISE

Make a simple contour drawing of the space of a real street and place outlines of people in the drawing. When drawing outside a viewfinder can help you compose the space. To practice you can copy the space of a street from a photograph. Copying brings familiarity and improved hand-eye coordination into drawing.

Try different public spaces, using the size of the figures as measuring devices to establish the scale of both spaces. One space should be of monumental scale and the other a small-scale space.

Frame your picture plane before you start and work from the foreground to the background.

ATMOSPHERIC PERSPECTIVE AND VALUE

Line can only frame the space and outline the forms. Value makes the drawing dramatic and increases the sense of space. Artists may follow actual patterns of light falling in the space or they may use light and dark to create space without an actual natural source. They can do this because they have a working knowledge of the properties of value changes in space and they understand how value changes space.

Gaetano Gandolfi's drawing of the prophet has many of the properties of atmospheric perspective. Atmospheric perspective creates a change of light in our visual field on the picture plane. Objects in the foreground seen close up are dark with sharply defined contrasts in value describing their surface. The tonal contrast diffuses in the background, and the shapes appear as gray tones or light hues. The light and dark on the prophet are inventions of the artist to create a

The Formal Elements: Perspective

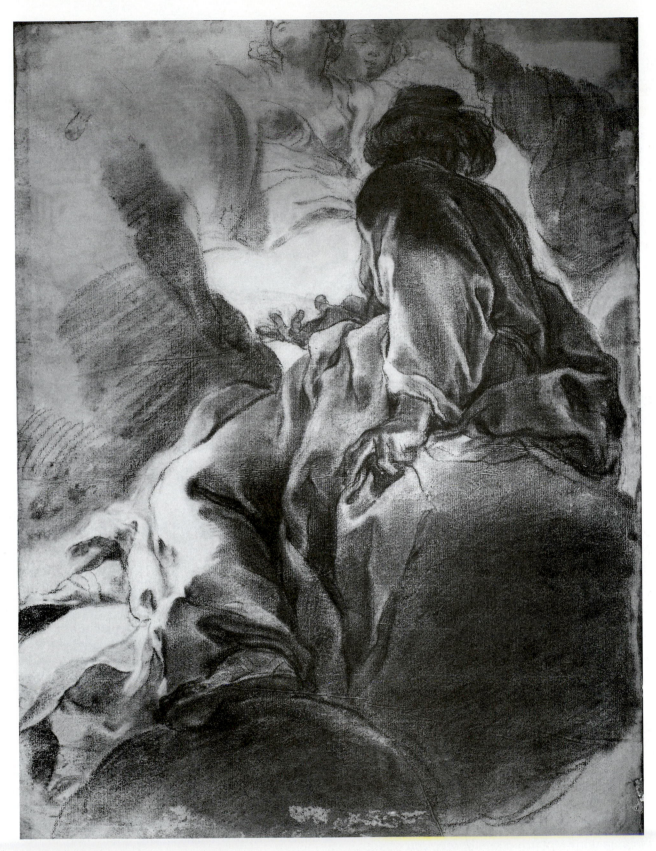

Gaetano Gandolfi, 1734–1802, *Italian Seated Turbaned Prophet*. Black chalk, stumped, gray wash, heightened with white, on beige paper. H 16⅝″, W. 12⁵⁄₁₆″ (42.2 × 31.2 cm). The Metropolitan Museum of Art, Gift of Jacob Bean, in memory of Donald P. Gurney, 1989. 1989.108.1.

The Formal Elements: Perspective

mysterious mood. Look at the rocks he sits on: they are dark. His foot rests on the rock in the dark foreground. His left hand sits on top of the rock in the illuminated spot. His leg turns from the darkness into the light. The placement of dark to light values coupled with the angle of his body creates the sense that the prophet is turning into the background.

In real space this change in light to dark back to light occurs from the dust particles in the atmosphere that are suspended in the air between the viewer and distant forms. This haze of pollution or natural dust obscures our view, reducing the distinctness of distant forms.

The contrast softens behind the prophet's head where there are white forms with shades of gray. Look closely and you will find two angels or muses floating in the sky.

The drawing on page 134 by Jennifer Borg has virtually no change in value either horizontally across the objects and the space or vertically on the objects and in the space. This drawing is the first layer of an ink drawing. The objects and the space were outlined first in pencil mapping out the composition. Wax was applied on the white areas and the first wash was painted over everything. As a result the drawing is visually flat, reading as a very shallow space.

Above, Merrilee Chapin, ink wash, value and space study; below, Shawn McClellan, conte, with white highlights, spatial study; bottom left, Sabrina Benson, charcoal, dark to light, student drawings, 1999.

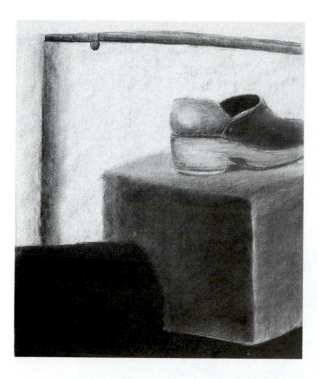

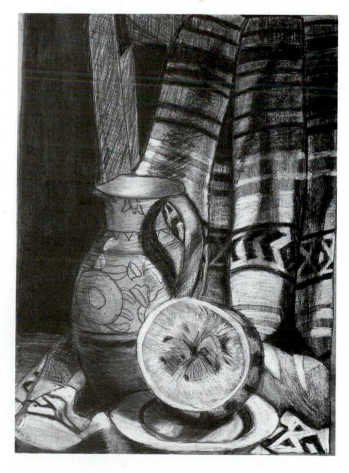

The Formal Elements: Perspective

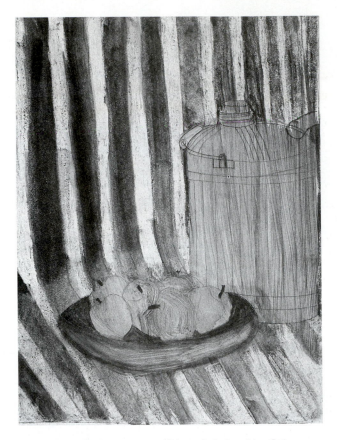

Lisa Cain's drawing below reflects two or three layers of ink wash and a final layer of charcoal pencil to increase the horizontal light changes across the objects. The vertical gradation of dark to gray moving from top to bottom increases the separation between the foreground and the background.

Line is a tool of drawing that we associate with defining shape by following the edge of an object. There really aren't lines in nature. What we perceive as a line is often value change. The contours, the beginning and end of the forms in all the drawings on the pages (133–134) were formed by value changes, not outlines. A shift in light or brightness can define the profile of the object. A range of tonal values across each surface from the highlights to the shadows differentiates and depicts both the object and the ground.

The space between forms is equally important. The greater the interval between overlapping forms, the greater the contrast between the light and dark values.

Above, Jennifer Borg, wax and ink wash; below, Lisa Cain, charcoal pencil, ink wash, student drawings, 1999.

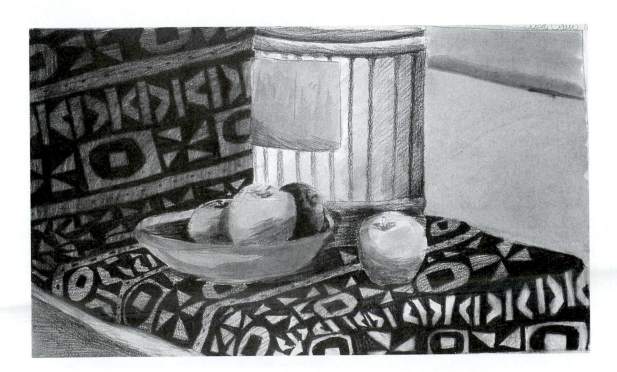

The Formal Elements: Perspective

DRAWING EXERCISE

Place a wooden chair on the floor with a pillow, a bottle or an iron on the seat. Drape a cloth, a sweatshirt or towel over the back of the chair on one side. Use HB, 3B, and 6B pencils for drawing. Sit directly in front of the chair to keep it at one-point perspective. Outline the chair, the fabrics, and the objects in HB pencil. Fill an 18 x 24" white piece of paper with the chair outline. Use the 6B to map out the very darkest areas of drawing. Analyze the space with what you know about light and dark in space. The areas that are under others, back, and behind will tend to be darkest. Identify the light areas in light outline or light hatching lines. Continue around the drawing, determining what will be light, gray, and dark before you start. Since you do not have a direct light source and you are using the light in the room, you will have to judge how light, gray, or dark each area should be to make a convincing drawing of the forms.

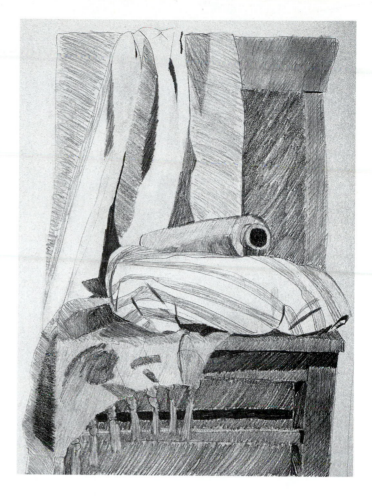

In perspective things get smaller as they recede to the horizon. In Deborah Finch's *Walnut* the forms in the foreground were drawn at a much larger scale than the forms in the background placed near the top of the paper. When the scale is changed from large forms to small forms, the eye reads the space as having depth. In this drawing she has reversed the values. The background walnuts have darker values defining them than do the foreground walnuts.

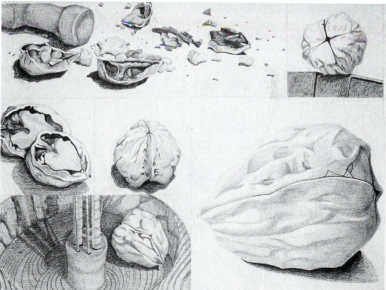

Above, Shawn McClellan, pencil; below, Deborah Finch, pencil, student drawings, 1999.

The Formal Elements: Perspective

FORESHORTENING

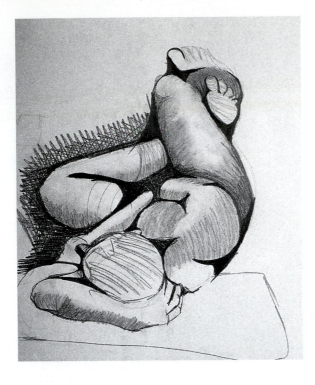

In foreshortening spatial relationships are compressed rather than extended. Foreshortening must be applied to objects that project forward in the space of the picture plane. All perspective is a process or technique to create the illusion of three-dimensional form on a two-dimensional surface. We must intensely alter what we know about the length of a form in the foreshortening process if we are to render figures or objects that are directly in front of us. The vase below in Lili's drawing is foreshortened. It is basically two circles, a small one in a large one. The modeling on the vase creates a volume sitting on a cushion. Dan's figure to the left is a good example of what happens in a foreshortened view. He is looking down a figure from the head over the chest to the feet. Each shape of the body overlaps the next one. The shape of the head is outlined against the chest; the chest ends in a value change out of which the thigh emerges. Line or value separations between the shapes are crucial in foreshortening. In foreshortening shapes get smaller as they recede. The baseline of the figure gradually moves up the paper. You have to intellectually

Above, Dan Loretz, pencil, figure; below left, Sarah Parish, red conte on pink paper, figure; below right, Lili Xu, pencil, two point study, student drawings, 1999.

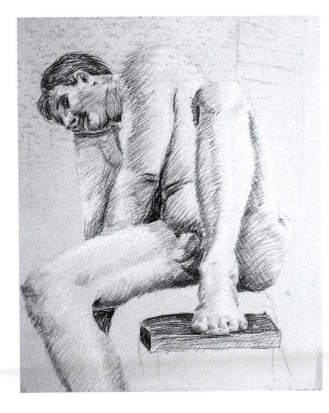

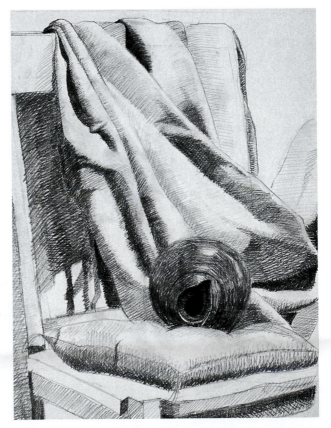

The Formal Elements: Perspective

counter the fact that you know a leg is two to three feet long because in a foreshortened view that distance is represented with a much shorter diagonal line.

Sighting is helpful in foreshortening. In Sarah's drawing to the left and below, the leg was drawn first. All the other parts of the body were then measured and proportioned against that leg. To sight, draw a line from the knee horizontally across the paper and locate with a vertical line the location of the shoulder, neck, chin, forehead, and the knee on the other leg. These marks will guide you in drawing the figure.

THREE-POINT PERSPECTIVE

If you were to draw a tall building by looking up from the base, you would need to use three-point perspective. In three-point the side planes of the building vanish to points on the horizon, just as in a two-point perspective, but the top of the building vanishes upward into the sky. The parallel lines of the building that are perpendicular to the ground, and form the side planes of the building seem to be converging into a third point above the top of the building. The use of value further emphasizes the building's verticality. This is a view a tourist in Chicago or an ant experiences looking up from the street. It is an extreme view.

Charles Sheeler, 1883–1965, American. *Delmonico Building,* 1926. Lithograph, printed in black, composition 9¾ × 6¹¹/₁₆" (24.8 × 17 cm). The Museum of Modern Art, New York. Gift of Abby Aldrich Rockefeller. Photograph © 2001 The Museum of Modern Art, New York.

SHADOWS

Light is important in a drawing. Light changes create focus, drama, mood, and volume. Forms sitting in direct light cast shadows. It is important to remember that where a form ends the shadow begins. The beginning of the shadow and the edge of the form casting the shadow are the same.

There are three factors to consider in drawing shadows:

1. What is the source of light? Is it natural or artificial?
2. What is the direction the light is falling? The direction of the light determines the direction of the shadows. Shadows are cast on the opposite side from the source of light or from where the light falls.
3. What is the angle of light. The angle determines the length of the shadow. At noon, when the sun is directly overhead, there are no shadows or there can be a very tiny one directly under the object the sun is shining on. At 10 A.M. and 3 P.M. the rays of the sun are at their steepest angle to the earth, and the shadows will be long.

In the drawings of the walnuts, Matt has used the four o'clock shadow under the large walnut in the center of his drawing. The walnut in the middle of the top row has the smallest shadow. A form would cast a shadow this size around 11 A.M. Lili's objects were lit from the front. The front form is casting a shadow on the cylinder behind it. Joseph's drawing, was lit from above about eleven o'clock. The watermelon's shadow is directly underneath it on the plate and it is casting a shadow on the pitcher behind it. If you follow the shadows back, you follow the direction the light is falling. All these drawings used artificial light. Matt made the light up completely from studies he had done in class. Joseph and Lili worked from direct observation.

Above, Lili Xu, charcoal value study; below, Matt McDonal, pencil walnut composition; right, Joseph Davis, conte still life, student drawings, 1999.

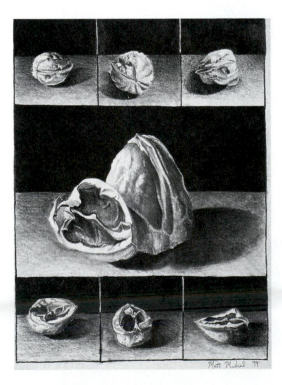

Heinrich Bürkel, 1802–69, *Italian Farmhouse among Ancient Ruins*, gray wash over pencil on cream wove paper. 247 × 360 mm. Cantor Arts Center, Stanford University Committee for Art Fund 1984.247.

DRAWING EXERCISE

Select one piece of fruit such as an apple or a pear. Set it on a table on a white piece of paper. Use a clamp-on light attached to an easel. Make three drawings, changing the direction of the light each time. Direct the light from the front, the side, and then from the back. In the third drawing, angle it down so it is not in your eyes. Hang the three drawings up and examine the shadow treatments.

LANDSCAPE LIGHT AND SHADOW

Light in landscape will follow the planes of the buildings or plants. Here the building is illuminated from the front. The side planes are in shadow. The bushes pick up the light on the top planes and the bottom planes are in shadow. In between the trees the shadows hold the spaces, letting the tree trunks show through.

Light also takes on the shape of the object that casts it across the ground or floor. Organic forms will cast round-shaped shadows and geometric forms will cast square, angled, or rectangular-shaped shadows.

The light in this landscape is carefully rotated from light to dark planes. In this way no two areas get muddled together, and we move easity through the space. The artist most likely has made up the light pattern.

CHAPTER 7
THE FORMAL ELEMENTS: TEXTURE AND PATTERN

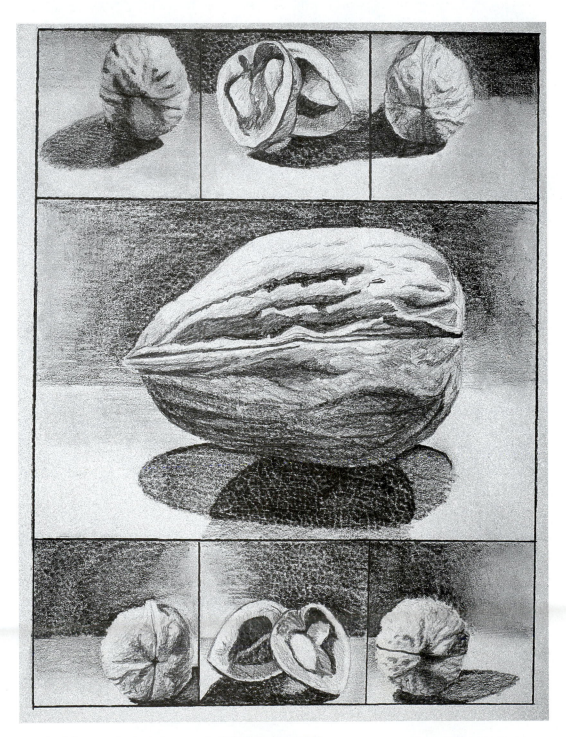

Chandra Allison, study of a walnut, pencil, student drawing, 1999.

When you look at a wall spotted with stains, you may discover a resemblance to various landscapes, beautified with mountains, rivers, rocks, trees. . . . Or again you may see battles and figures in action, or strange faces and costumes and an endless variety of objects which you could reduce to complete and well-known forms. . . . And these appear on such walls confusedly, like the sound of bells in whose jangle you may find any name or word you choose to imagine. Leonardo da Vinci

Texture depends on value and tonal changes. Value changes can convey light and the reflection of the light on a surface or on a form, but they can also create a surface. The sense that we are seeing a surface can result from various combination of lines. Often you create texture rather than draw it directly. Rubbing, wiping, and erasing might be used to create a texture. Texture is the the tactile sensation we perceive in nature.

RUBBING AND RENDERING

Chandra Allison's walnut study on the left uses rubbing to create texture in the space around the walnut. To make this texture she placed her paper on top of her black rough portfolio and used her pencil to transfer the portfolio's texture while at the same time she manipulated the value changes in the ground. This technique is called "frottage." Max Ernst, a German surrealist of the 1930s, was an early pioneer of alternative processes in creating art. He used rubbing as drawing and added rubbings into his drawings, preferring to have the image of a natural pattern actually taken from a weathered plank rather than recreating wood grain by imitating it in paint. Faux painting was the art of imitating textures in paint and it has resurfaced in this decade. The multicolored soft dabbing process to texture walls is Faux base. Contac paper, tile and Formica have been created with a textured surface look of marble and wood grain. The effect of light on the walnut describes the surface and defines its placement in space.

The surface of the walnut was drawn in a range of tonal values. The walnut's exterior poses exactly the same problem a drapery does. The surface rolls from the top plane into a groove or back plane. These planes are much smaller than the ones on the drapery but the process is the same; light rests on the top planes, gray forms the side planes, and dark fills the inside of the grooves. The interior of the walnut at the top has a light center and at the bottom one of the halves has a dark cavity. By leaving the rim of the shell in white and the nut the same value they fight for the same visual space. It is important to think the light changes in a drawing in terms of the location each object and part of a form occupies.

Chandra Allison, pencil rendering of a green pepper, student drawing, 1999.

INVENTED TEXTURE

Pen and ink, lead pencil, and charcoal pencils are all media that can be used to create texture. There are several basic techniques: crosshatching, hatching, stippling, and scribbing. Each of these techniques requires a gradual buildup of marks or careful side-by-side placement. Each mark or stroke has its own nature or quality. Tonal value is expressed through the relative proportion of light to dark, spacing, and density in a drawing. The direction of the stroke affects how the viewer perceives the rendering.

LINE

In the top drawing William invents a textured look by employing a strict, clean hatching line to render a push pin. He has balanced the lines with x's to create the shaft and used stippling for the head of the pen.

STIPPLING

Andrea's scissors to the left are an example of stippling. Stippling is a technique that uses very fine dots. Stippling is made with a fine-tipped ink pen on a smooth paper such as plate Bristol. The dots are painstakingly placed side by side one at a time. You need patience to build the value dot by dot. Tightly spaced dots define sharp, distinct edges, and looser lines or groups of dots create a softer contour or surface. The density of dots controls the value. The farther apart the dots are, the lighter the value. Large dots result in a coarse texture. Even spacing of dots creates a light value. The darkest areas may have dots placed on top of each other.

Above, William Duffy, ink line; below, Andrea Hellwege, ink, stippling; right, Jeff Darbut, ink, stippling with solid dark values, student drawings, 1999.

The Formal Elements: Texture and Pattern

DRAWING EXERCISE: INTERPRETING FORMS IN MARKS

The three drawings on the facing page are the creative solutions for the following assignment:

Select a simple object to render without using an outline. Use only line, marks, or stippling to form the shape and surface of the object. On a 10 × 10" illustration board center a 5 × 5" square to place the drawing. Jeff's design below on the facing page is a rendering of a rubber sink plug. He has interpreted a molded rubber stopper with a number of light and dark marks.

Liza Blevins, ink hatched pliers, student drawing, 1999.

HATCHING

Hatching is composed of a series of parallel lines. The lines can be long or short, ruled or drawn freehand. The spacing, density, thickness, and thinness of the lines control the value they will reflect. Thin lines with white space between them read as a light value, whereas thick, close lines read as a dark value. Pen is the natural tool for hatching. The lion and the horse in Delacroix to the right are hatched and crosshatched.

Crosshatching darkens the value by placing overlapping strokes horizontally, diagonally, and vertically on an area of the surface. Dense hatching creates solid volumes. Open hatching indicates water reflections, the light of the sky, and grass covering the ground. The ends of hatching lines feather out like the tips of tall grasses. This technique in which the line changes from thick to feathery thin forms and fits the lines to follow the planes on the subject.

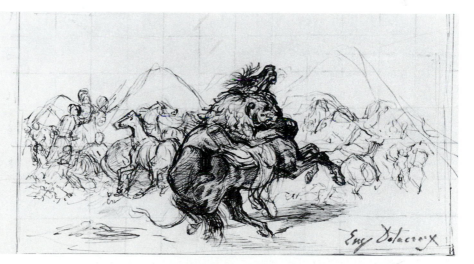

Eugene Delacroix, French 1798–1863, *Moroccan Lion Hunt*. Pen and ink on paper, no date, 4 × 6½". Portland Art Museum, Oregon. Helen Thurston Ayer Fund. 47.19.

The Formal Elements: Texture and Pattern

TROMPE L'OEIL AND ACTUAL TEXTURE

Andrea Hellwege
5/12/98

Andrea Hellwege, texture study, water drops, ink, student drawing, 1999.

Texture may be "actual," duplicating the tactile surface characteristic of an object. In the context of drawing "actual" is an authentic representation while invented textures are not necessarily. The water drops on the left by Andrea Hellwege were created with a light ink wash. The highlight or small white dot on the surface is set against a light gray, and the entire round drop is set off with a tiny dark shadow underneath each one. She has followed the process of chiaroscuro, transforming a circle into a sphere. To recreate a natural surface an artist must examine the subject very closely. Trompe l'oeil is a French term that means "to fool the eye." When forms and their surfaces are rendered so realistically that the viewer believes the drawing is a real form, it is called trompe l'oeil.

Maria Sibylla Merian studies from nature rendering a butterfly, a moth, a strawberry, and a pea pod are watercolor on vellum. There are no recognizeable brush strokes on the planes constructing the surface of each study. To accentuate each form's shape and model the surface, she relied on a range of tonal values. The interplay of tonal values conveys the vivid lifelike representation creating a visual, tactile sensation. We feel we are looking at an actual butterfly. Line and value combine creating the images. The strawberry is a good example of what relative light to dark means. It has a shaded side or dark side and a shadow, but the dark is relative to the light. It is not as dark as the stripes on the moth's wings, but it is dark enough by comparison with the light area to read as the shaded side and to turn the form into a volume.

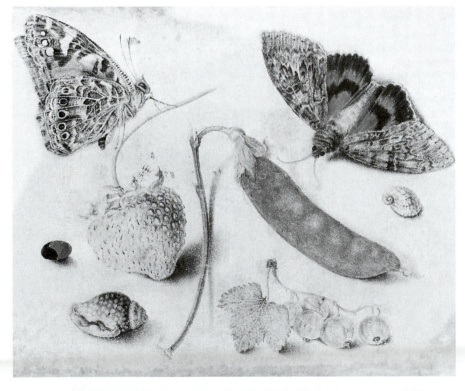

Maria Sibylla Merian, German, 1647–1717. *Studies from Nature:* butterfly, moth, strawberry, pea pod, white currants, shells. Watercolor on vellum. H. 9.2 cm., W. 11.3 cm. The Metropolitan Museum of Art, Fletcher Fund, 1939. 39.12.

The Formal Elements: Texture and Pattern

DRAWING EXERCISE: PAPER AND MEDIA EXPERIMENTS

The texture of the paper affects the way the pen and pencil cover the paper's surface. A rough paper will have white areas in charcoal or Conté surfaces. This results from the grain of the paper. Heavy pressure on the drawing tool will eliminate these white dots or bumps. When you let the texture of the paper show through the Conté that area reads as a lighter value. Although the coffee cup is not a result of rough-surfaced paper, the drawing has employed space between the the marks to change the value on the surface.

Sherry Holliday, ink, point-line-plane, student drawing, 1999.

Art supply shops sell a wide variety of paper. For the following drawing exercise buy a collection of various papers from smooth to rough. Try BFK, rice paper, canson, charcoal paper, Bristol plate and vellum finishes, and a handmade paper if you can find it. You may want to go together with three other students. These sheets can cost from $1.00 to $5.00 apiece, but they measure 22 × 30″. You could divide the paper among four or five people easily for this study.

Use lead pencils, lead sticks, Conté, charcoal, and ink to explore the effects of the media on the different papers.

The lead stick is excellent for making rubbings on the rice paper. To make a rubbing place the rice paper on a rough surface with letters or texture and using the flat of the lead stick rub over the back of paper. The charcoal paper and the canson paper will have a rough surface experiment first with Conté lightly covering an area of three or four inches square. Return to the square and on one half of it use the Conté in a second layer applying a firm pressure on the stick. The BFK will take wash well. Use your compressed charcoal and draw a shape. Dip a brush in water and lightly wash over your compressed charcoal lines spreading them. When this area dries you can draw on top of it with pencil or charcoal pencil. Follow your first wash with a second darker wash on the BFK.

Ker-Xavier Roussel, 1867–1944, *Women and Children in a Park*, c. 1892–93. Pen and brown ink, with touches of pencil, on tracing paper, 200 × 305 mm. 1971.32 Museum Purchase. Stanford University Cantor Arts Center. © 2001 Artists Rights Society (ARS), New York/ADAGP, Paris.

VISUAL TEXTURE

Visual textures are invented to simulate smoothness, roughness, patterns, and fabrics and not necessarily for the purpose of accurate representation. Visual textures serve the artist's vision and purpose. Texture and pattern are devices in drawing to organize the space, to create visual interest and rhythm. Visual textures have a range of expressive possibilites.

In the sketch above by Roussel the patterns creating textures on the women's dresses are constructed of marks. The white space between the marks balances the marks for light to medium values. This study is an advanced stage in Roussel's compositional planning for a painting. He used tracing paper to redraw this drawing from earlier studies. The main figures are represented in firm but lively lines. A grid was drawn over the drawing to transfer it to a canvas. Roussel was one of the Nabi painters, along with Bonnard and Vuillard. Around 1891, in France, the Nabi painters rejected naturalism in their subjects for decorative effects, harmonious arrangements of forms and colors, bold arabesques and expressive surfaces.

DRAWING EXERCISE: CREATING TEXTURE AND PATTERN

On the facing page, Tom Breeden and Betsy Backlund created drawings using invented textures. These are abstract and decorative textures based on repetition, patterns, lines, dots, and planar divisions. Tom selected one vegetable, repeating each outline by overlapping the one before it across a 10 × 15" illustration board. Betsy drew 3 apples across the picture plane and expanded the design using textured grounds. She never outlined her apples but she changed the texture and size of the pattern for the edge of the fruit.

The Formal Elements: Texture and Pattern

Above, Tom Breeden, ink and textures; below, Betsy Backlund, ink and textures, student drawings, 1999.

The Formal Elements: Texture and Pattern

147

OBSERVING TEXTURE

To represent surface qualities on a two-dimensional picture plane, it is necessary to use one or more of the following: tone/value, pattern, controlled and directed marks, texture, or color. Texture is perceived through two senses, touch and sight. Tactile textures are perceived through touch, visual textures by sight. Through the sense of sight we distinguish between different objects in our environment. Through seeing and touching we determine the shape, depth, contour, and color of an object, which are the characteristics drawing interprets in marks. Seeing and touching first provide your imagination with valuable information about the subject.

SURFACE TEXTURES AND EXPRESSION

Tiepolo's drawing or sketch is much like the drawings done today. It contains two seemingly unrelated subjects in one picture plane, both drawn from different perspectives. For Tiepolo this is most likely a study for a larger work unlike contemporary work where it could be the final statement. The pen and ink strokes on the stag convey a feeling of hair on the surface with a value change that creates a sense of volume.

Giovanni Domenico Tiepolo, 1727–1804, *Lying Deer and Head of Crocodile.* Pen and bistre with sepia wash. H. 11¼ × w. 7⅞″ (28.5 × 20 cm.) The Metropolitan Museum of Art, Robert Lehman Collection, 1975. 1975.1.521.

This is a foreshortened view of the deer. The hindquarter is darkened, creating a line between it and the stomach. The light value on the shoulder creates a visual distance between the hip and the shoulder. This change from dark to light creates spacial distance. The ground under the deer is a smooth wash without texture except for the foliage change at the front corner.

The alligator is modeled with short light to dark strokes, creating a rough surface. It appears to have been drawn from a description rather than from life.

Ink and ink wash are good grounds for pencil and charcoal pencil to create hair textures and other surfaces.

The textural character of the drawing and the nature of the surface are determined by a choice of materials. The inventiveness of the artist controls the expression.

The Formal Elements: Texture and Pattern

DEFINING SPACE WITH TEXTURE

Beginning students associate line with outline or the contour first. The next step in learning to draw is to free line to define air, space or a natural form without the outline. These lines reflect what we see without outlining. In his drawing, Bonnard has used scribbles, marks, hatching, and crosshatching to define the space of the garden. He can later translate these marks into brush strokes and color in a painting. Losing the outline frees the artist to interpret space. Bonnard's drawing is an expressive use of texture. He is influenced by the light in the landscape, the character of the forms in his landscape, and his choice of materials.

The activity of drawing develops an increased sharpness in our eyes. Our awareness evolves and expands as we learn to see in new ways, developing a new understanding of the things around us.

Pierre Bonnard, 1867–1947. *The Goatherd.* Pencil and black and red chalk. H. 10⅝ × W. 8¼". (27 × 21 cm.). The Metropolitan Museum of Art, Robert Lehman Collection, 1975. (1975.I.570r). © 2001 Andy Warhol Foundation for the Visual Arts/ARS, New York.

DRAWING EXERCISE: SCRIBBLE LINE LANDSCAPE

Using pieces of paper cut to around 4 × 5" or a small sketchbook go outside to draw with a pen. Select a part of the landscape to draw. Use various lines—hatched, scribbled, light to dark—to record the location of forms in the space you have selected. Draw the space from front to back by starting with the space of the foreground and adding the receding grounds to it. Scribble and hatch in the direction the forms grow.

Manipulate the value with layers of line and by varying the pressure on the pen. Make a dozen sketches of the same area from different sitting positions or angles. Lay all the drawings out on a wall and look at them when you are done.

1

4

#4 & 5 Nicole Stowers, rubbing translation in ink, student work, 1998.

2

3

PATTERN

The way you see and what you see are socially conditioned. Our eyes transmit information to the mind's eye which extracts, processes, and censors the information. The mind's eye makes conclusions about what you are seeing. To do this it seeks known patterns or features that fit the image of the world we have formed. The mind's eye creates meaning, and it will fill things in that aren't really there in order to achieve closure. To draw, you must challenge the mind's eye to work harder and not make up visuals. A made-up visual is your eye telling you that the sky is blue, the grass is green, and the mountains are brown. This is not always true, however. Now you must make your eyes work and interpret new information forming new patterns from visual phenomena.

Pattern in drawing can result from interpreting patterns found in nature. Images numbers 1 and 2 on the left are lead rubbings. The student then translated them into image number 3, which is a pattern adapted from a real texture.

Image number 4 above is a rubbing. The original sheets of rubbed textures were edited into four two-inch squares. The four two-inch squares were then arranged together in the above finished format for presentation. Image number 5 is a drawn adaptation by the student to re-create the rubbed texture in ink wash and charcoal pencil.

Pattern is often used in still life as background and foreground. In Matt's still life wax has been used to texture the flowers and the box behind the skull. When wax is rubbed on first and an ink wash placed over it, a bumpy texture occurs, graying the value of that area.

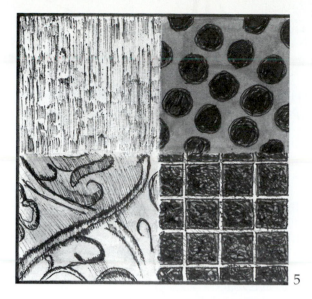

5

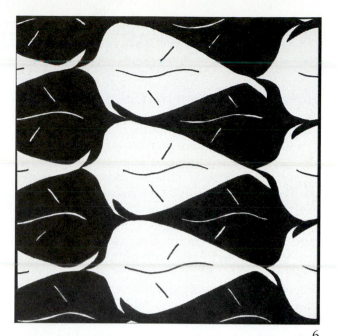

6

Jeff Darbut, ambiguous pattern, student drawing, 1998.

AMBIGUOUS PATTERNS

Image number 6 is an ambiguous pattern. The design is balanced evenly between the black pattern and the white pattern. If you look at the white pattern and then at the black pattern, you see that what is positive can become negative space and what was negative space can become positive space.

DRAWING EXERCISE: AMBIGUOUS PATTERN

Select a symmetrical figure to create an ambiguous pattern using only black and white. The design is composed by repeating the figures in rows. The figures must share a common contour line. The figures are arranged in a grid of alternating rows, each row facing a different direction. If two different figures are used, they must have similar shape characteristics and share a common contour line. Selecting and manipulating the symbol will take concentration. The resulting visual should be a balanced composition that fluctuates between seeing the white and then the black as the dominant pattern. It is a reversible design.

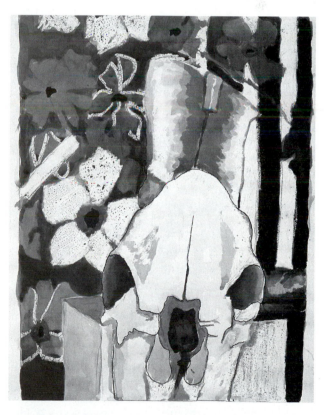

Matt McDonal, wash and ink, student drawing, 1999.

PROFILE OF AN ARTIST: VINCENT VAN GOGH

Vincent van Gogh was born on March 30, 1853. His father was a clergyman in Zundert, a small town in a poor region of southern Holland. In the van Gogh family there were two daughters and another son. Theodorus, or Theo van Gogh who played an important role in Vincent's life, supporting him financially and emotionally.

Van Gogh was an extremely emotional child given to sudden and violent outbursts of rage. His mother could never understand him, but he was able to talk with both his father and Theo. His education began in public school, where he was briefly enrolled, but his parents thought the contact with the other boys was making him too rough and took all their children out of school. A governess was hired to teach them at home. Vincent's contact with nature during this time developed his love of the country, the earth, the animals, peasants, and all living things. These times provided him with his happiest boyhood memories.

Vincent's illness may have been caused by a traumatic childhood experience or he may have had a form of epilepsy. He would have terrible seizures followed by long periods of calm and mental clarity. He did not fit the cliché image of a painter gone mad from art. It is more likely his madness was the result of a serious physical condition.

Vincent's first drawings at the age of ten were conventional studies of flowers in pencil and watercolor that he copied from illustrations in books. There is a good deal of whimsical humor and playfulness in these drawings, unlike the serious work he is mostly known for. The sketches were of dogs' heads, rabbits, birds, butterflies, kittens, and there was one of a dog wearing a hat and smoking a pipe. This drawing might have had a direct influence on the return to the primitive image by the neoexpressionists in New York in the 1980s. In the section on color there is a drawing by Roy deForest that looks very similar to these particular van Gogh drawings. These drawings ignore proportion and perspective but reflect a real interest in landscape.

At eleven van Gogh went to a small private boarding school, staying until he was sixteen. He left to take a job with Goupil Gallery in the Hague, and he never finished school. In May 1873 he was transferred to the London Gallery of Goupil. This was possibly the happiest time of his life. He had enough money to live on and the opportunity to visit the museums. He studied the great masters, admiring the work of Corot, Millet, and most of the Victorian artists. The human condition and the focus on human interests attracted him to the work of Corot and Millet. This happy time ended when he fell in love with Ursula Loyer, his landlady's daughter, and she rejected him. He neglected his job and was fired. During the next three years he worked as a bookseller's clerk, and then studied to be a lay preacher but was dismissed by his superiors for "excessive zeal."

In 1880 he turned to art. Millet's *Sower of the Fields* had become a symbol of life to him. He studied anatomy and perspective in Brussels, thinking he might be destined to be a "peasant painter" like Millet. His work was dark during this period. It was during a short stay in Antwerp that van Gogh saw the work of Rubens. The vitality and rich color of this work appealed to him. At the same time he saw the prints of Hokusai, the Japanese printmaker. In 1886 he joined Theo in Paris. Impressionism was everywhere. He left the dark and somber paintings of his Dutch period and painted views of the Seine, the boulevards, and other favorite Impressionist subjects. He met Monet, Pissarro, Degas, Seurat, Signac, Toulouse-Lautrec, and Gauguin. Van Gogh's work had a different emotional quality from that of the Impressionist paintings—it was more forceful.

Dissatisfied with Paris, in 1888 he moved to Arles in the south of France. The hot sun of Provence thrilled him. He felt he could start over here.

His drawings are beautifully composed, seeming like a personal graphic or "handwriting." He used a broad reed pen to cover the paper in overlapping, often dense strokes, but not heavy strokes. The drawings have tremendous sense of texture through the use of dots, dashes, whirling strokes, hatching, and crosshatching which form the space of his landscapes. Van Gogh made diagrammatic sketches in his letters to Theo to share with his brother his ideas for paintings. He also made complete line studies for paintings with precise color notations. Painting and drawing for him were not about creating luxury objects, but they were an extension of life, a part of his environment.

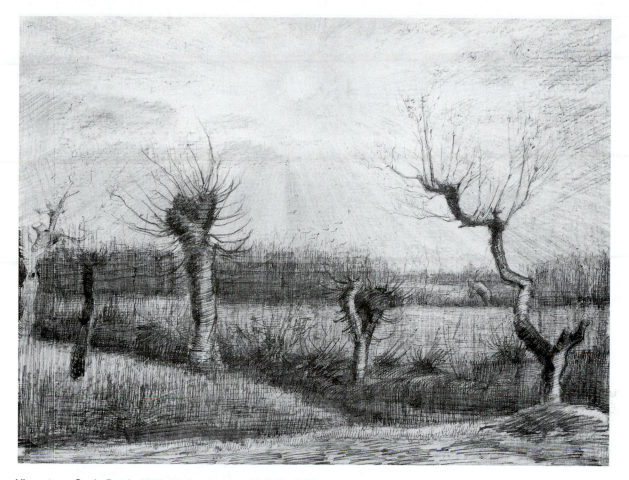

Vincent van Gogh, Dutch, 1853–90, *Landscape with Pollard Willows*. Pen and brown ink over graphite on ivory laid paper, 1884, 34 × 44 cm., Robert Allerton Fund, 1969.268. Photograph by Kathleen Culbert-Aguilar. © 2001 The Art Institute of Chicago, All Rights Reserved.

Van Gogh dreamed of an artists' cooperative in the south of France, and invited artists to join him but Gauguin was the only artist to respond. Gauguin came to work with van Gogh and their relationship was pleasant and mutually stimulating at first. Gauguin's personality was domineering and egocentric and it soon became intolerable for the high-strung van Gogh. The friction between them brought on a terrible attack of madness, and Vincent attacked Gauguin in a state of frenzy where he cut off his own ear. When his rage became more serious, Theo was concerned, and got Vincent to agree in February 1889 to enter the asylum at nearby Saint-Rémy. Here he was allowed to paint and wander outside the walls.

During this one year in the south of France he made around two hundred paintings and one hundred drawings and wrote some two hundred letters to Theo and Émile Bernard. He had lived his life with a burning intensity and dedication to his art. Contrary to the thinking that he madly and unconsciously worked, his letters to Theo and Émile Bernard reveal great lucidity about his artistic aims. He was one of the most articulate of painters and his intentions were clearly expressed in his strong, elegant drawings. One of the reasons he did so much work in this last year was that the ideas for each painting were vividly in his mind. His life ended tragically when he committed suicide in 1890 by shooting himself. He lived for a day, dying in Theo's arms.

CHAPTER 8
COMPOSITION:
SPACE, PLANE, AND SHAPE

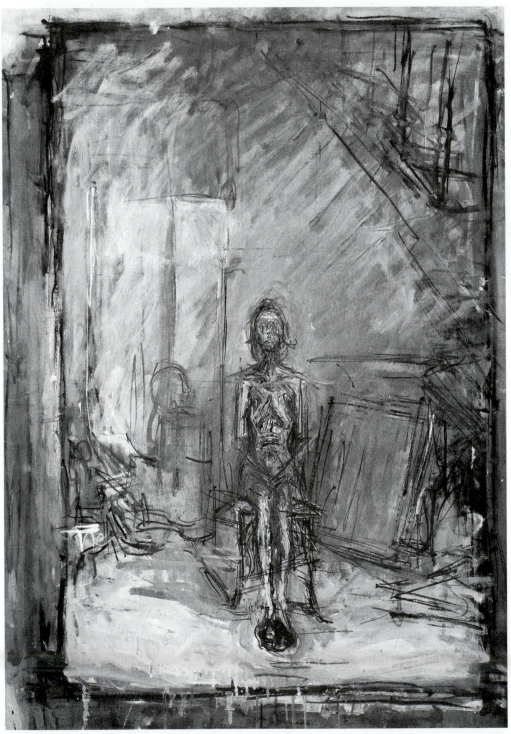

Alberto Giacometti, Swiss, b. Borgonovo, 1901–66, *Annette Seated in the Studio*. Oil on linen, 1954, 36⅜ × 25¾". Joseph H. Hirshhorn Purchase Fund, 1996 Hirshhorn Museum and Sculpture Garden, Washington, D.C. 96.18. © 2001 Artists Rights Society (ARS), New York/ADAGP, Paris.

SPACE REFERS TO the area within the picture plane. The picture plane is the same as the space of the paper for the drawing, framing the space of the drawing. Space is not dependent on perspective. One-, two- and three-point perspectives are techniques to arrange the space of the picture plane. The space of a drawing is defined by the way the artist organizes the visual elements—line, shape, value, color and texture—in the drawing. This arrangement of elements is referred to as a "composition." In a composition the elements may be structured and balanced in a harmonious arrangement, either symmetrically or asymmetrically.

Composition is governed by the principles of drawing, which are balance, placement, and space. These principles were established in the Renaissance and since that time, artists have constantly redefined these rules. Great drawings tend to break the rules on one or many levels, but first the artist must have a full understanding of the possibilities of space, the function of all drawing media, perspective, a control of value, as well as an understanding of the properties of line, color, texture, gesture, and composition.

A drawing is said to be complete when nothing can be added or taken away without unbalancing the whole.

PROFILE OF AN ARTIST: ALBERTO GIACOMETTI

Giacometti's lines define space and the relationships of the forms or objects in that space. Our perception of space is generally inaccurate. There are people who are born with an amazing sense of space. These genetically gifted people have no trouble translating from three-dimensional space to two-dimensional space. The rest of us need help in understanding what the space of a room looks like on a flat piece of paper. Often beginning students will draw in miniature, placing the chair, the window, and the sink in separate parts of the drawing in an effort to render the space of an room without overlapping the objects.

Perception and seeing can be developed through drawing exercises. The artist must be willing to erase and change or draw over the first lines to get the final composition in an accurate relationship or in perspective on the paper. Measuring with organizational lines can help improve our sense of spatial relationships.

"To render what the eye really sees is impossible," Giacometti said at dinner one night. In his work he focused on the relationship of the figure to its enveloping space. Giacometti's goal was to discover the accurate visual appearance of his subject and to render it with precision.

He sought to render precisely what he saw at a given distance. He placed himself nine feet from the model's eye. From this given distance he organized the space as whole—drawing both the space and the object.

He was not interested in the reflection of light, as were the Impressionists, or in the camera, which offers a distorted view by failing to register distance changing the space seen by the human eye. To Giacometti his subjects are thin, surrounded by enormous slices of space.

Giacometti's figures hardly ever vary. There are the standing females, hands on hips, the male heads, or walking men. They do not have a sense of individuality; nothing interested Giacometti less than making a psychological interpretation of the individual. It is not individuality but universality of the human being that he expressed. Some have said his figures seem lonely, even alienated. The severity of their appearance is a result of the intensity with which he worked his materials to reach the visual representation he saw. He worked and reworked both paper and clay until he finally stopped working, hoping to achieve the goal in the next piece. Nothing was ever finished for him.

Alberto Giacometti, Swiss, b. Borgonovo, 1901–66, *Jean-Paul Sartre*, (ca. 1946–49). Pencil on paper, 11½ × 8¾″. Hirshhorn Museum and Sculpture Garden, Smithsonian Institution. The Joseph H. Hirshhorn Bequest, 1981. HMSG 86.2215. © 2001 Artists Rights Society (ARS), New York/ADAGP, Paris.

Giacometti has been described as an "existential" artist because of his unrelenting singleness of purpose, both in his life and in his work. In his work he felt the fundamental contradiction arising from the hopeless discrepancy between conception and realization, both necessary components in all artistic creation. This helps to explain the anguish that is an unavoidable component of the art experience. He worked for the moment when just once he would succeed in representing what he saw. He strove to convey tangibly the intangible sensations of a visual perception of reality—an impossible task and the very measure of his creative drive. The many lines in his work may be a record of his struggle to achieve a likeness to his model— coming back into the drawing over and over, he was searching for the location of his subject in the drawing.

At one point in his career Giacometti and his brother Diego were designing vases, lamps, chairs, and tables for a fashionable Paris decorator. He realized he was working on the vases the same way he worked on his sculpture. Feeling he had to separate the two pursuits, he returned to the studio to work from life for a couple of weeks. He was to work all day for the next five years. It was during this time that a sculpture of one human form became no larger than a pin, reduced to the ultimate minimum. After World War II the new figures emerged. As Giacometti drew, changing, adding, or subtracting, each step of the drawing, painting, or sculpture was also a study for a new work. He moved from drawing to painting to sculpture without really separating them. The uneven, rough heavily worked surfaces of his paintings, sculptures, and drawings bear witness to the artist's struggle with vision.

Giacometti's work is a result of his search. He doesn't use line to decorate the surface. Nothing is placed or removed without careful consideration for the compositions as a whole. His paintings, drawings, and sculptures retain their integrity, standing unreachable and not allowing us to come into intimate contact with them.

Alberto Giacometti, Swiss, *Two Sculptures in the Studio: Bust of a Man and Standing Woman*. Pencil on paper, 21¼ × 14¾″. Hirshhorn Museum and Sculpture Garden, Smithsonian Institution. 66.2026.A-B. © 2001 Artists Rights Society (ARS), New York/ADAGP, Paris.

Composition: Space, Plane, and Shape

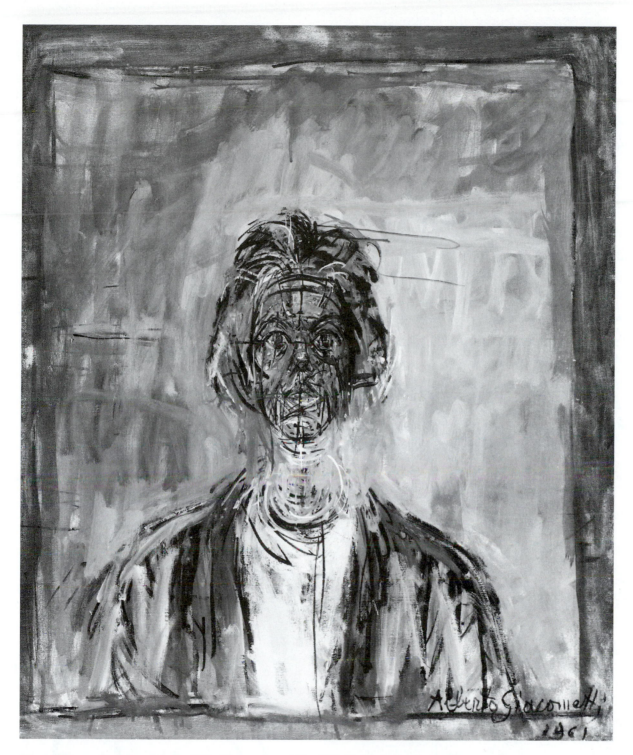

Alberto Giacometti, Swiss, *Annette,* 1961. Oil on canvas, 21⅝ × 17¾″. Hirshhorn Museum and
Sculpture Garden, Smithsonian Institution. The Joseph H. Hirshhorn Collection. 66.2023. © 2001
Artists Rights Society (ARS), New York/ADAGP, Paris.

EXERCISE IN SEEING

To develop a better understanding of an interior space, set up a still life using three objects of three different heights. Establish a spot where you can sit to draw the still life and the space of the room around it. You must hold your head in one position, keeping it level and at the same angle through the entire drawing. You can draw only what you can see from where you are standing or sitting. If you move your head, you change the perspective of the drawing and all relationships change. You may rotate between light lines that cross space and dark lines that define the edge of a chair, table, or wall in the space.

The lines in this drawing will measure the distance, the size, and the location of all the forms and objects to be located in the picture plane. These lines have nothing to do with the outline of the objects and the forms. These lines should crisscross the surface of the paper horizontally and vertically, seeking to establish the heights and widths of the objects in the still life and the background shapes of the walls, doors, windows, bookcases, chairs, and tables in the room that are in your framed view.

Start with the still life, and using a gesture line, establish the location of the forms near the center of the page. Avoid making a hard outline; use an unconnected line. The line is to be loose and can be repeated to define the forms.

Draw horizontal lines from the base of the objects to the edge of the paper and then look along those lines at what in the background intersects those lines.

Chandra Allison, pencil, student study, 1999.

Misako Mataga, charcoal, student drawing, 1999.

Composition: Space, Plane, and Shape

Use vertical lines to establish where the lines of a door or window in the background intersects these first horizontal lines.

Run a horizontal line from the top of one of the still life forms to the left or right, and mark off on the line where the forms behind the still life intersect that line.

Where is the ceiling in comparison to the location of the still life objects? Can you see a wall, a window, or a chair in the space of the room? Use loose gestural lines to establish the comparative location of other objects in relation to the still life objects by marking off their locations along the horizontal and vertical lines extending from the still life.

Draw a vertical line from the tabletop to the floor. From the bottom of the table leg draw a diagonal line to the front edge of the picture plane to establish the floor plane.

Alberto Giacometti's still life below uses a loose gestural line to find the relationship of the fruit bowl to the space it sits in. It is a careful examination of each plane in the picture plane and where one plane intersects the other planes. By using a loose, searching line he can shift things as he checks each relationship.

Once the space is mapped out, you can use a crisp, sharp line to darken and shape the still life or background objects to emphasize a focal point in the drawing.

The student drawings on the facing page use two approaches in measuring with line. There are horizontal and vertical lines within the space of the still life to establish scale, location, sizes and proportions.

The staff in the figure drawing serves to establish the location of the parts of the figure. The artist places the head and the hands first. Then he establishes the angle of the legs, arms, and the torso in relation to where they are to the staff.

Alberto Giacometti, 1901–66, *Still-Life* (1958). The Thaw Collection, The Pierpont Morgan Library, New York/Art Resource, U.S.A SO156457. © 2001 Artists Rights Society (ARS), New York/ADAGP, Paris.

Composition: Space, Plane, and Shape

David Park, 1911–60, #819 *Four in the Afternoon*, c. 1952. Collage with colored and India ink mounted on brown kraft paper. 2070 × 2310 mm. 1965.128 Gift of Dr. Oliver Frieseke. Stanford University.

POSITIVE AND NEGATIVE SPACE

The space of the picture plane translated directly to the two-dimensional space of the drawing surface is manipulated by the artist to interpret an idea or render an image from direct observation. The balance of the positive and negative spaces is crucial to that composition. Identifying and seeing the positive shapes is easier than seeing the negative shapes. Positive shapes are the "nouns" of the composition. They stand out like the faces above in David Park's drawing. Our eye is pulled around the space of the drawing from the front face to the heads on the left that overlap and recede into the picture plane. Our view is turned directly behind the large front head with heads now looking to the right. If there were no space between the white heads, they would become one large shape and it would be be very difficult to move from one to the next. It is the negative space between the heads that provides a visual gap separating the positive shapes and allowing us to see each one individually.

In David Park's drawing the negative space is black and gray. The bodies of the figures should technically be positive shapes, but in this drawing they function as inner space or negative space. It is the space between the white heads that defines them. The gray ground with palm trees in the back of the drawing serves as a negative shape in the

drawing. The floor plane on the left in a black and white checkerboard serves as a negative space under the white figures. Park's drawing is so well balanced between the black and white areas that it borders on being an ambiguous space where your eye becomes unsure of what is foreground and what is background.

David Parks manipulated the scale of this drawing beautifully. The use of overlapping shapes creates a sense of space. In addition, the large head in the foreground comes forward moving away from the group, which makes us think there is more space between the two than he has drawn. The sense of space in the drawing results from the reduced size of each overlapping shape. He has flattened the images to the picture plane and at the same time alluded to there being a deep space in the drawing.

In the student drawing of the cow skull it is the negative spaces of the eyes in black ink that allows us to perceive the three-dimensional depth of the skull. Fabric on the left in the background serves as a negative space between the skull and the edge of the picture plane. The boot behind the cow skull is rendered in dark values that make this positive shape seem more like a negative shape.

Jennifer Borg's drawing above is of negative space. The space in between the table legs and chair rungs is drawn, leaving the positive area of the chairs and stools as the white of the paper. The negative space becomes negative shapes.

At first glance the drawing seems flat until you look more closely at the diagonal top surfaces of the chairs. This diagonal turns our view back into the picture plane, and we feel a sense of space that is a shallow space.

Jennifer Borg, Conté, negative space drawing, student drawing, 1999.

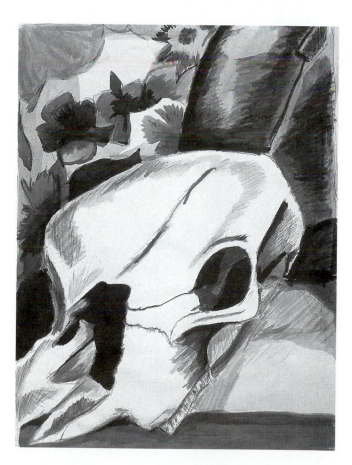

Andrea Galluzzo, ink wash, student drawing, 1999.

Composition: Space, Plane, and Shape

DRAWING EXERCISE

The subject of this drawing is a stack of chairs and stools in a tall pile. Frame the picture plane drawing a one-inch border on your paper. This outline clearly identifies the beginning and the end of the shapes and the space inside the picture plane.

Hold a piece of black Conté between your thumb, forefinger, and middle finger, start on the border line at the bottom and draw the space between the legs of the table. Draw along the outside contour of the leg, across a horizontal and down the opposite leg. Darken the area of the negative shape you drew to keep track of your location in the drawing. Resist the temptation to draw the positive outline of any object and then fill in the negative space with black. That defeats the purpose.

Conté can be used on its side to create the shape as well as on the end to outline the space. Follow the structure along horizontal, diagonal, or vertical lines.

The drawing may not be completely accurate—you may miss a shape or get off your line, that is to be expected. Continue adding negative shapes until you have filled the paper.

This exercise increases your awareness of negative space. It is important not to outline around an entire positive space. Drawing negative space is a completely different experience.

In Josh Turner's Conté still life on the left, he has balanced the positive and negative space using a large negative space for contrast.

Above, Michael Taddesse, Conté negative space drawing; below, Josh Turner, black and white Conté on gray canson paper, student drawings, 1999.

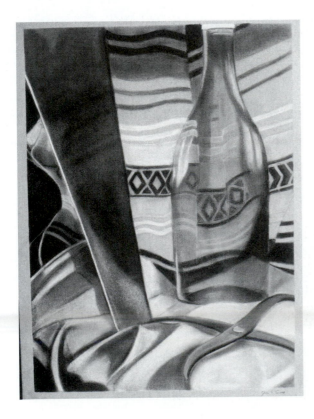

162

Composition: Space, Plane, and Shape

FIGURE-GROUND RELATIONSHIP

In still life positive and negative space must be dealt with equally. Both are important in achieving unity in the composition. Value and value changes contribute not only to the quality of the light in the space but directly in developing a sense of space.

Beginning students tend to concentrate on the object more than on where it should be placed in the picture plane. The relationship of the object to the space it sits in is referred to as a figure-ground relationship. The terms figure, ground are also referred to a figure, field. Figure-ground is one of several relationships—positive and negative space, figure and field, foreground and background.

The space of the drawing below is flat, balanced between the black ground and white figures. We recognize the shapes, but without modeling, a value change from light to dark on the forms, they technically are flat in the drawing. Rex Slinkard was an American Modernist from Los Angeles before World War I. His Symbolist style expressed a romantic union with nature as illusive, dreamlike forms.

Alisa Baker, charcoal pencil, ink and wash, student drawing, 1999.

Rex Slinkard, 1911–60, *Ferry Horses.* Pen and wash, 153 × 211 cm. Stanford University.

Composition: Space, Plane, and Shape

BALANCING LIGHT AND DARK

When the balance of light and dark is equal, the space of the drawing is ambiguous, creating an interchangeable foreground and background. The drawing by Rex Slinkard on the previous page is not ambiguous, it is a balance of positive and negative spaces that do not overlap, and have no gray values to shift the view.

The arrangement of the values in Joseph Davis's drawing rotates the eye rhythmically from black, to white to gray. In some places the white comes forward and the darks recede. In other places the darks seem to push forward equally with the white areas.

Joseph Davis, charcoal value study, student drawing, 1999.

POSITIVE AND NEGATIVE ABSTRACT SHAPES

Collage, an art form that mixes drawing with other media and objects is one of the additions to the category of drawing from modernism. Pablo Picasso and Georges Braque led the way in establishing collage as an art form in the early 1900s. This collage by Jean Arp is very refined in its delicate washes and gently tapered cutouts. Arp composed the collage according to the laws of chance.

Working "according to the laws of chance" meant that Arp did not design or directly lay out the composition. The black shapes were placed on the ground from the right side, moving off the top of the picture and plane and then down and off the left side by a process Arp designed in which the forms found their own location. This placement, even if by chance, moves the eye across the the surface. You are uncertain as to the point of view. Are you looking from above down on shapes floating on a surface far way? Or are you looking directly at polywogs swimming by in a glass aquarium?

Jean Arp was attracted to biomorphic forms, organic forms, such as leaves,

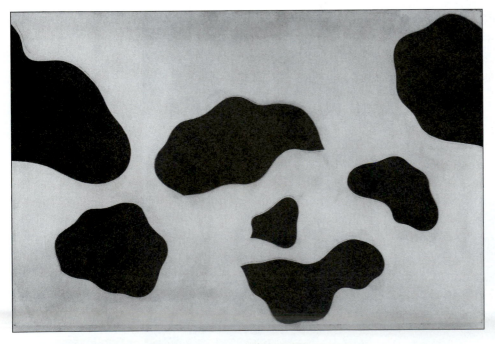

Jean Arp, 1886–1966, *In Memory of 1929: Collage Arranged According to the Laws of Chance* 1955. Collage with pencil and pinkish white gouache on blue-gray laid paper with black cutouts, 312 × 455 mm. Signed verso in pencil: Arp. 1984.502 Bequest of Dr. and Mrs. Harold C. Torbert. Stanford University. © 2001 Artists Rights Society (ARS), New York/VG Bild-Kunst, Bonn.

Composition: Space, Plane, and Shape

trees, roots, and torsos. For this collage, the shapes were trimmed and cut into rounded shapes of paper. These flat black shapes sit on a ground first worked with both pencil lines and washes of varying intensity, some of which appear as shadows along the rocklike black paper cutouts. The black shapes are like rocks rising above the tide pools of uneven pale pinkish white gouache.

This drawing calls reality into question. It challenges your ability to read it. The reason Arp arranged the pieces automatically, without will, according to the laws of chance, was that he felt he was creating life. By following the laws of chance, he was following the same laws from which all life arises.

AMBIGUOUS SPACE

Space that has no strictly defined figure-ground relationship in which one space is background and one space is foreground is ambiguous. When the figure and ground move back and forth between each other, it is difficult to decide what is positive space and what is negative space. It is ambiguous space.

Willem de Kooning virtually invented ambiguous space in drawing. In his drawing below the lines glide across the surface expanding and contracting without defining any forms but glancing off the edges of the objects. There are no specific contours and no closure. The only form you can place in the space of the drawing is the window, in the upper right-hand corner. The window orients the spectator to an interior space by indicating there is a back wall with a window. Since you cannot traverse this, the space from the foreground to the illusionistic background, the drawing is kept ambiguous. The way the line moves constantly changing prevents ordering of the forms. De Kooning used a brush called a liner to make this drawing. A liner has long, thin hairs, and can carry great amounts of ink which permit

Willem de Kooning, b. 1904, *Composition-Attic Series*, 1950–51. Ink, 75 × 90 cm. Virginia Wright Fund. Washington Art Consortium: Henry Art Gallery, University of Washington, Seattle; Museum of Art, Washington State University, Pullman; Northwest Museum of Arts and Culture, Spokane; Seattle Art Museum: Tacoma Art Museum; Western Gallery, Western Washington University, Bellingham; Whatcom Museum of History and Art, Bellingham. 76.1 VWF. Photo credit: Paul Brower. © 2001 Willem de Kooning Revocable Trust/Artists Rights Society (ARS), New York.

Composition: Space, Plane, and Shape

Robert Rauschenberg, b. 1925. *Untitled,* 1965. Combine drawing, 39.4 × 57.8 cm. 76.10 VWF. The Virginia Wright Fund. Washington Consortium: Henry Art Gallery, University of Washington, Seattle; Museum of Art, Washington State University, Pullman; Northwest Museum of Arts and Culture, Spokane; Seattle Art Museum: Tacoma Art Museum; Western Gallery, Western Washington University, Bellingham; Whatcom Museum of History and Art, Bellingham. Photo credit: Paul Brower.

long, continuous single strokes. The brush can create thick lines as well. His lines allude to planes in the space, but without closure they remain undefined. Areas of the drawing push forward and are pulled back into the flat ground at the same time. Without a fixed figure ground relationship the drawing is ambiguous.

AMBIGUOUS RELATIONSHIPS

If the mark is the figure, and space between them is the ground, Robert Rauschenberg's drawing above has redefined our previous understanding of positive and negative space as well as figure-ground relationships. Gravity seems to be absent. He has used rhythm and repetition as ordering devices. For example, the black leg forms at the top of the page are repeated by upside-down walking legs to the right. Below the V from a piece of architecture echoes the legs,

and the ram's horns farther down repeat the V shapes. The arrow on the bottle cap points up while the column below it points down. The fence in the middle is mirrored in the columns of the building on the left.

The most confusing rubbing is the one farthest to the right. At first glance it is black, white, and gray forms. A closer look reveals it is a man and a woman walking. They have been placed sideways. The amounts of black, white, and gray are so equal with the open sides that the eye flips back and forth, unable at first to distinguish the figure from the ground.

Rauschenberg has redefined not only space but also drawing. None of the images were drawn by him; they were found and transferred by him. Rauschenberg's rubbings are taken from newsprint soaked with lighter fluid. When the image is placed face down on paper and then rubbed across the back, it transfers off the newsprint onto the paper, but it reverses the

Composition: Space, Plane, and Shape

Ron Graff, *Box, Steamer, and Shell*. Charcoal, 24 × 26", 2001. Courtesy of the artist.

images and they are backwards in the drawing. Rauschenberg's drawing space does not imitate real space. Instead, it is a space in which these real-world fragments have fallen into a loose organization. The logic of the drawing escapes us, but although it refuses to reveal its meaning, it reflects his will, intention, memory, attention, and associations.

The absence of outline and hard edges in Ron Graff's drawing alters your perception of the space in the drawing. The close values and predominance of gray makes it difficult to calculate the depth of the space, so that it feels as if a haze lies between you and the objects. This atmospheric fog diffuses the light, blurring our ability to see clearly into this space, even making it impossible to decide what kind of drapery lies under the steamer and the shell.

The space is fascinating, proving still life remains challenging to our perception. Drawing really isn't about what you draw, but how you draw. The level of quality in a drawing is directly related to how well you understand the characteristics of the medium, and how well you can manipulate them in a drawing.

Ron Graff never accepts his first attempt at a drawing. He draws, and wipes it off, draws again, wipes it all off and so on for hours. He often wipes all the work he does in one day away because it isn't what he wants.

The amount of time you are willing to spend on a drawing along with the number of changes you are prepared to make directly controls the quality of the drawing you will be able to produce.

Composition: Space, Plane, and Shape

COMPOSING
IN THE PICTURE PLANE
AND THE EDGE

The quality of a drawing requires a knowledge of the media, manipulating charcoal, pencil, Conté, pen, and ink. The organization of the space in the picture plane determines how the eye will move around the drawing. This organization is a composition. Line, shape, value, texture, pattern, and color are the formal elements which are arranged according to the principles of design, balance, harmony, rhythm, repetition, scale changes, and spatial focus. When the elements of art are used to render the intent and vision of the artist, the composition has full meaning and a sense of unity.

Planning a drawing requires thinking about the foreground, middle ground, and background. A thumbnail sketch is often helpful in working out the spatial arrangements. Jacques Villon, whose real name was Gaston Duchamp, was Marcel's brother. Gaston changed his name to Jacques Villon because his father disapproved of the humorous and racy illustrations he drew for Parisian weeklies.

His sketch on the opposite page shows Marcel Duchamp and his wife playing chess. Marcel sits in the foreground, his wife's hat sits on a chair in the middle, and his wife is sitting in the back of the picture behind the table. Notice how the legs of the chair mimic the posture of Marcel. The arrangement of line in the drawing moves our eye easily from the front to the back. You sense the space.

Lili Xu's drawing of a walnut is the opposite the space is very shallow and there is no attempt to create a sense of space. The focus was on rendering the walnut and creating a volume, not a deep space. Even the overlapping of the small walnut across the larger one behind it won't move your eye back into the picture plane. The walnut is beautifully rendered and everything focused in the foreground.

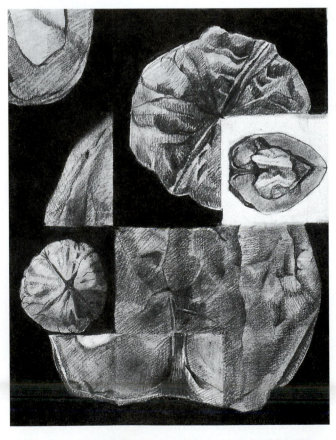

Lili Xu, walnut composition, pencil and charcoal, student drawing, 1999.

Composition: Space, Plane, and Shape

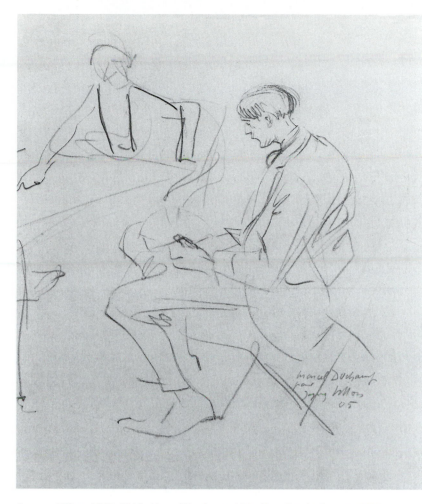

Jacques Villon, 1875–1963, *Marcel Duchamp 1905*. Pencil on buff wove paper. 265 × 224 mm. 1976.94 Mortimer C. Leventritt Fund. Stanford University.

mately one inch in from the edge, framing the picture plane.

Some artists use a viewfinder to focus the composition. The viewfinder is very similar to a camera. Holding the viewfinder at arm's length, close one eye, framing the subject. This will help you understand what will fit in a drawing from a still life or a landscape. Everything you see is too much information for one drawing, the paper has limits. Selecting a section of the still life or a part of the landscape is the first step in composition.

Unlike the camera, the artist can move things in and out of the composition, so a tree may be replaced by one the artist likes better. In a still life one object may be exchanged for another. This is known as *artistic license.*

A composition may be open or closed. An open composition extends beyond the boundaries of the picture plan. Open is free or expansive, unrestrained. Closed suggests a controlled composition in which the images are contained. We look into the picture plane and we look around at everything in it, we stay focused there.

SELECTING THE FORMAT

The composition begins with the size and shape of the paper. The edges of the paper are the first four lines of the drawing. All the lines, shapes, and other elements function in relation to these first four edges and then to each other. The rectangle is the most commonly used format, and it can be placed vertically or horizontally.

In the beginning students take the paper for granted. They look at the subject and begin drawing without framing what they will draw. This often results in things being too small in the picture plane, which leaves large areas of blank paper around the forms. Students may also draw too large, running the forms over the edge of the paper losing the balance in the drawing.

To avoid either of these problems, start by drawing a border around the paper approxi-

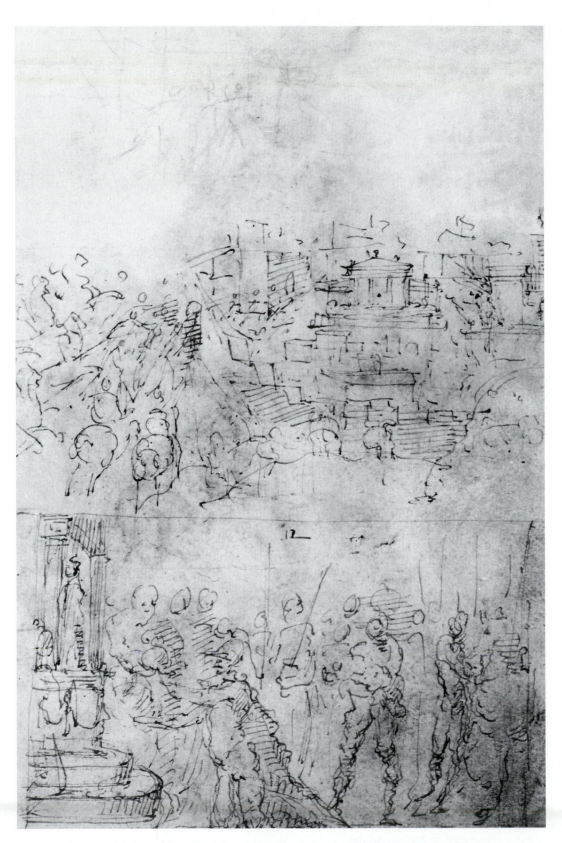

Domenico Beccafumi, Italian 16th c., *Page from a sketchbook*. Pen and light brown ink (some figures redrawn in dark brown ink). The Metropolitan Museum of Art, The Robert Lehman Collection, 1975. 1975.1.272 v.

Composition: Space, Plane, and Shape

PLACEMENT

The placement of objects in the picture plane has no hard-and-fast rules. It is up to the artist depending on the purpose of the drawing. The picture plane may serve to create the illusion of three dimensions or it can be treated as a flat surface. The tradition from the Renaissance forward was to use the picture plane like a window through which you look. The drawing on the left by Beccafumi Domenico is a pen and ink sketch in which he was planning the space for a future painting. This type of drawing calculates the relationships and scale of the figures in a future work. The top of the sketch shows one idea and the bottom is a second idea. Planning the composition in a thumbnail sketch can help you avoid the pitfalls of unbalanced compositions or visually lacking drawings.

DRAWING EXERCISE

Take a sheet of white drawing paper 18 x 24" and rip it into different sizes and shapes. Set up a still life for a subject. Select one piece of ripped paper and make a drawing from the still life on it. Consciously calculate what part of your still life might fit best on this shaped paper. Not having the traditional rectangle will force you to consider the space of the picture plane in relationship to your subject.

Consider the placement of the objects in the picture plane. Look at where the objects are sitting (in the foreground, middle ground or background).

You may want to lightly sketch your first thoughts in HB pencil, using light pressure on the pencil. You can rub these first lines into the paper and draw easily over them. Take a few pieces of ripped paper outside and draw from the landscape. Utilize the shape of the paper.

SPACE OF THE PICTURE PLANE

Each of the four drawings on these two facing pages defines space differently.

Megan Brown's drawing to the left has eliminated the middle ground. The drawing has a very shallow space as a result of no vertical value change on the background pattern. The fabric reads as a flat design behind the can and bowl which sits directly behind them.

Chandra's drawing on the facing page top right has a foreground, middle ground, and background. There are vertical light changes from top to bottom. There are horizontal light changes on the objects. This drawing reflects more space.

Matt's drawing below Chandra's is a tighter view of the same still life Chandra drew. This drawing is focused on one object in the foreground. It borders on becoming ambiguous the way the forms are cropped and the way the light rotates through the picture plane. It is the large light gray negative space on the left that breaks the pattern and stops the sense of ambiguity. Still it is an illusive space because of the way the values are organized and the shapes are cropped.

Joseph Davis's composition is a high contrast drawing. He has constructed hard edge shadows and definite divisions of light. The space of the foreground, middle ground, and background are controlled by where value and texture, are placed. The size you choose to make the objects and the value you assign them will dictate how the viewer sees the space of the drawing.

The concerns of the picture plane in drawing are overwhelming at first. We must see, interpret, translate the space, adapt the information to a flat paper, and develop the image with a drawing media, none of which are natural and all of which are learned. This awareness or consciousness comes with practice.

Above, Megan Brown, ink wash; below, Joseph Davis, pencil, student drawings, 1999.

Composition: Space, Plane, and Shape

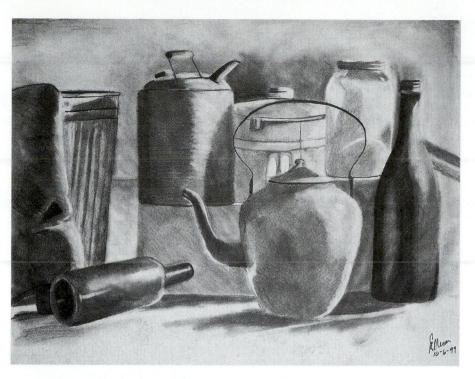

Chandra Allison, pencil, student drawing, 1999.

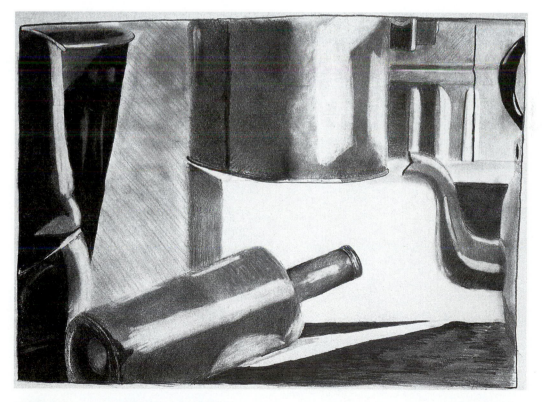

Matt McDonal, pencil, student drawing, 1999.

Composition: Space, Plane, and Shape

BALANCE

When a drawing is in balance, the eye moves effortlessly through the composition or it can be challenged by the drawing while it continues to look at a chaotic structure. Balance falls into two categories, symmetrical and asymmetrical.

Symmetrical balance is achieved by dividing the picture plane in half either horizontally or vertically. The visual elements are then identical on either side of the dividing line. Asymmetrical compositions have more visual weight on one side or the other.

An example of asymmetry is Watteau's drawing on the opposite page. Watteau has placed the figure on one side of the picture plane in *Study of a Nude Man*. The figure stands on the right of the picture plane. The paper has been ripped through the figure's left arm. It is possible that in the first draft the arm was off the paper outside the picture plane. This may have felt compositionally unbalanced to Watteau. To change the balance he added another piece of paper on the right to draw the arm in completely. Revision is a tool of drawing that allows the artist to change the balance of a drawing. Artists constantly rub out parts and move them over, leaving the traces of the first lines visible when the second lines are added.

A drawing must integrate line, value, texture, shape, placement, and amounts of each element into a balance, with the resulting harmony moving the eye through the drawing in and out of significant relationships, avoiding static compositions.

DRAWING EXERCISE: USING BALANCE

Cup or rip one piece of 18 × 24" white drawing paper into fourths. Set an apple on a table. Take each piece of paper and use a ruler to mark the halfway point on each side of the paper (each piece is 9 × 12" so make a mark at 6" and 4.5").

Divide each side into quarters by marking the measurement on the edge. The paper is divided with a grid to help you size objects.

On the first paper draw the contour of the apple, filling one-half of the paper horizontally and three-fourths of the paper vertically.

Take a 6B Pencil and hatch the entire shape with a dark value.

On the second paper draw two apples the same size and value, side by side in the middle.

On the third paper draw one apple in the bottom right-hand corner and one apple in the top left-hand corner. Darken one in value. (What size did you choose to make the apples?)

On the fourth paper draw two apples on the left side of the paper approximately 3 × 3" each. Darken the value of each outline.

Hang up all five drawings, and consider what happens to the space of the picture plane depending on what is in it and where it is.

Composition: Space, Plane, and Shape

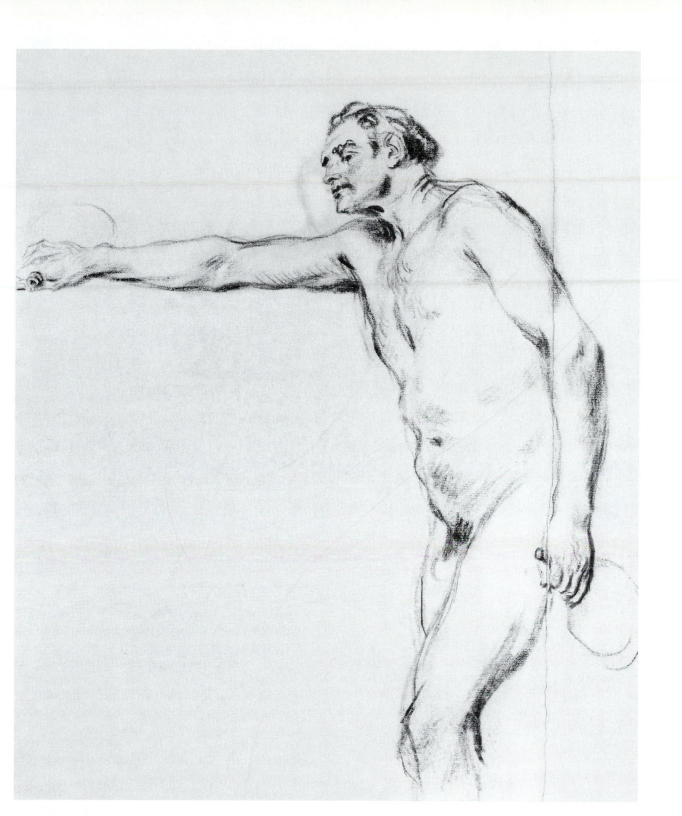

Jean-Antoine Watteau, 1684–1721, *Study of a Nude Man Holding Two Bottles:* Made for figure of *Satyr filling Bacchus Cup in Autumn.* One of four panels (four seasons), commissioned for dining room in Pierre Crozat's "hotel" on rue de Richelieu. Black, red, and white chalk, lined. H. 27.2, W. 22.6 cm. The Metropolitan Museum of Art, Bequest of Walter C. Baker, 1971. 1972.118.238.

Composition: Space, Plane, and Shape

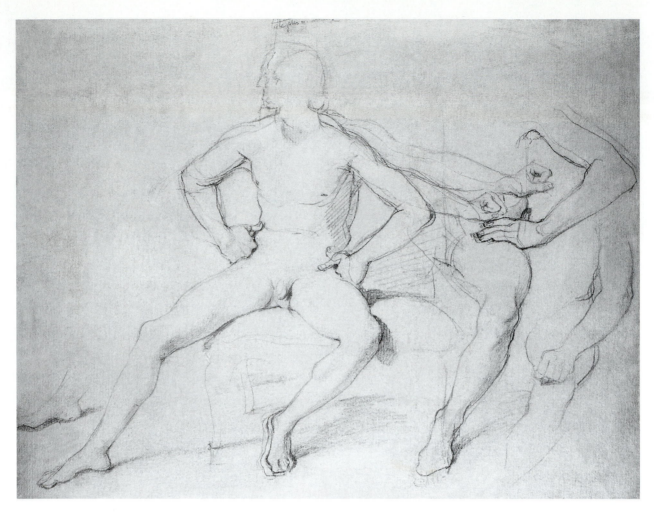

Jean Auguste Dominique Ingres, 1780–1867. *Study of a Seated Nude Male.* Black chalk, 29.2 × 37.9 cm. The Metropolitan Museum of Art, Rogers Fund, 1961. 61.128.

REVISING A DRAWING

Drawings can be planned out very carefully, but you can never anticipate everything. When a form looks wrong in the space, you must change it. Erasing is unproductive. Artists tend to leave the first lines and draw from them. With the first lines in place, it is easier to make changes and move things. You can see the space where the forms should move and that makes repositioning and moving them easier.

Ingres in the drawing above is unsure about the location and position of the model's left arm and leg. To find the correct placement he moves the leg to where the knee is much more forward;

the hand then sits with the fingers on the thigh. Changes in a drawing should be made during the process or at the end as you analyze your drawing. Drawing reveals visual thinking; it records and then remains a record of the artist's changing thoughts. One of the great benefits of drawing is how quickly you can change spaces with the media. Even ink, if the first layers are diluted with water, can be covered with darker lines to change the position of the objects in the drawing.

Nothing should be too precious to change. Your abilities to draw will improve, you will see forms differently, and you will improve your sense of proportion with practice.

Composition: Space, Plane, and Shape

EVALUATING THE COMPOSITION

In Megan Brown's drawing #1 on the right she framed the space with four border lines and mapped out the shapes first with a line drawing. Overlapping ink washes created the values in the picture. A quick review revealed the skull didn't fit in the picture plane, the space felt crowded and unbalanced. In the bottom drawing #2, she corrected these things by first orienting the paper as a horizontal format instead of a vertical one and increasing the darker values to strengthen the drawing considerably. In addition she shortened the foreground leaving a very small plane from the objects to the front of the picture plane. Had she placed a dark gray wash on the left under the cowboy boot and over the bottom half of the flower patterned drape she would have increased the visual depth and created a sense of more space in the drawing.

The lack of dark values in Charlie Green's drawing on the lower right restricts our perception of the space. It reads as a shallow space. Imagine the difference had he darkened the space under the chair or behind the drape.

After you can render objects, compose a still life and you have control of some of the concepts of drawing you must critique your own drawings in terms of what you know about spatial relationships to make sure you have put everything into the drawing it needs to be read by the spectator. Some things you can directly render from observation but some manipulations of a drawing are done to increase the quality of the drawing from what you know of concepts like chiaroscuro and perspective.

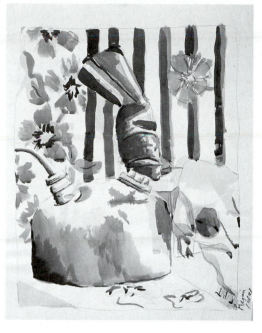

1. Megan Brown, ink, student drawing, 1999.

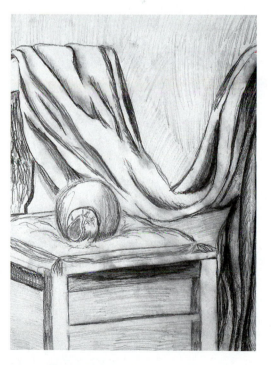

Above, Charles Greene, chair, charcoal pencil, student drawing, 1999.

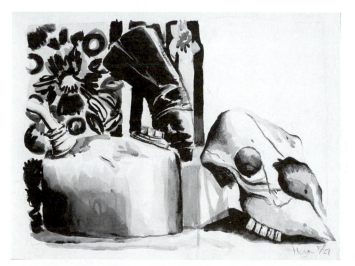

2. Megan Brown, ink, student drawing, 1999.

Composition: Space, Plane, and Shape

ORGANIZING THE COMPOSITION WITH THE GRID

The grid is an organizing tool. It has been used to locate and organize figures and forms since the Renaissance. The grid provides a process and measuring system in which the proportions of the figure can be correctly determined.

The paper is divided into equal increments that then visually and physically provide an underlying order for the drawing. This geometric division can be used to transfer and enlarge a drawing or reduce it.

The grid works as a tool for David to proportion the figure and balance it in the space. The figure is rendered in a seamless manner. You are unaware of one part fitting into another. The drapery is beautifully developed while the hands are yet unrealized. Even in this formative study stage the background has been darkened to set the ground back from the figure or push the figure forward. David manipulates the values of light moving the figure in and out of the space.

He employs the four qualities of light beginning with light falling on the light surface of the drape for the lightest part in the drawing (the light on light). In the shadows of the drape he uses dark on light with dark on dark under the arm in the robe.

The darkest areas occur in the grooves of the robe and on top of the box Crito is sitting on. The balance and rotation from light to dark is crucial in developing a volumetric drapery.

The grid provides guidance with proportion. In figure drawing the head is used as the unit of measurement. A standing figure is between seven and a half and eight heads tall. Sitting down this figure measures only approximately six heads tall.

Composition: Space, Plane, and Shape

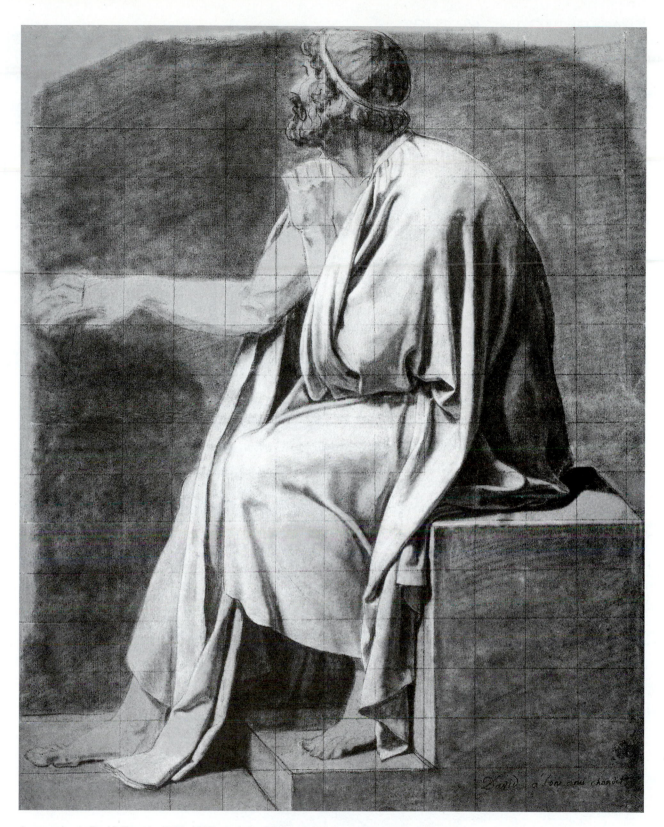

Jacques Louis David, French, 1748–1825, study for the figure of Crito, in *The Death of Socrates,*
painting in the Metropolitan Museum of Art (31.45). Executed in ca. 1787. Black chalk, gray wash,
heightened with white on brownish paper, squared off in black chalk. H. 31 1/16, W. 16 5/16". The
Metropolitan Museum of Art, Rogers Fund. 1961. 61.161.1.

Composition: Space, Plane, and Shape

FLATTENING THE PICTURE PLANE WITH THE GRID

Modern and contemporary artists have used the grid to flatten the picture plane instead of proportioning it. John Whitaker's drawing on the right uses the grid to divide the picture plane into twelve small boxes. Each box is like a small window through which you look into the space. Each drawing has something to do with a walnut but they have no other noticeable connection to each other. The lines for the grid are of uneven thickness and shifted out of a straight vertical and horizontal alignment. This shifts the boxes, giving the appearance that each unit is actually unattached to the others, so you could be looking at a stack of building blocks.

Mike Vandeberghe's grid presents three rows of walnuts that have been activated by the change of value around each one. The background gradations, moving from light to dark or dark to light, seem like auras.

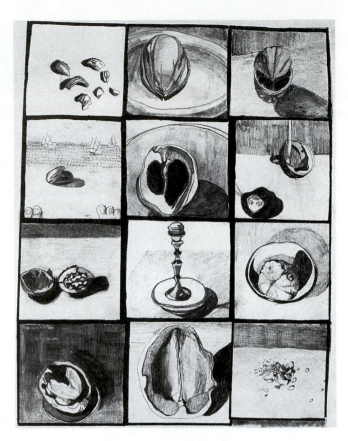

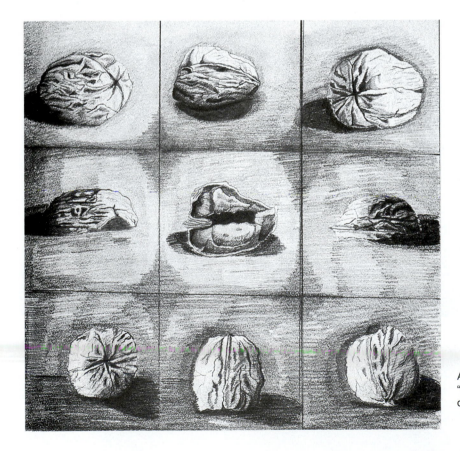

Above, John Whitaker, and left, Mike Vandeberghe, "Using the Grid" to describe a walnut, student drawings, 1999.

Composition: Space, Plane, and Shape

Adolph Gottlieb, b. 1903. *Structure,* 1956. Gouache 52 × 73 cm. The Washington Art Consortium
Collection. Virginia Wright Fund. Washington Art Consortium: Henry Art Gallery, University of
Washington, Seattle; Museum of Art, Washington State University, Pullman; Northwest Museum of
Arts and Culture, Spokane; Seattle Art Museum: Tacoma Art Museum; Western Gallery, Western
Washington University, Bellingham; Whatcom Museum of History and Art, Bellingham. 76.1 VWF.
Photo credit: Paul Brower. 75.8 VWF.

Adolf Gottlieb's drawing above is flat to the
picture plane. There is no background or middle
ground. There is only the drawing in the front of
the picture plane, with parts of the drawing
pushing out into the viewer's space. Look
closely; there are black calligraphic marks in the
center on top of what seems to be a black outline
of white shapes. Once you see the black marks,
the front outline is a dark gray by comparison.

The borders of the drawing are somewhere
beyond the edges of the paper. We know this
because the lines lead our eyes off the paper. The
drawing is not contained by size of the paper or
the end of the paper.

DRAWING EXERCISE

Select one object as your subject (a walnut,
a tool, a paper clip). Divide a sheet of paper
18 × 24" into equal grid sections (use all or
part of the paper). Compose a drawing
considering value, texture, scale, line,
placement, and positive and negative space.
You may use any media or mix media. You
may shrink or expand the grid. You may
shrink or expand the subject. Consider the
edge, frame, and picture plane. Try to create
a composition that is balanced and feels
unified in all its elements whether it is
symmetrical or asymmetrical.

Composition: Space, Plane, and Shape

PROFILE OF AN ARTIST: RICHARD DIEBENKORN

Richard Diebenkorn was born in Portland, Oregon, in 1922. His father was a sales executive for Dohrmann Hotel Supplies. The name Diebenkorn is said to have originated in Sweden. It means "grain stacked in the shape of a house." The family moved from Portland to San Francisco, where Richard grew up. His first drawing surface was a shirt cardboard, a slick, shiny-surfaced paper that his father brought home. As a result, later he preferred to draw on gloss-coated paper, which was seldom used for artist's drawings.

He began his art career under the influence of the French moderns (Cézanne, Matisse, and Picasso) and the New York School, to be named later the Abstract Expressionists. His first work was abstract until about 1955, when he suddenly shifted to representational work. This change from the abstract style of the avant garde and his refusal to leave California and live in New York caused him to be ignored for many years by art writers and critics as well as the galleries and museums. To be a West Coast artist was to be forgotten by the art world.

Diebenkorn changed from abstraction to realism because abstraction no longer challenged him. He felt he was making paintings the way he thought they should look, instead of from an internal reality. Realism provided a visual challenge for him where he could do more problem solving. He wanted his ideas to be altered by nature, changed by what he saw in the world. Depicting subject matter provided a necessary resistance to his imagination, which had to confront it. For him drawing was essentially an exercise in seeing.

There is a tension beneath the calm in his work. He composes his drawing by ordering the shapes. Forms are overlapped by other forms to weld everything together. Each shape in the drawing is given consideration. Value is assigned and determined by the location of the shape in the

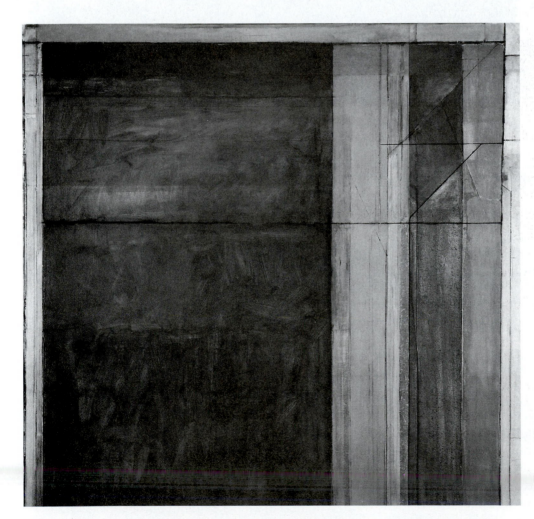

Richard Diebenkorn, American, 1922–93, b. Portland, OR, *Ocean Park #111*, 1978. Oil and charcoal on canvas, 93⅛ × 93¼″. Hirshhorn Museum and Sculpture Garden, Smithsonian Institution. Museum Purchase, 1979. HMSG 79.235.

Composition: Space, Plane, and Shape

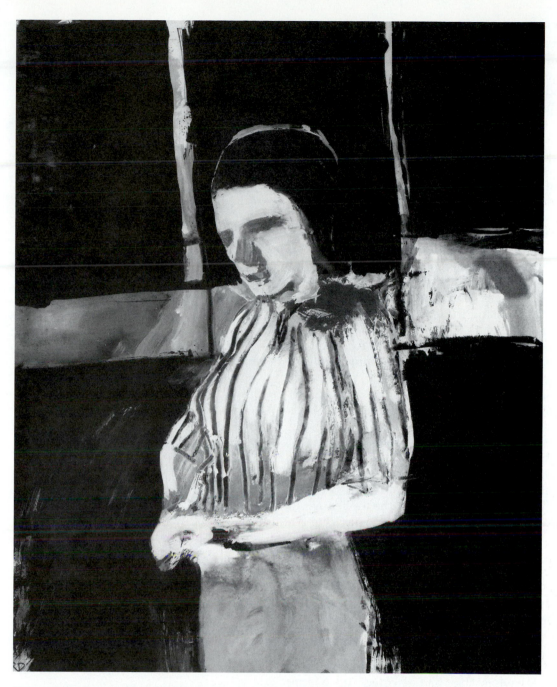

Richard Diebenkorn, American, 1922–93, *Woman by Window,* 1957. Gouache on paper. 17 × 13⅞".
(43.1 × 35.3 cm.). Hirshhorn Museum and Sculpture Garden, Smithsonian Institution. Gift of Joseph H.
Hirshhorn, 1966. HMSG 66.1369.

ground. Most of his figures seem self-absorbed. They don't look at you—they look to the
side or down.

 There is a sense of multiplicity in the layers of his work. In the figure drawing
above, we enter the space with the gleaming white of her blouse. Your eye is
immediately pulled to the dark back wall, then out the window and pulled back to her
skirt. The balance of gray, black and white pushes you through the entire composition.
He has balanced the drawing with light and dark. The scale of the drawing is
established by having the figure occupy over three-quarters of the vertical in the picture
plane. She is drawn over the window frames behind her to indicate space. Without
modeling the space remains flat or shallow.

Composition: Space, Plane, and Shape

Diebenkorn's drawings record actual observations, quietly but intensely, without sentimentality. They embody discovery rather than arbitrary construction. His economy of pen, pencil, and monochrome washes suggests the shape and character of matter. The precise use of the visual effects, both perspective and chiaroscuro, work to achieve a complexity of mood.

"Chiaroscuro" is a word coined in the Renaissance that describes light into dark or value change. When we refer to perspective, we mean the process of translating three-dimensional space into two-dimensional space.

The placement of the figure is dictated by the rules of perspective, and the use of value changes moves the viewer's eyes through the drawn space as well as creating a sense of volume. Diebenkorn is a master of rendering spatial relationships using the artist's tools, chiaroscuro and perspective.

He has reworked this figure drawing on the right, starting, then changing his mind, only to rub the first charcoal lines out and redraw the figure in the chair. Beginners should take heart and feel no sense of failure when the first lines don't accurately describe the form. Redrawing instead of starting over is the way you learn and improve.

Diebenkorn's drawings are the record of movement in time, a network of recorded movements, and the direct record of the movement of his hand. He doesn't conceal that his drawing is a result of a trial and error. He leaves the traces that allow us to follow his thought process. Drawing from external sources provided Diebenkorn with a knowledge that he converted to internal relationships that, once processed, informed his painting.

Diebenkorn worked his entire career from a moral imperative of achieving "rightness" in his work—something impossible to define but recognizable when he had created it. Milton Resnick once summed this feeling of knowing when your work is complete as, "It feels like you feel when you come home." He was a serious artist with a deeply rooted sense of ethics about his art.

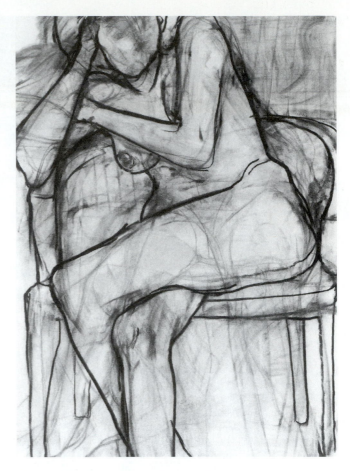

Richard Diebenkorn, *Seated Nude*, 1966. Charcoal on paper, 33 × 23½ (83.8 × 59.7). San Francisco Museum of Modern Art; gift of the Diebenkorn family and purchased through a gift of Leanne B. Roberts, Thomas W. Wiesel, and the Nmuchin Foundation.

Composition: Space, Plane, and Shape

PLANE

Volume is defined by planes. Planes are easy to identify in geometric shapes. The side of a box is a plane as well as the top and bottom of the box.

It is more difficult to identify the planes of the cylinders. The drawing on the bottom left by Deborah Finch is a planar division of the volume of the cylinders. Since light can not turn around a form, and only fall in one direction, understanding where the planes change on form will help you determine where to change the value. By modeling forms in light and dark values we increase the sense of volume on the two dimensional surface of the paper.

Feeling the form will help. Hold a bottle in your hand and place your palm on the surface. You are sitting on a plane. Turn your hand to cover the area next to the first area you touched, and when it rests you have moved to the next plane.

Goya has used value differently. The lights and darks in his drawing don't reflect light falling on form. He has applied light and dark to balance his composition spatially. It is more of a rotation by plane from light to dark. This drawing of revenge is about the death of Constable Lampinos for his persecution of students and women of the town. Many of Goya's drawing reflect the social conditions and inequalities in Spain during his lifetime.

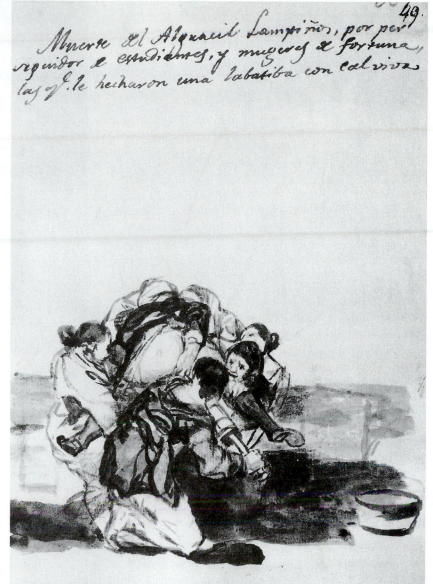

Francisco Jose de Goya y Lucientes 1746–1828, *Revenge upon a Constable.* Wash drawing in sepia. H. 8¹/₁₆, W. 5¹¹/₁₆″. The Metropolitan Museum of Art, Harris Brisbane Dick Fund, 1935. 35.103.49.

Deborah Finch, planar analysis, pencil, student drawing, 1999.

Matt McDonal, pencil, planar analysis, student drawing, 1999.

Sabrina Benson, charcoal, value by plane, student drawing, 1999.

DRAWING EXERCISE: PLANAR ANALYSIS

Color on objects can be confusing. To avoid this confusion, select four or five objects—vases, pitchers, small boxes—and spray them completely white. When they are dry, arrange them on a table.

Examine each one first by drawing each object in a precise contour. Then divide the surface of each object by plane. Note that bottles have a horizontal plane at the bottom of the neck. This area attaches to the bottom of the cylinder to the top. Plane lines echo the outside contour line. Repeat the direction of the outside contour line to define the planes.

Determine the direction of the light and assign values from light to dark on each form and the ground. When you change planes, you need to change value also.

Work to have a vertical change in light and a horizontal light change on both the objects, the background, and the foreground.

Lili Xu, pencil, value by plane, student drawing, 1999.

CROSSHATCHING COMPOSITIONS

Crosshatching must be done with a very sharp pencil or charcoal pencil. The value is determined by the number of hatching layers applied. To create value, the hatching lines are placed side by side with the ends feathering into the hatching lines on the next plane. The location of the plane determines when you turn the strokes in the hatching and when you should change the pressure on the stroke. The more pressure, the darker the hatching line will be. Hatching lines may be applied diagonally, vertically, and horizontally in one layer or over each other. Crosshatching has a different look in a composition than the smooth surface achieved with charcoal modeling.

DRAWING EXERCISE

Use white objects with the black cylinders, in a still life. Direct a light on the still life, and study the way light falls on the forms by plane. Interpret the values for each plane using crosshatching. Use an HB or 3B pencil for the white forms, dark forms should be drawn with 3B, 4B, and 6B pencils. The term "relative values" can be understood by looking at the drawing above. The black bottles have a light side but that light is not as light as the light side of the white form. The light side of the black bottle must be rendered relatively lighter than the dark side.

Composition: Space, Plane, and Shape

SHAPE

Composition is structured by the relationship of the shapes in the picture plane, then by repetition, and by placement of the volumes and values. Shape in the pure sense is a flat form, a contour or outline without volume and recognizable planes. However, overlapping shapes may well be volumetric. By overlapping shapes you create space. The drawing on the left is composed of contour shapes. We recognize the shapes and as a result we believe there is space in the drawing. Shapes may be positive or negative in the composition.

Joseph Davis, contour drawing, pen, student drawing, 1999.

Beth Stinson, charcoal, negative space, student drawing, 1999.

Composition: Space, Plane, and Shape

DRAWING EXERCISE

Set up a still life. Place the objects close together.

Use a piece of clear wax as a drawing tool. Look at the shapes in the still life and form their outlines or draw the entire shape by pressing the wax firmly on the paper.

The bottom drawing by Justin is an example of forms completely filled in, while Sabrina above has maintained a simple shape outline.

Keep track of where you are in the drawing as best you can and fill the paper with shapes. Dip a Chinese brush in ink and paint over the paper top to bottom to reveal the drawing.

Drawing without being able to see the image allows you the freedom to visually investigate your subject.

Above, Sabrina Benson, blind wax and ink, wash; below, Justin Smith, blind wax and ink still life shapes, student drawings, 1999.

Composition: Space, Plane, and Shape

CHAPTER 9
Drapery

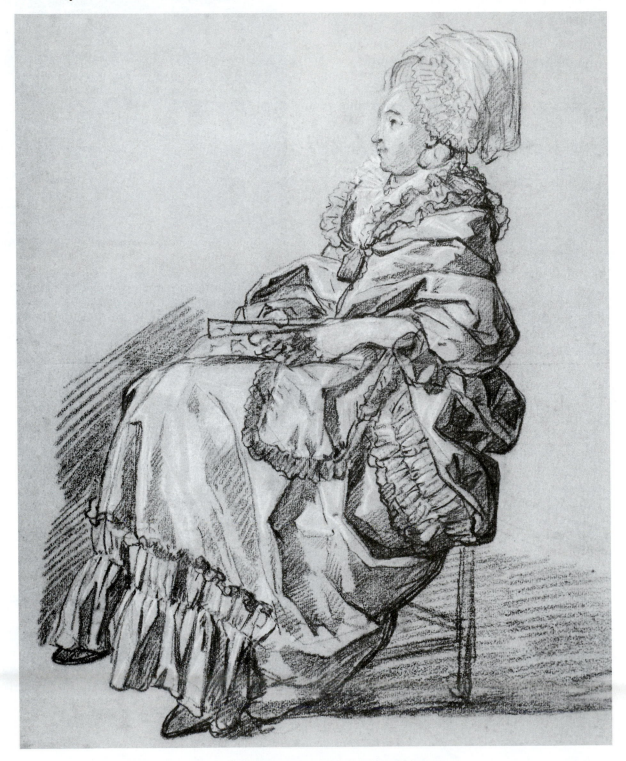

Francois-Louis-Joseph Watteau, called Watteau de Lille, 1758–1823, *Portrait of a Fashionably Dressed Woman Seated in a Chair.* Black chalk, heightened with white, on buff laid paper. 540 × 395 mm.1974.199 Committee for Art Fund, Stanford University Cantor Arts Center.

PROFILE OF AN ARTIST: ANTOINE WATTEAU

Antoine Watteau was born in 1684 to a very poor family in Valenciennes, which had been annexed to France six years earlier. Watteau's work was inspired by elegant society and theater. His graceful, silken-clad figures appear in a world between reality and make-believe.

Watteau trained in studios where theater set design and the process for making ornamental panels for Paris residences using fashionable *chinoiserie* and *singerie* (monkey and rustic motifs) were developed. His work with elegant motifs used for interior design just precedes the rococo.

Watteau should be considered a prophet of the rococo rather than a representative. The rococo movement reached its height in 1730. Madame de Pompadour, who epitomizes French rococo, was born in 1721, the year of Watteau's death. Watteau died at the age of thirty-seven, the same age as Raphael, Van Gogh, and Toulouse-Lautrec at their deaths.

Watteau began his career by drawing from life in the public square. He would go to the square to draw the actors and performers, like Rembrandt, Daumier, and Toulouse-Lautrec. He recorded this small view of life removed from reality capturing the essence.

Known as a "painter's painter," he was most appreciated by a small circle of close friends. He was elected an associate of the French Academy in 1712 an organization of officially recognized artists. He became a full member five years later, but in his lifetime he was not famous.

He drew constantly from nature. His practice was to keep his studies in a bound notebook. In addition to his nature studies, he had many elegant fancy-dress costumes in his studio and would dress up his friends who agreed to model for him. It was from these sketches that he would compose his paintings. He would select figures from the sketches, then place the figures in a landscape or background he imagined. Rarely would he compose the entire composition in a sketch before painting it. The studies are usually detached figures or parts of figures, heads, hands, or details of costumes. The high quality of his finished work is a tribute to his extraordinarily sensitive perception.

Watteau broke with the classical tradition of Poussin and Claude Lorrain by working out his compositions directly on the canvas, something unheard of at the time. It was the Neoclassicist of the Davidian School whose scorn pushed Watteau's work into almost total oblivion.

For Watteau the use of costumes gave a more poetic dimension to reality. His deep love of music influenced his personal vision in his compositions. The drawings feel as if they were made for the sheer delight of drawing them.

In drawing he preferred to use the white of the paper for lightness and highlight rather than touching up with white crayon, although sometimes the white crayon was necessary. He combined black and red chalk and used pastel or gouache but never pen and ink.

He preferred drawing to painting, feeling he could express the spirit and truth of the subject with his crayon better than with the oils. In the drawings there is a sudden turn of a charming head, the tip of a nose, or the rustle of drapery that he communicated better with the directness of drawing.

Antoine Watteau's work had many of the qualities we think of as French—subtlety, sensitivity, an awareness of the ironies and contradictions of life combined with elegance. To these was added a complex, high-strung personality and a deeply poetic imagination.

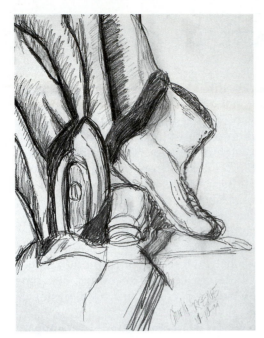

DRAWING DRAPERY

There is a formula you can use to address the problems of rendering drapery. Looking at drapery at first is overwhelming, but once you direct your study of the drape in terms of planes, it will be easier to draw. When the drapery is held against a wall with a pin, the folds radiate from that point, flowing out in a triangular shape as they drop to the floor. On the figure drapery will radiate from the knee or the elbow in much the same way.

To draw cloth, first follow the folds with a simple line drawing from the pin down. The folds can be mapped out in three planes—a top plane, a side plane, and a back plane. Your first decision is to determine where the top plane ends and the side plane begins. Imagine the palm of your hand is lying on the top surface of a fold. When you must turn your hand to follow the drape back to the wall, you have changed from the top plane to the side plane. The back plane begins when the drape touches the wall. When the top plane is white the side plane is a gray value and the back plane is dark or a black value.

On these two pages are student examples of drapery studies. Charlie Greene's drawing, top left, illustrates a simple division between the top plane and the side plane. In the next study, Megan Brown started her drawing with

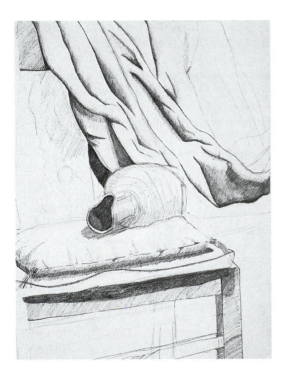

Above, Charlie Greene, pencil; second from top, Megan Brown, pencil; right, Lili Xu, pencil, student drawings, 1999.

Drapery

an outline of the folds adding a gray value where the shadows were the deepest on the drape. Work from dark to light in a drapery study, first placing black on the back plane then gray on the side planes and leaving the top plane the white of the paper. Lili Xu's drawing on the bottom of the facing page is a good example of how value changes create volume in a drawing of drapery. The white top planes radiate from the top narrow pin. The folds widen as they fall. Folds can turn under abruptly, when this happens the side plane is eliminated. For drapery to appear volumetric the surface must reflect a change in value. Gray top, side, and back planes will look flat. It is hard to see where the folds in the drapery change planes. The light on the drapery does not always reveal gray and black. It is up to the artist to translate the light to create the illusion of rolling folds on the paper.

It is the rotation of value from light to black that gives drapery a sense of form. In Joseph's drawing below, he has used a lighter value system. The still life on the right is Conté on gray paper with white highlighting. The Conté has been rubbed and layered to build the values. Students tend to be afraid of making a plane too dark but even though your eyes don't see black in the recesses of the folds, black is what visually creates the recess on paper.

Chandra's drawing on the bottom right is pencil that was rubbed with a tissue. She then used her plastic and kneaded erasers to pull out the light planes. Using the eraser as a drawing tool, she got very crisp top planes. Notice the difference in the size of the top planes among these three drapery studies. The top planes reflect the fullness of a drapery. Try to make them as large as possible.

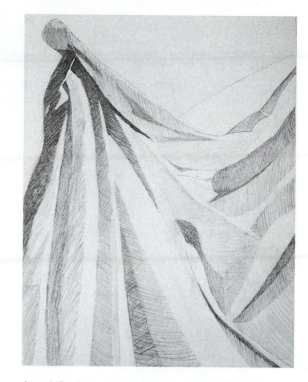

Joseph Davis, pencil, student drawing, 1999.

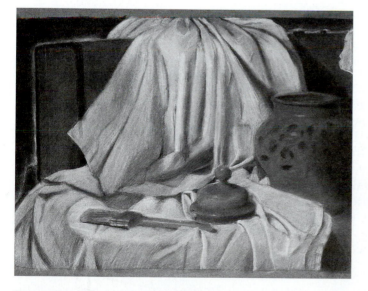

Ryan Coffman, Conté with white highlight on gray paper, student drawing, 1999.

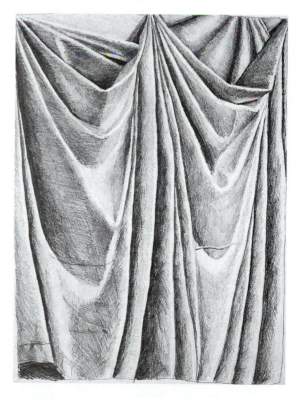

Chandra Allison, pencil, student drawing, 1999.

Media

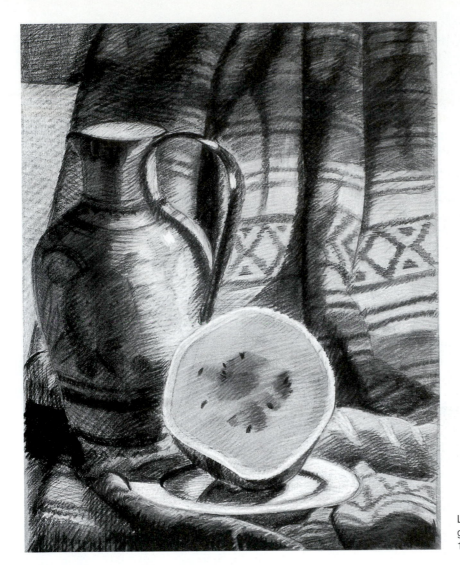

Lili Xu, still life, black and white Conté on gray paper, still life, student drawing, 1999.

In the drawing above, the light was cast from a floodlight standing to the right of the still life. Lili has interpreted the light in black and white Conté (soft B grade). There is a vertical change in light from the top of the drawing to the bottom and a horizontal change across the forms and the drapery. It is also a good example of the four types of light. Light on light is the whitest area of the drawing. In this rendering it is the light on the white plate and the white pattern on the drape. The second quality of light, light on a dark surface, is the loaf of bread or the right side plane on the watermelon. The third quality of dark on light or where a shadow falls on a light surface is the shadow on the white plate under the watermelon. The entire left side of the white pitcher illustrates dark on light. The local or actual color of the drape was brown and in shadow it is the fourth quality of light, dark on dark.

The location of light to dark, the value changes, in this drawing are convincing in creating the illusion of space.

Drapery

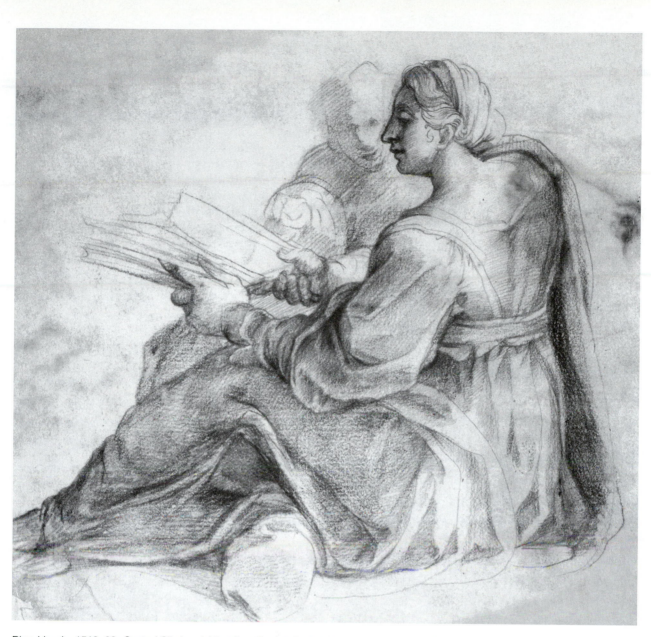

Pirro Ligorio, 1513–83, *Seated Sibyl and Attendant Genius*. Red chalk on beige paper. H. 24.5, W. 26.5 cm. The Metropolitan Museum of Art, Pfeiffer Fund, 1962. 62.120.7.

Pirro Ligorio was a painter, architect and antiquarian. He was the architect who followed Michelangelo in finishing St. Peters's Church in Rome. He was noted for his highly plastic treatment of forms reminiscent of Michelangelo's. The ponderous figures with monstrous hands clumsily attached to the arms by grotesquely deformed wrists are the characteristics that signal his work.

The drapery follows the planes of the figure, in a clearly defined if not exaggerated example of drapery on a figure. The light falls first on the back of her dress which is predominantly white with gray grooves. The values change from white to gray where the back plane of the figure turns into the left side plane. The right side of the figure is rendered in the darkest planes. The area under the cape and on top of the left arm are farthest from the light, and darkened.

Drapery

HATCHING AND DRAPERY

Oskar Kokoschka was a German Expressionist who worked in Vienna with Egon Shiele and Gustav Klimt. The Expressionists preferred gesture drawing or sustained gesture drawing to traditional posed line drawings. In his drawing on the left you feel the spontaneity of the line forming the woman's dress. The folds in the drapery are loosely rendered with hatching strokes. This loose, repeated line gives the appearance that the woman is standing up or sitting down, but she seems about to move.

DRAWING EXERCISE

Use a white twin bedsheet as your subject. Take two pushpins to hold the corners. Tack two points up letting the drape loosely hang between the first tack and the second one. Direct light from a flood light or clip-on light attached to an easel onto the drape to illuminate the curves across the surface. On newsprint make a warm-up drawing first using a light line to define and separate the planes. Start the lines from the pin drawing down. Drapery tends to fan out from top to bottom into a triangular shape. In the warm up drawing use sustained gesture where your line can flow into the grooves, up the sides of the folds, to the top plane which remains the white of the paper. On white drawing paper, make a second drawing to practice using crosshatching. Sketch a plan of the drape defining the top planes,

Oskar Kokoschka, Austrian 1886–1980, *Portrait of a Girl.* Conté crayon, no date. 56.5 × 44.5 cm. Portland Art Museum, Oregon. Ella Hirsch Fund. acc.no. 38.49. © 2001 Artists Rights Society (ARS), New York/ProLitteris, Zürich.

side planes, and grooves or back planes. Apply hatching strokes across the back and side planes. Return to the back planes and crosshatch the areas to darken the value. Decide how many layers of line each side plane and back plane should have to create the correct value.

Drawing fabric on a model is excellent practice to develop an understanding of the flow of a drapery. The volume of the figure supports the drapery, and the drapery follows the structure of the figure. You can work on two drawing problems at once.

When the gray side plane is absent drapery is reduced to pattern. Justin has stylized the drapery behind the skull into dark and light stripes. This creates a flat background. Even the curve that bows the stripes on the background isn't quite enough to lift the surface from being perceived as flat. This is not a bad thing; it is a choice for artists today. This drawing provides a good contrast to the others, illustrating how important the definition of the planes are to the perception of the space in a drawing.

Lili Xu, drapery on the figure, student drawing, 1999.

DRAWING EXERCISE

Select some of your heavier clothing—a sweatshirt, a pair of jeans, a sweater, a jacket—and fold them into fourths. Stack them up in a pile and use a 6B pencil with light pressure to draw the pile. Let your line go around the contour across the surface, and into the stack. As your eyes move across the planes notice where the fabric rolls into a groove, thicken the line to darken this area. Use hatching lines on the side plane to change the value of these planes.

Justin Smith, ink and wax still life, student drawing, 1999.

Drapery

CHAPTER 10
The Portrait

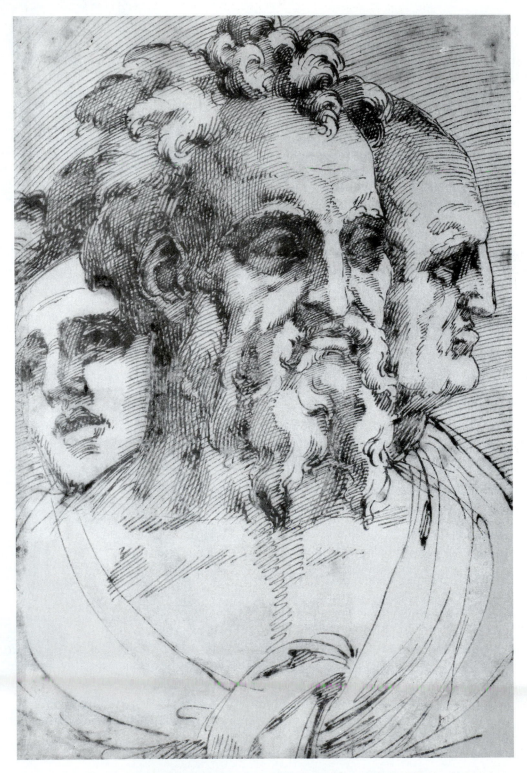

Baccio Bandinelli, 1493–1560, *Three Male Heads*. Pen and brown ink. H. 12⅜, W. 8″. (32.1 × 20.7 cm.)
Drawings. Italian, Florence. XVI. The Metropolitan Museum of Art, Rogers Fund, 1963. 63.125.

INTRODUCTION

THE PORTRAIT, the likeness of the human face, was drawn, painted, or sculpted by artists from earliest times. We know the Egyptians drew and painted the likeness of human figures and faces. We have stone sculpture from Mesopotamia with carvings in the likeness of kings depicting them engaged in military victories. In 7000 B.C. in Jericho artists made likenesses by putting plaster on the skulls of dead people to make molds of their heads. The popes, the nobility, and later the emerging class of wealthy industrialists and merchant princes all had their portraits painted by artists. The *Mona Lisa* is probably the most famous portrait by Leonardo da Vinci. In Spain, the court artist Velázquez painted Spanish royalty. *Las Meninas* is one of his finest paintings. Napoleon had David paint his portrait over and over. There are rooms at Versailles with nothing but huge paintings of Napoleon on horseback leading the men to war. The camera made portraiture affordable for everyone, not just the rich. This technical change freed the artist to experiment with the portrait and to go beyond rendering a person's features to expressing feelings and other sensibilities.

The accurately drawn portrait demands precise observation skills and measuring. A portrait can convey tension, strain, peace, thoughtfulness, anxiousness, as well as being a psychological study. Adding perception and emotion to a drawing creates a complex drawing problem.

In drawing the head or the portrait, it will be important to make careful measurements for the placement of the features. Close and careful observation will reveal that the shapes of the eyes, the nose, and the lips are never constant or the same between any two people. You need to look closely and carefully at each facial feature, scrutinizing its shape.

Students often have trouble with the head because they try to draw the features as flat on the paper. The skull is a round globe, and the features sit curved across the surface; they are neither symmetrical nor perfectly horizontal. It is crucial to understand the planes of the face if you are to sculpt the features out of the paper. You can use your own face to understand and locate where the planes change. Move your hand across your forehead to where your skull curves back at the middle of the eyebrow; feel the bridge and side planes of the nose continue across the cheeks down to your chin. Touching your own face will help you understand the shape of the face.

In the drawing on the left. Bandinelli has modeled three heads with crosshatching. On the front head the hatching begins on the forehead at the point where the skull turns to a side plane, which is very near the middle of the eyebrow. The eyes are set back in the skull, and Bandinelli accentuates this with shading, darkening the receding planes.

The top plane of the nose on all three figures is white. Where the top plane turns into the side plane the artist has hatched a shadow to form this side plane. The top lip of the figure on the left has been darkened, along with the opening of the mouth.

Each head is separated from the one next to it by a value change. It is the value changes from light to dark, from the top plane to the side plane that create the volume of the head. The space of the drawing also depends on value changes. It is the rotation from light to dark between the heads that creates a sense of depth in this two-dimensional surface. On the left side the youth looks up, his face composed of large white planes, shaded lightly on the side plane. The hatching strokes turn with the planes of the face.

PLANAR ANALYSIS OF THE HEAD

The plane is the basic structural unit for all figure drawing. A plane can be defined as a flat or curved surface. The boundaries of a plane are where the terrain of the form changes. The cube is the easiest form to use as an example of plane and plane changes. The cube is composed of a top plane and four side planes. It sits on the bottom plane. The use of lines to identify plane changes is a graphic convention helpful in mapping out a form in terms of its planes.

Lines don't exist in nature. What we think of as a line is a plane change. In addition, light changes control value change, texture change, or color change. There are no lines on the face, which is why it is so important to understand the planes of the face.

Julio Gonzalez has created a Cubist head on the left. He has made strict and simple plane changes to depict the head. Lines are useful to draw the creases or folds on the face, the outline of the eyes, the shape of the lips and the outline of the ears, but it is value that creates the volume.

The face and drapery have many of the same problems in drawing. It is easiest to start with the large planes and search out the small attached planes. To locate and draw all the small planes first results in a weak drawing where the form is obliterated in little details.

Julio Gonzalez, Spanish, 1876–1942, *Screaming Head.* Pen and black ink, with brush and gray wash, over graphite, on off-white laid paper, 1940, 31.6 × 24 cm., McKee Fund, 1957.358. Photograph © 1995, The Art Institute of Chicago. All rights reserved. © 2001 Artists Rights Society (ARS), New York/ADAGP, Paris.

DRAWING EXERCISE

Stand in front of a mirror with a sketch pad 8 × 11" in your hand and study your face. Use a 3B pencil and draw only the large planes. Use line to define the large planes of your face. Draw the forehead and the sides of the forehead, the top of the nose and the side plane of the nose, the cheeks, the chin, the side of the head, and so on. Add a value change with hatching to one of the planes. Hatch either the side plane or the front plane to separate the two. Try making one- and two-minute sketches of your family without having them sit still.

The Portrait

THE SKULL

Animal skulls are good subjects for studying the structure of the skull. By studying the basic structure, connections, and overlapping planes of large cow skulls you gain familiarity with the skull structure. Some art departments have plastic human skull replicas to draw. Studying the underlying structure of the face will help you to locate the planes later.

DRAWING EXERCISE: SELF-PORTRAIT

Before you start skull studies make a self-portrait drawing. After you do skull studies, make a second self-portrait and compare the differences. Generally the first portrait will emphasize the features, but they will be flat across the face. The back of the skull is often missing in first study, which creates a flat appearance to the head. A working knowledge of the skull will help you place and shape the features into a natural-looking portrait.

THREE-DIMENSIONAL STUDY OF THE FACE

Using foam core and tape, build a mask based on the planes of your face. Examine your face and use a mirror to draw the shape of the planes on the foam core. Looking at a photograph and touching your face helps you determine the shape of the planes. Cut the planes out and tape them together.

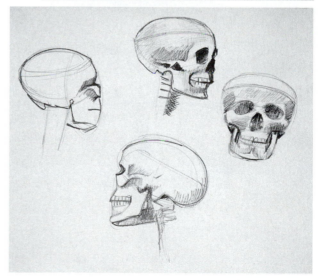

Above, Chandra Allison, cow skull ink wash; middle, Brooke Cutsforth, three-dimensional model of the planes of the face; below, Lili Xu, skull studies, student drawings.

The Portrait

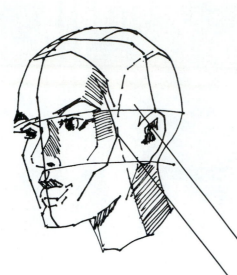

PROPORTIONS OF THE FACE AND HEAD

A careful analysis should be made of the head before you start. Like most subjects we draw, the human face is very familiar to us. We recognize it immediately, but we need to study and carefully observe the anatomical structure in order to draw a portrait. You may use your pencil as a sighting tool. There are a few general rules in mapping out the face and head that will help you draw accurately:

Front View

1. Draw a vertical line on your paper. This line aligns with the top of the head and runs through the middle of the chin in a frontal pose. Indicate the top of the head and make a line for the chin.

2. The eyes lie halfway between the top of the skull and the chin. Draw a horizontal line across the vertical to place the eyes.

3. Divide the face in thirds from the hairline to the chin. The eyebrows are one-third of the way down, and the base of the nose is two-thirds of the way down.

4. The center line of the lips is one-third of the way between the nose and the chin.

5. The ears sit on the side of the head between the eyes and the bottom of the nose.

6. The width of the eye is an important measurement. The head is five eyes wide. The distance between the eyes is one eye length; the distance from the corner of the eye to the side of the head is one eye length.

7. The distance between the eyes is the same as the width of the nostrils.

8. The features remain at right angles to the center vertical line no matter how you tip your head from front to back.

In Profile

9. In a profile pose, the distance from the chin to the eyebrows is equal to the distance from the ear hole to the top of the nose.

10. The distance from the back corner of the eye to the back edge of the ear is equal to one-half the height of the head in profile.

11. In a side view the head is divided in front of the ear, creating equal parts on both sides of the line.

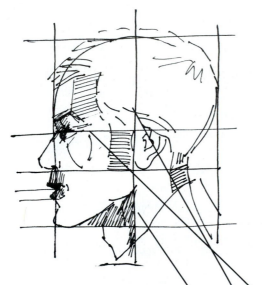

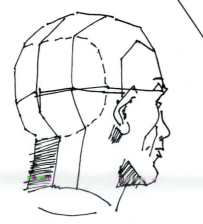

THE FEATURES

These isolated fragments from different compositions by Tiepolo were made for a large canvas he worked on with his two sons, Domenico and Lorenzo, between 1751 and 1753. The work was done for Prince-Archbishop Greiffenklau in the Imperial Hall at Würzburg in Franconia. The drawings parallel the finished work so closely that some scholars feel they were done after the work was finished as a way of keeping a record. *The Fall of the Rebel Angels*, which was painted for the palace chapel, is a large canvas rather than a fresco. The artists were executing vast frescoes and a large altarpiece at the same time. These studies were originally felt to be rapid notations of the individual details. Some historians think they may have been drawn during the course of the painting, as exploratory drawings rather than made as preparatory studies. The fragments of the design in the drawing seem more painterly than graphic. When they reappear in the finished painting, there is little change. To their credit and history's amazement, the Tiepolos completed a large number of various projects for the archbishop in a very short time.

Careful observation of the facial features in Tiepolo's drawing reveals the thickness of the eyelid. The eyes are not almond-shaped; the lower lid slides under the corners of the upper lid. Look for the high point of the curve on the upper eyelid. Then look for the low point on the lower lid. At the inside corner of the eye there is a tear duct, and the iris of the eye seems to rest on the lower lid. In profile the eye will appear as the shape of a V on its side.

In Tiepolo's drawings of the lips they are not outlined. Notice the line between the lips which gives them their shape, and the shadow under the bottom lip. It is the little shading on the upper lip that gives them form.

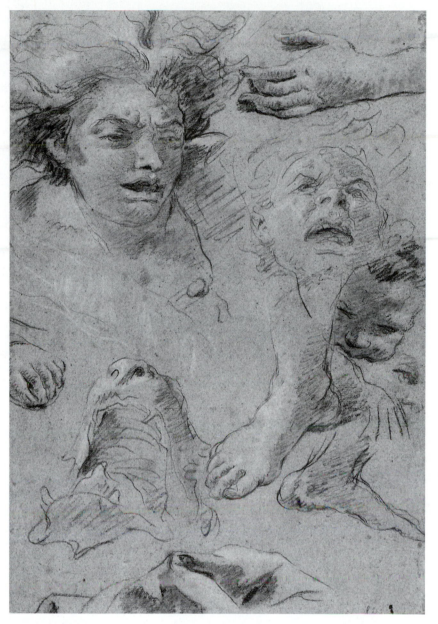

Giovanni Battista Tiepolo, 1696–1770, Studies for *The Fall of the Rebel Angels* in the Chapel of Würzburg, c. 1751–52. Red chalk, heightened with white, on blue laid paper. 394 × 272 mm. 1982.170. Committee for Art Fund. Stanford University.

The Portrait

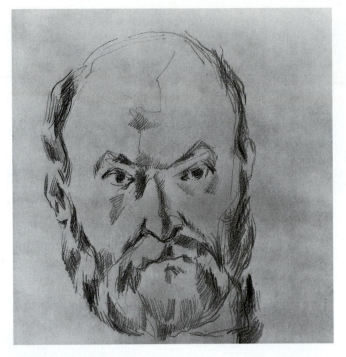

DRAWING EXERCISE

Practice drawing the lips, eyes, ears, and the nose from photos out of fashion magazines. Models have extreme features which make them very photogenic and help you to see detail. Their features are good examples for practicing drawing pages of features.

SELF-PORTRAIT

Paul Cézanne once said that nature could be thought of as a sphere, a cone, and a cylinder. He was referring to the geometry in nature. His landscape paintings were organized by a form of planar analysis. In his still lifes the planes of the fruit were delineated and separated by color and value changes. It was Cézanne who inspired Picasso and Braque who later developed Cubism.

In his self-portrait on the left the hatching strokes in the beard form the cheeks and jaw line on either side of the face. There is one line for the lips with a shadow under the bottom lip. The light planes of his face are left untouched. The side planes are darkened comparatively creating the volume of the head. Value changes on the face are relevant to each other in their amount and degree of darkness to lightness. Cézanne didn't use black instead he worked with light and medium gray values.

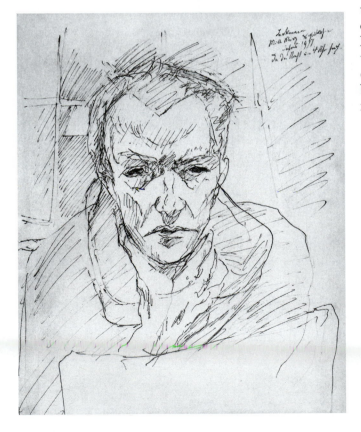

The Portrait

DRAWING A PORTRAIT

The gaze of the person in a portrait is an important consideration. In a modern work the gaze may be directed at the spectator. Cézanne looks past the viewer, his gaze averted.

Erin's drawing of John below gives the feeling that John is looking inward instead of at the room. The modeling on John was created by rubbing pencil across the surface and erasing the light planes. The rubbed pencil creates soft effects.

The proportions of children's faces are different from those of adults in that the eyebrows mark the halfway point between the top of the skull and the chin. The eye line then drops one-quarter of the way into the lower half of the face. This drawing by Cézanne of his son is perhaps a rapid or quick study, but could be a drawing from memory.

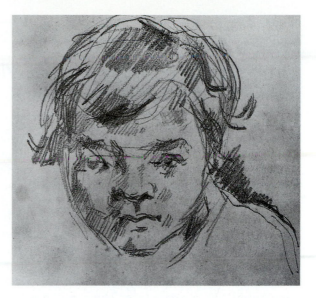

Above, Paul Cézanne, French, 1839–1906, detail from the sheet with *Self-Portrait and Portrait of the Artist's Son.* Pencil, 1878–82, Arthur Heun Fund, 1951.1. The Art Institute of Chicago.

DRAWING EXERCISE

1. Set a mirror where you can look at yourself and have your paper and drawing board in front of you. Use a sharpie permanent pen or ballpoint pen. Place the pen on the paper, look in the mirror, and make a blind contour drawing of your face. Use one unbroken, continuous line. Draw slowly and keep your eyes on your face in the mirror. Draw what you see. Make four of these drawings on one sheet of paper, taking only five minutes to do each one. This study increases your visual knowledge of the features and planes of the face. Our brains store information about the shape and form of the face after repeated studies.

2. Using a 6B drawing pencil, draw your face and head by looking in a mirror and checking back and forth between the paper and the mirror. Try to look at the paper only briefly to make sure you are in the right spot by comparison with what you are looking at in the mirror. Complete the drawing in twenty minutes.

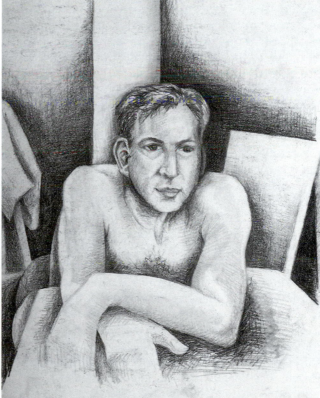

Erin Stephenson, *Portrait of John,* student drawing, 2000.

PROFILE OF AN ARTIST:
MARIE LOUISE ÉLISABETH VIGÉE-LE BRUN

Élisabeth Vigée-Lebrun was born in 1755, the daughter of an artist, Louis Vigée, a portraitist who worked in the style of Watteau. We know more about her than about any other woman painter of this period because she wrote and published her memoirs. She began to study painting at the age of eleven under a painter named Davesne. Her childhood friend Anne Bocquet Filleu began with her but was persuaded by her husband to quit. Vigée-LeBrun considered this a great loss. The early death of her beloved father brought confusion and melancholy into her life. These emotions soon turned into an ironclad resolve to become a serious painter. She was able to support her mother with her painting. When her mother remarried, her stepfather insisted Elizabeth turn all her painting fees over to him. Her mother thought she would be secure in a marriage to a wealthy man and urged her to marry LeBrun, an art dealer. At this time, she was twenty years old, free from any major life anxieties, and earning a good deal of money. She felt no desire to get married, but to escape the torment of her stepfather she agreed. In her memoirs she says that on the way to the church she kept saying to herself, "Shall I say yes? Shall I say no? Alas, I said 'yes' and changed my old troubles for new ones." LeBrun was likable enough, but he had a passion for gambling and his extravagant habits drained her receipts for her portrait commissions.

Neither marriage nor maternity stopped Vigée-LeBrun's painting. She took her pregnancy lightly, making absolutely no preparation for the birth of her daughter during the entire nine months. On the day her labor started she continued working on the painting *Venus Tying the Wings of Love* in between her contractions. Madame de Verdun, her oldest friend, happened to come into the studio and seeing this, asked her if she had provided all that would be necessary for birth. Vigée-LeBrun looked astonished and said that she didn't even know what all was necessary. De Verdun responded, "That's just like you; you are a real boy." When Vigée-LeBrun was told she needed to go to bed, since the birth was near, she exclaimed, "No, no, I have a sitting tomorrow. I will not go to bed today." However,

she did go to bed and gave birth to her daughter, Julie. The following portraits of her with her daughter are stunning in their perfection.

Vigée-LeBrun was a court painter to Louis XVI and Marie Antoinette. She did a splendid painting of the queen with her children around her. The painting was intended to be a historical statement portraying the vitality and health of the royal family, but it was criticized by some who thought it was too large and extravagant. The queen had lost one child prior to this painting, and the young Dauphin, her son, died after the painting was finished. It was then too painful for the queen to look at and she had the painting put in storage. This is the only reason the painting survived the destruction by the people during the French Revolution when the palaces were sacked, and works of art were destroyed and stolen.

Vigée-LeBrun's salon, a social event, was frequented by so many guests, she bragged that the marshals of France had to sit on the floor. She arranged musical evenings, witty conversations, and elaborate costume parties. She was the center of gossip and speculation about her private life because of her popularity as a society hostess and fame as a painter. She responded to this criticism in her memoirs, saying, "Has one ever known a great reputation, in whatever matter, that failed to arouse envy?" On May 31, 1783 Vigée-LeBrun was finally admitted to the Academy, the organization of officially recognized artists in France during this time. This ended the rumors that because she was a woman, she had not painted the works attributed to her.

She had been devoted to the royal family and thus had to flee France on the eve of the Revolution. She spent twelve years in exile, but wherever she went she was treated as a celebrity and made a member of the local Academy. She painted dozens of portrait commissions during her exile. In her lifetime she completed 660 portraits. She made her subjects look glamorous but at the same time encouraged them to come in an informal attire so that the portraits would have a sense of intimacy and spontaneity.

She returned to France under Napoleon Bonaparte and lived out her long life painting and entertaining the survivors of the Revolution.

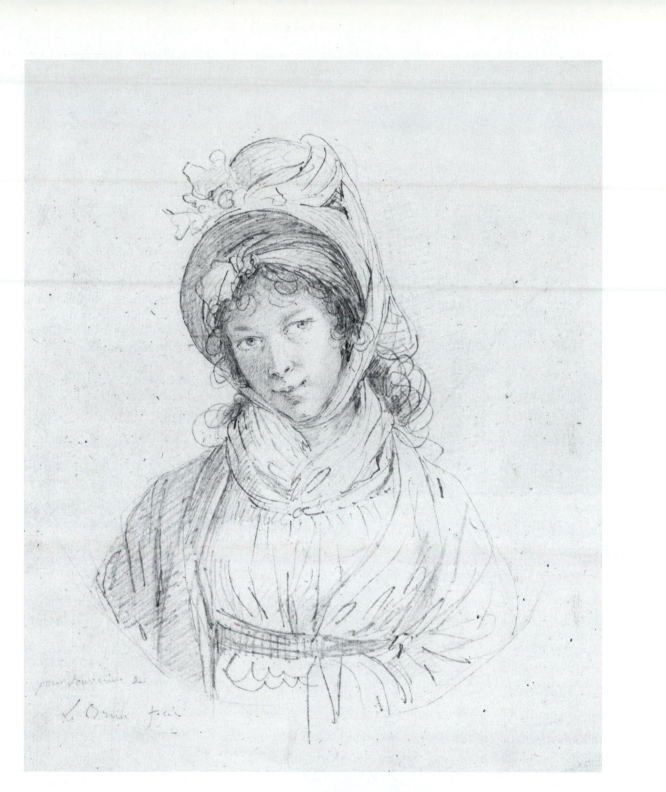

Louise Elisabeth Vigée-LeBrun, *Self-Portrait.* The Pierpont Morgan Library/Art Resource, NY.
SO157527. 1955.8.

She recounts in her memoirs that once at a party a man did her horoscope. He foretold, "I should live a long while and become a lovable old woman, because I was not coquettish. Now that I have lived a long while, am I a lovable old woman? I doubt it."

PHOTOGRAPHIC REALISM

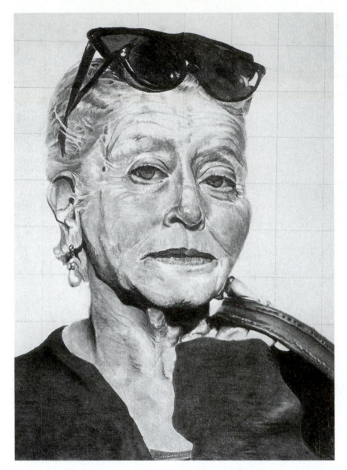

Some artists seek a clear photographic likeness of their model. In Matt's portrait he has buried the mark and any strokes that would take away from a very polished surface.

In pencil you use the side of the pencil to get a smooth application of lead. Rubbing the lead on the paper with a cloth or your finger will create a surface that represents the texture of skin.

Matt has been very careful with his value changes across the face and hair. This drawing took two weeks. By slowly building up layers of lead, he got the finished product he wanted.

Photographic realism is often painstaking to execute. You can't rush through the drawing.

By graying the background Michael creates a ground for his figure. The light planes are exaggerated against the gray ground. The visual interaction between the light planes of the face and the ground creates a sense of volume. In the style of Rembrandt his face turns out of the darker ground and then rotates back into a shadow, in the space of the background.

Above, Matt McDonal, pencil, grid transfer portrait, 18 × 24″; below, Michael Taddesse, pencil, grid transfer portrait, 18 × 24″, student drawings, 1999.

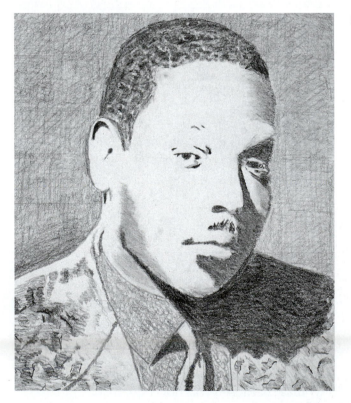

The Portrait

EXPRESSIVE PORTRAITS

Matt's portrait on the left and Kevin's portrait on the right are good examples of the difference between an expressive portrait and a photo-realistic portrait. Kevin has used a boldly hatched loose stroke that makes his portrait active. It has the quality of a drawing, not of a photograph. He has hidden half of the subject's face in a shadow.

In Andrea's drawing of the same model below you see another interpretation. Andrea is much closer to photorealism in her rendering. It is important to note where each value on the planes of the face starts and stops.

DRAWING EXERCISE

The drawings on these two facing pages were made from magazine photographs. Each student selected a photo 8 × 10″. The photo was then divided into a grid of one-inch squares. A second grid was constructed on a piece of white drawing paper, with a two-inch grid.
The photo had eight squares across the top and ten squares down the side. The white paper doubled the size of the small photo to a 16 × 20″ format.
The students were then asked to transfer the information in terms of value changes from the small photo to the drawing paper. The squares between the two grids correlate, thus the location of the values and the lines in the top right square of the photo's grid are drawn and expanded in the top right square of the large grid on the paper. Continue transferring line, value, and shape square by square.

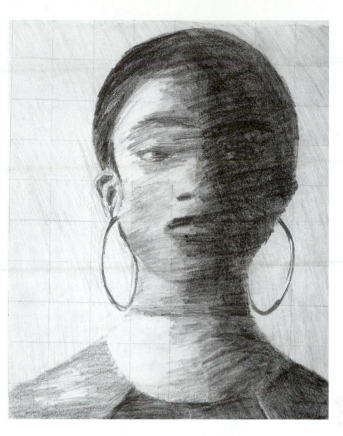

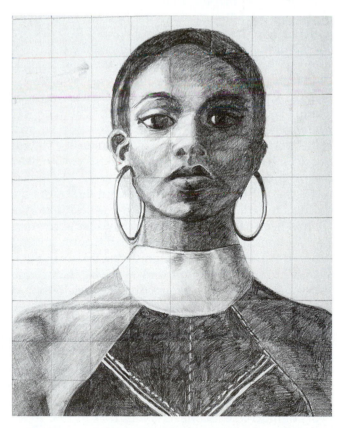

Above, Kevin Cunningham, pencil, grid transfer portrait, 18 × 24″; below, Andrea Galluzzo, pencil, grid transfer portrait 18 × 24″, student drawings, 1999.

PROFILE OF AN ARTIST: ELAINE DE KOONING

In addition to being a painter, Elaine de Kooning was a prolific writer. In 1944–45 she and her neighbor Edwin Denby, a music critic for the *New York Herald Tribune,* would attend ballet performances. What started as a simple act of companionship grew into a career. Denby was so impressed by her assessments of the dance programs that he began sending her to performances he couldn't get to when there were two on the same night. They would then get together afterward in the *Tribune* offices and write the critiques. Then in 1946 de Kooning had an article published in *Mademoiselle* on all the ballet companies.

Later she wrote art criticism for *Art News.* Elaine de Kooning, along with Tom Hess, Meyer Schapiro, Eugene Goossen, and Harold Rosenberg, were the first art critics to see the intellectual and emotional depth of the art being done in New York by Resnick, Rothko, Willem de Kooning, Motherwell, Pollock, Hofmann, and many others. In *Art News* she created a series called "Makes a Painting," with each article focusing on a different artist, such as Mark Rothko, Franz Kline, Willem de Kooning, or Jackson Pollock. The articles discussed the artists and their work in formal terms. Her writing was greatly informed by her life. As a painter she understood the new art culture of New York. Married to Willem de Kooning, in 1943 she was in the center of it all. She had access to artists' studios and was taken into their confidence. She learned their thoughts and techniques, information artists usually share only with each other.

Like many painters in New York at this time Elaine's painting was inspired by Arshile Gorky. In 1948 she attended Black Mountain College near Asheville, North Carolina. She drew constantly in both abstraction and realistic, still lifes, in cityscapes and portraits. Her portraits were marked by how well she established the stance of the body, capturing the sitter to make the portrait more than just an illustration. She painted her wide circle of friends, including Harold Rosenberg, Joseph Hirshhorn (on the right), the poets Frank O'Hara and John Ashbery, the painter Fairfield Porter, and her most famous subject, President John F. Kennedy.

Elaine was a talented painter, and an astute art critic. Along with Grace Hartigan and Pat Passlof, Elaine was one of the few women admitted to "The Club," which was formed by the artists in the New York School to get together to discuss current problems in the arts. Started in 1949, The Club was the only place advanced artists in New York could find companionship with like minds. Previously artists had been getting together in café's, having a cup of coffee, and discussing the meaning of art. These cafés were also frequented by longshoremen. One night the longshoremen got into a fight that ended when one of them threw the other out the front window of the café. After this the artists decided to rent a loft to meet in. It was Phillip Pavia who put the money up for the rent. He had been saving money to put into his sculpture, but he felt this was more important.

Women artists have always had trouble getting recognized. The artist-wives during the forties and fifties, although strong artists in their own right, gave their unquestioning support to their artist husbands, making major sacrifices such as giving up motherhood to put their husbands' careers first. Esther Gottlieb, Annalee Newman, Musa Guston, Lee Krasner, and Elaine de Kooning were among those women. With Bill's support Elaine managed to maintain her professional position within her relationship. If Bill said I'm hungry expecting her to cook, she would say me too. They both agreed they needed a wife.

To the art world, however, she was first a wife, then a painter. Being the wife of one of the most admired artists in the world did not help her career. Dealers walked right by her work without noticing to get to Willem's. She separated from Willem in 1956 after 13 years of marriage. Elaine left New York in 1957 to teach at the University of New Mexico. In 1977 she returned to live with Bill at the house and studio on Long Island, in the Springs. Although they maintained separate houses and studios, she was only five minutes away and joined him every night. She returned because he was very ill and needed

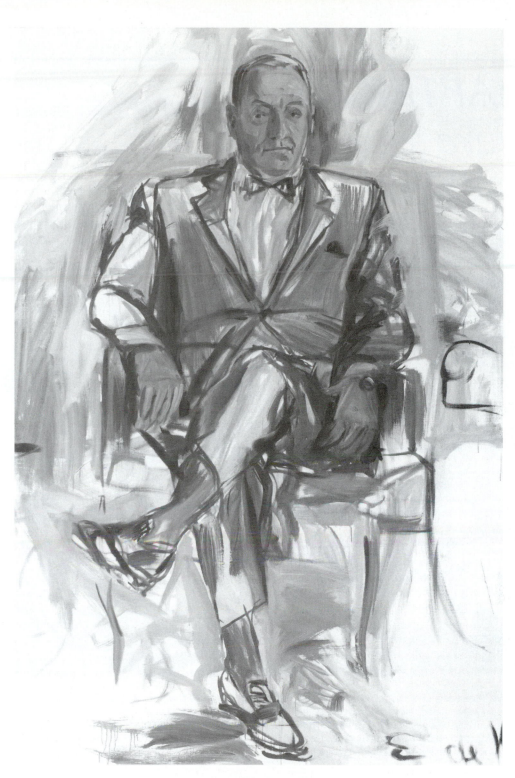

Elaine Marie Catherine de Kooning, American, 1920–89, *Portrait of J. H. Hirshhorn,* 1963. Oil on canvas, 72 × 48″. Hirshhorn Museum and Sculpture Garden, Smithsonian Institution. 66.1182.

someone to take care of him. She did not receive real recognition for her work until a few years before she died.

Regarding the act of painting, Elaine said, "When I do something I didn't expect or consciously intend to be doing, it's not an accident." When asked how she made decisions while painting, she said, "When you're dancing, you don't stop to think: now I'll take this step. It just flows."

The Portrait

CHAPTER 11
Figure

Jean Auguste Dominique Ingres, *Odalisque with Slave*. Pencil, black and white chalk, white gouache, gray and brown wash, especially on the Moor's face, hands, and cuffs; surface scratched in places to produce highlights; on cream-colored wove paper. Design area: 13³⁄₁₆ × 18¼″ (335 × 462mm), on sheet measuring 19¼ × 24¼″ (488 × 616 mm). Signed, inscribed, and dated at lower left, J. Ingres/Rom. 1839. #66 The Thaw Collection, Pierpont Morgan Library, New York.

ODALISQUE WITH SLAVE by J. A. D. Ingres was executed in Rome in 1839. Ingres had a lifelong fascination with the subject of the odalisque using it often in paintings and drawings. The pose for the odalisque was set as early as 1809 in another of his studies. The early study was used in preparation for *La Dormeuse de Naples,* a painting that is now lost but had been purchased by the collector Murat. The painting resulting from drawing on the facing page is now in the Fogg Art Museum at Harvard University. A replica was painted in 1842 and is in the Walters Art Gallery in Baltimore. The only difference between the two is that the odalisque in Baltimore rests in a landscape rather than sitting in the interior of a room. Ingres was commissioned by Charles Marcotte d'Argenteuil to do this painting. The story goes that the painting was hung in the smoking room of his house, a room used only by the men after dinner. It was hidden behind a curtain that was opened for viewing while the men sat with brandy and smoked cigars.

The painstaking labor in this drawing which is of lithographic or photorealistic quality indicates that Ingres intended it to be an independent work. Lithographic quality means an artist would go to these lengths to prepare a lithograph that could then be reproduced some two hundred times. In a market sense a lithograph gives the artist a better return for the work.

The meticulous finish of this drawing is another indication that Ingres spent a great deal of time working on it. The balance of wash, pencil, and chalk with gouache and highlights is perfect. The drawing seems fused in a soft light. It is a peaceful, quiet, and a relaxed scene. It takes hours of patience to make a drawing of this caliber.

We might call a drawing made in this manner "mixed media," although a mixed media drawing today is generally more active, bolder, and marked more heavily. The media are more evident on the surface in a modern drawing and are often the subject of the drawing. The media are not the "handmaiden" of the subject, as they are here. In Ingres's drawing you are unaware of the media. The drawing is completely tonal and resembles a photograph in its absence of line. This approach is relatively rare. It is pure sensual luxury.

Figure

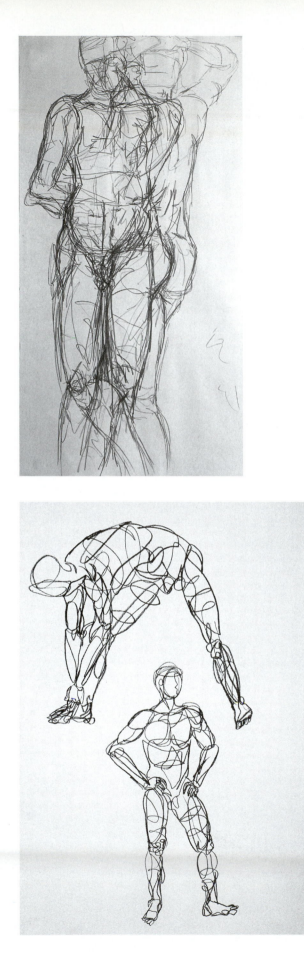

BEGINNING FIGURE STUDIES

One of the hardest forms to draw is the human figure. It is large, complicated, angular, round, and structured by connecting small and large planes that twist and shift. It poses problems in determining scale, proportion, perspective, space, and it is often draped. The contour of the figure is composed of linear measurements that become lines. A line that starts to define the figure's contour can move from the outside to the middle of the form. If you look carefully, you will see that the contour shifts and is very much affected by the joints of the figure (the knee, elbows, and wrists). Beginners tend to be preoccupied with the contour, surface conditions, and minor details. If a figure drawing is to be convincing, it must address the basic structural nature of the figure; it must be a volume in space.

GESTURE

Gesture depends on a rhythmic line. The drawing on the left, below, is a gesture drawing following the planes of the figure and including the invisible back planes as well as the front planes. The line wraps around the back and the chest. It envelops the entire figure. In this way it communicates volume or a sense of volume. The line follows, forms, and crosses the planes of each body part, hinging them together at the elbows, knees, ankles and wrists. The line runs through the groups of shapes forming the body.

The drawing to left and above is a gesture drawing of one figure overlapping itself three times. The model strikes a pose, holding it for eight minutes. He or she then turns a quarter turn, leaving one leg in the same position. After eight minutes the model turns again. The figure is redrawn over itself each time the model turns. The student has three drawings in which to study the figure's volume, shape, and proportions. In addition, the overlapping lines add movement to the drawing of the figure.

The drawing on the right page at the bottom is another example of the figure drawn three times as the model turns every ten minutes. In this drawing the artist unthinkingly redrew the entire figure, forgetting to keep the stationary leg for each of the three drawings. It is more open and reads more like a group of men standing around.

Above, Eric Bailey, pen figure; below, Sabrina Benson, figure study, student drawings, 1999.

Figure

MASS GESTURE

Mass gesture drawing creates volume. Rather than outlining the figure, it is rendered by defining the planes with flat strokes of Conté or charcoal. It is another process to study the parts of the body and the relationships between those parts. The drawing is built up slowly from light strokes to dark.

DRAWING EXERCISE: MASS GESTURE

Mass gesture is done with charcoal or Conté. Using the tool on the flat side, you rub, twist, and turn the stick to construct as much as draw the planes of the body. Pressure is key to this exercise. You start with very light pressure on the tool, wiping the shape of the planes gently on the paper. Start with the top plane of the shoulder and roll over the shoulder to the chest. From the shoulder you can construct the top and side planes of the arm. In the drawing on the right at the top, once the figure's right arm was built the artist could move back up the body with the Conté and connect the hand to the waist, the waist to chest. You add one body part onto the next. As you continue to examine the figure, you increase the pressure on the Conté or charcoal to define the planes that turn under and back or away from the front planes. If you make the arm or leg too small, just expand the volume with more strokes of Conté or charcoal. If the pressure is light, you will be able to easily add on to the form. Line is added last to define the contour, but the line should not be continuous or an outline. Use a short, broken line. The value of the line should be the same on the plane it defines. Otherwise the line separates from the plane and flattens the form.

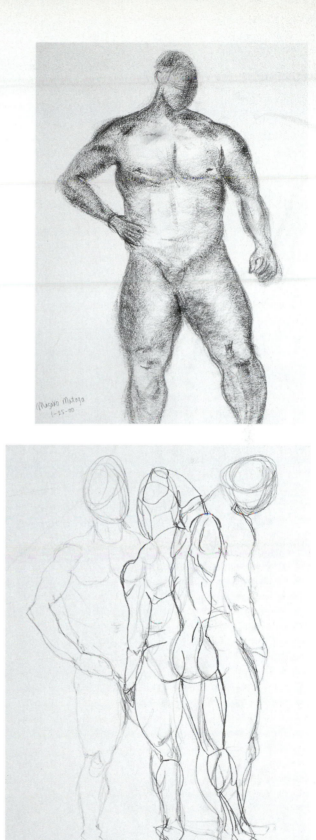

Above, Misako Mataga, charcoal; below, Alicia Frederick, pencil and charcoal pencil, student drawings, 1999.

Figure

215

CROSS-CONTOUR

In cross-contour drawings the figure is described by lines that are drawn horizontally across the figure following the surface level of the planes. Like a cartographer, or mapmaker, you draw the lines rising and falling across the figure's terrain. A good cross-contour drawing could provide a sculptor enough information to create the figure from just the drawing. The lines probe the surface, following and turning with the planes. They chart the volume of the figure. The lines should be close together. Sarah Parish has created the figure in a cross contour drawing on the left.

CONTOUR

Mandy Reeves used a loose contour line in the drawing below. This pose is excellent for drawing using the relationship of one body part to another. The model's left front leg was drawn first overlapping the shape of the thigh, and the space of the stomach is reduced or foreshortened in this pose. The rest of the figure was drawn by looking at each part in relation to this first leg.

DRAWING EXERCISE

To locate the body parts in relation to each other draw the forms from the front to back. Establish the height and width of the front planes, locate the head, and draw a vertical line from the nose to the ground. Mark off the location of any body parts that intersect it. In the drawing on the left the knee, the calf, the bottom of the thigh on the left leg and the back ankle all intersect this line. Draw a horizontal line across the drawing under the chin. Using your pencil to sight the placement of the breasts, both shoulders, the arms, and lightly draw them. Notice where these parts intersect the horizontal line. Draw a second vertical line from the ear down the drawing. Continue to draw vertical and horizontal lines from the knees, the ankles, and the feet across your paper, to construct the figure in proportion.

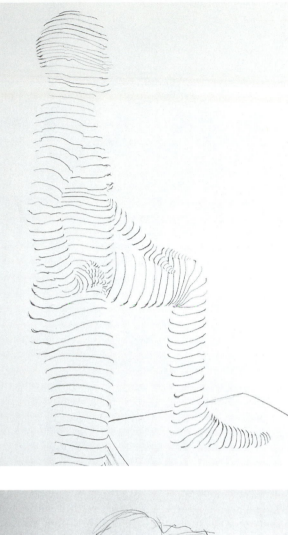

Above, Sarah Parish, cross contour; below, Mandy Reeves, planar analysis, student drawings, 2000.

Figure

THE FIGURE AS A CYLINDER

The best drawing instructor I ever had, Professor Ron Graff, introduced me to the figure as a series of connected cylinders. He called it "the garbage can theory of figure drawing, where one can fits or slides into another." If you think of the neck as a cylinder and you draw it round at the top and the bottom, it changes where you locate the shoulders. The knees, ankles, elbows, and wrists are the beginning and ending of the sliding cylinders. These cylinders are tapered, not even or straight like a tube. They are tubes with a narrow end and wider end. Drawing the figure as a series of cylinders describes the changing contour on both the outside and inside contours. Studying how the parts are connected, sensitizes your visual awareness to the specific shapes of the body's contour replacing the generalized version.

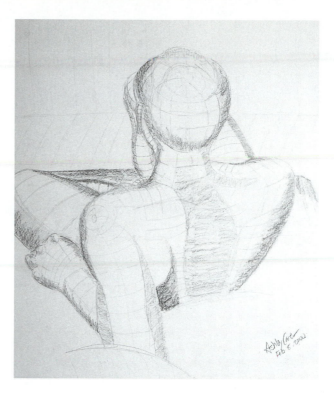

DRAWING EXERCISE

Have the model strike a standing pose leaning on one leg with the arms free in space. Begin with a torso, which you construct with ellipses. Use an ellipse for the waist, one at the chest, and one at the base of the neck. Connect them with light curved diagonal lines. From this start you add an ellipse for the top of the neck. Place the head on the neck, checking the angle of the head. Sight over from the neck to the shoulders and locate the arms off the shoulders. Use ellipses drawn vertically for connecting the hips to the torso. Draw the legs one cylinder at a time. For the hand each finger is a series of small cylinders fitted into the palm and top of the hand.

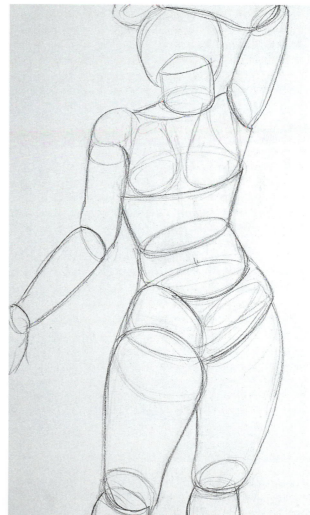

Above, Ashley Carter, cross contour, pencil; below, Mandy Reeves, cylinder drawing, pencil, student drawings, 1999.

Figure

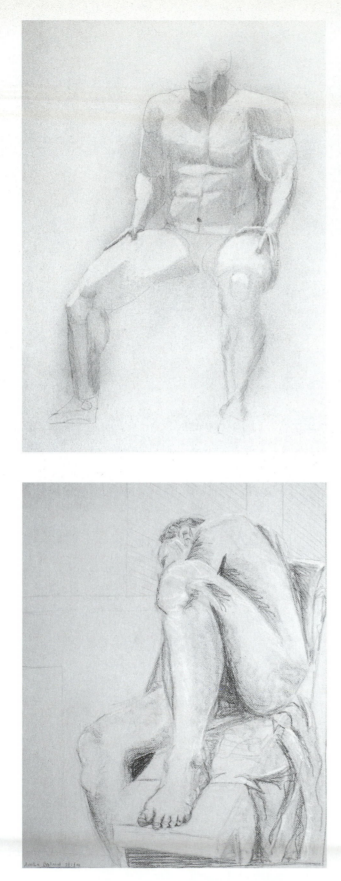

LIGHT AND PLANAR ANALYSIS

Contour drawing alone cannot describe the structural nature of the figure. The volume of the figure is established and revealed through value. Value is often misunderstood by students. Beginning students often think they will be looking at the figure and recording the way light falls on the planes or the forms of the figures. Actual light patterns can destroy structure. Light strikes any object in its path, sometimes revealing the structure, sometimes camouflaging and sometimes destroying it. For example, a figure standing in the cast shadows of a fence will be lost in the light patterns. Overhead lighting that spreads out, brightly illuminating the figure can flatten it. Understanding the process of chiaroscuro—where a directed light or focused light falls both vertically, and horizontally—allows you to model the form expanding the quality of the existing light.

In Vlad's drawing on the left is a planar analysis created by rubbing lead over an outline of the figure in which the planes were outlined first. The light changes by plane which reveals to volume of the figure.

DRAWING EXERCISE: RUBBED AND ERASED PLANAR ANALYSIS

Draw a seated figure, using the cylinder approach to draw the figure. Decide which planes are light and which are dark. Map out the top, side, and back planes in a light outline. Using a 6B pencil on the side of the tip apply a layer of lead to all the darkest planes on the figure. Take a tissue or paper towel and rub the lead across the entire figure. Rub firmly to cover the entire paper. Use a white plastic eraser and remove the rubbed gray value off lightest planes. Shape them boldly with the eraser, and then gently use the tissue at the edge of each plane. To change an area, rub over it again with a tissue and erase areas or add value to darken. Use the 6B to darken planes further.

Above, Vlad Voitovski, pencil, rubbed and erased; below, Amelia Eveland, black and white Conté, student drawings, 1999.

PLANAR ANALYSIS

The plane is the basic structural unit of the figure. A plane may be flat or curved. The boundaries of a plane may be described by lines. These lines represent changes in the surface of the figure. The planes of a cube are easier to identify than the planes on the body. Each side or surface composing the cube is a plane joined at the edge to the other planes. In nature planes may be clearly identified with a change of color, texture, or value. To analyze a figure's structure, start by locating the large planes of the head, chest, pelvis, hips, knees, lower legs, and arms. Then find the small planes that hinge the large planes together.

Planes are a result of muscle groups attached to the skeleton. In analyzing the structure of the figure, establish the shape, scale, and direction of the major planes first. Focusing on the small planes first will make the drawing fussy and weak.

Tonal divisions or value changes from light to gray to dark clarify and establish the planes, convincing the viewers that they are looking at a volume, not a flat figure. The drawing on the facing page at the bottom uses light to dark on the figure and the drapery under the figure to establish the figure and the ground. The value changes turn the eye across the form.

DRAWING EXERCISE: PLANES OF THE HAND AND THE FEET

Concentrate on your own hand or your own feet as the subject of this drawing. For the hand study, close your fingers into a fist. As you look at the top of your closed hand, you will see a plane from the wrist to the beginning of the fingers and another plane from the knuckles to the first joint of the fingers. Draw this, noting the angle of the hand and the direction of the planes. Make three drawings of this view of your hand, changing the position for each pose.

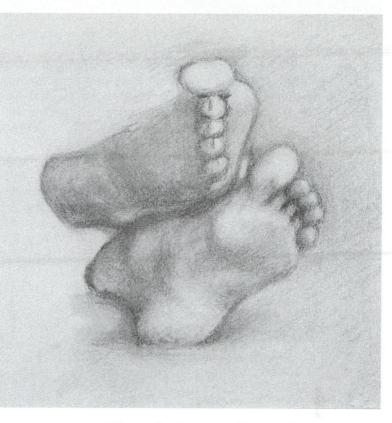

Ivan A. Tomicic, Conté on paper, 12.5 × 12.5″, 1989.

Turn your hand over, now looking at your palm. There is a plane at the end of the fingers, then a top plane for each finger. Draw this view of your hand. Change the position of your hand and draw three views of this side. To draw your feet, prop them up where you can see them and study their structure by plane. The large top plane rolls over to a side plane at the ankle and over the arch. Each toe has a top plane and two side planes with a bottom plane you may or may not be able to see. Draw your feet large. It is easier to understand the complicated structure of the foot if you have room to manipulate the form.

Figure

FORESHORTENING

The figure is subject to the laws of perspective. One aspect of linear perspective holds that any view of any solid mass involves the foreshortening of some planes, forms, or surfaces. When a form or body part projects out toward you in the picture plane, your understanding of shape and form is challenged. You cannot draw this pose by using remembered size and shape notations about the form of the arm or leg. In foreshortening, the fact that an arm or leg has length is negated by its position in the space of the drawing. All the planes centered in the viewer's line of sight are drawn as foreshortened. Those at a right angle to the line of sight are not foreshort-

ened. Depending on your experience with fore-shortening, you may or not be able to identify that a pose is foreshortened. The less you can see of a plane of a body part, the more foreshortened it is. In the drawing below a man is stretched out on the ground. This is a foreshortened view. The drawing starts at the front of the picture plane with the feet. In that way, each receding shape can be added on to the one in front of it. The major and secondary planes are modeled as overlapping and interjoined. The distances for the segments of the body are shortened, as you draw the body moving to the head. The chest is one large mound separated from a huge nose. We don't see the neck. We see the chest and then the man's head and nose. Foreshortening

Giovanni Battista Tiepolo, 1696–1770, *Drunken Punchinello*. Thaw I, no. 48. Pen and brown ink, brown wash over black chalk. 6¼ × 6″. Pierpont Morgan Library, New York.

Figure

demands that you look very carefully at the location of each shape in the drawing. As your ability to see shape like a silhouette or a flat puzzle piece increases, you will improve your level of perceptual skill and ability to construct a foreshortened drawing.

The figure can be drawn in proportion by looking at the relationship of one part to another. Relating one part to another determines the location, and size or scale of each body part. In the top drawing on the right, the front arm was drawn first, the back and the chest were added on in terms of where they visually intersected the arm. Notice how the right arm flows from the line for the back at the eyebrow level. The bent back leg fits between the chest and the hand of the right top arm. The calf of the right leg covers the bottom left leg seen in the bottom area of the background. This drawing was made by adding parts from the front to the back and checking where they start and stop in terms of the other parts of the body. It is foreshortened. The figure has no waist. We believe his back is large, but the actual space it occupies in the drawing is very small. Foreshortening convinces you all the parts are there and that they are in the correct human scale.

To start a drawing of the figure from the front like the drawing below on the right, establish the level of your horizon, your eye level, first. Remember that lines below the horizon vanish up and lines above the horizon vanish down. This will set a format for you into which you can place the figure. Always draw from the front forms to the back. Here the feet and legs are in the front of the picture plane. If you start with the figure's head and shoulders, the proportions will never be right. For him to sit in the picture his shoulders should fit inside the space of his legs, not outside. His hips will be slightly tapered to sit back in the chair. The width of the figure in a one-point perspective diminishes. If you drew the chair in perspective, the seat would be smaller in the back than at the front. The sizes of forms composing the figure follow that same rule. The hips should fit into the two parallel lines vanishing to form the chair.

Above, Amelia Eveland, charcoal wash; below, Mandy Reeves, brush and ink, student drawings, 1999.

Figure

221

George Bellows, 1882–1924, *Dempsey through the Ropes*. Black crayon. Metropolitan Museum of Art, Rogers Fund, 1925. 25.107.1. New York.

VALUE AND SPACE

The space of a drawing is controlled by the placement of light and dark values. Actual light falling in a space has little to do with where an artist might illuminate a drawing or darken it. The location of light and dark in a drawing has more to do with how artists want the viewer to perceive the space of the drawing, where they want the focus of the drawing or want the viewer's eye drawn. With an understanding of the process of chiaroscuro, you can apply the quality of light to your drawing.

In the drawing above, George Bellows has captured the drama of Jack Dempsey being knocked through the ropes by Firpol, the Bull of the Pampas. The light figures are framed by black background, giving the feeling of deep space. The men in the front catch Dempsey and put him back in the ring.

In *Carnival Scene,* the drawing on the top right, the even balance of the background shapes flattens the background. We don't move back in this space; we move back and forth across the space trying to decipher the blurred images.

The white figure on the opposite page emerges out of the black background. The face and back arm have been grayed setting them back from the front of the picture plane. Angela's drawing to the right reverses the values, darkening the front planes against a light background.

Figure

Eugenio Lucas, 1824–70, Spanish, *Carnival Scene.* Bistre wash with red chalk. H.10, W.15¼". Fletcher Fund, 1942. Metropolitan Museum of Art. 42.186.2.

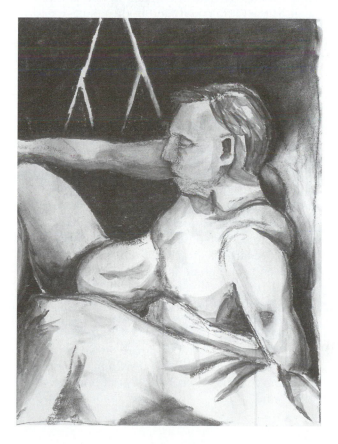

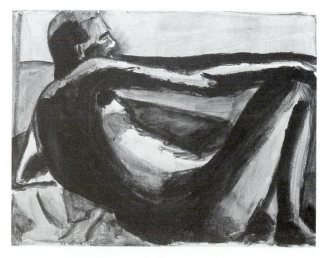

Left, Erin Stephenson, charcoal wash; above, Angela Gross, charcoal and ink, student drawings, 1999.

Figure

PLACING THE FIGURE IN SPACE

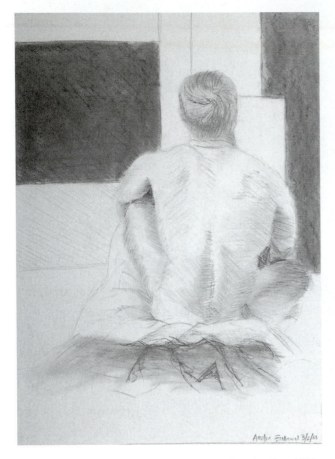

Amelia Eveland, Conté on colored paper, student drawing, 1999.

Correctly proportioning the figure is equally important to drawing the space around the figure. A figure alone is interesting only to a point. A figure acting or located in space is much more striking.

Value, scale, texture, and line all play important parts. On the left a figure sits where the space of the studio has been converted to planes of light and dark framing him. His body is modeled from light to gray with dark on the right leg and the areas between the arms and torso. The rotation of value between light and dark moves our eye through the space of the picture plane, convincing us we are looking at real space.

On the facing page Mary Cassatt has balanced the space of the picture plane in the manner of the Japanese print. The shapes without modeling seem flat. The thin simple lines define the shapes and their edges ever so slightly. The most important aspect of this print is how she balances the size of each form in the drawing. The woman occupies over one-half of the picture plane. The chair she sits in fills the entire front of the picture plane. Notice how the tilt of her head drags your eye into the space of the print. The scale of the table is reduced in the space, locating it in the back of the space. This follows the rule of perspective that things get smaller as they move away from us. Her head overlaps the table, increasing our visual perception that the table is across the room. Cassatt has handled the lamp in an interesting manner. The lamp is at the back of the picture plane, but by adding the mirror with a reflection of the lamp, she has increased its presence, not decreased it.

She has flattened the space of the picture plane. Everything in the scene fights to come forward. Nothing really wants to sit back being unnoticed. Her rotation of light to dark reinforces the total sense of flatness. Every form except the table is attached to the edge of the picture plane. The chair is attached to the front of the picture plane, the fan to the left side, the mirror to the top and both sides. The lamp spreads out with its reflections to attach to the top and both sides also.

When you draw a figure in space or the space of a room, carefully consider the relationship and the size of both the figure and the space or ground.

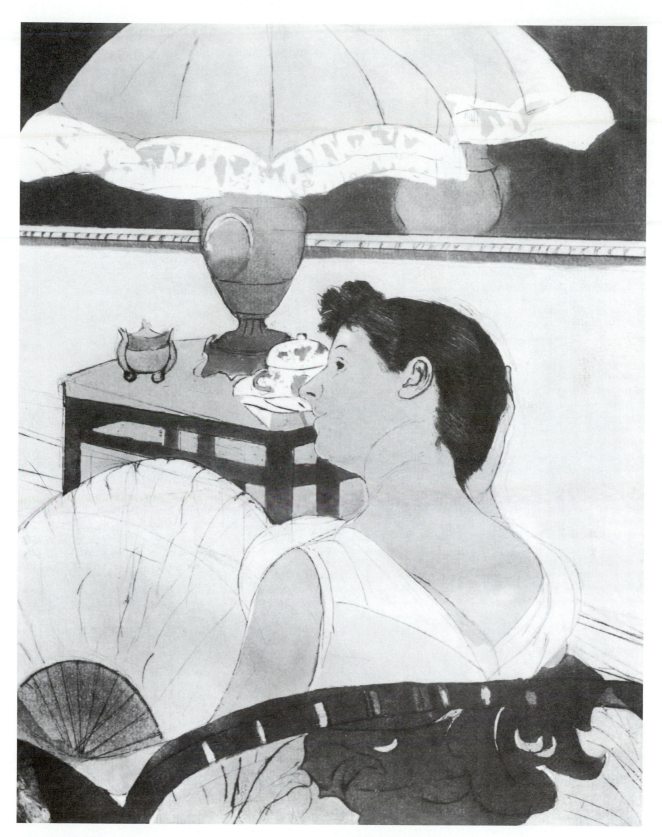

Mary Cassatt, 1845–1926, *La Lampe,* print. Dry-point and aquatint printed in color. Gift of Paul J. Sachs, The Metropolitan Museum of Art, Acc.No. 16.2.6. © 2001 Artists Rights Society (ARS), New York/ADAGP, Paris.

Figure

THE CLOTHED FIGURE

The beginning student may be more comfortable with a clothed model than with a nude model. The clothed model presents three drawing problems. First, the proportions of the figure can be addressed, then the drapery can be drawn, and finally a portrait or facial studies can be made. Figure studies depend on a good understanding of basic foundation skills.

The folds and creases of drapery are determined by the skeletal and muscular network of the figure. The volume of the figure can be revealed in the form of the drapery. The drapery studies earlier of hanging and folded cloth can now be applied. There is a difference in how we perceive the figure clothed. Chandra's drawing accentuates the way drapery turns in and out. There is an attention to preciseness.

Chandra Allison, student drawing, 1999.

Figure

DRAWING EXERCISE

1. Practice drawing the clothed figure by sitting in a park or at a cafe and sketching people sitting with their backs to you or walking by. If a friend will sit for you, make five- ten-minute drawings by using a continuous line. Follow the folds and curves of the drapery around, drawing them with a free-flowing line. Let your eyes move up and down across the subject's clothing, forming their shapes. In a long pose map out the figure and the folds of the drapery on the clothing of your model.

Use value change to define the shape. Darken the undercuts and sides of the drapery that turn back or into the body. Leave the top planes white.

2. Put a glove on your hand and draw your gloved hand. It will help you with drapery and with the underlying structure. First draw the relaxed hand and then the tense hand.

PROPORTIONS OF THE FIGURE

The traditional unit of measure for the figure is the head or skull. Leonardo determined the adult figure to be eight heads high. When measuring the figure, you will find the head measurements fall between major parts of the body—the chart below has been divided into the eight parts. Note where the divisions intersect the male and female figures. The hip, is generally considered the mid-point of the figure, with the top of the pubic bone the halfway mark. Use sighting to proportion the figure by establishing the size of the head. The head measurement, can be established by lining the end of the pencil up with the top of the head and placing your thumb where the chin line intersects the pencil's shaft. This is the one unit you repeat. At the beginning of a figure drawing mark off eight heads on your paper. Fit the figure into the predetermined proportions.

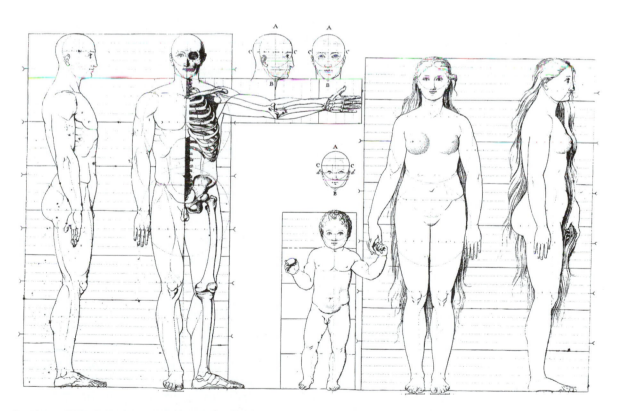

Borghese, From Savage's *Anatomie du Gladiateur Combattant,* Plante 19, Francis A. Countway Library of Medicine, Boston.

Figure

Taddeo Zuccaro, 1529–66, *Standing Nude Man*. Red chalk, heightened with a little white. H. 16⁹⁄₁₆, W. 11⁵⁄₁₆". (42 × 28.7 cm.). The Metropolitan Museum of Art, Rogers Fund, 1968. 68.113 recto.

In the beginning you might make the body parts too long. Once the figure takes a pose, some part of it will be foreshortened. You will need to adjust from what you know of the length of an arm or leg to what you are actually seeing.

Both arms and the torso of the figure on the right have been foreshortened. The legs occupy the front of the picture plane, and the torso is turned toward the back of the picture plane. To create this turn inward, the arms and torso are foreshortened. The large legs in the front help to create the effect of turning back into space. The twist is so subtle you feel it is completely natural. Notice the placement of the feet, the angle of the knees, and the beautiful diagonal line from the chest to the front foot.

DRAWING EXERCISE

The top of the pubic bone is the midpoint of the figure. That is the distance between the soles of the feet and the top of the head. The knees are halfway between the groin and the feet. The point just at the bottom of the breasts is halfway between the pubic bone or groin and the top of head. With these divisions in mind, mark off eight equal parts on a piece of paper and copy the drawing by Taddeo Zuccaro by fitting it into the eight measured proportions.

DRAWING, THE NUDE MODEL

It is best to warm up with a number of one- to five-minute gesture drawings when you first start studying the figure. Newsprint and pens or 6B pencils work well at this stage. Some schools have plaster casts of the figure or head to work from in the beginning. This is

Figure

helpful in getting accustomed to the intricacies of the human form. Don't concentrate on making the figure look correct at first. Concentrate on uniting all the parts of the figure and noticing the relationship of one part to the others. Try to see the figure for the first time each time you draw. If you impose the order you carry in your mind's eye, your figure will be lifeless and often out of proportion. In a gesture drawing the angle of the spine is important. Find the angle of the spine first, and then find the angle of the arms and legs attached to the spine. Look carefully at how the body is bent or bending. Rarely will the figure be at 90-degree angles to you and your paper. Here is where imagining a picture plane between you and the figure helps you determine the angle of the figure.

It is easiest to draw from the front planes to the back. In the drawing by Zuccaro you would start with the figure's left leg.

When the figure is seated as in the drawing on the top right, you can use four to five heads to measure to hip as a general measurement. Any figure leaning back away from you is going to be foreshortened, so the measurement won't be accurate by heads. The relationship of one body part to another can help you locate the knee and foot. In Mandy's drawing the first line established the angle of the body, the head was drawn behind the arm. To locate the parts of the figure draw a vertical line from the nose down the paper. Mark off the location of the other body parts where they intersect this line. Draw a line from the elbow down, and one from the wrist. Organizational lines help you locate the parts of the body.

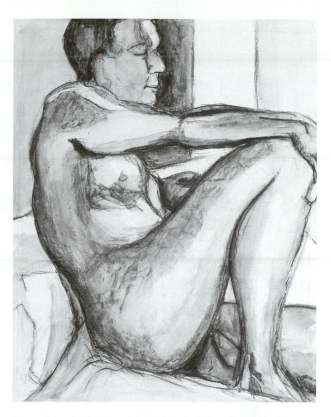

Above, Mandy Reeves, charcoal wash; below, Sarah Parish, charcoal wash, student drawings, 2000.

TWO FIGURES

The large mural drawings by the Renaissance artists as well as later works with groups of figures were composed from figure studies of individual models. The artists had done so many studies they had committed the human form to memory. They could make up figures with their imaginations based on this knowledge.

The drawing on the lower right is two models posing at the same time. Drawing two models increases the importance of the space. Value delineates the planes and changes on the figures and from front to back in the space.

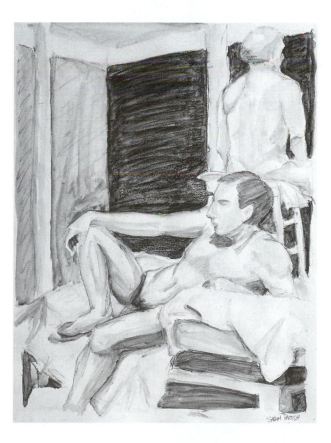

Figure

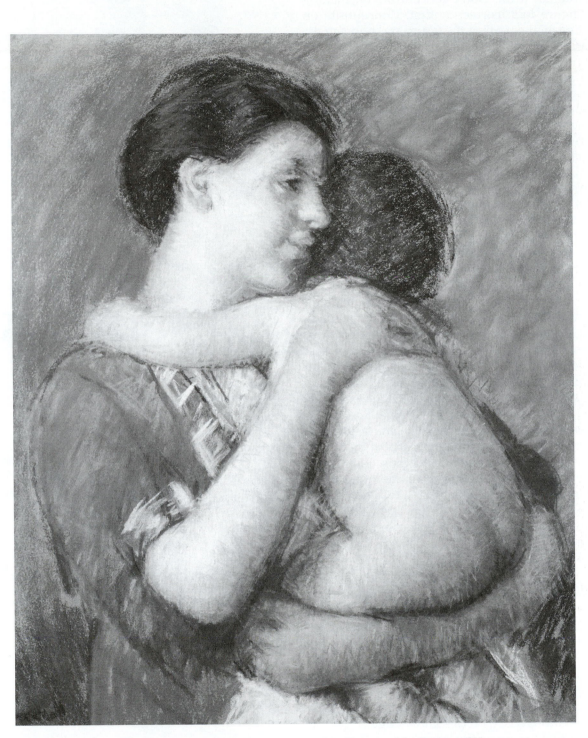

Mary Cassatt, 1845–1926, *Mother and Child*. Pastel. The Metropolitan Museum of Art, bequest of Mrs. H. O. Havemeyer, 1929. The H. O. Havemeyer Collection. 29.100.50. © 2001 Artists Rights Society (ARS), New York/ADAGP, Paris.

Figure

COMPOSITION

Mary Cassatt based many of her drawings on the theme of mother-and-child. It is the classic reference to Mary and Jesus. The two figures are drawn together in an embrace or often with the mother leaning over the child.

To draw is also to design. Composition can be thought of as a sense of order. Artists gives life to the drawing by the way they compose the picture. Spatial structure depends on the content, the medium, and locating the forms in concert on the page. Good techniques of drawing or handling the surface with any medium are meaningless without a quality of life invested in the subject. A drawing is balanced when all these aspects exist and support one another.

Pastel exists between painting and drawing combining features of both. The hatching marks that Cassatt used to build the drawing are part of the graphic linear tradition. Drawings are traditionally black and white. The color of the pastel makes it a color drawing. In addition, this hatching stroke adds a soft but blurred impression of the two figures. The hatching stroke as a technique is used to layer the pastel from light to dark.

Diego Rivera, Mexican, 1886–1957, *Sketch for the Lenin Panel.* Rockefeller Center, 1933. Pencil on paper. Portland Art Museum, Oregon. Gift of Lucienne Bloch and Stephen Dimitroff.

Diego Rivera in the sketch above was planning the composition of a large mural he was commissioned to paint by the Rockefellers about Lenin and the Russian Revolution. The figures are arranged in a triangular format. This mural was composed of a number of related parts collaged together to create the whole. The figure-ground relationships of the final composition were complex.

Figure

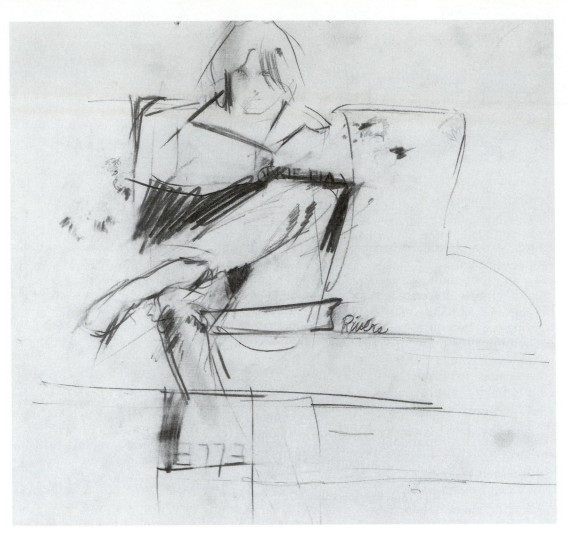

Larry Rivers, b. 1923, *Seated Woman,* c. 1965–70. Pencil on buff wove paper. 357 × 424 mm. Anonymous gift. Cantor Arts Center, Stanford University.

CONTEMPORARY FIGURES ABSTRACTION AND REALISM

Larry Rivers is more a Pop artist than an Abstract Expressionist, in the American art movement in New York from 1945 to 1960. Pop artists in New York in the 1960s, sought to draw from the common moment or from everyday experiences. Common objects were made art. The Campbell's soup can was one of the more famous subjects used by Andy Warhol.

Here the figure is loosely structured in the space. Not all the body's parts are drawn. Rivers leaves the arms out, a foot is missing, and the right shoulder is shifted off axis. Value is used as a part of the composition, not as a device to

impart a sense of volume but as an element to divide the body parts. You might think this is an early sketch or a beginning, except that if you look at Rivers's paintings, you find he brings this sense of incompleteness into a finished painting quite often. He is expert at collaging images and text together. Unlike other pop artists, he often used the figure as his subject instead of only popular objects. His paintings re-created historical scenes like George Washington crossing the Delaware in the Revolutionary War and the classic pose of Napoleon painted by David. He once made a painting of an Old Masters cigar box that had used Rembrandt's painting *Masters of the Syndics Guild* for its corporate image. The Rembrandt painting was reproduced on the inside of the cigar box lid. Rivers incorporated

Figure

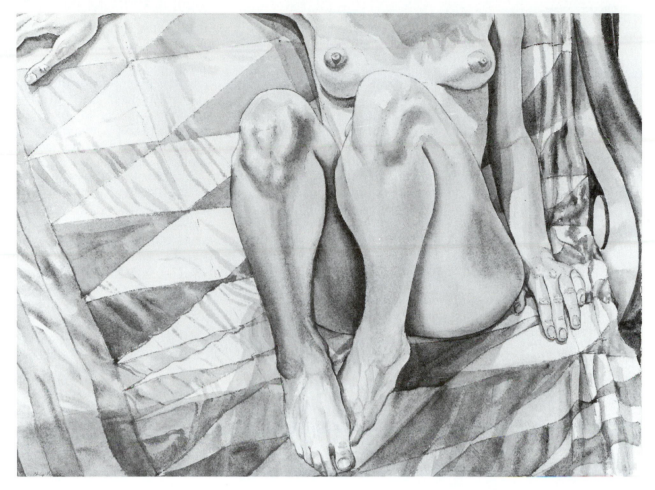

Philip Pearlstein, American, 1924–), *Female Model Seated on a Lozenge Patterned Drape,* 1976. Sepia wash on paper. Portland Art Museum, Oregon. Purchased from Anonymous Purchase Fund.

the line and wash techniques, plus the ambiguous figure-ground inventions of the abstract expressionists.

Phillip Pearlstein is close in age to Larry Rivers but has a completely different approach to rendering the figure. His style is not loose but graphically tight. His figures are photographically real. This separates them from the tradition of figure drawing, which although realistic, was not as real as photorealism. There is a softness to traditional drawing or drawings prior to 1900. The new realism in art after 1960 is bold and can be harsh. Here Pearlstein brings the figure in a well-modeled state flat up against the picture plane. He contradicts our understanding of space by eliminating high value contrasts. This figure does not have the amount of space she needs to sit back into the space of the drawing. It is deceptive: you think you are looking at a figure sitting in space, but if you look closely you will see there is no modeling on the chair she sits

on to place her flatly on the chair. The drapery is taut on the left. It doesn't reveal any of the underlying structure of the chair; it is more curtainlike than background. There are slight value changes under her on the drape from a shadow she casts on the fabric. We are to assume her feet rest on the edge of the chair, but a closer look reveals they could also be floating above the edge of the chair. There is a lot of tension in this pose when you examine it instead of accepting your first impression that it is only a beautifully drawn figure.

Figure

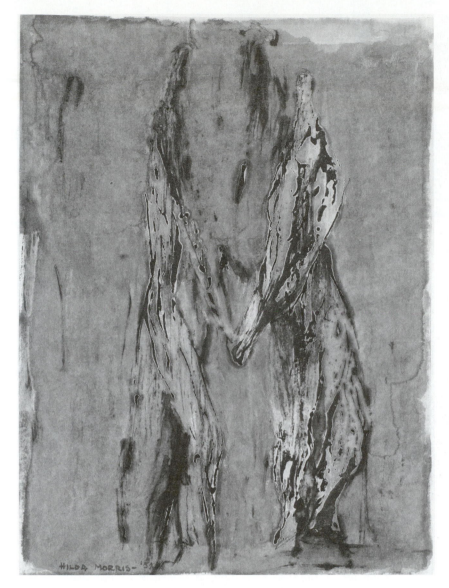

Hilda Morris, American, 1911–91, *Night Figures*, 1952. Colored ink on paper. Portland Art Museum, Oregon. Gift of Mrs. Mildred Beail.

MODERNISM IN ART SINCE 1900

With the Industrial Revolution and the invention of the camera, artists were freed in their creative pursuits to open the doors of perception and change the definition of art. Abstraction replaced realism.

Hilda Morris was an artist in the Pacific Northwest. She followed the path set by Picasso, Braque, Giacometti, and Matisse in learning the lessons of Modernism. She worked mostly in Portland, Oregon. Her drawing *Night Figures* on the left is colored ink on paper. The figures are abstract and yet recognizable in a dreamlike sense. She has drawn the essence of the figure.

In the summer of 1952 Willem de Kooning moved to Southampton, Long Island, to work. He left his New York studio and the large canvases of woman after woman where he had wiped out the paint many times in an unrelenting quest. He told critic David Sylvester, "The Woman paintings became compulsive in the sense of not being able to get hold of it—it really is very funny to get stuck with a woman's knees, for instance. You say, 'What the hell am I going to do with that now?'"

Away from the city he reduced the size of the work and brought two women into the composition. He also began working in pastel. Concentrating on the tricky new medium, he let the images tumble out in a kind of automatic stream from the stored images he had saved from working on *Woman I.* The women are set in the countryside. Windmills of Holland make an appearance in some of the drawings, along with clams, hamburgers, tables, and chairs on the

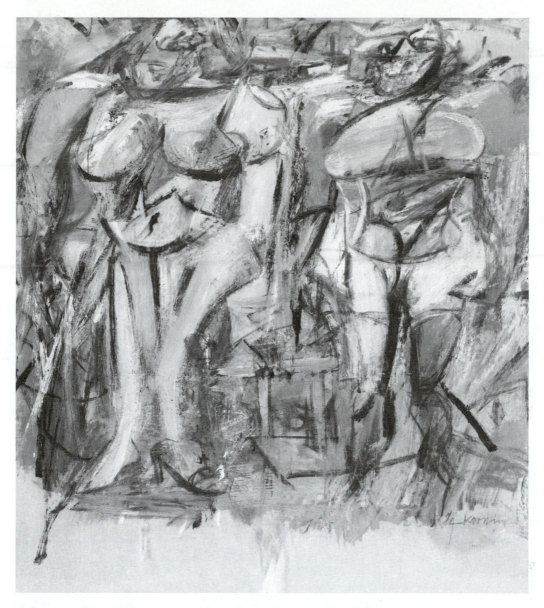

Willem de Kooning, *Two Woman in the Country*, 1954. Painting, oil, enamel, and charcoal on canvas. Alternate # JH64.159, JH 3678. Hirshhorn Museum, Washington D.C. © 2001 Willem de Kooning Revocable Trust/Artists Rights Society (ARS), New York.

lawn. The shapes of the women drift in and out of this ambiance, warmed by the sun and dappled with reflection of the beach and meadow.

De Kooning pulled the anatomy apart, flattened it into shapes, and often pushed the shapes to seem heart-shaped. He had a concept of interchangeable parts of the body, or "intimate proportions," as he called them. Each part was given an emphasis that, carried to conclusion, became independent and equal in weight to all the other parts. So the "thumb" could become a "thigh," which could become something else and could also become "nothing"—an abstract element.

The painting above follows two years of drawings on this subject of two women in the country. De Kooning keeps the same tension and movement in his paintings that we find in his drawings. Where he cuts the figure apart, the space becomes a shape. The painting is an elaborate variation of shapes and of spaces in between shapes. It is woman and her environment. De Kooning always insisted that the woman was not only a figure but also a structure for his painting. Using two eyes, one nose, one mouth, two breasts, and one belly he had an objective framework that he expanded, inventing the composition from his inter sensations, and his imagination.

Figure

CHAPTER 12
Landscape

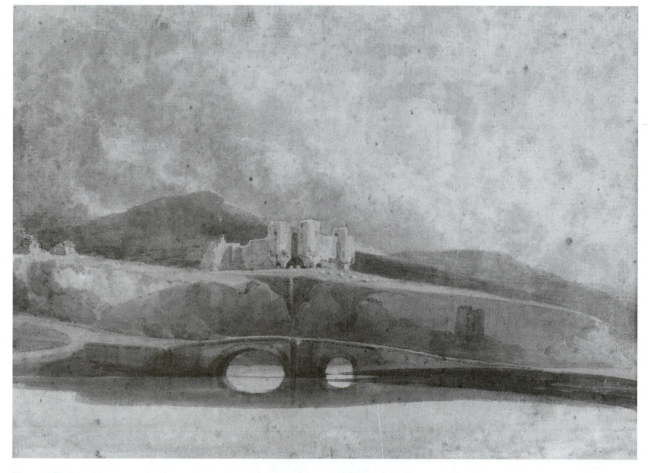

Thomas Girtin, 1775–1802, *Rhuddlan Castle* 1799. Pencil and watercolor on ivory laid paper, 287 × 396 mm. Cantor Arts Center, Stanford University, 1989.62.

"Nature imitates art."
Oscar Wilde

Landscape has been a focus for artists since Leonardo da Vinci. In landscape the artist has weather and light changes to render and interpret. There are textures and patterns in light and in nature's forms to explore. Landscape can be realistic, surrealist, expressionist, or abstract. Landscapes may be drawn in pencil, ink, wash, Conté, or charcoal. It is all determined by the preference of the artist.

When you first read the quote from Oscar Wilde, you think, "What is he saying?" If we remember that the way we see is developed by the people around us, the meaning gets clearer. People weren't particularly interested in atmospheric conditions in the past. They were something you tolerated—a part of life but certainly not art. Then Turner painted his sunsets and people would be heard to remark,"Oh, look it's like a Turner" or "It's a Turner sunset." Thus nature imitates art.

LANDSCAPE AND WASH

Thomas Girtin was a contemporary of Turner. His training at the informal "academy," at Adelphi Terrace the home of Dr. Thomas Monro was spent copying watercolors by J. R. Cozens in the doctor's collection, from this traditional line of study, he developed his personal style. It was his sketching tours in Yorkshire and the Scottish Lowlands that further advanced his personal style. The watercolors he brought back from these trips were large and energetic, noteworthy in the painterly handling of color. Instead of underpainting his watercolors in gray monochrome as the tradition dictated, Girtin laid in the main forms and the ground in strong local colors, giving them a rich effect. Local color is the actual color of an object—for example, an apple is red.

He started with broad washes in his underpainting over a light pencil sketch of the space to be painted. Soft rags and tissues were used to lift wash out to create an uneven effect in the value. Girtin's sky has that unevenness. The unevenness of the ink wash is especially perfect for rendering a cloud-filled sky and the surface of the water. When a loose, broad wash was placed on the sketch, the lightest areas had to be painted around, and the white of the paper was left.

This wide sweep of vacant space is striking. The horizontal format is countered by the gateway to the castle, the ravine below it, and the pier of the bridge all aligned along a vertical axis. Girtin rotated the values from light to dark back and forth from the sky to lake, creating the space.

Karl Blechen, 1798–1840, *Birch Trees at a Stream, Sketches of the Trunk of a Willow Tree*. Pen and gray and black ink on buff wove paper: 245 × 218 mm. Cantor Arts Center, Stanford University.

Landscape

WORKING OUTDOORS

Drawing *en plein air* (outdoors) involves facing the elements and setting up a comfortable area to work. Georgia O'Keeffe painted outside in New Mexico. She would load her Model T with canvases, paint, brushes, and her maid and go off camping for three days in the desert.

Monet would get up before light, have breakfast, also prepared for him by a maid, and then his boatman would take him to his raft out in the lily pond, where four or five canvases stood waiting. Each canvas represented a certain hour of light. He would work on the first one until the light changed, then move to the second one, and so on until noon, when he went home for lunch. In the afternoon he worked in his studio.

For drawing outdoors, you will need to prepare a small kit of tools with brushes, pencils, charcoal, and ink. A portable easel comes in handy. For wet media you will need a water container and cup. Paper can be loose sheets taped down or watercolor pads that are twenty-some sheets glued together on a hard board. These watercolor pads are very easy to use. If you take loose sheets, you will need a drawing board. You can either sit on the ground or bring a folding chair. If you draw in charcoal, it can smear when you transport it. Use no-odor Blair spray fix or place a piece of newsprint taped over the drawing to prevent it from smearing. Don't forget to take a hat and sunglasses, as well as a sandwich in case you get hungry.

PICTORIAL ELEMENTS IN LANDSCAPE

Karl Blechen's ink drawing on the opposite page was executed in heavy pen strokes made with a reed pen. The hatching is rounder and softer with a pen. It is balanced to define the side of the trees, leaving a large light front plane. His strokes create the grass and the leaves. The density of the ink in the top of trees is balanced with the white ground below. The way he made the strokes is important. He has imitated the grass with different strokes through the drawing. Changing the size of the stroke is important in rendering space. Strokes all one size and shape will flatten the picture. The size of the stroke reflects the shape of the grass and the light around it. The small strokes for leaves in the trees allow light to show through the branches.

Landscape can be overwhelming. It is important to focus the space you wish to concentrate on. You can't draw the entire expanse. Select a view, frame the space with your hands, or use a cardboard viewfinder, which you make by cutting a rectangle out of the center of a piece of cardboard. Select a section of the landscape by looking through the viewfinder with one eye closed.

In Blechen's picture he has focused on this group of standing trees with a couple of downed trees nearby. The area behind the trees is very unclear. Black and gray strokes merge with one silhouette of a tree in the back of the picture plane.

Pay close attention to the linear details in nature and don't generalize form. You can use either bold black and white or subtle gradations of value. Look carefully at the size and shape of your subjects.

Yasuo Kuniyoshi, *Near the Ice House Provincetown,* 1940. Portland Art Museum, 4040.

COMPOSITION
ESTABLISHING THE SPACE

Each individual form and shape in the landscape get careful consideration in terms of their placement, value, and texture. To compose the space, the relationships of the forms must be considered. After you determine what will be in the picture, you must decide where it will be drawn on the paper.

PLACEMENT is crucial in composition. The fact that your eyes see the trees and the houses in the landscape doesn't mean they know how to intuitively inform your brain or communicate the information with the mind's eye, which orders everything. You should use your knowledge of one- and two-point perspective to place the forms in the drawing.

VALUE

VALUE is important as it directs the viewer in seeing the space of the drawing. Determine the direction the light is falling to control the light and dark in the picture. If you make everything one value, the viewer's perception of the drawing will be that it is flat. It is value changes that physically push and pull the viewers eye around the composition.

SCALE the size of each element in the picture must be considered. The scale of each form and the relationship of one form to another is an important consideration in determining the final composition.

Yasuo Kuniyoshi in his drawing *Near the Ice House Provincetown* (1940), above, has framed the space of the drawing on the left from top to bottom with the trees in black. A single "widow maker," or dead snag, is positioned in front of the trees reaching farther into the sky. The snag is drawn with a lighter value to sit it in front of the trees. The smaller scale of the houses sets them back in the drawing. The lighter values in the background increase the sense of space fading to the horizon.

In Rembrandt's drawing the vanishing point is again to the right on a diagonal line, as in Kuniyoshi's drawing. The line composing the

Rembrandt van Rijn, Dutch, 1606–69, *Two Cottages*. Pen and brown ink, corrected with white chalk and/or body color. H. 150, W. 191 mm. 17th c., ca. 1636. The Metropolitan Museum of Art, The Robert Lehman Collection, 1975.1.801.

Two Cottages is loose and gestural. The placement of the loosely described cart on the right creates space in the drawing. Because it sits in front of and overlaps the cottage, we know there is a plane or a road or a yard between it and the cottages. Ink is an excellent medium to use in sketching because you start with a single line contour that can be overlapped with more lines to model and change the form. The tree for example, was drawn first and then the lines for the fence were drawn over its base.

The front porch of the cottage on the left has been substantially darkened with hatching lines. The artist leaves two figures standing in the doorway. His line is so gentle you can feel the thatched roof sagging.

DRAWING EXERCISE

Take a sketch pad with a drawing tool such as a roller ball pen or other pen, a pencil, or charcoal, and select a group of houses in your neighborhood to concentrate on. First determine which houses and spaces should be included in the picture. Organize with a light sketch the location of the trees and houses, determining the perspective with the location of the horizon and vanishing point. Consider the scale for the drawing, the size of each element, and the location of each form to the others. Add modeling lines, darkening the forms in the foreground. Leave the background to the horizon in lighter values. Look at the sky and determine how to create the texture of the air. Perhaps there will be clouds to help with the space, but if not consider Kuniyoshi's solution allowing value to hold the space of the sky.

Camille Pissarro, Saint Thomas (lesser Antilles) 1830–1903, Paris, *Landscape at Eragny-sur-Epte.* Watercolor 7¾ × 9¹⁄₁₆″ (184 × 230mm). Pierpont Morgan Library, New York #76.

TEXTURE AND PATTERN

The work above by Camille Pissarro is a water-color over traces of graphite. It was painted at a house he lived in with a garden and a field about two hours from Paris. Pissarro placed great emphasis on working from direct observation of nature. The weather as well as the changes of light though the day and through the seasons was taken into account in his work. Some call him a neo-Impressionist because of his use of certain stylistic traits of the neo-Impressionists. His work had a certain compositional rigidness. His careful use of complementary colors may also have had to do with the fact that in 1885 he met Seurat and Signac. Seurat was a famous pointillist. The pointillist style of placing dots to build forms and leaving white paper between them creates a shimmering effect. The points may be concentrated, far apart, or evenly spaced. Each arrangement references light falling. This process, a form of stippling, textures the entire work. It is a good way to graphically describe light. From about 1885 to 1890, Pissarro made drawings and watercolors in this pointillist style. His letters indicate that they were intended to be sold as independent works, and were not studies for future paintings.

DRAWING EXERCISE

Select a grove of trees, a tree in the park, or a tree in the yard as your subject. Draw a border on your paper to frame the space of the drawing. You will need a cup with a little water, ink, and a Q-tip. Dip the Q-tip in the ink lightly and then mix that drop into the water. Work from the background to the foreground by placing dots of the ink wash far apart in the sky. Use light and dark ink dots to develop the entire composition. To darken the wash reduce the water and add more ink.

Thomas Girtin, 1775–1802, *The Eruption of Mount Vesuvius,* London. Brush and gray wash, over some pencil. #57 Pierpont Morgan Library, New York.

IMAGINATIVE DRAWINGS

Thomas Girtin, after studying at the Monro Academy, joined a sketching society in London. It was often referred to as Girtin's Sketching Club. One of their meetings was at the home of Robert Ker Porter. They would take a topic for the evening and invent a painting to reflect the topic. They usually selected a "poetick passage"—lines of poetry from poets like James Thomson, a Scottish poet, best known for his four poems titled "The Seasons." Each season confirmed the sublime power of nature. Such would be the inspiration for the painting that night.

On the back of *The Eruption of Mount Vesuvius* it says "Drawn in the House of R.K.P., 1800." According to the rules of the sketching society, the drawing was given to the host, Robert Ker Porter, at evening's end. Since the society's records show this session was held November 2, 1799, the date on the back may be wrong. A possible reason for this might be that Girtin recreated this marvelous work based on his earlier drawing or that the inscription was added later and the date remembered incorrectly.

The scale of the drawing is beautifully manipulated. Girtin brings the viewer into the picture across a large ground plane of a lake or body of water. A small village sits at the base of the mountain on the left. The explosion is powerful but not violent. The lights and darks in the top two-thirds of the picture are organized with great thought and a well-developed sensibility directing the wash to achieve the desired effect.

To work from your imagination you must have control of the media. You need to understand the tools of your trade. To invent a picture, the experience of drawing from life or copying the drawings of masters will prove invaluable.

Marsden Hartley, American, 1887–1943, *Rocky Coast,* 1941. Crayon on paper. 33.3 cm. × 40.7 cm.
Portland Art Museum, Gift of Suzanne Vanderwoude. 80.119.

SEASCAPE

Rendering water brings with it new complexities. Water is moving and at the same time transparent. The surface of water reveals reflections, and in really clean water you can see the bottom of the river or pond.

Above Marsden Hartley uses strokes and gestures to build the mountains that reach out into the ocean, but he leaves the water without embellishment.

DRAWING EXERCISE

Practice drawing reflections by placing objects on a mirror lying flat on a table. An object's reflection duplicates the object. It appears directly below your subject, just as it would if the mirror's surface were a water line. The angle from which you view the object will change your perception. Draw the object and its reflection and then move your drawing position back and draw it again from a farther distance. The object's reflection may look smaller than the object itself. If you draw with an ebony pencil or 6B, you can rub the surface completely with a paper and then use your eraser to cut horizontal breaks through the outline of the reflection.

Joseph Mallord William Turner, 1775–1851, *The Pass at Faido,* St. Gotthard, Chelsea, London. Watercolor, point of brush, scratching out over traces of pencil. 11¹⁵⁄₁₆ × 18½" (303 × 469 mm). Pierpont Morgan Library, New York. Thaw Collection #59.

Turner's drawing is not a seascape; it is a drawing of a river. He has focused our attention upon a rush of water over rocks. The river merges with the sky and the mountains. Here Turner gives form to the concept of the sublime, nature as an awe-inspiring force. Turner is at his best here, evoking the overwhelming power of nature. It is so rough that you hardly see the small figures and their carriage at the lower right. Someone dares to travel this route.

Turner made this drawing during one of his six trips to Switzerland. He filled many sketchbooks, recording what he saw. At first he made only monotone notations and drawings in pencil or wash on gray paper. In 1836 he introduced touches of color, and then by 1840 he began using watercolor. He showed these studies to his dealer, Thomas Griffith, and they generated little interest until his patron, John Ruskin, reproduced this watercolor as an etching in his *Modern Painters* book.

Turner used these sketches later as references for larger paintings he completed in his studio in London. Turner's drawing is as much invention as it is an accurate rendering of reality.

He later expanded and enhanced *The Pass at Faido.*

DRAWING EXERCISE

Select a body of water to draw. Use Bristol board to draw on with a soft lead pencil of 4B, or an ebony. Using light pressure and the side of the pencil, follow the flow of the water and wave the line over the board to reflect the directions the water moves. Now gently rub the surface and use a plastic or kneaded eraser to remove the lighter areas. With a stick scratch texture into the surface but don't rip the paper. Make a light wash and lay it over the darkest areas of the water, using small strokes and a soft, flat brush. Consider the effects you are achieving and continue experimenting.

PROFILE OF AN ARTIST: JOHN CONSTABLE

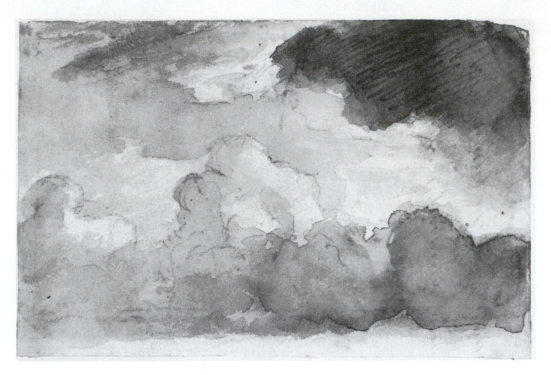

John Constable (England, 1776–1837) Cloud Study, pencil and watercolor, 93 × 140mm. Iris & B. Gerald Center for Visual Arts at Stanford University; 1971.33. Museum Purchase Fund.

John Constable is considered the father of modern landscape. Landscape painting as we know it today emerges in the late eighteenth and early nineteenth centuries, culminating in the work of Constable and Turner, two tremendous landscape artists whose intimate feeling for nature and the outdoors is only rivaled by the poets of their time.

Landscapes in the seventeenth and eighteenth centuries had been in demand by well-to-do patrons who wanted records of their country houses and grounds. Canaletto spent nine years in England in the mid-eighteenth century painting stately homes. At this time landscapes were made in the studio and based on traditional composition from Claude Lorrain. No one went out on site to draw or paint. These "idea" landscapes were often views of the Roman Campagna and were considered serious by the wealthy British only if the artist had an Italian name.

The Industrial Revolution and the growth of the city removed many people from an everyday experience with nature. William Wordsworth's *Lyrical Ballads* are a reaction against the urbane sophistication of the eighteenth century. Wordsworth promoted simplicity, feelings, and contemplation in nature. The divine spirit is to be found in trees, meadows, flowers, mountains, and valleys, he wrote. This corresponded with Constable's belief that the painter should "walk in the fields with an humble heart."

Unlike Turner, Constable felt no need to travel abroad. He declared his art could be found under every hedge. He refused to make scenes that evoked lofty or melancholy sentiments. He preferred to work outdoors following the example of John Robert Cozens, whose work Constable felt was all poetry.

He painted the landscape where he grew up in the country around East Bergholt in Suffolk. In a letter to a friend, Constable wrote of strong influences from his youth, "the sound of water escaping from the mill-dams, willows, old rotten planks, slimy posts and brick work—I love such things. . . . They made me a painter, and I am grateful."

Constable developed his own visual language to respond to his passion for nature. He

felt oppressed rather than exalted by mountains and preferred to relate his landscapes to the human scale. He drew the barges on the river Stour, the canals, the views of the mill, the church, and the wooded vale of Dedham.

He would make small oil sketches on site and often before beginning a large six-foot painting he would draw a full-size sketch in oil on a canvas of equal size. These large oil sketches are now considered some of his best work. They were never shown in his lifetime. He would exhibit only what he called "finished work." Often he would overdetail the final painting to the point of adding touches of white to imitate the flickering light or effects of light. His critiques called this "Constable snow."

Chiaroscuro, as a rich tonal contrast of black and white were important to him, and he balanced his work with light in mind. He loved the windy skies and made cloud studies in 1820. On the back of each sketch he wrote the exact time it was drawn and the weather conditions at that moment. He called these notations "skying." He did the same in a series of studies about trees.

Constable's great picture *The Hay Wain* was first exhibited at the Royal Academy in London in 1821. No one showed any interest. When it appeared in Paris at the Salon of 1824, it created a sensation and he won a gold medal. Young Eugene Delacroix was greatly influenced by Constable's fresh feeling for nature.

Constable combined an accurate observation of nature with a deep poetic feeling to express the sense he felt of life running through everything in nature. He set out to capture in paint and pencil the wind, the dew, the bloom, and the freshness. "Painting is with me but another word for feeling," he said.

John Constable (1776–1837) *Pollards*. Black chalk on paper. 6½ x 9". The Metropolitan Museum of Art. x.251

John Constable, 1776–1837, *The Southern Transept of Salisbury Cathedral Seen from the East 1816*. Soft pencil on white wove paper. 113 × 88 mm. Pasted down on cardboard. 1981.264 Purchased with funds given in honor of Robert E. and Mary B. P. Gross. The Cantor Arts Center, Stanford University.

Landscape

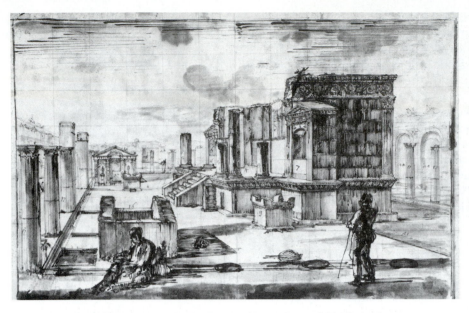

Giovanni Battista Piranesi, 1720–78, *The Temple of Isis at Pompeii,* Mogliano Veneto, Rome. Quill and reed pen in black and some brown ink, black wash, over black chalk; perspective lines and squaring in graphite; several accidental oil stains. 20½ × 30⅛″. Pierpont Morgan Library, New York. Thaw Collection #38.

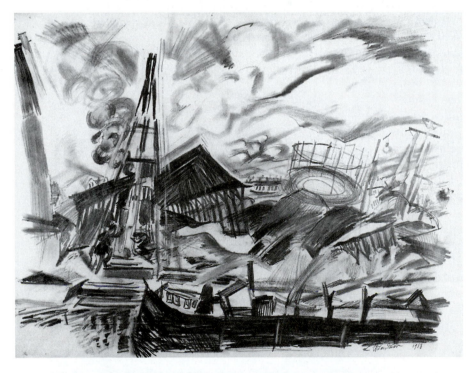

Ludwig Meidner, 1884–1966. *Industrial Landscape* 1913. Soft pencil (with areas of turpentine wash) on ivory wove paper. 465 × 590 mm. 1983.87 Committee for Art Fund. The Cantor Arts Center. Stanford University.

CITYSCAPE

Piranesi's drawing to the left was done on site. In the 1770s he took a number of trips to the ancient ruins around Naples to study and draw them. He considered publishing them as a series of etchings. With this in mind he studied the temple and its sanctuary from every point of view. He used linear perspective and the devices of converging lines, diminishing scale, and overlapping forms to create the illusion of this space. He developed the darker values with vertical hatching lines and used horizontal lines for the shadows.

EXPRESSIONISM

Ludwig Meidner has drawn a symbolic interpretation of an industrial landscape, using an approach completely different from Piranesi's above. Meidner uses no linear perspective; in fact, the forms explode out of perspective. Germany was going through turbulent times, and this drawing may reflect both the artist's emotional temperament and society's anxiety as the prospect of war grew. The early 1900s saw explosive growth in the cities; great industrial complexes and mazes of railroad tracks burst onto the scene. Meidner believed in the necessity of creating an art of one's own time:"Let's paint what is close to us, our city world! . . . the wild streets, the . . . iron suspension bridges, gas tanks . . . the roaring colors of buses and express locomotives . . . the drama of a factory smokestack."

Landscape

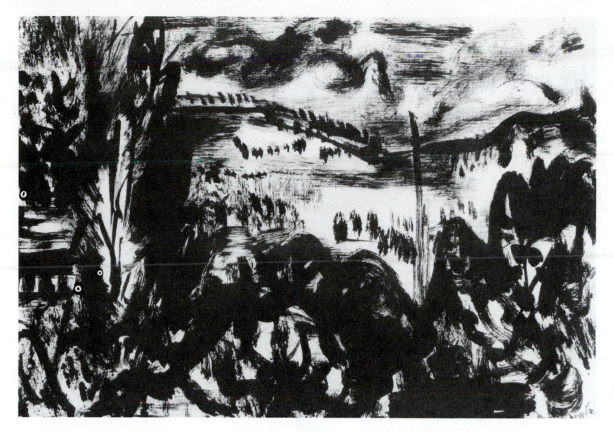

Mark Rothko, American, 1903–71. *Untitled.* Acrylic on paper, mounted on masonite, 1967. Gift of the Mark Rothko Foundation. The Portland Art Museum. 85.128.1. © 2001 Kate Rothko Prizel & Christopher Rothko/Artists Rights Society (ARS), New York.

An almost painterly quality results from the rubbed soft pencil. He often used a reed pen, whose thick lines heightened the mood of anxiety. The angular, slashing strokes are characteristic of German Expressionism.

ABSTRACTION

Mark Rothko was an Abstract Expressionist in New York in the forties and fifties. In the sixties he was called a "field painter" or minimalist. None of these terms have anything to do with who he was as an artist. About the only thing the artists of the New York School had in common was abstraction. Each artist pursued it down a different avenue.

Abstraction is nonrepresentational work that expresses how an artist feels about a subject—such as landscape. The drawing media are the same as those used in realism. The drawing techniques of line, gesture, chiaroscuro, light, and dark are all used in abstraction. Abstraction may evolve as a simplification of shape, plane, and space. In Cubism, an early form of abstrac-tion, the space was flattened, and the objects reorganized as shapes, placed in the composition in pieces, all shifted off center. The patterns in Cubism could be real or invented. Foremost in Abstraction was the flattening of the picture plane. Perspective was abandoned but not space. Space stayed although now a shallow space. Space was created with overlapping strokes, whose size and relationships to the shapes in the drawing was important.

In Rothko's drawing we see a symbolic representation of landscape. The structure of brush strokes in the foreground lends itself to a sense of looking through something, perhaps trees and bushes. The three small marks in the white opening have a figurative sense about them, and the wavy lines at the top of the picture seem to imitate clouds. They seem to rest above a hill line. Since the drawing is *Untitled,* there is no way to know for sure whether this is a work of pure Abstraction. If it is, then the marks represent nothing but marks on white paper. Abstract drawings can be completely about themselves, the marks, and the space they create.

CHAPTER 13
MODERN
TO CONTEMPORARY
DRAWING

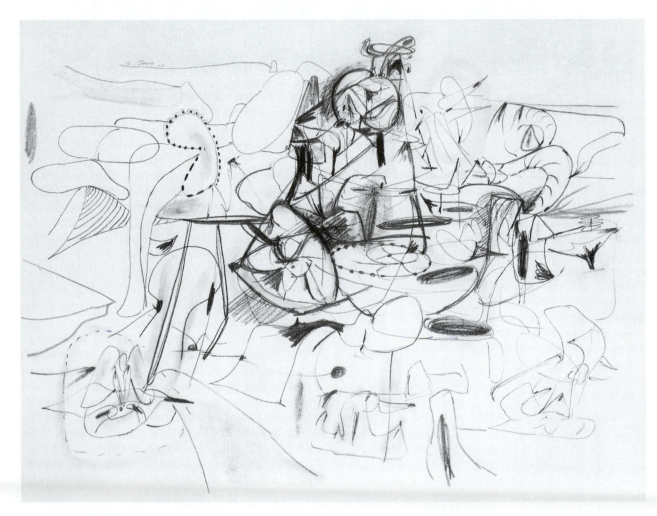

Arshile Gorky, American, b. Khorkom, Armenia, 1904–48. *Untitled,* 1944. Pencil and crayon on paper, 23 × 291/8″. (58.4 × 73.9 cm). Hirshhorn Museum and Sculpture Garden Smithsonian Institution. The Joseph H. Hirshhorn. Bequest, 1981. JH 64.1, JH3517. © 2001 Estate of Arshile Gorky/Artists Rights Society (ARS), New York.

PROFILE OF AN ARTIST: ARSHILE GORKY

Arshile Gorky was instrumental in introducing the concepts and theories of Modernism to America. He believed that the history of art was an unbroken chain in which all art evolved from past artists.

Arshile Gorky was born Vosdanik Manuk Adoian in Khorkom, Armenia, in 1904. His mother, Lady Shushanik der Marderosian, was the descendant of generations of Armenian Apostolic priests. His father was a farmer who owned an extensive rural estate. Gorky was passionate about his Armenian heritage and based the painting, *Garden in Sochi*, on his recollections of his youth. He spoke of the garden near their home: "My father had a little garden. There was a blue rock half buried in the black earth with a few patches of moss placed here and there like fallen clouds." The garden was also considered a source of magical power by the villagers, who would rub their bodies against the rocks in hope that their wishes might be fulfilled.

When Gorky was four years old, his father left Armenia to avoid conscription into the Turkish military service. He would have been forced to fight against fellow Armenians. Turkey was escalating attacks on Armenia during the years

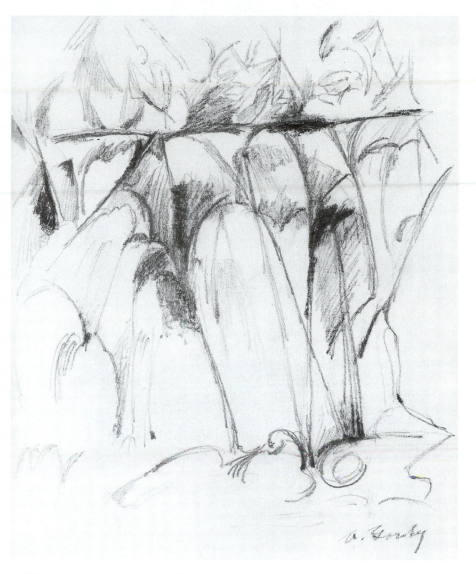

Arshile Gorky, Armenian, 1904–48, *Waterfalls.* Pencil and crayon on paper, 14⁹⁄₁₆ × 11⅜". (36.8 × 28.8cm.). not dated. JH64.160. Hirshhorn Museum, Washington D.C. © 2001 Estate of Arshile Gorky/Artists Rights Society (ARS), New York.

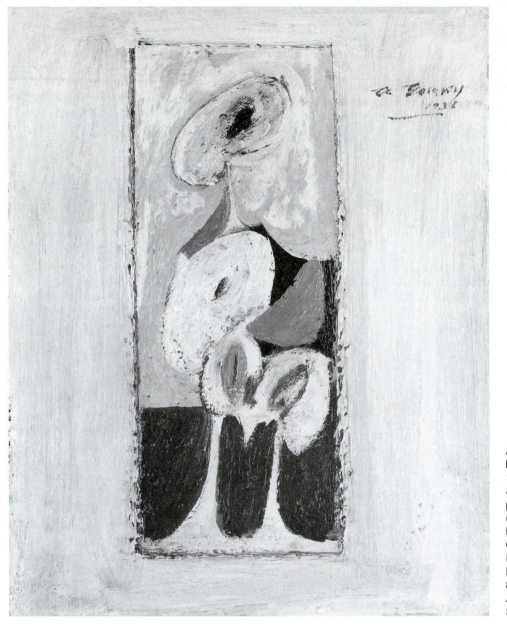

Arshile Gorky, American, b. Khorkom, Armenia, 1904–48. *Personnage composition No.2.* Oil on paper board, 1936. 10¼ × 8″. (25.9 × 20.4 cm). Hirshhorn Museum and Sculpture Garden, Smithsonian Institution. The Joseph H. Hirshhorn Bequest, 1981. 86.2341. © 2001 Estate of Arshile Gorky/Artists Rights Society (ARS), New York.

before World War I. The boy's youth ended late in 1915 when Akiesdan came under attack by the Turks. Gorky and his mother with his three sisters fled. They survived a grim hundred-mile journey. Living in exile for three years with no money and little food, Gorky's mother became seriously ill and died of starvation in her son's arms. Gorky was very attached to his mother. It was she who imparted to him high moral standards with a love of nature and beauty that would inform his work later. The fifteen-year-old Arshile and his thirteen-year-old sister Vartoosh made their way to the United States to join their father.

Once in America Gorky was determined to become an artist. In 1922 he enrolled in the New School of Design in Boston. Shortly thereafter he became a part-time instructor there. Gorky believed an artist's purpose was to capture both the mood and formal essence of the subject. Information that should then be transformed into a timeless, universal image. Gorky felt Cézanne had done exactly that, and he studied Cézanne's work carefully.

In 1924 Gorky moved to New York and found a large studio on Sullivan Street, near Washington Square in Greenwich Village, where he could live and work. Determined to develop

Modern to Contemporary Drawing

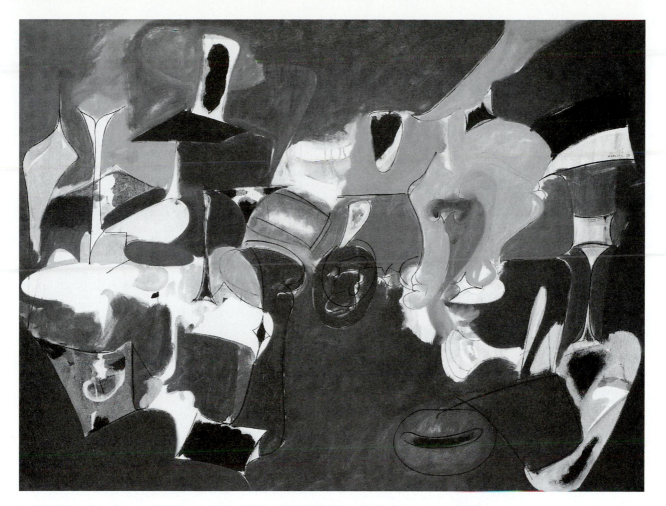

Arshile Gorky, American, b. Khorkom, Armenia, 1904–48, *Soft Night,* 1947. Oil, india ink, and Conté crayon on canvas, 38⅛ × 50⅛". (96.7 × 127.1 cm). Hirshhorn Museum and Sculpture Garden, Smithsonian Institution. The Joseph H. Hirshhorn Bequest, 1981. 86.2341. © 2001 Estate of Arshile Gorky/Artists Rights Society (ARS), New York.

his career as an artist, he adopted the fictitious name Arshile Gorky. He hid his Armenian identity with a Russian name because he felt he would be better accepted in America as Russian. "Arshile" derives from the Armenian royal name "Arshak," which translates to "Achilles" in Russian. Gorky is Russian for "bitter." This symbolic combination of old and new parallels his search for a style of painting that would grow out of the Old Masters' tradition into the realm of the modern. He fabricated his past, giving his birthplace as Kazan, Russia, and stating that he had studied art at Nizhu-Novgorod.

Gorky was hired to teach art at Grand Central School of Art, a position he held until 1931. At this time Cubism, Fauvism, and Surrealism were virtually unknown to American students, so it was remarkable that Gorky was able to discuss the complex theories and ideas of these new art styles with his students. He was extremely familiar with the work of Paul Cézanne, Pablo Picasso, Georges Braque, Henri Matisse, and the Surrealist André Breton. His primary sources of information were periodicals at the Weyne bookshops in New York, where the avant-garde magazine *Cahiers d'art* appeared in 1926, along with imported French art books. He may have seen *La Révolution surréaliste,* published between 1924 and 1929. After the Armory show in 1913, where Americans were first introduced to modern art from Europe, international exhibitions of modern art appeared sporadically in New York along with exhibitions of private collections. The Brooklyn Museum showed Braque, Miró, Picasso, and Kandinsky in 1926. Gorky saw every show. There is a story that he went with a group of artists to see a Picasso exhibition and they noticed a drip on the painting. Chiding

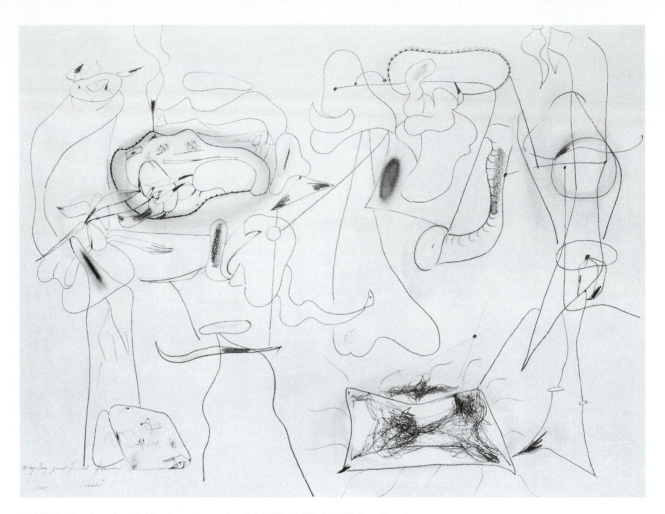

Arshile Gorky, American b. Khorkom, Armenia, 1904–48. *Untitled,* 1944. Pencil and crayon on paper, 19¹³⁄₁₆ × 25⁷⁄₁₆". (50.2 × 64.5 cm) Inscribed LL in Pencil: To My Dear Good Friend Jeanne/Arshile/ 1944. Hirshhorn Museum and Sculpture Garden, Smithsonian Institution. The Joseph H. Hirshhorn Bequest. 1981. JH64.178. © 2001 Estate of Arshile Gorky/Artists Rights Society (ARS), New York.

Gorky about the drip, he responded, "If Picasso drips Gorky drips."

Gorky is the indisputable link between European modern art and the New York School or the Abstract Expressionists. Following Cézanne's lead, he painted placing small patches of pigment side by side to build up form and pictorial structure. A self-taught artist, he blended elements of Cubism and Surrealism into his paintings and drawings.

Surrealism challenged the traditional faith in reason and consciousness as the source of all reality. It claimed the unconscious, the irrational, and the magical were a higher reality.

Gorky's work was in direct response to the natural world and referenced his religious background, but he camoflauged his subjects, developing an abstract style of painting and drawing before anyone else in New York.

The drawing *Waterfall* could be considered a foundation for work done in 1940–44, where he again referenced the waterfall. The waterfall paintings of 1942–43 come out of his response to nature and are oil paintings in which Gorky by diluting his paints created the same transparency and translucency one could achieve only in watercolor. The sensation of a rushing cascade of water is created by allowing the paint to drip and run

Modern to Contemporary Drawing

over and next to large areas of unpainted white canvas. This technique created openness in his paintings creating a new pictorial vocabulary, between painting and drawing.

He desired a timeless quality to his images, a spatial ambiguity where the forms floated mysteriously. His feelings and memories materialized into a poetic vision along with images, shapes, and colors. These spontaneous images from unconscious levels of his thinking process were woven with other images based in nature. From the early 1940s until his death in 1948 Gorky approached the working surface as a mental landscape. It was neither flat nor concave but shallow, covered with forms. In drawing Gorky used a hairline or thin outline that extended in a fluid manner across the ground. The line was a way to create space but not separate the objects from the ground or each other. Gorky found the models for the delicate organisms in his drawings in nature. He once said, he had begun to look into the grass not at it. Drawing for Gorky was a metaphoric response to nature, allowing for unconscious reactions to the people and objects resulting in simplifyied forms.

Gorky's painting and drawing in the early 1930s consisted of broad, abstracted planes of color, curved shapes played against angular shapes, illustrating his deep interest in Cubism. this painting from 1938 on page 252 is organized in a system of interlocking rectangular and curvilinear shapes that lie flat on the surface.

Gorky's mature work, *Soft Night*, on page 253, would break out of this rigid geometric structure. Here you can see the universal shapes he preferred, which are nearly impossible to read as either animate or inanimate, natural or manmade.

In 1929 Gorky met Stuart Davis. Davis had begun the *Eggbeater* series in 1927. This series was based on a still life of an eggbeater, an electric fan, and a rubber glove sitting in his studio. He transformed these mundane objects into Cubist planes, flattening the lines and planes to the surface. Davis referred to the still life in his studio as "the painter's formal friend," meaning it was a constant source of information that could be translated into paintings and drawings. Gorky praised Davis's work as "symbols of tangible spaces." The still lifes in Davis's *Eggbeater* series were virtually nonobjective, or "plastic symbols," as Gorky called them. Neither Picasso nor Braque had achieved this level of pure visual abstraction, which is what now distinguished the work of the Americans from the Europeans and emphasized the innovative nature of Davis's and Gorky's

painting. It was Gorky's feeling that "true art must mirror the intellect and the emotion."

Gorky's friendship with the Surrealists early in 1939 in New York had some influence on the direction of his compositions. His shapes hover in unfixed, spatial relationships recalling the painting *Dutch Interior* by Joan Miró. Biomorphic forms capture the essence of a garden without depicting it literally in Gorky's drawings and paintings. Gorky's line is nervous, fast-moving, and perhaps "automatic." Automatism was the unconscious drawing process of the Surrealists in which one draws unfettered by the rules of logic or schooled hand-eye coordination. The imagery flows from the unconscious uncensored by the left brain. Gorky used a random line to connect the images into a web of highly activated space.

Once while drawing outdoors, he was observed by his mother-in-law, who commented she couldn't see what he was drawing from the trees he was looking at. He replied, "I am not drawing the trees—I am drawing the space between the trees." In Gorky's work color and line seem in constant flux. André Breton in late 1944 wrote of Gorky that he was the only Surrealist who maintained direct contact with nature, penetrating nature's secrets to discover the "guiding thread" that links together the physical and the mental structures. Gorky later rejected the Surrealist practice of automatism and their theories that ideas surfaced from the unconsciousness to guide the artist's hand in favor of the idea that consciousness controls with the thinking mind.

INTRODUCTION

Until the end of the nineteenth century the general consensus was that the basic elements of good drawing were lifelike imitation of nature, technical expertise in controlling the media, and an extensive knowledge of ancient art. Vasari had described draftsmanship as "the imitation of the most beautiful parts of nature in all figures." Absolute accuracy, precision, and hand-eye coordination characterized drawing in the High Renaissance. In the twentieth century the avant-garde artists cast off the tyranny of this classical tradition. New attitudes toward nature and new approaches to the picture plane, the subject, and the purpose of drawing replaced the long-established techniques and styles. Drawing became more preparations for a large painting. Imitating nature was no longer enough.

Paul Cézanne, a major influence on twentieth-century art, admired the Old Masters. It was out of respect for tradition that he transformed our reading of space by flattening the picture plane. His theoretical feeling that nature could be treated in terms of the sphere, the cylinder, and the cone was translated into the understanding that the picture plane is composed of many planes. Cézanne created the bridge between painting and drawing. In painting pigment often covered the entire surface of the canvas, while in drawing the surface of the paper was often visible through the drawing. We read drawings as we read text, interpreting sign-like marks and gestures into narrative. Prior to 1850 artists composed using traditional rhetorical formulas for posing the figures and creating the narrative. The gesture of the figures in the posed composition was drenched in meanings that the viewer understood. With Cézanne the language of human gestures was replaced with a system of marks. The actions of the people represented were no longer his subject, and he with other artists soon began to undermine the viewer's expectation of what was represented. Cézanne's multiple contours or pentimenti with the separation of line and plane lead the way to replacing the rhetoric of gesture with a new rhetoric of mark-making. Now the picture contained signs of the working process. Following Cézanne, Pablo Picasso and Georges Braque altered the viewer's perception by both flattening and shifting the planes in the picture plane in the artform called Cubism.

Henri Matisse, working at the same time in Paris, transformed drawing by leaving multiple contours visible from rubbing his charcoal drawings and then drawing over the rubbing to create a kinetic record of layers. This process allows the viewer to see his successive attempts in placing the lines.

In the postmodern world, traditional distinctions between media have broken down, and the distinction between drawing, painting, and sculpture, has disappeared. A drawing is defined as any work on paper. Paper has unique qualities. It interacts with the tools used to mark upon it. For instance, it absorbs paint. As Jack Flam has put it in an essay on "Modern Drawing": "When one draws [or paints] on paper one also draws [or paints] into it." By way of contrast, in painting on canvas images are built up and layered over the surface. When an artist such as Milton Resnick paints on paper, he isn't making studies for other work nor is he drawing. For Resnick, it is all the same. Like Cézanne he is interested in more than what you see represented here. He said to me, "The idea of a picture is what you are trying to realize. The picture begins when I can feel the emotion and hold on it. Emotions have a distance. I find the distance with paint. If I have the good luck to understand the paint, I can follow what the paint does." In finding the feeling, the paint and the brush respond better than a pencil for Resnick. It was while working on a very large painting that his sense of his work changed. He discovered that he couldn't focus on it all at once. But when he caught a glimpse of his work from a peripheral point of view, he saw the picture he wanted. The unfocused view had a feeling that the focused view did not. Resnick continued, "When you are concerned with the 'whole,' there is no focus point. The space expands continually. Then at a certain point the space becomes one whole and you don't see it as focused you see it all." Resnick paints "The Whole."

Modern to Contemporary Drawing

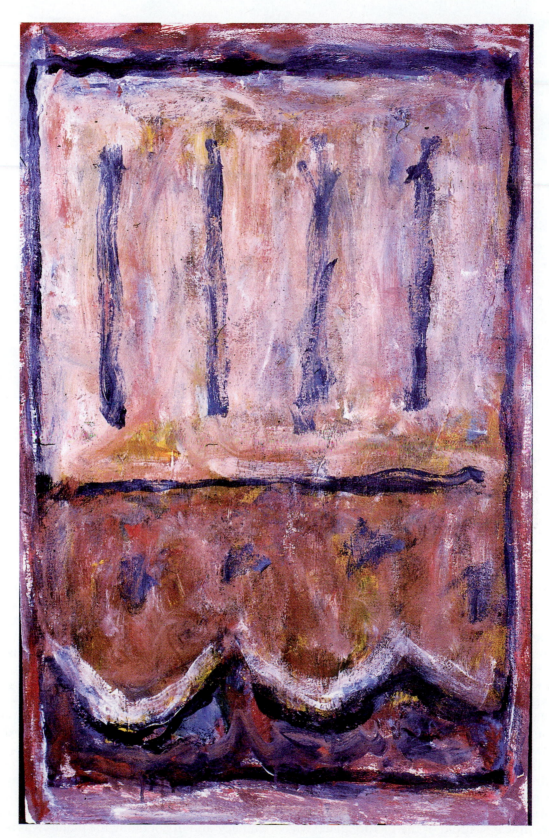

Milton Resnick, 1918– *Untitled,* 2000, 22 × 30″. Acrylic on paper. Courtesy of the artist.

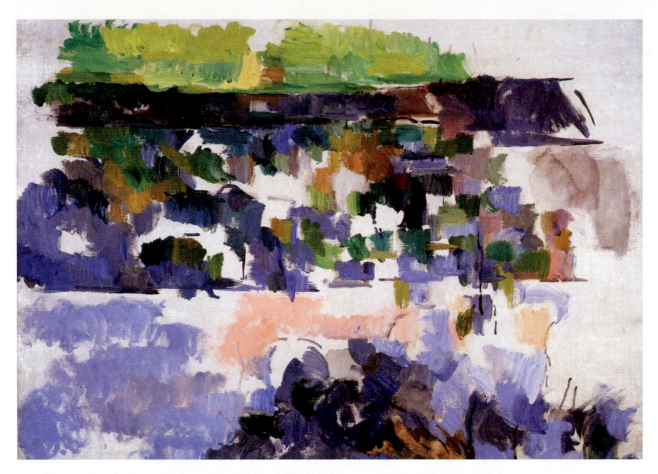

Paul Cézanne, *The Garden at Les Lauves.* c.1906. Venturi 1610. Oil on canvas, 25¾ × 32″. 65.5 × 81.3 cm. The Phillips Collection, Washington. Cat.55.

Cézanne created a new interdependence between painting and drawing. He once said to Emile Bernard, "Drawing and color are not at all separate: To the degree that one paints, one also draws; the more harmonious the color, the more precise the drawing."

To Cézanne the whiteness of the field of either the canvas or the paper was perceived as a field for the painter's brush to act on. Cézanne composed with structural planes of color, defining the landscape not by shape but by plane. His freely drawn lines were linear scaffolding to hold strokes of color now freed from their job of outlining a shape.

The linear scaffold of the picture plane was opened up with partial erasures in the paintings, creating pentimenti, or traces, which revealed sections that were painted out but also remained in the final image. In this way you see what the artist accepts and what he refuses. It's like looking at the artist's mental process.

The white space increased in Cézanne's art to where the trees, rocks, and the riverbank float in an engulfing white. In *The Garden at Les Lauves*, the white void makes them seem to cease to exist.

By 1910 Cézanne had created a new pictorial language and new conventions for painting and drawing. This new language and way of picture making would effect the process of making art for the next 90 years. His process of indeterminacy, and in not fixing the planes was reflected in multiple contours, interpenetrated spaces, and

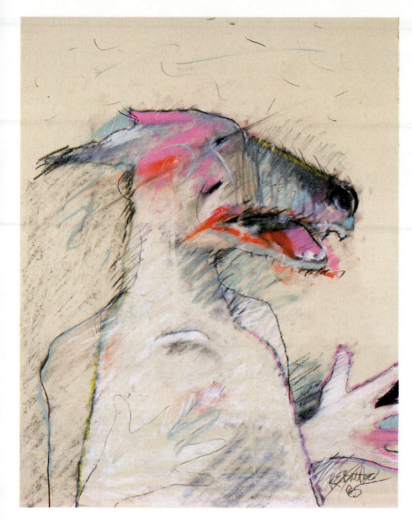

Rick Bartow, American, 1946–. *The Trickster*. Graphite, charcoal, oil pastel on paper. 1985. 76.6 × 56.7 cm. Portland Art Museum, Oregon, Blanche Eloise Day Ellis and Robert Hale Ellis Memorial Collection Fund.

shapes between them. Cézanne's two systems of representation function here at the same time. The linear system operates in an extremely complicated equilibrium with the planes of color. The conventions Cézanne invented—the multiple contours, the transparent planes, the free lines and marks, and the emphasis on the plane— influenced the direction of modern art.

Rick Bartow is an artist of Native American descent working currently in the Northwest. His drawing opposite demonstrates the use of hatching marks and color freed from their traditional assignment of modeling form. The hatching gives a textural effect but it is not there to create texture. It functions spatially, weaving in and out across the contour of the figure with an animal's head. Marks can create space by their scale, color, and placement across the horizontal and vertical planes. The light marks at the top of the drawing seem distant while the marks across the arm on the left veil the form. His color is subjective, a personal choice, not local color or the actual recognizable color of the subject.

CUBISM AND SURREALISM

There were two movements that formed Modernism's foundation, Cubism, with the invention of the collage, and Surrealism. These two movements asked the question, What is the nature of reality? Is it made of things or of states of mind about things? Are the elements to be perceived as stable or fluid?

Cubism was deeply rooted in drawing practices that used an underlying geometric structure to compose angular, gridlike spaces. The space of the picture plane was divided with vertical fracturing, a device forcing us to reconstruct the subject in our minds eye. The nature of reality was altered. However, the work of the Cubists always referred to some representational space such as a still life. The pictorial structure had been shifted, but there remained a sense of reasoned order. Late Cubism saw line as the medium of analytic thought. To the Surrealists line represented the manifestation of the unconscious. Modern drawing began to simultaneously project image and idea.

transparent planes. He extended the language of drawing, operating two systems simultaneously. This network of marks seemed to exist independently from the planes of color. The planes separated by white space seem to float free from gravity. Cézanne's goal in flattening the picture plane was his desire to ensure the viewer knew they were looking at a picture, not an illusion of space. His painting was like an extension of drawing.

Paul Cézanne's painting opposite is like a colored drawing. The linear movements, or the lines don't encircle the strokes of color. The pieces of color seem to have been hung on a scaffold that was placed in front of the picture plane. Such a scaffold would function like a grid. The colors float, and their contours define the white

Georges Braque, French, 1882–1963. Collage, composed of charcoal, graphite, oil paint, and watercolor on a variety of cut laid and wove paper elements laid down on dark tan board, c.1912, 35.1 × 27.9cm. Gift of Mrs. Gilbert W. Chapman, 1947.879. The Art Institute of Chicago.

In the Cubist collage, the character of the ground was altered by pasting elements onto it while the drawing itself continued over the paper and the pasted elements. Hatching, a traditional marking process used to create the effects of volume on a two-dimensional surface, was redefined by Cubism. Hatching was transformed into flat linear patterns, often reversing the perception of positive and negative spaces. A number of other techniques came out of drawing and moved into twentieth-century painting. Frottage, decalcomania, drips, spatter, and staining further dissolved the traditional boundaries between drawing and painting.

Surrealism saw line as a manifestation of the unconscious. Line was liberated from any descriptive function. The space of the picture might appear as the collection of random linear gestures, signs, and symbols. The artist may very well have had in mind very specific images, but the spectators were left to decipher what they saw. Artists like Miró and Gorky, used flowing curvilinear lines to draw fantastic figures and fragments of naturalistic images. The picture space was no longer directly correlated to the space of the real world.

Classical myth tells of how art was invented by a Corinthian maid, the daughter of Butades, who, her hand guided by Cupid, traced the outline of her sleeping lover's shadow on the wall. The myth reminds us of both our fascination and connection to creating an image that speaks. Drawing is another form of language or personal expression that today is multidimensional. Art, like life, has gone beyond the conventional and traditional compositional rules. In the following pages we will investigate the many aspects of contemporary art.

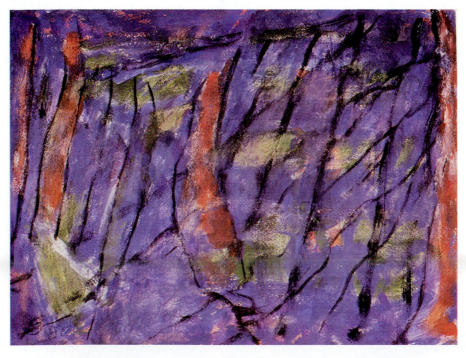

Pat Passlof, 1928– , *Birches*, 19 × 25″, 1999. Acrylic on paper, Courtesy of the artist.

Modern to Contemporary Drawing

PROFILE OF AN ARTIST: PAT PASSLOF

In 1946 most colleges and universities did not have studio art departments. Pat Passlof had been studying at Queens College, where they offered only art history. She left to study at Black Mountain College where the list of faculty and students read like Who's Who in American art today. Joseph Albers was the director of the college, the faculty was composed of professionals such as Buckminister Fuller, Willem de Kooning, Anni Albers, Merce Cunningham, and his assistant John Cage. Black Mountain College is often thought of as an art school but it offered a full compliment of course work. Poets such as Jonathan Williams and M. C. Richards were in residence. When Passlof returned to New York she found a loft to serve as a studio on Tenth Street. These unpartitioned spaces had no kitchen, no water, no heat, and no bathroom. The toilet was down the hall, a public toilet shared with the workers in the building.

Painting in New York was changing, a new energy was developing from a new way of thinking, along with a new painting process. Certain philosophers assumed that if the literary or narrative meaning as they understood it in the tradition of painting was absent then the subject of the painting must be the artists themselves. This version of what was changing evolved into the assumption that these painters painted from their "guts." It was a misleading oversimplification of a more complicated process. In fact these artists held complicated ideas about art and painting. There were intense debates long into the night over the different points of view. Artists such as Milton Resnick, Ad Reinhardt and Willem de Kooning came together at the now famous Artist's Club. The Artist's Club was formed by the artists to provide a space where lengthy discussions about painting, literature, philosophy, and poetry could be held.

The loose structures and free flowing lines in these paintings from the '40s and '50s aren't the result of a lack of training. These painters all had strong technical skills. The structure of their paintings was deliberate.

Similarly Passlof has strong painterly skills but she chooses to find ways to work that challenge those skills. Passlof may use large, or ruined brushes in painting because they will make unexpected marks to which she can respond. She works in ways in which the results can surprise her.

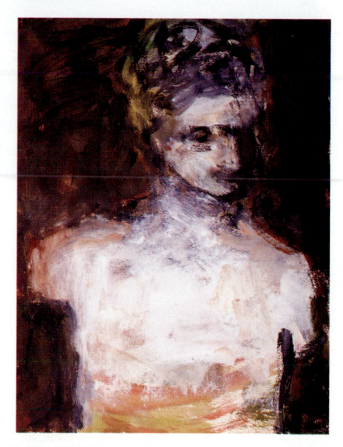

Pat Passlof, 1928– , *Head*, 1996, 16 × 12″, mixed media. Courtesy of the artist.

For Passlof, making a picture is like "making a stab in the dark." You make a brush stroke, the first stroke does something to the canvas, the second brush stroke responds to the first one, and the third one responds to the first two strokes. This process continues stroke by stroke, shaping and giving character to the space of the canvas. "The strokes determine the fate of the painting. When you lose your interaction with the picture you repaint," Pat said. "Drawing divides and painting brings together. The picture plane is the plane that allows you to see the whole painting." Pat told me "What I'm trying to do is capture an emotion, whether the work is abstract or figurative. When you paint, the paint multiplies what you do. I don't make studies, because the flexibility of painting in oils doesn't require a plan. I respond spontaneously to what happens on the canvas without being constrained by an arbitrary plan. The signs of calculation are not beautiful."

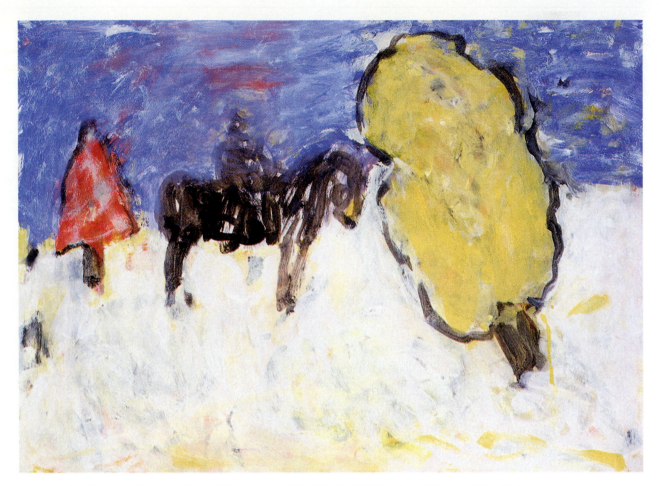

Pat Passlof, 1928– , *Two Trees and Rider.* Oil on canvas, 1992–93; 19 × 25″. Courtesy of the artist, New York.

So why horses? I asked. "Everybody likes horses, horses have a wildness we envy," she said. Passlof doesn't start with images. She starts with brush and paint. She finds the images in the paint and pulls them out. Some of her work informs other work. The small paper drawing on page 260

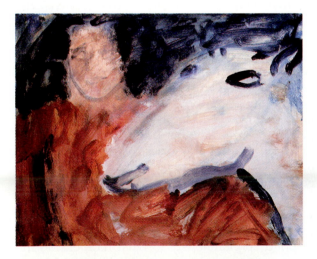

Pat Passlof, 1928– , *Mor with Horse Head.* Gouache on paper, 19 × 25″, Courtesy of the artist, New York.

comes directly from being outdoors and working at her home in the country. That drawing informed works like some of the horses.

She feels that the apparent simplicity of the painting belies the steps in its making. In *The Little Red Horse,* the horse is held in suspension at the top of a leap, so there is only potential movement. The red over the black of the horse, the bleak little landscape, and the person who watches contribute to the magic in the painting.

For Passlof it is a fluid process in which she builds up the layers of paint into each other working wet on wet, holding the forms in suspension. Chance plays a role along with watchfulness and concentration. "The painter must be watchful, considering what each stroke does and how it changes the painting. Everyone has trouble knowing when to stop. Sometimes it helps if you can "ambush" your painting to see it from a fresh vantage point." Pat said. "The act of

Modern to Contemporary Drawing

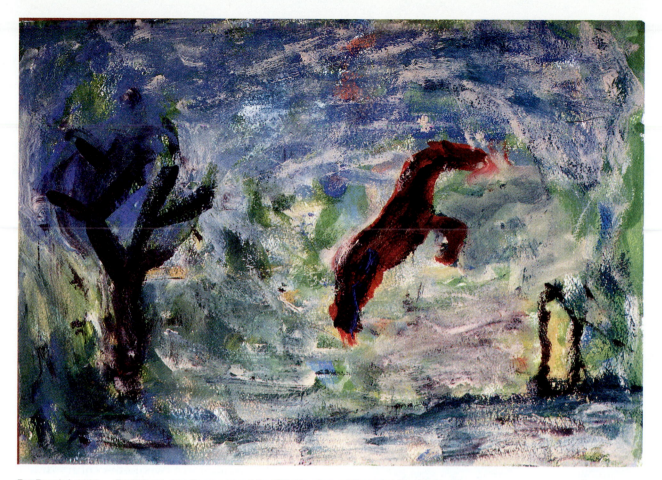

Pat Passlof, 1928– , *Red Horse*. Acrylic on paper 14 x 19½. Courtesy of the artist, New York.

painting is not random. Thoughtful moves balance spontaneous outbursts."

Passlof works continuously aware of the stroke under her brush as well as the stroke at the farthest corner. Some of her paintings are thirteen feet long. She says, "Painting is the only art that must be taken in all at once. All the others are sequential, even the succinct Haiku."

The artist leaves herself open to the flow of events. A drip or even a mistake may provide a fresh and more objective look at the painting and may even point to a different direction than the one being pursued. She acknowledges cannot be strictly controlled. She accepts random elements, like the 'lump' for example in the *Red Horse*. She playfully refers to the wrapped (as in a cloak) figure as a lump, an eloquent lump; eloquent because a tweak of the brush has given this utterly simple shape an elbow, another tweak, a head, and another boots—all in one stroke. We even know that it faces away from us and toward the leaping horse.

Passlof's work ranges from small mixed media works on paper to large oils on canvas. The works on paper fall into the broadened definition of drawing that museums and galleries promoted by the 1960s. It was the practical pressure of trying to build a drawing show in an art market where traditional drawings were rare that redefined Contemporary Drawing as works on paper in any medium.

Pat's process is to work out her ideas in each piece as an end in itself. Even so, she may work from one to the other in order to explore and further develop ideas which are complete in their original context but can be expanded and transformed in another. Occasionally, she works from nature or may set up a still life. Her work, like that of many good artists, comes out of the encyclopedia she has built from everything she's seen in her life. It is a reservoir she draws from.

Modern to Contemporary Drawing

INNOVATIONS

The innovations of twentieth-century drawings revolve around the degree to which they make visible things that cannot be seen—states of mind, ideas, and processes. Drawing ceases to be only about fine technique and narrative composition. Once the conventional strategies of drawing were rejected in the fifties, sixties, and seventies a new relationship between materials, form, and tools evolved.

In the sixties, the art movement, Minimalism was an art movement based on the process. Jan Reaves's "Nuf" drawings develop from a series of drawings made of construction machines, factories and construction sites. The five drawings on the left of the page are about the materials—gouache, ink, Conté, pencil, and wax—from which they are made. The juxtaposition of the shapes creates meaning in their associations. Both the artist and the viewer find meaning in the relationships of these familiar shapes. The series is constructed on paper using both the back and and front of the paper. If bound together, they would make a book. The forms change as their relationships change. They seem endlessly spatial, layered on top of one another, and yet

Jan Reaves, 1945– , *Nuf Series*, 10 × 101/2", ink, acrylic, Conté pencil, wax, 1999–2001. Courtesy of the artist

Modern to Contemporary Drawing

Roy Dean De Forest, American 1930– , *Untitled* (water, mountain, people, dog). n.d. Pastel and crayon, 57 × 76.5 cm.. Portland Art Museum, Oregon, Pratt Fund Purchase.

Reaves' drawings depict no real space. They are analogous to the reflective surface of water, at once transparent, flat, and mirroring space. They do not represent the factory or any organic forms. The artist has no direct intention of conveying any precise meaning, for her the process of making the drawings is the creating force.

This focus on the process and the emphasis on materials begins with the Cubists but is intensely examined and thought through by the painters in New York in the late forties and fifties. A drawing for the New York artists could be made by dragging the pencil or crayon, scratching, smudging, smearing, and scrawling. It might resemble a dirty object instead of a shiny figure, a shaky stain, not a perfect shape.

With Modernism came an investigation of the primitive arts of Africa by both the Cubists and the German Expressionists, who relied on quick gesture drawings reflecting primitive art as composition for paintings. Their garish, bright color came from the French Fauve painters, Henri Matisse and André Derain. In Denmark

after World War II a group of artists, called Cobra, came together united against European Formalism. The group's disenchantment opened the door to a new style in which the folk arts and the art of children were a major focus.

By 1970 critics gave the name "Neo-Expressionism" to a group of artists who harked back to movements like Cobra and the German Expressionism, celebrating a primitive approach. Roy De Forest works in a style free of what artists felt to be the dead weight of their tradition by drawing in a primitive manner. His narrative is intended to create a dialogue with the spectator. To read this illogical composition you must use your imagination, and what you find in it will depend on your personal experiences in life. Neo-Expressionism is a manifestation of Postmodernism thinking. It recognizes chaos and diversity must exist with order. The idea of truth is contingent on place, time, history, and social context. Truth is no longer a universal norm, because the psyche can be constructed or reconstructed by our environment. This means there is no one truth.

Modern to Contemporary Drawing

Utawaga Kuniyoshi, Japanese, 1798–1861, *Warrior and the Goblin Misume Kozo.* Color brush drawing, 34.7 × 24.3 cm. Portland Art Museum, Oregon. Binney Fund Purchase. 66.76.

Modern to Contemporary Drawing

COLOR

The way our eyes function is extremely complex, and some researchers have expressed the theory that the eye is so powerful it seems to have its own small brain. We know that when the nerve cells in the retina of the eye are stimulated, we see patterns of light at various intensity and color. Our eyes process these patterns, separating light and dark while also defining edges, contours, sizes, and any movement. In this way we can separate objects in space and perceive space. In previous chapters, studies of chiaroscuro and the way light falls on the planes of forms defined for us the interaction of light with objects and surfaces. In color drawings tone or value again plays an important role.

Albert Munsell was a German artist who published one of the first standardized systems of color in 1905. Munsell determined color could be defined by hue, value, and intensity. Hue is a specific color—for example, red, blue, or yellow. Red, blue, and yellow are also known as the primary colors. Technically magenta is the true red; yellow and cyan (a green-blue) are the primaries. Primaries cannot be mixed from any other colors. Color mixing starts with the primary colors. When you mix any two primary colors together, you will get the secondary colors. Red and blue make purple, blue and yellow make green, and red and yellow make orange. The student study on the right is a value study. Value in color is the light and dark of one hue. White will lighten a color and black will darken a color. Another way to change the value of a color is to make a gray out of two complementary colors. Complementary colors are opposites. The complements are red and green, yellow and purple, blue and orange. If you mix red and green together, at a certain point the mix turns black. When you add white to this mixture, you can create light gray to dark gray depending on the amount of white in the mix. By adding a little light gray from a red-and-green mix to red, will lighten the red without turning it to pink. If you add the dark gray the red turns to maroon. Jennifer's design on the right is eight monochromes gradated from a light center to a dark background. In this color arrangement the light center advances and dark background recede.

Utawaga Kuniyoshi's brush drawing on the left page is an example of nineteenth century Japanese art. After the opening of Japan in the mid 1800s Japanese prints and drawings were

Jennifer Tavel, *Design I*, student work, 1999.

introduced into Paris. The elegent outline of the patterns and shapes and the close-hued color of the drawing flattens the space of the picture. This organization of space influenced the work of Parisian artists Vincent Van Gogh, Edouard Manet, Edgar Degas, and Mary Cassatt.

Sherry Holiday, *Design I*, student work, 1998.

Intensity describes the strength of a color. Colors directly out of the tube are bright, when gray is added, the degree of pigment saturation is reduced and the intensity is lessened. Tertiary hues are created by mixing a secondary and a primary hue together. Red-violet, blue-violet, blue-green, yellow-green, red-orange, and yellow-orange are tertiary hues. Yellow, orange, and red are warm hues, while blue, green, and purple are considered cool.

Color has many functions in compositions. It creates a mood. The theologians Annie Besant and C. W. Leadbeater did color research at the beginning of the twentieth century. From this work they assigned emotions to colors. Blue was the color of high spirituality, purple was devotion mixed with affection, brown with blue spots was a selfish religious feeling, yellow was highest intellect, scarlet red was pride but darker red was anger, orangish-brown was low intellect, green was sympathy and adaptability, and fear was lavender. This study can be found in the book *Thought-Forms* published by the Theosophical Society in 1969.

Color in modern art has been freed from representing only local color—that is, the actual color in nature seen in the flat light of noon. The Fauves, a title given to a group of painters meaning "wild beasts," painted in the south of France in 1906. The title refered to their choice of bright colors. They painted trees red and skies green, leaving patches of white between the colors to increase the vibration. Henri Matisse, André Derain, and Georges Braque were originally Fauve painters. At the same time, the Impressionists were interpreting light into color. To paint the effects of atmospheric light the artists worked from life at the same time each day. The Impressionists were called, "pleinair" painters, meaning painters who worked in the "open air." Using perceptual color a haystack painted by Claude Monet at sunset would be in reds with afterimages of green flashing throughout the surface— not in local color of yellow for hay. Pointillism was Seurat's experiment in optical color mixing. He believed he could place two colors side by side, and the eye would make the third color. The surface was organized in dots, with the final effect controlled by the size of the dot, the choice of hue, and intensity. The painting could vibrate, shimmer, or turn muddy depending on the relationship of these elements. The Expressionists in Germany at this time were influenced by the Fauves and Henri Matisse. Their color was dramatic and intensified, with maximum saturation. Their use of complementary colors in their compositions created stunning color effects and somewhat garish or loud paintings.

COLOR EXPERIMENTS

Edward Cheong's design below is a color gradation from dark to light. When the entire surface is close-hued or a monochrome, a single color, the space of the pictured plane is flattened. When a darker color is placed beside a lighter color a visual jump occurs that moves the eye either backward, forward, or sideways. The placement of color in a composition controls the movement of the spectator's eye in the composition.

DRAWING EXERCISE: COLOR

Use napthol or acra red, blue, cadmium yellow and titanium white acrylics. Mix two complements on a plastic palette. The mixture will need more of one color than the other. Red and green, for example, will use more green to get to black. Check the mix by adding a touch of white at the corner to see if it is black. Bring a little of this mixture to a pile of white to make light gray. Add white to one edge of the red and green mix to get the dark gray. You should have light, medium, and dark gray mixtures. Use the gray mixtures to change the value of red and then green. Use small amounts of the gray to change the value of red and green. Use a square or circle format, and paint directly on the white background. Arrange the values from a light to dark.

COLOR HARMONIES

Basic harmonies create visual balance. Perception is controlled by the placement, proportion, dimension, value, and intensity of each color. Color harmonies may be studied as complementary, triadic, analogous, and monochromatic. Each quadrant of Edward's design on the right is monochromatic, one color where only the value and intensity of the color change. Sherry Holliday's work above on the left is a triad harmony. It uses red (red-orange), and green (yellow-green), which are complementary colors, and blue-violet in the background. Triad harmonies are three hues that are equidistant on the color circle.

Above, Christopher Pangle, 1999; below, Edward Cheong, student drawing, 1998.

Beverly Buchanan, *Memories of Childhood, #9 Three Burned Shacks,* 1994, 20 × 26", pastel on paper. Courtesy Bernice Steinbaum Gallery, Miami, FL.

SOCIAL AND POLITICAL SUBJECTS

Social and political themes have moved in and out of fashion throughout art history. Human experiences and our values about what is acceptable and unacceptable in the world are important. Art is an open forum for the expression of injustice, inequality, and discrimination. There are many ways to make a statement. In New York in the seventies and eighties, a group of women wearing gorilla masks to hide their identities appeared in street performances pointing out the inequalities facing women in the arts. One of the Gorilla Girls famous slogans was, "Does a woman have to be nude to get into the Metropolitan Museum of Art?" A direct reference to the number of paintings about women as compared to the number of women shown by the Metropolitan Museum. Another interesting example is perhaps the first performance artist, Jacques

Louis David. After the downfall of Louis XVI in France around 1790–91, the painter Jacques Louis David organized *grandes fêtes,* celebrations and festivals that were promotions for the Revolution. He designed the choreography, arranged and directed the parades, and put on performances for the new government.

A more tragic example of political art was evidenced in Spain. In 1810 Spain was invaded by the French, Goya responded in 1814 with two paintings, *The Second of May,* and *The Third of May* depicting the slaughter of Spaniards. He also created an edition of prints called *The Atrocities of War* which includes drawings of Spaniards dying by firing squads and other scenes of destruction.

In Germany Kathé Kollwitz at the beginning of the 1900s pointed out the plight of the German factory workers in her work. She fought for the poor and for workers' rights. Her work continued to reflect the suffering of the German people after the catastrophic losses in World War I.

Modern to Contemporary Drawing

Beverly Buchanan is an African American artist from Georgia, who grew up in the segregated south. She witnessed the growth of the civil rights movement in the south. She has focused her work on the structure of houses or shacks. In the drawing on the left there are two things at work the influence of the New York School or Abstract Expressionism plus the bright colors of the Fauves and German Expressionists. Her drawings have a primitive quality, seemingly simple with bright color and gesture lines activating the entire composition. A political message can be communicated through the imagery or through the title which allows the spectator to bring all the knowledge they have of that moment, or incident into interpreting the meaning of the work. The title, *Three Burning Shacks,* may indicate an accidental fire but it may also refer to arson or a set fire. The shacks were homes people constructed out of found materials. They were homes people put a lot of work into and they were proud of their homes. Shack dwellers were self sufficient providing for themselves not seeking welfare.

Jaune Quick-to-See Smith's monoprint on the right has the feeling of prehistoric pictoglyphs from the rock walls of caves. Pictoglyphs drawn by Native Americans remain in Oregon, Colorado and New Mexico in addition to other areas. Being a Native American herself Jaune Quick-to-See Smith is acutely aware of the environmental concerns for the earth today. She combines a knowledge of modern art and her heritage in her work. Both Beverly Buchanan's drawing and Jaune Quick-to-See Smith's monoprint, a drawing that is printed, signify something beyond what you see. It isn't just what you see that is important it is what you know about what you are seeing that helps you to interpret the images of Smith and Buchanan.

Interpreting contemporary art depends on our ability to interpret our real life experiences and use our imaginations. These expressive drawings require more than skillful manipulation of media and technique. Knowing the techniques and how to use the media must be coupled with the courage to stand by your ideas and put them down on paper.

Jaune Quick-to-See Smith, *Fixing the Hole in the Sky,* 1996. Monoprint, 22½ × 15⅛". Courtesy of Bernice Steinbaum Gallery, Miami, FL.

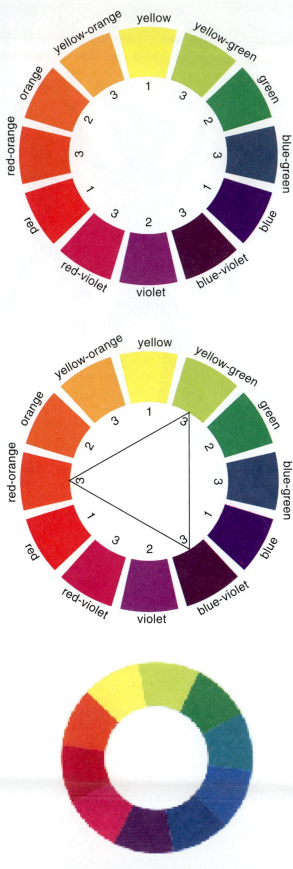

TRIAD HARMONY AND SIMULTANEOUS COLOR CONTRAST EXERCISE

The primary hues are equidistant from each other on the color wheel. By using an equilateral triangle in the center you can determine the four combinations of Triad harmonies. The combination of yellow-green, blue-violet, and red-orange is the combination Sherry Holliday used in her composition on page 268. Select a triad harmony to use in your design.

The layout of the composition should be a geometric pattern where each unit has three sections. The square is a unit that when divided and repeated in a grid will create a pattern. The square can de divided corner to corner, side to side, a circle fits in a square and the circle can be divided. You can use repeated squares drawn as squares inside squares. Assign the three hues of the triad to the three sections of your geometric composition

Sherry Holliday's design is a simultaneous color contrast in which one color has a visual influence on another color when they are placed next to each other. A simultaneous color contrast is influenced and changes according to value, satura-tion, and hue. The proportion of one hue to another is important to the final visual effect. Sherry used a triad harmony as her color choice, manipulating the surface with value changes from light to dark both in the background and on the circles in the foreground.

A Tetrad Harmony is composed of four colors, two complementary colors and two tertiary colors. Yellow, violet, red-orange and blue-green would be a tetrad. There are two colors on the color wheel between the colors in the tetrad combinations.

Above, Conventional Color Wheel; middle, Triad Combination; bottom, Munsell Color Wheel.

Modern to Contemporary Drawing

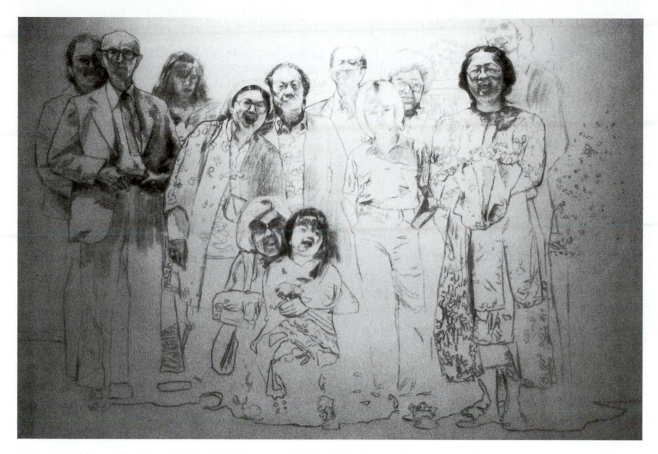

Hung Liu, *Branches* (Three Generations of the Wong Family), 96 × 265″, triptych. Oil and charcoal on canvas. Courtesy of Bernice Steinbaum Gallery, Miami, FL.

Hung Liu was born in Changchun, China in 1948, the year that Chairman Mao forced the Nationalist Chinese off the mainland to Taiwan. Under Mao's Cultural Revolution she wasn't allowed to go to school until 1970 after working for four years as a peasant in the fields. Deemed "reeducated" by the working class she returned to Beijing to study painting. The Chinese style of painting was abandoned by the Cultural Revolution and the strict Russian Social Realist style for propaganda portraits of Mao's new society were all she was permitted to paint. Feeling she was getting behind she put an art kit together that she could hide in her back pack and went out into the countryside to paint alone. She made many small paintings and drawings during this time. In 1984 she was granted a passport to study painting in the United States. She applied and was accepted to the University of California at San Diego. Her photorealist work references the old and the new from her culture.

The external world can provide the basis for our imagination to interpret our experience into art. Then drawing is more than technique.

An individual style in drawing develops from a combination of intangibles, including intuition, emotions, knowledge, and experience. You should never attempt to be "artistic", it will only result in contrived drawings that are not expressive and don't communicate to the viewer.

DRAWING EXERCISE

Draw a simple still life of three of four objects, select a triad or tetrad harmony and assign the colors to the objects and the grounds (foreground, middle ground and back ground). Use acrylics or watercolors to paint with. You could also use pastels, colored pencils or oil pastels. Change the value of the color by adding black to darken, white to lighten or diluting the color with water will also lighten the color. If you use chalk, pastel or pencils layer the colors to change the value.

ABSTRACTION IN PARIS

On a monument in Paris dedicated to Ingres, one of the great artists of the nineteenth century, are the words "drawing is the probity of art." For Ingres probity was obvious skill and craftsmanship in painting. For twentieth-century artists, probity came to mean following the truth of one's own temperament and one's personal vision of the world.

In Paris in 1910 Sonia Delauney and Robert Delauney were leading the development of modern abstract painting. Robert is well known for the target paintings and drawings constructed of rings and blocks in the rings of color. These disk paintings were called 'Simultaneous Disks' and were based on simultaneous color contrasts. Sonia Delauney was a designer and painter. She designed fabric, dresses, and costumes. One of her 1914 dresses was called "Simultaneous Dress." The poet Guillaume Apollinaire once described this dress in a newspaper article as "a purple dress, with a wide purple and green belt, and under the jacket, a bodice divided into brightly colored zones delicate or faded where the following colors are mixed—antique rose, yellow-orange, blue, and scarlet all appearing on different materials." Sonia was drawn to color in bright combinations. She once said, "Colors can heighten our sense of ourselves, and our union with the universe." Electric light had come to Paris in 1906. The lights of Paris were literally all turned on at once during a night in June during the World's Fair. She said, "The halos of the new electric lights made colors and shades turn and vibrate as if as yet unidentified objects fell out of the sky around us." The effect of light is obvious in her work.

Modern to Contemporary Drawing

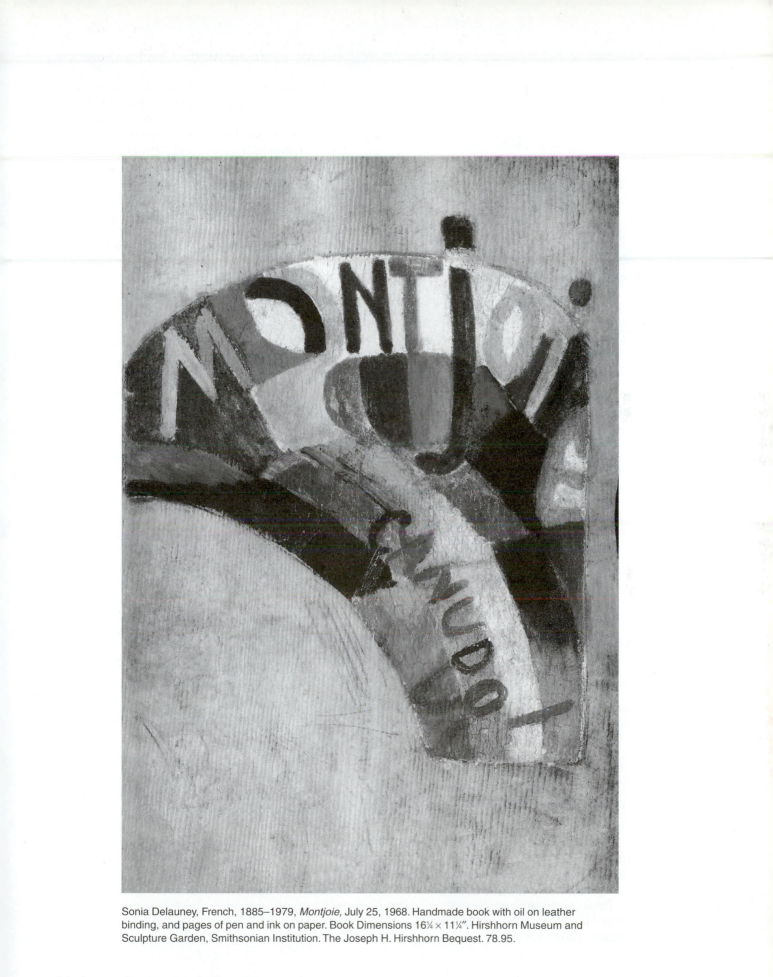

Sonia Delauney, French, 1885–1979, *Montjoie,* July 25, 1968. Handmade book with oil on leather binding, and pages of pen and ink on paper. Book Dimensions 16¼ × 11¼″. Hirshhorn Museum and Sculpture Garden, Smithsonian Institution. The Joseph H. Hirshhorn Bequest. 78.95.

Modern to Contemporary Drawing

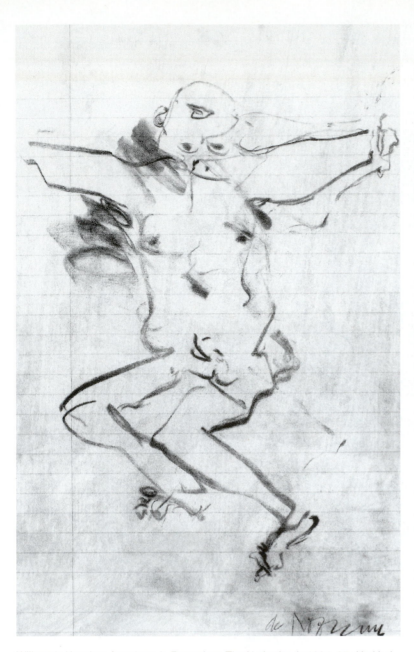

Willem de Kooning, American, b. Rotterdam, The Netherlands 1904–97, *Untitled*, 1964–66. Charcoal on yellow lined legal paper, mounted on paper, mounted on fiberboard. Image 12½ × 8⅟₁₆". The Joseph H. Hirshhorn Bequest, 1981. D395.74. © 2001 Willem de Kooning Revocable Trust/Artists Rights Society (ARS), New York.

ABSTRACT EXPRESSIONISM

The aesthetic criteria of the modern drawings of the New York School brings to mind those of fifth-century Chinese theorist Hsieh Ho, for whom the intangibles of the spirit, the life-force, and the structural use of the brush were more important than representaiton, color, or composition. For Hsieh Ho, creating depended on inspiration and imagination, not skill.

To the Abstract Expressionists the authenticity of feeling, a morale purpose to creating was preferable to creating mimetic or realistic images of the material world. Each of the so-called Abstract Expressionists invented their own language, creating a personal pictorial syntax of signs. This new attitude materialized into a change of touch and marking in pictorial space. The very nature of pictorial space changed. Whereas Cubism in its early days was founded on scientific truth, which created a system to make visible the essential structures of the world, the New York School moved further into abstraction, leaving the modeled and recognizable forms behind. Like Cubist works, de Kooning's figure drawings refer to a recognizable image of the figure. In a departure from Cubism, he may have drawn the figure at the left with his eyes closed, depending entirely of the unconscious to guide his hand. This is example of letting chance play a role. Here he leaves himself open to the flow of his energy and doesn't try to control or structure the drawing. The spontaneity of the artist's act in making art was the basis for the term "Action Painters" given to the artists in New York by Harold Rosenberg. Most of the painters rejected any labels (I use the term New York School because the artists still living from this time have told me they prefer it to Abstract Expressionist or Action Painters). The diversity in the work does not reflect one style, but many individual styles. These artists were extremely skilled and well trained, which may be why they could take chances like closing their eyes while drawing.

Drawing became an investigation of the processes rather than a process to render objects. Fragments of objects floated and pulsed in drawings like the "spots on walls" Leonardo mentioned.

Modern to Contemporary Drawing

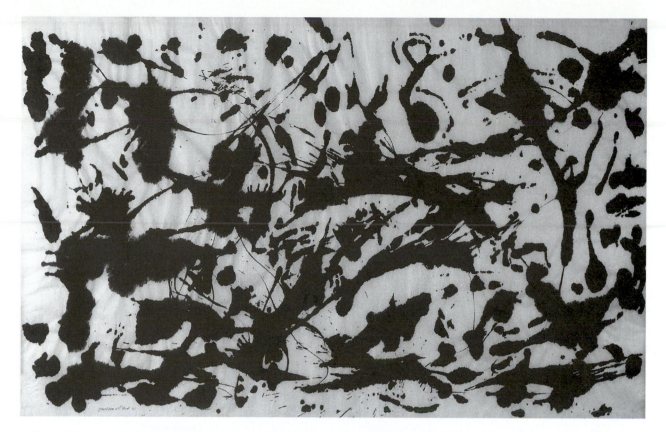

Jackson Pollock, 1912–56, *Number 3, 1951*. Ink, 62.5 × 98.5 cm. Virginia Wright Fund. Washington Art Consortium: Henry Art Gallery, University of Washington, Seattle; Museum of Art, Washington State University, Pullman; Northwest Museum of Arts and Culture, Spokane; Seattle Art Museum; Tacoma Art Museum; Western Gallery, Western Washington University, Bellingham; Whatcom Museum of History and Art, Bellingham. Photo Paul Brower. 74.9 VWF. © 2001 The Pollock-Krasner Foundation/Artists Rights Society (ARS), New York.

Hans Hofmann opened an art school in New York. Hofmann was German and had lived and worked in Paris with the Cubists. When he returned to Germany, he was forced to leave by the outbreak of World War II. An accomplished artist, he had developed many theories of art. He was fond of telling his students, "Depth in a pictorial, plastic sense, is not created by the arrangement of objects, one after another toward a vanishing point, in the sense of the Renaissance perspective, but on the contrary by the creation of forces in the sense of push and pull." In real space depth results from objects placed "here" and "there." Pictorially or on the surface of the paper, here and there are two points on a flat plane that are connected by a lateral, horizontal, or vertical line.

Jackson Pollock's work reflects the concept of all-overness developed by the New York School. All-overness is an articulation of flatness through a repeated network of similar marks. The act of drawing could be the subject of the work. Artistic integrity was equated with the medium and the truth of the artist's hand. The lines or marks making up the picture could be equated with certain psychic and ethical states of being. In the fifties artists developed an entire vocabulary of gestures out of multiple lines, erasures, smudges, flows, spills, splatters, and scratches, building a drawing or painting and holding it in suspension. Pollock's work is associated with spontaneity and dreams. He was attracted to the Surrealist notion of psychic automatism and using unconscious sources to create form.

The pictorial field opens expanding the sheet of paper is conceptually and physically into a space with a huge range of possibilities. Characteristic of works on paper by the New York School is a sense of all-overness and flatness holding illusionism at bay, forestalling the reading of space except through the shapes on the surface. The images are arbitrary, a pictorial syntax from Artists inventing their own language.

Modern to Contemporary Drawing

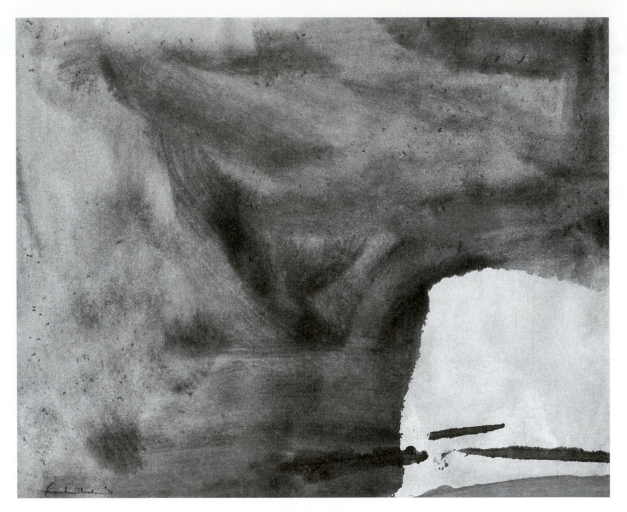

Helen Frankenthaler, 1928– , *Study IX,* 1971. Acrylic, 45.5 × 54 cm. Virginia Wright Fund. Washington Art Consortium: Henry Art Gallery, University of Washington, Seattle; Museum of Art, Washington State University, Pullman; Northwest Museum of Arts and Culture, Spokane; Seattle Art Museum; Tacoma Art Museum; Western Gallery, Western Washington University, Bellingham; Whatcom Museum of History and Art, Bellingham. Photo Paul Brower.

Pollock's 1951 line, blotchy and bleeding across the surface while being absorbed by the paper, influenced a new wave of young artists. Helen Frankenthaler saw that she could expand the deposit of pigment into a field by staining the paper or canvas. The staining process removed her hand from the making of the art in the sense that she pushed the paint around with a squeegee to form the field, removing any brush marks. The stained shape remains two-dimensional spreading across the flat ground of the paper. Her first works on canvas were done with oil paint. Oil on raw canvas creates a ring outside the color field and then rots the canvas. It was the invention of acrylics that allowed Frankenthaler to expand the possibilities of stain paintings. Her abstract style was derived from Hans Hofmann, Kandinsky, and Gorky. Like them she took inspiration from nature. She was also attracted to the surface qualities of late Monet paintings. Her stained color was luminous and radiant, a thin transparent film with the quality of light. The fields expand into an endless space. Her color is sensuous on this flat field, possibly implying texture. The sensuous surface reflects references to natural sensations that we associate with touch—like the feel of velvet, silk, sand, or wet grass. There is no actual depiction of such things, and she doesn't intend for us to find textures in her work.

Other painters followed her, using the stain technique. Morris Louis and Kenneth Noland visited her studio, asking her advice for their own work.

Modern to Contemporary Drawing

Barbara Hepworth, 1903–75, *Curved Forms with Blue* 1946. Pencil and white gouache and oil (?) over a prepared ground on laid paper; mounted on Masonite. 233 × 290 mm. Cantor Arts Center, Stanford University, 1984.521. Bequest of Dr. and Mrs. Harold C. Torbert.

Barbara Hepworth lived and worked in England at the same time the artists in New York were developing a new abstraction She first investigated adding color to her sculpture in 1938, but World War II interrupted her work. She pursued the addition of color in her drawings but not in her sculpture. By 1940, she knew Arp, Brancusi, and Mondrian, whose abstractions she respected. She began to think in more elliptical than prismatic shapes. Living in Cornwall with her husband and three small children, she found time to work only late at night. She wrote, "I did innumerable drawings in gouache and pencil—all of them abstract, and all of them my own way of exploring the particular tensions and relationships of form and colour which were to occupy me in sculpture during the later years of the war."

The drawing shown here is constructed of concentric curves that surround a deep hole in the center. The areas outside the blue center are gray, neutral surfaces delicately textured. The texture results from small parallel strokes scratched in a chalky, white impasto creating a surface reminiscent of the beach. This series of drawings is as close as she could come to carving in a two-dimensional medium. Inspired by the pagan landscape that lies between St. Ives, Penzance, and Lands' End, she developed her ideas about the relationship of the figure and landscape. She felt the figure was formed by landscape, a rocky island was an eye, an island an arm, and so on. Color focused her linear constructions, giving them a sense of three-dimensionality. In the mid-1940s the influence of nature is evident in her titles, *Crystal, Pebbles, Spiral with Red,* and *Form with Yellow on a White Ground.*

The drawing and print on the left by Tallmadge Doyle are organic shapes that came from a dream. The images came into her sleeping mind and she was so struck with them she woke herself up and noted them down. Her skill in developing the images first into a drawing came out of her formal training in drawing. The shapes are rather unrecognizable and somewhat unidentifiable. They seem familiar but maybe not in these relationships.

Shapes can come from anywhere but landscape is a particularly good source for shapes. The etching or intaglio print on the bottom left came directly from the drawing. This shows you how close drawing is to print making.

DRAWING EXERCISE: ABSTRACT DRAWING

Take a sketchpad and sit outside with a view of an uneven (rocky or up and down) landscape. Select a landscape with trees and rocks or fences and blackberry bushes. Focus on the negative shapes. Draw between the trees. Don't draw any positive outlines or contours. Draw the contour of one form and then draw the line through the air to reach the contour of the form next to the one you drew. Look in between leaves or between rocks. Take your sketches back to the studio and make adjustments to the shapes. You may shrink them or enlarge them. You may overlap them or stack them. When you place the shapes on a sheet of paper you may use line to circle or connect them. Continue arranging the shapes into a composition. You are making an abstract drawing that was based on forms from nature.

Tallmadge Doyle. Above, *Illusive Episode I,* 1956. Charcoal and graphite drawing; below, *Illusive Episode II,* Intaglio, 23 × 29″, 1991. Courtesy of the artist.

Modern to Contemporary Drawing

DRAWING EXERCISE:
CUBIST DRAWING

Set up a long and large still life out of bottles, vases, musical instruments, glasses, newspaper articles hung vertically, patterned tablecloths, old license plates, wheels, bikes, and other unassociated items. Place the items in different relationships. Let some be separated by two or three inches, overlap some, and place some upside down or sideways.

Make three large shape drawings where the forms from the still life are drawn as large as your hand or larger all over an 18 × 24" piece of paper. Use the words, the textures, and the patterns in the drawing. Then stop looking at the still life and cut the drawings up. Cut the shapes in half or quarters diagonally or vertically. Add hatching lines arbitrarily to some shapes as a texture. Use hatching lines as elements in the composition between shapes.

Take the cut-up shapes and reassemble them on another piece of paper or tag board. Add dark values where you want edge changes. Hang this drawing up and on a large piece of paper redraw a composition from the drawing you have assembled. Add or subtract shapes and textures as your internal sense of composition dictates.

This process helps you to see shapes and composition differently and to make decisions about the placement of each shape in a completely intuitive manner. You have also flattened the forms to the picture plane by eliminating value and full contours of overlapping shapes. The form of the composition comes from an internal order in your personality.

Nicole Williams, Cubist drawing, student drawing, 1999.

Modern to Contemporary Drawing

Jim Dine, 1935, *Untitled,* 1973. Collage, pencil, and mixed-media, 57 × 77 cm. Virginia Wright Fund. Washington Art Consortium: Henry Art Gallery, University of Washington, Seattle; Museum of Art, Washington State University, Pullman; Northwest Museum of Arts and Culture, Spokane; Seattle Art Museum; Tacoma Art Museum; Western Gallery, Western Washington University, Bellingham; Whatcom Museum of History and Art, Bellingham. Photo Paul Brower.

POP ART

The New York School became the target for a new wave of artists in New York by 1960. The content of Pop Art focused on three things: using images from commercial culture, raising their value from common to high-art status, and attacking the history of art, which had been the bank holding the value of art at lofty heights. They removed the personal touch from their work. The interaction between the hand and the finished work could be eliminated. Painting or drawing was now directed by a preconceived plan. Andy Warhol, for example, establishes The Factory, where his work is reproduced with the printmaking process and he has no hand in it.

Jim Dine continues to draw, which involves his hand but he removes sentiment from the meaning. The drawing above is part of a long series of self-portraits. The artist defines himself through the tools of his trade, banal objects of everyday reality. He avoids any psychological meaning. The objects are lined up in a row as they would be on a workbench. They cast a shadow on the paper. The real glove and the postcard contrast with the richly drawn objects and further point out the lack of depth in the drawing.

Roy Lichtenstein's drawing on the right page makes a skeptical attack on both the working process and values in Abstract Expressionist painting. Marks for the Abstract Expressionist painters had been spontaneous, authentic, and made with commitment. These artists of the fifties discussed existentialism and the moral position of man in society: "A man 'condemned to freedom' is free only to choose, and the significance of his life is the sum of those choices." Thus the spontaneous, uncorrected brush stroke had meaning. It was related to the painter's personality. Lichtenstein composed his drawing as an imi-

tation of spontaneity, calculated and planned. He submits the brush stroke to ironic scrutiny. The grid of dots across the surface imitate Ben-DAY dots used in the reproduction of the comics in the newspaper. It is the same process used for printing paper billboards. The uniqueness of a single drawing or canvas with its ethical values in its creation has been converted in Pop Art into a flat field with the printer's plate reproducing multiple images.

George Segal, applied the same irony and distance to the figure. Grouped with the Pop artists, Segal's sculptures are plaster casts models sitting in the space of the real world. The notions of "inner life" has been removed. They are hollow figures without personality. The sculptures were made by wrapping plaster over live human models who had straws in their mouths and noses to breathe while the plaster assumed their position and hardened into the shape of their body. In this drawing the figure sits at the surface or on the surface of the picture plane. There is no opening into the space of the ground, as figures had been drawn previously. There is no background. Visually we are stopped at the surface with the drawn figure. It is hard to feel personally involved or attracted to a figure without a head. It could just as well be a drawing of one of the artist's sculptures.

One of the more famous stories of an interaction between these two schools of art involves Robert Rauschenberg's visit to Willem de Kooning's studio to ask for a drawing that he could erase. De Kooning agreed and gave him a rich ink drawing, thinking it would be very difficult to erase. But in fact Rauschenberg did erase all de Kooning's ink marks.

Above, Roy Lichtenstein, 1923–99, *Mural Drawing,* 1969. Crayon and gouache, 52.55 × 206.5 cm. 75.1 VWF; below, George Segal, 1924–, *Untitled,* 1965. Pastel on red paper, 44.7 × 29.6 cm. 74.6 VWF. Virginia Wright Fund. Washington Art Consortium: Henry Art Gallery, University of Washington, Seattle; Museum of Art, Washington State University, Pullman; Northwest Museum of Arts and Culture, Spokane; Seattle Art Museum; Tacoma Art Museum; Western Gallery, Western Washington University, Bellingham; Whatcom Museum of History and Art, Bellingham. Photo Paul Brower.

Modern to Contemporary Drawing

PARODY

In the seventies and eighties marginalized artists moved into the mainstream as active participants. This can be credited to the recognition that the work of ethnic minorities and women, particularly, as well as the cultural production of the so-called Third World, spoke powerfully to the social and political issues of the day—the civil rights movement, the feminist movement, the sexual revolution, and the Vietnam War. A new consciousness was developing, one much more pluralistic in its understanding of life. The theoretical manifestation of this new thought was Deconstruction, which not only attacked the very possibility of a dominant mainstream discourse, but also challenged the finality of meaning. In the mainstream, white male artists had dominated the shows in the museums and galleries, with Deconstruction artists once considered "other" moved into the mainstream of the arts. Now for the last thirty years work by traditionally marginalized artists has gained more and more authority.

When the African American artist Robert Colescott was chosen to represent the United States at the 1997 Venice Biennale exhibition, the art of these marginalized voices could be said to have finally "arrived." Colescott's work was informed by a trip in 1964 to Egypt, where he discovered the 3,000-year old history of African narrative art. He began to analyze his own identity and the complexities of his own situation in light of this knowledge. Colescott had studied in Paris in a French school, including in the atelier of Fernand Léger from 1949 to 1950. He thus brings his knowledge of Cubism and other modern movements, along with his love of cartoons, into his compositions. He combines anecdotal humor and painterly invention. As he often does, he has taken his subject from the mainstream tradition of art which he intentionally parodies. *Susannah and the Elders* is based on a story that was painted by Rembrandt in 1647, Guercino in 1617, Artemisia Gentileschi in 1610, and Tintoretto in 1555. As the story goes, Susannah was a beautiful young woman who was married to a very rich man. The elders of the community visited him often for his council. Seeing Susannah, they became obsessed with her beauty, and determined to hide themselves in her garden where she went to bathe. They surprised her and sought sexual favors, which she denied them. Angry with being rebuked, they falsely accused her of lying with a young man, a lie they made up to tell her husband. She was brought to court, where she was sentenced to death for this supposed adultery. When the sentence was announced, she cried out to God for justice, knowing she was not guilty, and God spoke through Daniel, questioning the story of the elders, who had no proof but their word. The people listened and questioned the elders. Daniel in his wisdom separated the two elders and asked each one, "Under which tree in the garden did you see this act?" One elder said it was the oak tree, and the other named the evergreen tree. They were found out in their lie and both received the death sentence.

In both Rembrandt's and Tintoretto's versions of the story, the tension of the bath scene is reflected in the paintings' sharp contrasts of light and dark and in the way that Susannah's dazzling feminine beauty is contrasted with the caricatured ugliness of the elders. The same tensions inform Colescott's composition, but he has translated the scene into his own world, a modern bathroom in Harlem. The tension between light and dark in the traditional treatments is transformed into a treatise on race and class in the contrast between the white woman and the black janitor behind the bath. Where the tension between beauty and terror punctuated the original works, the tension of Colescott's work depends on the contrast between Suzanna slipping in the tub and the humor of his parody. In this modern version, Colescott has changed the spelling fom Susannah to the Suzanna, like in the song, "Ole Suzanna, Don't You Cry for Me."

Colescott's work turns the tables on the European tradition, relegating it to the category of "the other" by replacing it with a new statement in this drawing taken from modern life from an African American point of view.

Modern to Contemporary Drawing

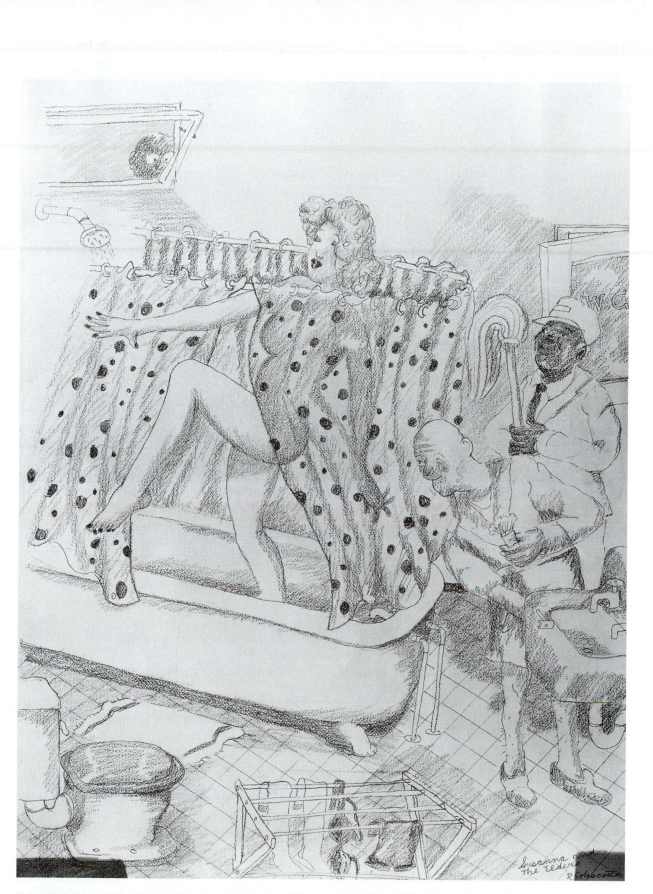

Robert Colescott, 1925– , *Susannah and the Elders,* 1980. Colored pencil and pencil on paper. H. 30 in., W. 22½″. (76.2 × 57.2 cm.). The Metropolitan Museum of Art, Gift of Arlene and Harold Schnitzer, 1982. 1982.153.1.

Modern to Contemporary Drawing

Brice Marden, *Untitled,* 1964. Virginia Wright Fund. Washington Art Consortium: Henry Art Gallery, University of Washington, Seattle; Museum of Art, Washington State University, Pullman; Northwest Museum of Arts and Culture, Spokane; Seattle Art Museum; Tacoma Art Museum; Western Gallery, Western Washington University, Bellingham; Whatcom Museum of History and Art, Bellingham. Photo Paul Brower. © 2001 Brice Marden/Artists Rights Society (ARS), New York.

For both Minimalism and Pop Art the picture surface or working surface did not imitate the spatial logic of the real world or a picture plane. Depicted as flat and opaque, drawings in Minimalism were made to remain on the surface. There was no intent to move the viewer beyond or through the surface. This is consistent in the work of Marden, Stella, Martin, Ryman, and Poons. The idea of expressive content was eliminated. There was no hidden psychological meaning to the work. As Stella once said, "What you see is what you see." The idea of the imagination as the force behind the mark was replaced by the process being the important force in the work. Materials gained new importance. There was no interaction between the marks and what the artist did next. There are "no accidents" in Minimalism the painter Frank Okada told me. The artist planned the approach with a choice of materials, marks, and colors to fill the surface of the picture from start to finish.

Brice Marden employed the grid in the drawing above like a scaffold for the drawing. The grid holds the graphite marks; it is an underlying structure that organizes and orders the space. The graphite laid over the grid takes on an extremely physical presence. The drawing is about the quality of graphite and the quality of the graphite is determined in its application. Minimalism strongly investigated the properties and possibilities of the materials of art and brought to art new materials such as plastic, roplex, an early form of a plastic gel that hardened, and vacuforming, a process where a plastic form was made from a mold. Virtually anything you could make a mark with could be appropriated as an art material.

Minimalism gravitated toward geometric forms, repetition, and modular sequences that created endless and real space. It sought ways to reveal itself to the spectator in a physical sense that was literal, not a metaphor or a representation of something else.

Frank Stella eliminated the rectangle as the definitive shape of painting. In so doing he eliminated any possible reference to the picture plane as a window into the space. The Renaissance concept of a window was abandoned for the flat surface of a shaped canvas. Now the exterior shape reflected the internal divisions. The *Eccentric Polygons* on the right are shaped prints. The edge of the painting was no longer a container of the pictorial elements. "The whole was the sum of its parts," Stella once said in a interview. Stella called the work a "deductive structure." He began working in series in addition to devising the deductive structure concept, which defined the generating force for the image. Organizing his work as a series established a mechanism, a director, that was external to the work while shaping its contents. He set the parameters of a series by first assigning a family of shapes, predetermining the color or colors, and determining the other variables such as the thickness of line, and lines for the general divisions, of one particular series theme. This process with predetermined compositional elements generated the individual works in the series.

The images were deprived of content or meaning. The geometric structure found no metaphor in the viewers' consciousness that would make them think or say, "Oh, that reminds me of . . ." Minimalism wasn't cold—it was indifferent, ironic and sarcastic. It was intellectually, not emotionally based. The subject matter was removed, as were the brush marks, eliminating content. The visual reality of the painting once it was a shaped object included the space of the walls around it as it undermined the convention of the rectangular format.

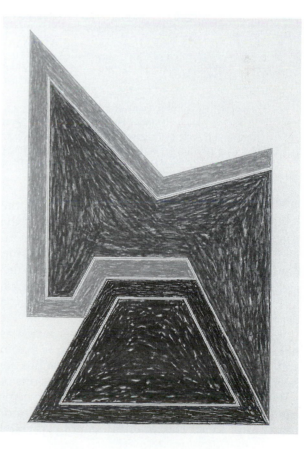

Frank Stella, b. 1936, *Eccentric Polygons*, 1974, [One of a portfolio of 11]. Lithograph/silkscreen prints, edition of 100, 56.5 × 43.8 cm each. 76.19 VWF. Virginia Wright Fund. Washington Art Consortium: Henry Art Gallery, University of Washington, Seattle; Museum of Art, Washington State University, Pullman; Northwest Museum of Arts and Culture, Spokane; Seattle Art Museum; Tacoma Art Museum; Western Gallery, Western Washington University, Bellingham; Whatcom Museum of History and Art, Bellingham. Photo Paul Brower. © 2001 Frank Stella/Artists Rights Society (ARS), New York.

Agnes Martin, b. 1912, *Untitled*, 1965. Pencil, 23 × 22.5 cm. 74.1 VWF. Virginia Wright Fund.
Washington Art Consortium: Henry Art Gallery, University of Washington, Seattle; Museum of Art,
Washington State University, Pullman; Northwest Museum of Arts and Culture, Spokane; Seattle Art
Museum; Tacoma Art Museum; Western Gallery, Western Washington University, Bellingham;
Whatcom Museum of History and Art, Bellingham. Photo Paul Brower.

The division between the means and the ends vanished with the art of this period. In the 1960s and 1970s Minimalism rejected the conventional strategies of drawing. The relationship between artistic tools and materials was reevaluated, and Minimalist artists refused to rely on technique or composition as a way to judge a drawing.

Agnes Martin's work is about perfection as her mind defines perfection. Her feeling is that in spite of this desire for perfection, the paintings are never perfect. In her work all literary allusions or representations have vanished. Her work seems calm, but it is a result of an intensive painting or drawing process. This intensity is not expressed by gestural brush work but by pursuing the idea for the painting day after day. She rejects most of her paintings, painting over them until only a few are left. In her work she creates a space for perception line by line: "My paintings have neither object nor space nor anything—no forms. They are light, lightness, about merging, about formlessness, breaking down form.... A world without objects, without interruption, making a work without interruption or obstacle. It is to accept the necessity of the simple direct going into a field of vision as you would cross an empty beach to look at the ocean." Her drawings and paintings are timeless. Sitting in the middle of her series of white paintings, while you look at them they

Modern to Contemporary Drawing

begin moving off the surface of the canvas into the space between you and their surface. They seem to expand as you look at them. The lines in her work are perfect lines of high quality. It is hard to imagine they were made by the human hand rather than a machine. You experience her work more than look at it in an exhibition.

In her writings Martin addresses the unity of truth and beauty in a work of art. She says in her book *Writings (Schriften)*, "Works of art have successfully represented our response to reality from the beginning. Reality, the truth about life and the mystery of beauty are all the same. . . . The manipulation of materials in artwork is a result of this state of mind. The artist works by awareness of his own state of mind."

Robert Ryman concentrated on the nuances of the abstract mark. He restricted himself to an all-white palette from the beginning of the 1960s. This heightened the "pure" reading of each component in the painting—the mark, the surface, the support, and the way the support is attached to the wall. His work is subtle: there are no metaphors and he is defining the mark. The grid provides a structure to arrange and present the matter of the work. For Ryman the grid is the infrastructure for a series of repeated marks.

For Larry Poons on the right the grid serves to methodically organize what he might call a visual incident. The organization of the lines creates an optical illusion that can be perceived to move endlessly through space. It has not been framed or bordered. The edges are open—these lines could be drawn to eternity. Unlike minimal sculpture where a sense of endless space can be physically constructed, painting must rely on illusion to create the sense that the space is expanding indefinitely.

Robert Ryman, b. 1930, *Yellow Drawing #5*, 1963. Charcoal, pencil and white pastel, 37.5 × 38 cm. 76.16 VWF. Gift of Virginia and Bagley Wright. Virginia Wright Fund. Washington Art Consortium: Henry Art Gallery, University of Washington, Seattle; Museum of Art, Washington State University, Pullman; Northwest Museum of Arts and Culture, Spokane; Seattle Art Museum; Tacoma Art Museum; Western Gallery, Western Washington University, Bellingham; Whatcom Museum of History and Art, Bellingham. Photo Paul Brower.

Larry Poons, b. 1937, *Untitled*, ca. 1963. Pencil, 20 × 40 cm. 76.15 VWF. Gift of Charles Cowles. Virginia Wright Fund. Washington Art Consortium: Henry Art Gallery, University of Washington, Seattle; Museum of Art, Washington State University, Pullman; Northwest Museum of Arts and Culture, Spokane; Seattle Art Museum; Tacoma Art Museum; Western Gallery, Western Washington University, Bellingham; Whatcom Museum of History and Art, Bellingham. Photo Paul Brower.

Modern to Contemporary Drawing

Robert Morris, b. 1931, *Blind Time XIX,* 1973. Graphite, 88 × 116 cm. 74.12 VWF. Virginia Wright Fund. Washington Art Consortium: Henry Art Gallery, University of Washington, Seattle; Museum of Art, Washington State University, Pullman; Northwest Museum of Arts and Culture, Spokane; Seattle Art Museum; Tacoma Art Museum; Western Gallery, Western Washington University, Bellingham; Whatcom Museum of History and Art, Bellingham. Photo Paul Brower. © 2001 Robert Morris/Artists Rights Society (ARS), New York.

PROCESS ART

Robert Morris moved away from Minimalism, into Process Art. Morris was a sculptor who was concerned with constructing an image of the body's space. Traditionally the human figure is a medium of sculpture, and although it appears in an abstract guise here. it still provides the foundation for the work. *Blind Time XIX* was constructed using powdered graphite applied directly by the artist's fingers. The surface mirrors touch itself. Here Morris allows the movement of the body to determine the outcome of the drawing. Morris made ninety-four drawings—in this series—*Blind Time,* blindfolded which eliminated his own vision from the process.

Morris set himself the task of covering a sheet of paper evenly with strokes of graphite in a predesignated amount of time for each drawing. The resulting images were a symmetrical projection of the internal plane of the body. The drawn space did not represent images or ideas but was the result of a particular act of expression which resulted from the activities of grasping, touching placing and reaching by the body. Morris often used materials considered impoverished in the tradition of art. His use of indiscriminate gestures and random acts such as hanging, rolling, scattering, and splashing moved making art into a new realm.

Drawing was a very compatible medium for Process Art, as drawing directly registers the process of the artist making the strokes. A drawing made by the artist's hand speaks to the hand's decisions. In Process Art drawing is no longer object-based work. Instead of representing something else, now drawing itself is the subject.

290

Modern to Contemporary Drawing

Michael Heizer, b. 1944, *Dissipate,* 1968. Collage, matches, tape, ballpoint pen, 34 × 35 cm. 75.9VWF. Virginia Wright Fund. Washington Art Consortium: Henry Art Gallery, University of Washington, Seattle; Museum of Art, Washington State University, Pullman; Northwest Museum of Arts and Culture, Spokane; Seattle Art Museum; Tacoma Art Museum; Western Gallery, Western Washington University, Bellingham; Whatcom Museum of History and Art, Bellingham. Photo Paul Brower.

EARTHWORKS AND SITE SPECIFIC ART

Michael Heizer pioneered the new genre of Site-Specific Art, or art that defines itself in its precise interaction with the particular place for which it was conceived. Heizer grew up in a family of geologists and archaeologists in Northern California. His affinity for the landscape grew into doing "dirtwork." One of his drawings was made by driving his motorcycle at a site in Nevada and photographing the tracks. Once again illusionism is rejected by focusing on the actual mass and weight of real cuts into the ground or real walls. The idea of art as a portable object was attacked, as were the institutions that showed art during these years. In 1969 Heizer with other artists rejected the museums and galleries that could neither show nor sell their major works. *Dissipate,* above, is a notation for one of the site-specific landscape-sculptures that would be executed by cutting trenches into the soil of the Nevada desert. Heizer has cut trenches 1,500 feet long, 30 feet wide, and 50 feet from top to bottom. His work can be seen only from afar; close up it can be experienced only part by part.

Anselm Kiefer, German, b. 1945, *The Staff* (*Der Stab*). Collage, melted lead, acrylic, charcoal, photographic emulsion, and leaves on photograph, mounted on paperboard, 27¹¹⁄₁₆ × 39½″. (70.3 × 103.0 cm.) Museum Purchase, 1985, Hirshhorn Museum and Sculpture Garden.

Process Art was continuing and evolving into the eighties with artists like Anselm Kiefer, Joseph Beuys, and Donald Sultan who expanded the list of materials that could be used in painting and drawing. Kiefer works in the German romantic tradition. Unlike the art of the late sixties and seventies, his work has emotional meaning and makes direct references to historical themes. It parallels mythology, including that of the Greek, Egyptian, early Christian, Jewish Cabbala, and Nordic cultures. Feeling that science does not provide the answers to the questions he has about life and the universe he has researched the major world religions.

Kiefer admired the materiality of Joseph Beuy's work, the American Minimalists, and Process artists of the sixties. He was attracted to real materials for his work for their presence and symbolism. He has made books of lead and paintings with straw, both of which change with oxidations and exposure during their time on exhibition.

Donald Sultan grew up when Minimalism and geometric abstraction were the dominant style. He inherited the grid, which is the underlying structure of the tiles he uses to compose his large works. Like moderns before him, he maintains the sense of flatness in his work with the silhouette of shapes. The tarred surface and the extensive structure he builds to physically support his work reference the material advances of the sixties and seventies. The range of images in Sultans' work runs from the Baroque through Impressionism to Abstract Expressionism.

Modern to Contemporary Drawing

Donald Sultan, American, b. Asheville, North Carolina, 1951, *Plant*, May 29, 1985. Painting, Latex, tar and fabric on vinyl tile mounted on fiberboard, 96 × 96". (243.9 × 243.9 cm). Thomas M. Evans, Jerome L. Greene, Joseph H. Hirshhorn, and Sydney and Frances Lewis Purchase Fund, 1985. Hirshhorn Museum and Sculpture Garden. 85.30.

His recognizable objects are defined with sharp figure-ground contrasts and sometimes atmospheric surroundings. For Donald Sultan paintings and drawings are in a continuous state of formulation. He will take a theme and try out variations, watching where the work takes him (an idea directly out of Abstract Expressionism). He takes his ideas from the world around him. His subjects may be the industrial landscape, chimney stacks, street lamps, explosions, or shapes of fruits and flowers. He uses modern life, the world of common objects (relating directly back to Pop Art) as his subjects. He looks for experiences that distinguish life today from what's gone before. His choice of materials gives his work a strong physical appearance. His modernness could be characterized by three things: its visual and stylistic level, his use of nonart materials, and his choice of subject as well as his source of subject. His paintings often look like drawings.

Modern to Contemporary Drawing

POSTMODERNISM

Phillip Guston, 1913–80. Above, *Inscapes: Words and Images*, print, 1976. Color serigraph on paper, sheet: 44 × 32¹⁵⁄₁₆". (111.7 × 83.7 cm.). 78.97; below, painting, oil on paper 1971, 22¼ × 28⅛". (56.5 × 71.5 cm.). Bequest of Musa Guston, 1992. Hirshhorn Museum and Sculpture Garden.

Until the sixties the term modern art covered the new abstraction, cubism, surrealism, etc. The term "Postmodern" was first applied to architecture in the sixties and by the seventies it referred to a change in the studio arts as well. There is no well-defined line between the end of modernism and the beginning of postmodernism. It was more a change in thinking, not a change in an art style.

Guston was one of the leading New York School painters, who in his youth wanted to be a cartoonist and studied at home through a correspondence course. A rebel from the beginning, he was expelled from high school with Jackson Pollock for publishing and distributing a leaflet against the faculty for emphasizing sports. He never went back to school; instead he read art journals like *Transition* and *The Dial* working with other intellectuals and artists. Guston was a self-taught painter. His association with the Mexican muralists José Clemente Orozco and David Alfaro Siqueiros in Los Angeles altered both his politics and his painting style. In 1931 Guston painted Ku Klux Klansmen whipping a roped black man and hooded Klansmen armed with crude weapons huddled in front of a gallows. He left the paintings in a friend's bookstore. One morning a group of Klansmen and American Legionnaires carrying lead pipes and guns broke into the bookstore and shot the eyes and genitals out of the figures in the paintings. There were eyewitnesses and Guston sued but the judge disliked his leftist politics and dismissed the case. This was a lesson about "justice" he never forgot.

Guston's paintings from 1951 evolved from the artist's interaction with the paint and the surface. His palette was reduced to black, red, and white. For him, touch rather than gesture was important. He painted a sensual surface, rich and saturated, until by the end of the fifties he felt it was "too easy to elicit a response" with his sensuous abstractions. He moved through a gray-and-black period to the sixties, when drawing played an important role, allowing him to move between the figurative and the abstract. He struggled with self-doubt during the transition, doing the "pure" drawings—drawings without objects—and then the drawings of objects, books, shoes, buildings, hands, heads, and cigars. The figures finally won out, and he created a private iconography, a pictorial language that would influence Georg Baselitz, Anselm Kiefer, and other artists who in the eighties and nineties would return the figure and narrative to art.

Modern to Contemporary Drawing

Joan Brown, American, b. 1938–90, *Woman Resting,* collage, 1961. Gouache and fabric on paperboard, 30 × 31⅝". (76.2 × 80.3 cm.) Gift of Joseph H. Hirshhorn, 1966. JH61.522. The Hirshhorn Museum and Sculpture Garden.

FUNK

Joan Brown worked with the Funk assemblagists and collage makers in California in 1957. Funk attacked the boundary between the art forms and the clarity of communication in art. Artists working in the Funk style might cut underground film clips together, reassembling them in a random order that made no sense, or build assemblages out of materials at hand using an intuitive process of construction. Preconception was eliminated and the spontaneous was celebrated. The work was often humorous, usually threatening the perimeters of "good taste." Joan Brown's funky paint surface comes out of the beat or hip assemblage aesthetic. She studied with Elmer Bischoff in 1956 and was also influenced by Francis Bacon and Willem de Kooning. Densely painted expressionistic surfaces are characteristic of her work.

PROFILE OF ARTISTS: GOAT ISLAND

Goat Island performing *The Sea and Poison,* 1998. Performers from front left: Mark Jeffery, Bryan Saner, Karen Christopher, and Matthew Goulish (front right). Photograph courtesy of Goat Island.

Here drawing is used to describe movement and plan a performance. What is two dimensional becomes three-dimensional. Lin Hixson, the director of Goat Island began her career in the studio arts. For her drawing is a natural tool to communicate her ideas in organizing a performance by Goat Island. Drawing provides her the first avenue for mapping out what will be a one to two hour performance in which she must coordinate four performers, the performance space, and the space of the audience.

Goat Island was founded in 1987. It is a nonprofit organization formed to produce collaborative performance works that are developed by its members. The Chicago-based group consists of Karen Christopher, Matthew Goulish, Mark Jeffery, Bryan Saner, C. J. Mitchell, the manager, and Lin Hixson, the director. All members contribute to the conception or idea for the work, the research, the writing, the choreography, the documentation, and the educational demands of the work.

"Characteristically we attempt to establish a spatial relationship with audiences, other than the usual proscenium theater situation, which may suggest a concept, such as sporting arena or paradeground or may create a setting for which there is no everyday comparison. We perform a personal vocabulary of movement, both dance-like and pedestrian that often makes extreme physical demands on the performers, and attention demands on the audience. We incorporate historical and contemporary issues through text and movement. We create visual/spatial images

to encapsulate thematic concerns. We place our performances in non-theatrical sites when possible. We research and write collaborative lectures for public events, and often publish either our own artists books, or in professional journals," said Lin Hixson.

In the drawing on the right, Lin Hixson has choreographed the section of *The Sea and Poison* called "Dead Red Buttons." The marks indicate where each performer starts and the direction they will move. The text below is a diagram for the performance and text directing more of the movements and interactions between the performers.

This work, *The Sea and Poison* investigates the effects of poison on the body and landscape including the pollution of time and space. The company focused their research on personal, historical and popular culture poisonings. The research ranged from the medieval choreographic epidemics known as Saint Vitus' Dance believed to have been caused by the mass consumption of contaminated bread to the poisoning of US troops and Iraqi civilians in the Persian Gulf War.

Goat Island has six completed works to date including: *Soldier, Child Tortured Man* (1987), *We Got a Date* (1989), *Can't Take Johnny to the Funeral* (1991), *It's Shifting, Hank* (1993), *How Dear to Me the Hour When Daylight Dies* (1996) and *The Sea and Poison* (1998).

Sequence following 5 impossible dances

(ending of 5th impossible dance)

K, B, MO go to star spots

M goes to new spot

all 4 do roll ending

B, K, MG, M go right into solos with B counting (no jumps or M's)

B, K, MG do solos exactly the same except they go back to star position and begin solos again right away

M does solos exactly the same except he is going counter direction to B, K, MG

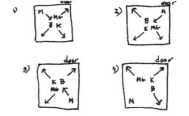

End of solos everyone goes to original Impossible Dance spots at M site. Everyone does roll.

M, Mg, K go put on backpacks and stand in a line

B goes to middle (George spot)

Music starts

B dances

Siren. Music stops.

M, MG, K go to Impossible dance spots

Put money on B

M, MG, B return to line

Illustrations by Lin Hixson directing the movements of Goat Island in their performance of *The Sea and Poison*.

Jonathan Borofsky, *Installation,* University of California, Irvine, 1977. Ink, Dayglow paint on wall (Detail shown here). Courtesy Paula Cooper Gallery.

CONCEPTUAL ART AND INSTALLATION

In the 1960s artists moved off paper and canvas onto the walls of the gallery, creating a new art called Installation.

Jonathan Borofsky graduated from Yale in 1966. He had stopped making objects and turned to Conceptual Art. In 1968 he started a piece that involved counting. He would write one number on a sheet a paper followed by the next number on a second sheet of paper. After counting for a few hours he began scribbling and drawing little figures on his paper. This led him to using both the numbers and figures in a painting. As of 1973 he had reached the number 2,208,287. The counting continues today.

Jonathan Borofsky, *Installation,* University of California, Irvine, 1977. Ink and paint on wall. Courtesy Paula Cooper Gallery.

In his show at the Paula Cooper Gallery in 1975 he filled the walls installing all the drawings he had been doing for the last year. He showed self-portraits, sketches on scraps of paper, and dreams he had written down. He censored nothing in an attempt to give people a sense of being inside the mind. Next he started drawing directly on the floor and walls of his studio. To transfer this work from the studio to the gallery he would use an opaque projector. Rather than arriving at the gallery with a number of objects to hang, Borofsky produced his shows out of a briefcase containing drawings to project. His purpose in drawing directly on the walls was to eliminate any sale of his work. He reasoned if you couldn't buy the work, then you would only come to interact with the work out of a genuine interest in the experience.

The installation pictured on these two pages was installed at the University of California, Irvine, in 1977. In this installation the drawing, *Blimp* was projected through a doorway and drawn on four separate surfaces, three walls and the edge of one wall. As installed, the drawing invites the viewer to walk through it. In this installation process Borofsky wants to activate the entire space, not allowing the viewer to focus on a single point. The viewer feels inside the work. Borofsky works as painters work on a canvas, moving around the space placing images in one part and balancing them with images in the other rooms or on other walls. He wants to create an energy. In this installation he used four walls, the ceiling, and the floor, which were colored green, pink, and yellow, to create a three-dimensional effect.

"I would find the key point of three-dimensional architectural interest in a room, the one I could do the most with, and play with the two-dimensional possibilities of a painting, trying to bring the two together."

Modern to Contemporary Drawing

Laura Vandenburgh, *Lacunae.*
Graphite, silverpoint, gouache, wood
and book, 15.5 × 50″. Courtesy of the
artist.

Laura Vandenburgh, *Still,* 1999. Graphite, gouache, mirrors, and
wood, 8 × 5.5″. Courtesy of the artist.

Laura Vandenburgh pieces are pencil and silverpoint drawings on wood panels and books. The units are hung as arrangements with other materials or in groups across the wall or across the corners. The photo top left shows a piece installed on the wall. As with other Installation Art, the viewers must make visual adjustments depending on the space between them and the wall. Some of the drawings on the prepared panels are derived from photographs in science books or textbooks. The piece above on the left is composed of drawings of tangled hair on each pale orange tile. The tiles are approximately four or five inch squares and rectangles. The drawing is light and visible only from a certain viewing distance. The hair reminds you of the drawing by Leonardo called *Deluge*. These hair piles are ambiguous—they could be clouds or a storm as well as hair.

She constructs the drawing out of birch panels that are gessoed and sanded. She then paints layers of gouache on the surface. The drawing is done in either graphite silverpoint. The silverpoint drawings are done with various types of metal wires mounted in a dowel. The images are rubbed back into surface by sanding and then returned with another layer of drawing. This is a slow process and rather like meditation, taking patience.

The piece on the bottom left is graphite on a 5.5 × 5.5″ primed or prepared birch panel. The two small squares placed above it are mirrors. When you see the drawing you see yourself at the same time, but you see only your eye or a part of your face. The artist has made you part of her piece.

Modern to Contemporary Drawing

Cy Twombly, b. 1929, *Untitled,* 1971. Chalk and gouache, 70 × 99.5 cm. 75.12 VWF. Virginia Wright Fund. Washington Art Consortium: Henry Art Gallery, University of Washington, Seattle; Museum of Art, Washington State University, Pullman; Northwest Museum of Arts and Culture, Spokane; Seattle Art Museum; Tacoma Art Museum; Western Gallery, Western Washington University, Bellingham; Whatcom Museum of History and Art, Bellingham. Photo Credit: Paul Brower.

CONCLUSION

Drawing has evolved from "the imitation of the most beautiful parts of nature in all figures," as Vasari defined it, through the requirement that draftsmanship demonstrate the highest technical skill in reproducing with absolute accuracy and precision everything that the eye sees, to being a reality in its own right. Drawing no longer represents something else—it is simply itself. The literalness with which the drawing's surface is stated and the sense that we cannot look through the surface into deep space is a major change from the Renaissance definition of drawing. Now the separation of the means and the ends in drawing has dissolved. Drawing today makes no claims that technique or composition determine a good drawing. The conventional strategies of drawing are rejected and the relationship between graphic tools and materials has been redefined. In the late

sixties and seventies drawing discredited and dismissed the idea of Gestalt, the idea of unified whole, and moved into Process Art, where the making of the art with often impoverished materials, in terms of art hierarchies or tradition, became its subject. There is one similarity between 1600 and 1970, then as now we can follow the path traveled by the artist's hand, each stroke registering the thinking process.

"Drawing," Ingres said, "is everything; it is all of art." Although he would not have acknowledged the drawings in the twentieth and twenty-first century as art, he would have understood the crucial role drawing has played. It has become an independent art form and has been critical in the development of modern painting.

As the contemporary sculptor, Richard Serra, has said, "There is no way to make a drawing—there is only drawing."

Index